P9-APS-013

ASYLUM

INSIDE THE CLOSED WORLD OF STATE MENTAL HOSPITALS

Photographs by

CHRISTOPHER PAYNE

With an essay by OLIVER SACKS

THE MIT PRESS CAMBRIDGE, MASSACHUSETTS
LONDON, ENGLAND

MIT Press books may be purchased at special quantity discounts
for business or sales promotional use. For information, please email:
special_sales@mitpress.mit.edu
or write to:
 Special Sales Department
 The MIT Press
 55 Hayward Street
 Cambridge, MA 02142.

Library of Congress Cataloging-in-Publication Data
Payne, Christopher, 1968–
Asylum : inside the closed world of state mental hospitals /
Christopher Payne ; with an essay by Oliver Sacks.
 p. ; cm.
 Includes bibliographical references.
ISBN 978-0-262-01349-9 (hardcover : alk. paper) 1. Photography.
2. Psychiatric hospitals—United States—Pictorial works.
I. Sacks, Oliver W. II. Title.
[DNLM: 1. Hospitals, Psychiatric—history—United States—Pictorial
Works. 2. Architecture as Topic—United States—Pictorial Works.
3. History, 19th Century—United States—Pictorial Works. 4. History,
20th Century—United States—Pictorial Works. WM 17 P346a 2009]
 RC439.P285 2009
 362.2'1—dc22
 2009003622

Produced, designed, composed, and edited by Scott-Martin Kosofsky
at the Philidor Company, Lexington, Massachusetts. www.philidor.com
Composed in Philidor Bodoni Text and The Sans with titles in Bureau
Grotesque and Eurostile. Prepress by Scott-Martin Kosofsky with
Christopher Payne.

FRONTISPIECE: Stairwell, Danvers State Hospital, Massachusetts.

Printed and bound in China by Everbest, using FSC-certified 157 gsm NEO Matte.
10 9 8 7 6 5 4 3 2

ASYLUM

INSIDE THE CLOSED WORLD OF STATE MENTAL HOSPITALS

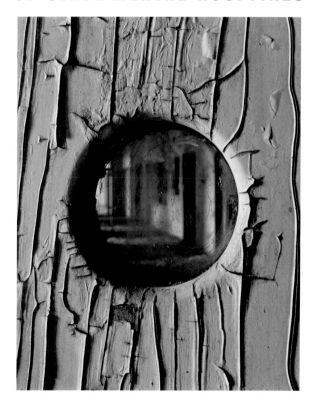

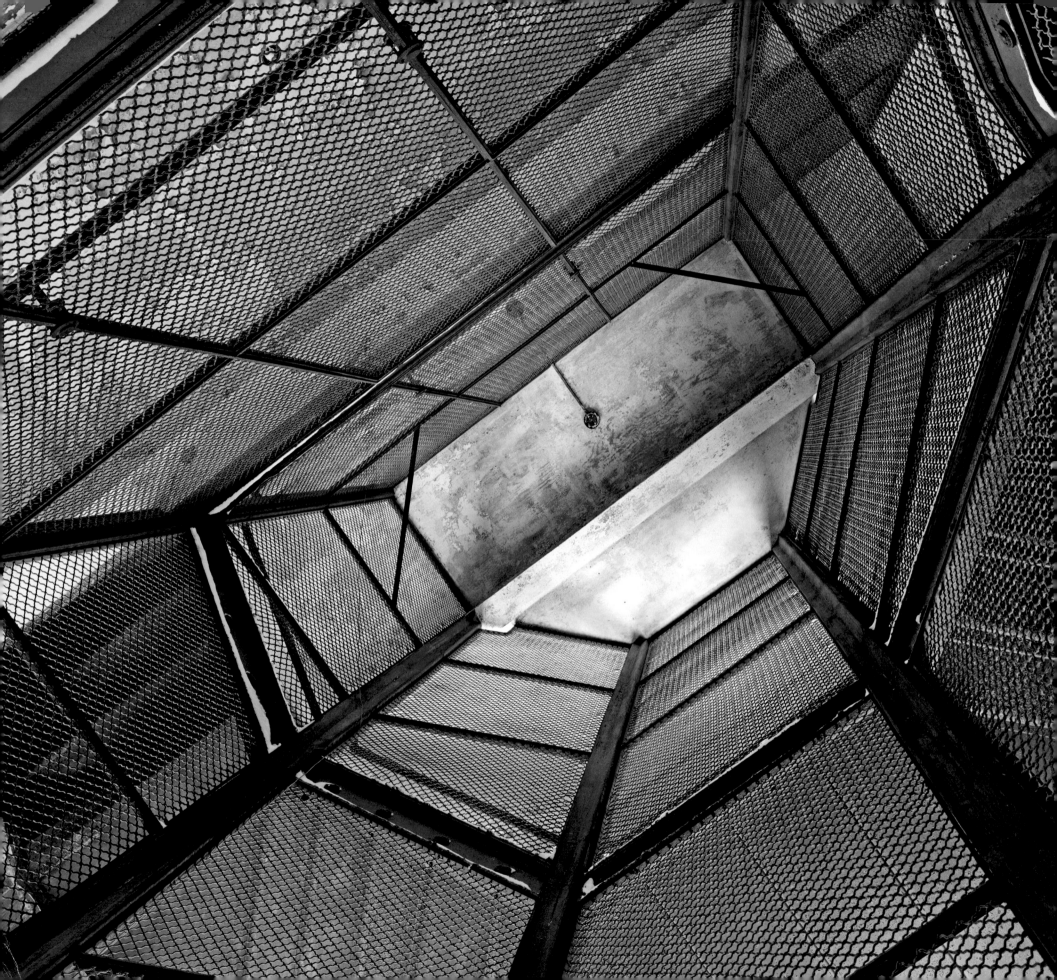

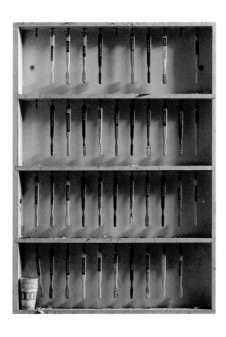

CONTENTS

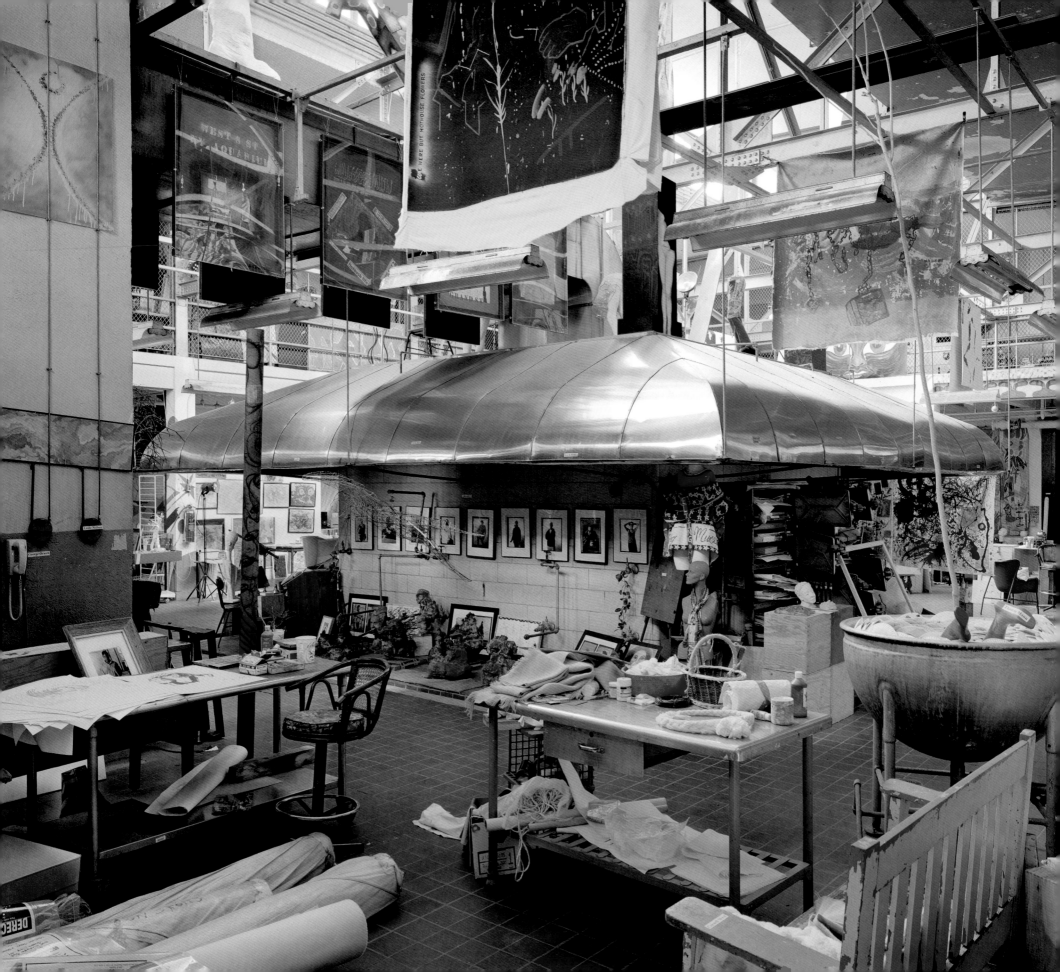

OLIVER SACKS
ASYLUM

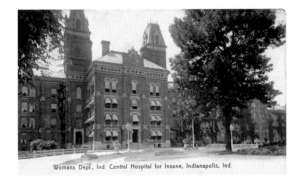

Womans Dept., Ind. Central Hospital for Insane, Indianapolis, Ind.

ABOVE: Women's Department, Indiana Central Hospital for the Insane, Indianapolis, ca. 1890.

LEFT: The Living Museum at Creedmoor State Hospital, Queens, New York, 2005.

WE TEND TO THINK of mental hospitals as snake pits, hells of chaos and misery, squalor and brutality. Most of them, now, are shuttered and abandoned—and we think with a shiver of the terror of those who once found themselves confined in such places. So it is salutary to hear the voice of an inmate, of one Anna Agnew, judged insane in 1878 (such decisions, in those days, were made by a judge, not a physician) and "put away" in the Indiana Hospital for the Insane. Anna's admission to the hospital was precipitated by her increasingly distraught suicide attempts, and her attempt to kill one of her children with laudanum. She felt profound relief when the institution closed protectively around her, and most especially by having her madness recognized:

> Before I had been an inmate of the asylum a week, I felt a greater degree of contentment than I had felt for a year previous. Not that I was reconciled to life, but because my unhappy condition of mind was understood, and I was treated accordingly. Besides, I was surrounded by others in like bewildered, discontented mental states in whose miseries . . . I found myself becoming interested, my sympathies becoming aroused. . . . And at the same time, I too, was treated as an insane woman, a kindness not hitherto shown to me. Dr. Hester being the first person kind enough to say to me in answer to my question, "Am I insane?" "Yes, madam, and very insane too!" . . . "But," he continued, "we intend to benefit you all we can and our particular hope for you is the restraint of this place." . . . I heard him [say] once, in reprimanding a negligent attendant: "I stand pledged to the State of Indiana to protect these unfortunates. I am the father, son, brother and husband of over three hundred women . . . and I'll see that they are well taken care of!"

In a memoir, Anna also spoke (as Lucy King recounts in her book, *From Under the Cloud at Seven Steeples*) of how crucial it was, for the disordered and disturbed, to have the order and predictability of the asylum:

> This place reminds me of a great clock, so perfectly regular and smooth are its workings. The system is perfect, our bill of fare is excellent, and varied, as in any well-regulated family. . . . We retire at the ringing of the telephone at eight o'clock, and an hour later, there's darkness and silence . . . all over this vast building.

The old term for a mental hospital was "lunatic asylum," and asylum, in its original usage, meant refuge, protection, sanctuary—in the words of the *Oxford English Dictionary*, "a benevolent institution affording shelter and support to some class of the afflicted, the unfortunate, or destitute." From at least the fourth century, monasteries, nunneries, and churches were places of asylum. And to these were added secular asylums, which (so Michel Foucault suggests) emerged with the virtual annihilation of Europe's lepers by the Black Death and the use of the now-vacant leprosaria to house the poor, the ill, the insane, and the criminal. Erving Goffman, in his famous book *Asylums*, ranks all these together as "total institutions"—places where there is an unbridgeable gulf between staff and inmates, where rigid rules and roles preclude any sense of fellowship or sympathy, and where inmates are de-individuated,

deprived of all autonomy or freedom or dignity or self, reduced to nameless ciphers in the system.

By the 1950s, when Goffman was doing his research at St. Elizabeth's Hospital in Washington, D.C., this was indeed the case, at least in many mental hospitals. But this was hardly the intent of the high-minded citizens and philanthropists who had been moved to found many of America's lunatic asylums in the early and middle years of the nineteenth century. In the absence of specific medications for mental illness at this time, "moral treatment"—a treatment directed to the whole individual, their potential for physical and mental health, not just a malfunctioning part of their brain—was considered the only humane alternative.

These first state hospitals were often palatial buildings, with high ceilings, lofty windows, and spacious grounds, providing abundant light, space, and fresh air, along with exercise and a varied diet. Most asylums were self-supporting and grew or raised most of their own food. Patients would work in the fields and dairies, work being considered a central form of therapy for them, as well as supporting the hospital. Community and companionship, too, were central, vital for patients who would otherwise be isolated in their own mental worlds, driven by their own obsessions or hallucinations. Also crucial was the recognition and acceptance of their insanity (this, for Anna Agnew, was a great "kindness") by the staff and other inmates around them. Finally, coming back to the original meaning of asylum, these hospitals provided control and protection for patients, both from their own (perhaps suicidal or homicidal) impulses and from the ridicule, isolation, aggression, or abuse so often visited upon them in the outside world. Asylums offered a life with its own special protections and limitations, a simplified and narrowed life perhaps, but within this protective structure, the freedom to be as mad as one liked and, for some patients at least, to live through their psychoses and emerge from their depths as saner and stabler people.

In general, though, patients remained in asylums for the long term. There was little preparation for a return to life outside, and perhaps after years cloistered in an asylum, residents became "institutionalized" to some extent, and no longer desired, or could no longer face, the outside world. Patients often lived in state hospitals for decades, and died in them—every asylum had its own graveyard. (Such lives have been reconstructed with great sensitivity by Darby Penney and Peter Stastny in their book *The Lives They Left Behind*.)

It was inevitable, under these circumstances, that the asylum population should grow—and individual asylums, often immense to begin with, came to resemble small towns. Pilgrim State Hospital, on Long Island, housed more than 14,000 patients at one time. It was inevitable, too, that with these huge numbers of inmates, and inadequate funding and staffing, state hospitals fell short of their original ideals. By the latter years of the nineteenth century, they had already become bywords for squalor and negligence, and were often run by inept, corrupt, or sadistic bureaucrats—a situation that persisted through the first half of the twentieth century.

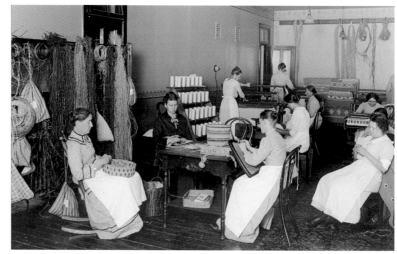
Hudson River State Hospital, Poughkeepsie, New York

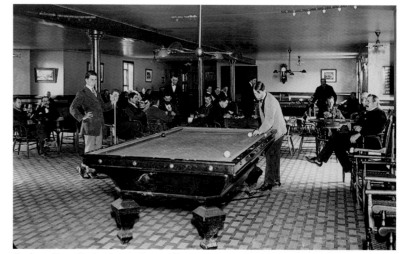
Hudson River State Hospital, Poughkeepsie, New York

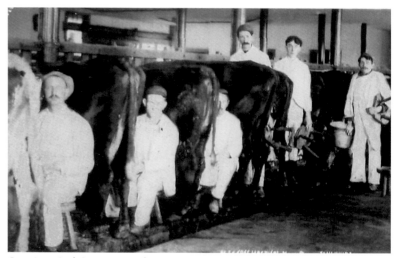
Greystone Park State Hospital, Morristown, New Jersey

There was a similar evolution, or devolution, at Creedmoor Hospital in Queens, New York, which had been established in 1912, very modestly, as the Farm Colony of Brooklyn State Hospital, holding to the nineteenth-century ideals of space, fresh air, and farming for its patients. But Creedmoor's population soared—it reached 7,000 by 1959—and, as Susan Sheehan detailed in her 1982 book, *Is There No Place on Earth for Me?*, it became, in many ways, as wretched, overcrowded, and understaffed as any other state hospital. And yet the original gardens and livestock were maintained, providing a crucial resource for some patients, who could care for animals and plants, even though they might be too disturbed, too ambivalent, to maintain relationships with other human beings. There were gymnasia, a swimming pool, and recreation rooms with Ping-Pong and billiards tables; there was a theater and a television studio, where patients could produce, direct, and act in their own plays—plays that, like the Marquis de Sade's theater in the eighteenth century, could allow creative expression of their own issues and predicaments. Music was important at Creedmoor—there was a small patient orchestra—and so, too, was visual art. (Even today, with the bulk of the hospital closed down and falling into decay, the remarkable Living Museum at Creedmoor provides patients with the materials and space to work on painting and sculpture. One of the Living Museum's founders, Dr. Janos Marton, calls it a "protected space" for the artists.)

There were gigantic kitchens and laundries, and these, like the gardens and livestock, provided work and "work therapy" for many of the patients, along with opportunities for learning some of the skills of daily life, which, with their withdrawal into mental illness, they might never have acquired before. And there were great communal dining rooms, which, at their best, fostered a sense of community and companionship.

Thus, even in the 1950s, when conditions in state hospitals were so dismal, some of the good aspects of an asylum life were still to be found in them. There were often, even in the worst hospitals, pockets of human decency, of real life and kindness.

The 1950s brought the advent of specific antipsychotic drugs, drugs that seemed to promise, if not a "cure," at least effective alleviation or suppression of psychotic symptoms. The availability of these drugs strengthened the idea that hospitalization need not be custodial or lifelong. If a short stay in the hospital could "break" a psychosis and be followed by patients returning to their own communities, where they could be maintained on medication and monitored in outpatient clinics, then, it was felt, the prognosis, the whole natural history of mental illness, might be transformed, and the vast and hopeless population of asylums drastically reduced.

During the 1960s, a number of new state hospitals were built on this premise, dedicated to short-term admissions. Among these was Bronx State Hospital (now Bronx Psychiatric Center). Bronx State had a gifted and visionary director and a handpicked staff when it opened in 1963, but for all its forward-looking orientation, it had to deal with an enormous influx of patients from the older hospitals, which were now

starting to be closed down. I started work as a neurologist there in 1966 and, over the years, I was to see hundreds of such patients, many of whom had spent most of their adult lives in hospitals.

There were, at Bronx State as at all such hospitals, great variations in the quality of patient care: there were good, sometimes exemplary, wards, with decent, thoughtful physicians and attendants, and bad, even hideous ones, marked by negligence and cruelty. I saw both of these in my twenty-five years at Bronx State. But I also have memories of how some patients, no longer violently psychotic or on locked wards, might wander tranquilly around the grounds, or play baseball, or go to concerts or films. Like the patients at Creedmoor, they could produce shows of their own, and at any time, patients could be found reading quietly in the hospital library or looking at newspapers or magazines in the dayrooms.

Sadly and ironically, soon after I arrived in the 1960s, work opportunities for patients virtually disappeared, under the guise of protecting their rights. It was considered that having patients work in the kitchen or laundry or garden, or in sheltered workshops, constituted "exploitation." This outlawing of work—based on legalistic notions of patients' rights and not on their real needs—deprived many patients of an important therapeutic mode, something that could give them incentives and identities of an economic and social sort. Work could "normalize" and create community, could take patients out of their solipsistic inner worlds, and the effects of stopping it were demoralizing in the extreme. For many patients, who had previously enjoyed work and activity, there was now little left but sitting, zombielike, in front of the now never-turned-off TV.

Deinstitutionalization, starting as a trickle in the 1960s, became a flood by the 1980s, even though it was clear by then that it was creating as many problems as it solved. The "sidewalk psychotics" in every major city were stark reminders that no city had an adequate network of psychiatric clinics and halfway houses, or the infrastructure to deal with the hundreds of thousands of patients who had been turned away from the remaining state hospitals.

The antipsychotics, the medications that had ushered in this wave of deinstitutionalization, often turned out to be much less miraculous than originally hoped. They might lessen the "positive" symptoms of mental illness—the hallucinations and delusions of schizophrenia—but they did little for the "negative" symptoms—the apathy and passivity, the lack of motivation and ability to relate to others—symptoms that were often more disabling than the positive symptoms. Indeed (at least in the manner they were originally used), the antipsychotics tended to lower energy and vitality and produce an apathy of their own. Sometimes there were intolerable side effects, movement disorders like parkinsonism or tardive dyskinesia, which could persist for years after the medication had been stopped. And sometimes patients were unwilling to give up their psychoses, psychoses that gave meaning to their worlds and situated them at the center of these worlds. So it was common, and remains common,

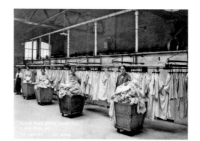
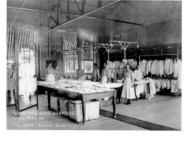

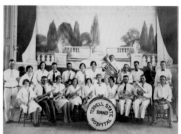
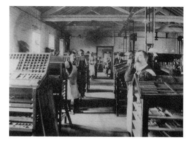
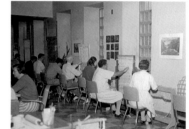
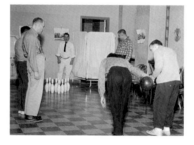
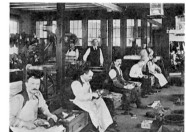
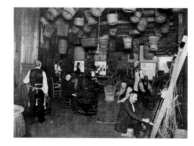
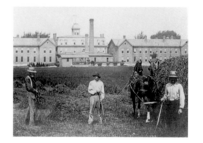

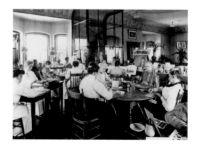

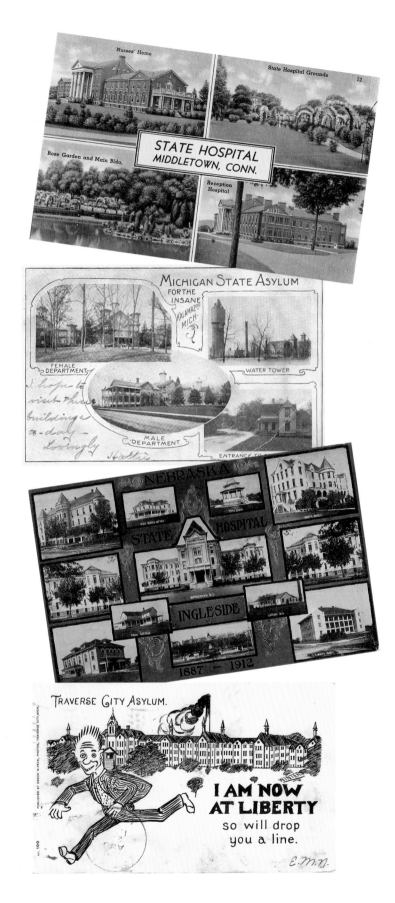

for patients to stop taking the antipsychotic drugs they had been prescribed, unless there was elaborate supervision and support.

Thus many patients who were given antipsychotic drugs and discharged had to be readmitted weeks or months later. I saw scores of such patients, many of whom said to me, in effect, "Bronx State is no picnic, but it is infinitely better than starving, freezing on the streets, or being knifed on the Bowery." The hospital, if nothing else, offered protection and safety—offered, in a word, asylum.

By 1990 it was very clear that the system had overreacted, that the wholesale closings of state hospitals had proceeded far too rapidly, without any adequate alternatives in place. It was not wholesale closure that the state hospitals needed, but fixing: dealing with the overcrowding, the understaffing, the negligences and brutalities. For the chemical approach, while necessary, was not enough. We forgot the benign aspects of asylums, or perhaps we felt we could no longer afford to pay for them: the spaciousness and sense of community, the place for work and play, and for the gradual learning of social and vocational skills—a safe haven that state hospitals were well-equipped to provide.

ONE MUST NOT BE TOO ROMANTIC about madness, or the madhouses in which the insane were confined. There is, under the manias and grandiosities and fantasies and hallucinations, an immeasurably deep sadness about mental illness, a sadness that is reflected in the often grandiose but melancholy architecture of the old state hospitals. As Chris Payne's photographs attest, their ruins, desolate today in a different way, offer a mute and heartbreaking testimony both to the pain of those with severe mental illness and to the once-heroic structures we built to try to assuage that pain. Payne is a visual poet as well as an architect by training, and he has spent years finding and photographing these buildings—often the pride of their local communities and a powerful symbol of humane caring for those less fortunate. His photographs are beautiful images in their own right, and they also pay tribute to a sort of public architecture that no longer exists. They focus both on the monumental and the mundane, the grand facades and the peeling paint. Payne's photographs are powerfully elegiac, perhaps especially so for someone who has worked and lived in such places and seen them full of people, full of life. The desolate spaces evoke the lives that once filled them, so that, in our imaginations, the empty dining rooms are once more thronged with people, and the spacious dayrooms with their high windows again contain, as they once did, patients quietly reading or sleeping on sofas or (as was perfectly permissible) just staring into space. They evoke for me not only the tumultuous life of such places, but the protected and special atmosphere they offered when, as Anna Agnew noted in her diary, they were places where one could be both mad and safe, places where one's madness could be assured of finding, if not a cure, at least recognition and respect, and a vital sense of companionship and community.

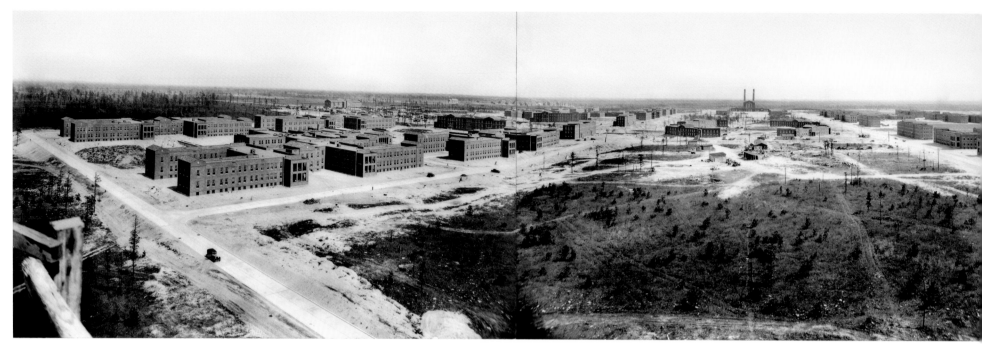

Pilgrim State Hospital, New York, in construction, 1933. Courtesy of Pilgrim Psychiatric Center.
Opposite page: A map of the Pilgrim complex.

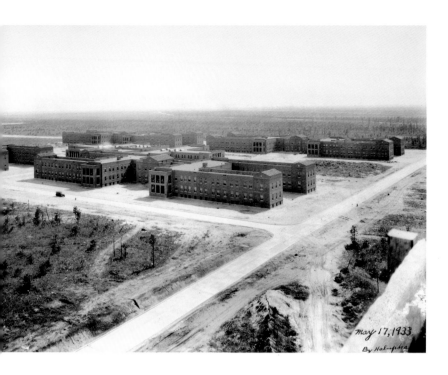

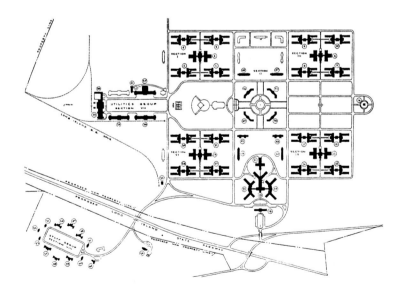

CHRISTOPHER PAYNE
THE STATE MENTAL HOSPITALS
THEIR ORIGIN, CONSTRUCTION, AND DEMISE

IN 1928, THE STATE OF NEW YORK purchased 1,000 acres of farmland on Long Island to build the world's largest mental hospital. The four existing hospitals serving the metropolitan area had become overcrowded, and the new Pilgrim State Hospital, with its up-to-date facilities and 10,000 new beds, was intended to provide much-needed relief. By the mid-1950s, Pilgrim State had grown into a small city, with a population exceeding 14,000 patients. Yet it was not the only mental hospital in the vicinity: not far from it were Central Islip State Hospital and Kings Park State Hospital, the second and third largest hospitals in the state. The three combined had over 33,000 residents, making this stretch of Long Island the mental hospital capital of the world. But by 2002, when I first visited there, the two smaller hospitals were closed, and Pilgrim State resembled a ghost town, with most of its buildings abandoned, streets quiet, and residents largely gone.

New York was not alone in providing care for the mentally ill. From the midnineteenth to the early twentieth century, close to 300 institutions for the insane were built throughout the United States. In 1840, there were only eighteen asylums, but by 1880 that number had jumped to 139. Even in the midst of the Great Depression and World War II, when shortages of resources, funding, and qualified staff burdened the system, the hospitals survived and continued to be filled beyond capacity. A nationwide survey published in Illinois, in 1948, counted 539,000 patients in 261 state mental hospitals and residential schools for "mental defectives," sufferers of epilepsy, and other neurologically handicapped persons. And so it was that one of every 263 Americans lived in such institutions—a statistic that did not include patients in private hospitals. The cost to the State of New York, which alone cared for 95,000 people in 27 institutions, and employed more than 24,000 persons to do so, accounted for over a quarter of the state's annual budget.

For more than half the nation's history, vast mental hospitals were prominent architectural features on the American landscape. Practically every state could claim to have at least one. The catalyst for their creation was the schoolteacher-turned-reformer Dorothea Dix (1802–1887), who, beginning in the early 1840s, traveled the country lobbying states to build hospitals for the proper care of the "indigent insane." Dix's humanitarian appeals were persuasive, and they were well timed: expansionist America was eager to erect large civic institutions that would serve as models of an enlightened society. Public schools, universities, prisons, and insane asylums were all part of this agenda, though high-minded rhetoric was not always matched by the less-than-altruistic motives of politicians. As David J. Rothman asserts in *The Discovery of the Asylum*, political leaders intended to "buttress the social order" and to counter the perceived ills of increased urbanization, immigration, and population growth. This was often achieved by moving problem populations out of view.

Dix was the catalyst for the first wave of asylum building, but it was Thomas Story Kirkbride (1809–1883) who provided the blueprint for their expansion. As superintendent of the Pennsylvania Hospital for the Insane in Philadelphia, Kirkbride drew

on his own experience and travels abroad to European counterparts to devise a model asylum. His work culminated in the treatise, *On the Construction, Organization, and General Arrangements of Hospitals for the Insane* (first published in 1854 and revised in 1880), which was endorsed by the Association of Medical Superintendents of American Institutions for the Insane (AMSAII, the precursor to the American Psychiatric Association) and adopted as its guidebook for the construction of mental hospitals in the United States.

A skilled administrator, Kirkbride was obsessed with asylum design and management. He believed that a well-designed and beautifully landscaped hospital could heal mental illness, and that by removing the afflicted from society and placing them in a peaceful environment filled with a regimen of structured activity performed under the paternal supervision of a strong superintendent, many would regain their senses and be able to reenter the outside world as improved individuals. This concept of therapy was known as "moral treatment." As the program spread throughout the country and giant investments were made in the construction of the hospitals, so, too, grew the profession of psychiatry. The historian Carla Yanni, in her definitive study, *The Architecture of Madness*, observed that "the professionalization of psychiatry *as a specialty* took place in asylums," as it became publicly accepted that lunacy could only be cured in a hospital, not at home.

The asylum building itself was the cornerstone of Kirkbride's idea. It consisted of a central administration building flanked symmetrically by linked pavilions, each stepping back to create a shallow "V," like a formation of birds in flight. The prescribed layout facilitated a hierarchical segregation according to sex, illness, and even social class. The most disturbed patients were housed in the outermost wards, while those more socially adjusted lived closer to the center, where the staff lived. The stepped arrangement of the wards made the hospital easier to manage while at the same time admitted an abundance of light with views of the outdoors.

The location of the hospitals, in the countryside, away from the city, afforded ample privacy and an abundance of land for farming and gardening, which were integral to the patients' daily regimen of exercise. The land immediately surrounding the asylum was appropriated for pleasure grounds, where patients could enjoy a relaxing stroll and take in picturesque views. Frederick Law Olmsted and Calvert Vaux designed many of these landscapes, some of which became prototypes for public parks. The grounds provided relief from the indoor sights and sounds of the asylum and also served as a dramatic setting for the buildings, enhancing their grandeur. As visitors to the asylums never penetrated beyond the public lobbies of the administration buildings, it was these spaces and the landscapes that acted as the chief agents of propaganda to exert a positive influence on public perception.

The "Kirkbride Plan" was an American invention. For many, especially those who had never been to a major city, a Kirkbride would likely be the largest building they would ever see. Indeed, some of the buildings were gargantuan: Greystone Park State

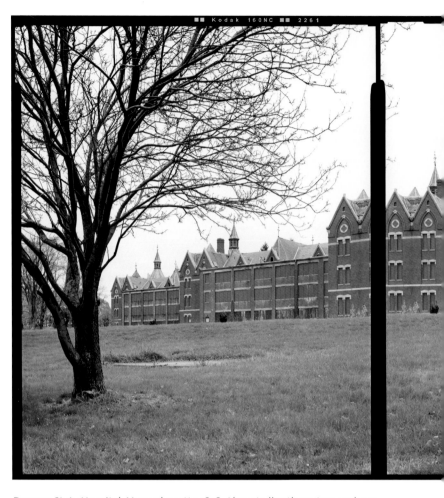

Danvers State Hospital, Massachusetts, 1878. Almost all 19th century asylums were built according to the Kirkbride Plan, which consisted of a central administration building flanked symmetrically by pavilions housing the patients. Danvers closed in 1992, the result of budget constraints, and was razed in 2006 to make way for condominiums. Below is a floorplan of its design.

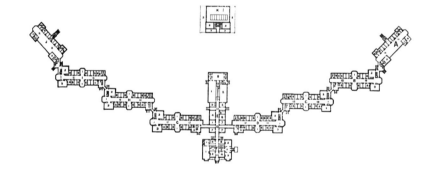

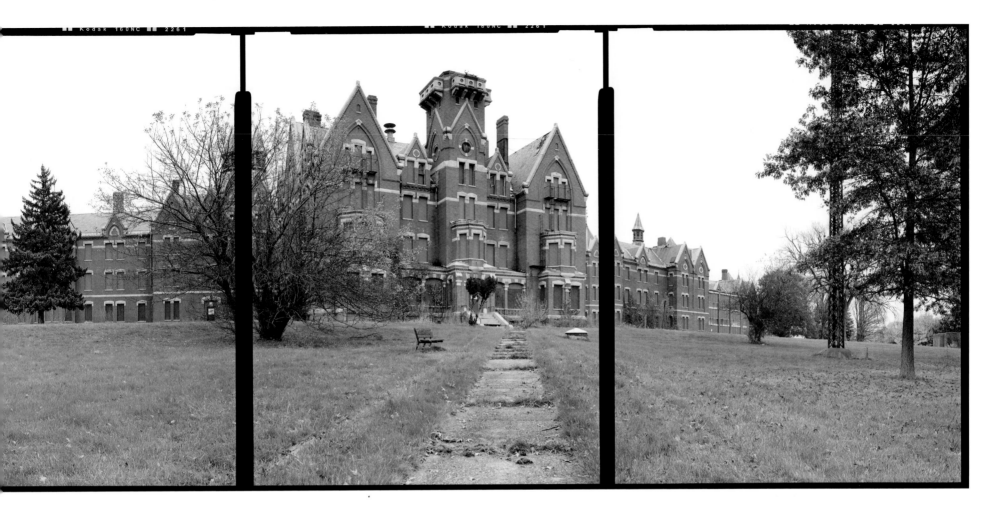

Hospital, which opened in 1876 as the New Jersey State Asylum for the Insane at Morristown, was purported to have the largest continuous foundation in the United States, surpassed only by the Pentagon some seventy-seven years later. The Second Empire-style building comprised 673,706 square feet of floor space, nestled in 743 acres of land. The connected pavilions with their right-angled setbacks created a single, elongated mass that dominated the landscape. Early construction photographs show how out of context the asylums first appeared, rising high above the land, yet not part of it.

The building of asylums required enormous state expenditures and an army of workers who lived on-site during construction. Towns competed fiercely for the asylums, as they insured economic prosperity, especially in rural areas reliant on agriculture. Large cities, like Buffalo, New York, viewed an asylum as a cultural necessity—as prestigious as a museum or university—and therefore befitting of architectural beauty. Buffalo State Hospital, situated at the northern edge of the city, was H. H. Richardson's largest commission and a joint effort of local doctors, businessmen, and civic leaders. Samuel Sloan, another prominent architect, built his reputation on asylums, and as Kirkbride's chief associate, he is credited with the design

of some seventeen hospitals. Before they became subjects of derision, the asylums were sources of civic pride, appearing on postcards and in guidebooks as "must see" tourist attractions.

The Kirkbride hospitals were technological marvels of their time, offering modern amenities such as fireproof construction, central heating, plumbing, and gaslight. But they were not hospitals in the modern sense of the word. On the outside the Kirkbrides exuded grandeur, but on the inside they resembled dormitories. Each pavilion in a Kirkbride was typically three stories, with one ward per floor. The ward consisted of a long, wide hallway lined by small bedrooms. Each ward also contained a dining room, a parlor or sitting room, bathrooms, storage closets, and rooms for attendants. Patients spent most of their time in the hallways and common areas, not in the bedrooms, which were locked during the day and used only for sleeping. Period photographs often show well-appointed interiors, with plants, rugs, framed artwork, and rocking chairs—all the comforts of a typical Victorian home. Their outward similarity to great resort hotels of the era is striking.

Like so many lofty ideals, the asylums failed to live up to their expectations. They soon became overcrowded by an influx of the urban poor, many of them foreign born, who did not respond well to "moral treatment," which had (in today's parlance) a class bias. The elderly and the chronically ill—two groups that would never get better—began filling up the wards. As patient populations expanded and became more heterogeneous, the need for control prevailed, and the pendulum of treatment began to swing from curative toward custodial. Moreover, state hospitals were held accountable to state legislatures and subject to fiscal pressures. The financial panics of 1873, 1893, and 1907, as well as periods of recession, all took their toll, leading to budget cuts and staff shortages. Low wages, high turnover rates, and inexperienced attendants led to patient abuses and corruption. But the asylums remained popular, even as their quality of care declined, and they remained central to public policy because they offered a convenient solution to custodial care and helped insure the public's peace of mind.

As the patient populations grew, so did the hospitals, until many reached monumental proportions. Kirkbride's initial design called for a hospital of 250 patients, but at the AMSAII meeting in 1866, members agreed to increase the size to 600 patients. Construction of the asylums could not keep pace with admissions, and it was often the case that after a state built its first one, subsequent hospitals were built soon after—not to meet future needs, but to relieve pressure on the existing institutions. Still, the Kirkbride Plan persisted well into the late nineteenth century, long after moral treatment had fallen out of fashion. It had become the status quo, and the growing psychiatric profession was not eager to give up its leading symbol of prestige and authority. Ironically, as the reputation of asylums waned, generous expenditures

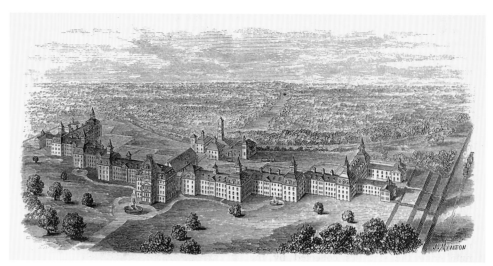

Greystone Park State Hospital, Morristown, New Jersey

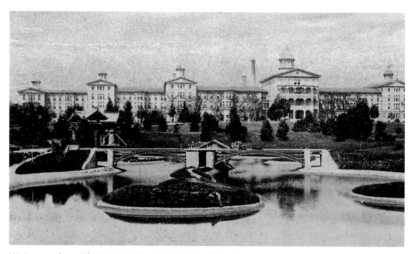

Water gardens, Elgin State Hospital, Elgin, Illinois

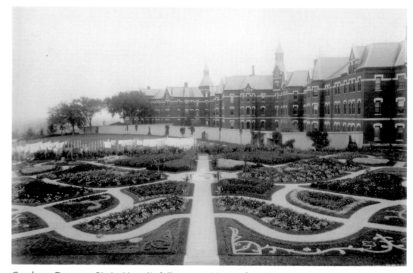

Gardens, Danvers State Hospital, Danvers, Massachusetts

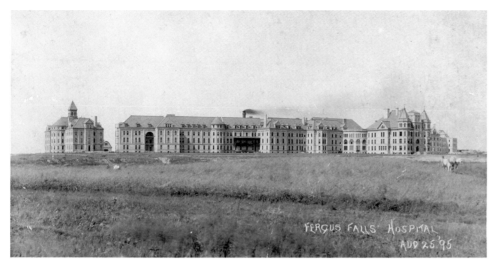
Construction photograph, Fergus Falls State Hospital, Fergus Falls, Minnesota

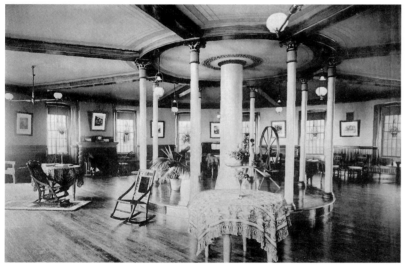
Hooper Hall day room, Worcester State Hospital, Worcester, Massachusetts

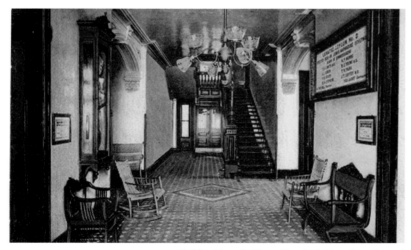
Lobby, Nevada State Hospital, Nevada, Missouri

continued to be lavished upon their design. Some of the grandest Kirkbrides were built during this later period in the 1870s and 1880s: Napa, Nevada, Pontiac, Buffalo, and Danvers State Hospitals among them.

The Kirkbrides were not easy to abandon: their planning and construction took years, sometimes decades. State committees had been formed, land purchased, architects chosen, plans approved, contractors hired, with each group often representing a political power base. Construction on Buffalo State, for example, began in 1870 and was not completed until 1899, long after Richardson's death. Cherokee State Hospital, in Iowa, was finished in 1902, and Fergus Falls State Hospital, in Minnesota, took 17 years to complete after it opened in 1890. With no cure for mental illness in sight, it became increasingly difficult to justify the need for large, expensive asylums. Two new models, Willard and Kankakee State Hospitals, offered alternatives that incited a debate within the profession. Willard State Hospital (1869), in upstate New York, was built specifically for the chronically ill (those who would never get better) and as such presaged the custodial role the asylums would soon assume. Kankakee State Hospital, known initially as Illinois Eastern Hospital for the Insane, opened in 1879 and included a Kirkbride plus outlying dormitories. Proponents of both styles claimed that some patients required less attention and would benefit from a less formal atmosphere, while the elderly and chronically ill—the incurables—simply needed a comfortable place to live. Critics, namely the older members of AMSAII, protested, saying everyone should be housed under one roof for better supervision and quality of care. Anything less, they claimed, was an admission of failure on their part—that insanity was incurable.

The dormitories at Kankakee State were less ornate and cheaper to build, and they helped pave the way for the adoption of the "Cottage Plan," which called for clusters of separate buildings organized like a college campus. The breakup of the asylum into smaller pieces was inevitable as the Kirkbrides grew in size to an almost absurd point of impracticality: Buffalo State Hospital was more than one-third of a mile long. Most institutions with existing Kirkbrides just built new structures off to the side to meet the demands for additional space. Some later Kirkbrides reflect the shift in scale toward the Cottage Plan, and, like St. Lawrence State Hospital in upstate New York, resemble a string of separate buildings linked together rather than one monolithic structure. Although the Cottage Plan appeared to create a freer environment, it was still an institution, operating along the same lines as before.

The harshest criticism of the asylums came from the professional ranks. After the Civil War, medical advances forged on the battlefield led to a new medical specialty: neurology. These new specialists saw their future in science and had little inclination to tend to the chronically ill. They also had little use for the antiquated methods of asylum doctors, whom they criticized for being bureaucratic, corrupt, and isolated. Around the turn of the twentieth century, in keeping with the times, and reflecting

an effort to assimilate psychiatry into mainstream medicine, "insane asylums" were rebranded euphemistically as "state hospitals," though eventually this, too, became a derisive term.

The last wave of state hospitals built up until World War II looked nothing like their Victorian predecessors. The ornate architecture was gone and so were the prominent architects. The hospitals had a decidedly institutional, functional feel, looking more like Depression-era public housing than castles on a hill—such was the economic situation of public building at that time. Yet some essentials remained the same; located in rural areas where land was cheap, they operated as near self-sustaining communities, producing almost everything they needed, including food, water, and power. Despite ever-shrinking budgets, hospitals were able to stay afloat because of the large pool of patient labor. As in the era of moral treatment, patients helped construct buildings, grow crops, raise dairy cattle, pigs, and chickens, and make furniture and clothing. The state hospitals, with thousands of residents and staff, and hundreds of acres, functioned more like work farms than medical facilities.

After a peak in the mid-1950s, patient populations started to decline steadily with the introduction of psychotropic drugs, changes in commitment laws, and a shift in policy toward community-based care. In came the era of deinstitutionalization. A series of court decisions, beginning with the landmark Alabama case *Wyatt v. Stickney* confirmed a constitutional right to treatment and established minimum standards of care. This ultimately resulted in the loss of patient labor and deprived hospitals of their precious workforce, which delivered the fatal blow to their economic viability. As the 1970s progressed, state hospitals wound down agricultural and manufacturing operations. Shops closed, services were contracted to the private sector, and farms were sold off to help pay for mandated services. Buildings already in disrepair were left to deteriorate further, too expensive to renovate and bring up to code. As patient numbers plummeted, the hospitals shut down, one by one, though no state has yet closed all of its hospitals. Today most people with mental illness are treated within their own communities. For those who are committed, their stays are usually numbered in days instead of months or years. Hospitalization is a last resort.

In the wake of deinstitutionalization, many state hospitals were abandoned to ruin and have become surplus property to be sold to developers, who prize the land but have little interest in saving the architecture. A few hospitals have been converted successfully for residential, commercial, and even academic uses; others have been reopened as prisons—ironically so, as many of the former patients who have been left to fend for themselves on the streets now find themselves incarcerated as prisoners. One institution, it seems, has been traded for another.

At present, only a few Kirkbrides still serve their original function. The very qualities that made them appealing in the first place—their monumental size, heavy

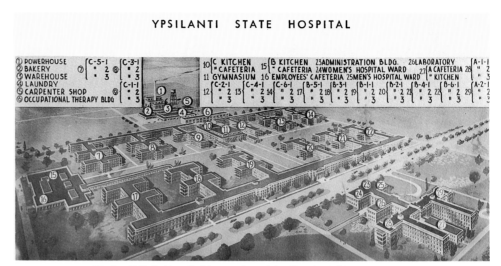

Ypsilanti State Hospital (opened 1931), Ypsilanti, Michigan

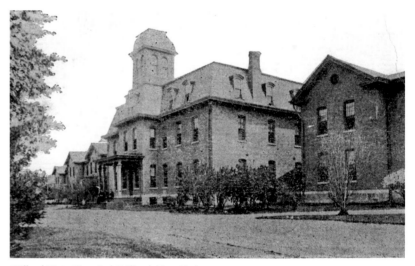

Willard State Hospital, Willard, New York

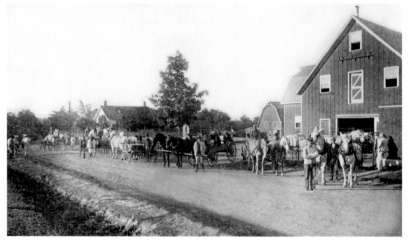

Barns, Williard State Hospital, Willard, New York

construction, and distinctive (but not easily altered) floor plan—have made them difficult to repurpose. While preservationists struggle to find new uses for the decaying structures, they must also grapple with the inherent stigma attached to these buildings. As vestiges of a less enlightened era, the Kirkbrides do not elicit the same nostalgia as do other historic structures. Sadly, few Americans realize that these institutions were once monuments to civic pride, built with noble intentions by leading architects and physicians who envisioned the asylums as places of refuge, therapy, and healing.

BIBLIOGRAPHY FOR OLIVER SACKS AND CHRISTOPHER PAYNE:

Annett, Jr., Bruce J. *Asylum: Pontiac's Grand Monument from the Gilded Age*. Pontiac, Mich.: Oakland County Pioneer and Historical Society, 2002.

Baxter, William E., and David W. Hathcox III. *America's Care of the Mentally Ill: A Photographic History*. Washington, D.C.: American Psychiatric Association, 1994.

Cooledge, Harold. "Samuel Sloan and the Philadelphia School of Hospital Design 1850–1880" in *Charette* 44, no. 6 (1964): 6–7, 18.

Deutsch, Albert. *The Shame of the States*. New York: Harcourt, Brace, 1948.

———. *The Mentally Ill In America: A History of Their Care and Treatment from Colonial Times*. New York: Columbia University Press, 1962.

Dowdall, George. *The Eclipse of the State Mental Hospital: Policy, Stigma, and Organization*. Albany: State University of New York Press, 1996.

Foucault, Michel. *Madness and Civilization: A History of Insanity in the Age of Reason*. New York: Vintage Books, 1988.

Goffman, Erving. *Asylums: Essays on the Social Situation of Mental Patients and Other Inmates*. New York: Anchor Books, 1961.

Grimes, John Maurice. *Institutional Care of Mental Patients in the United States*. Chicago: Self-published, 1934.

Grob, Gerald. *The Mad Among Us: A History of the Care of America's Mentally Ill*. Cambridge: Harvard University Press, 1994.

Hurd, Henry Miles. *The Institutional Care of the Insane in the United States and Canada*. Baltimore: The Johns Hopkins Press, 1916

Illinois Department of Finance. *A budget survey of state mental hospitals, presenting the replies from the forty-eight states on the questionnaire "Commodity Costs and Budgeting for State Mental Hospitals."* Springfield, Ill.: 1948.

Johnson, Heidi. *Angels in the Architecture: A Photographic Elegy to an American Asylum*. Detroit: Wayne State University Press, 2001.

King, Lucy Jane. *From Under the Cloud at Seven Steeples 1878–1885: The Peculiarly Saddened Life of Anna Agnew at the Indiana Hospital for the Insane*. Zionsville, Ind.: Guild Press/Emmis Publishing, 2002.

Kirkbride, Thomas Story. *On the Construction, Organization, and General Arrangements of the Hospitals for the Insane*. New York: Arno Press, 1973 (reprint).

Morrison, Ernest. *The Physician, the Philanthropist, and the Politician: A History of Public Mental Health Care in Pennsylvania*. Harrisburg: Historical Committee of the Harrisburg State Hospital, 2001.

Pennsylvania Department of Welfare. *A Pictorial Report on Mental Institutions in Pennsylvania*. Harrisburg: Pennsylvania Department of Welfare, 1946.

Penney, Darby, and Peter Stastny. *The Lives They Left Behind: Suitcases from a State Hospital Attic*. New York: Bellevue Literary Press, 2008.

Rothman, David J. *The Discovery of the Asylum: Social Order and Disorder in the New Republic*. Revised edition. New York: Aldine de Gruyter, 2002.

Schneekloth, Lynda, Marcia Feuerstein, and Barbara Campagna, eds. *Changing Places: Remaking Institutional Buildings*. Fredonia, N.Y.: White Pine Press, 1992.

Sheehan, Susan. *Is There No Place on Earth for Me?* New York: Houghton Mifflin, 1982.

Shultz, Margaret. "From Victorian Asylum to Modern Psychiatric Hospital: A History of Greystone Park State Psychiatric Hospital, 1876–1950." Master's thesis, William Paterson University of New Jersey, 2002.

State of New York. *First Annual Report of the Board of Visitors of the Pilgrim State Hospital at Brentwood,*

N.Y. to the Department of Mental Hygiene for the fiscal year ending June 30, 1932. Utica, N.Y.: State Hospitals Press, 1933.

State of New York. *Sixty-ninth Annual Report of the Department of Mental Hygiene State of New York for the year ended March 31, 1957*. Albany: 1958.

State of New York Department of Mental Hygiene. *These Bear the Torch: New York State's Program for Mental Health*. Utica, N.Y.: State Hospitals Press, 1949.

Talbott, John. *The Death of the Asylum: A Critical Study of State Hospital Management, Services and Care*. New York: Grune & Stratton, 1978.

Tomes, Nancy. *The Art of Asylum Keeping: Thomas Story Kirkbride and the Origins of American Psychiatry*. Philadelphia: University of Pennsylvania Press, 1994.

Yanni, Carla. *The Architecture of Madness: Insane Asylums in the United States*. Minneapolis: University of Minnesota Press, 2007.

CAPTIONS FOR HISTORICAL IMAGES, PAGES 14–17:

PAGE 14, *clockwise from top left:*
Weston State Hospital, Weston, West Virginia
Elgin State Hospital, Elgin, Illinois
Traverse City State Hospital, Traverse City, Michigan
Pontiac State Hospital, Pontiac, Michigan
Worcester State Hospital, Worcester, Massachusetts

PAGE 15, *clockwise from top left:*
St. Joseph State Hospital, St. Joseph, Missouri
Utah State Hospital, Provo, Utah
Kankakee State Hospital, Kankakee, Illinois
Central State Hospital, Milledgeville, Georgia
Napa State Hospital, Napa, California

PAGE 16, *from top to bottom:*
Terrell State Hospital, Terrell, Texas
Nevada State Hospital, Nevada, Missouri
Cherokee State Hospital, Cherokee, Iowa

PAGE 17, *top row, left to right:*
Athens State Hospital, Athens, Ohio
Buffalo State Hospital, Buffalo, New York
Napa State Hospital, Napa, California
South Carolina State Hospital, Columbia, South Carolina

second row:
Warren State Hospital, Warren, Pennsylvania
Taunton State Hospital, Taunton, Massachusetts
Topeka State Hospital, Topeka, Kansas
Greystone Park State Hospital, Morristown, New Jersey

third row:
Danville State Hospital, Danville, Pennsylvania
Pontiac State Hospital, Pontiac, Michigan
St. Louis State Hospital, St. Louis, Missouri
Central State Hospital, Louisville, Kentucky

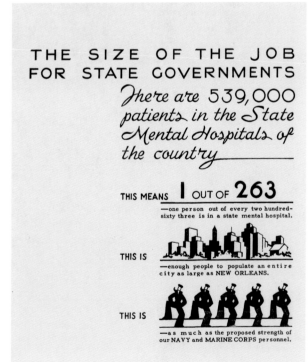

THE SIZE OF THE JOB FOR STATE GOVERNMENTS

There are 539,000 patients in the State Mental Hospitals of the country

THIS MEANS 1 OUT OF 263
—one person out of every two hundred-sixty three is in a state mental hospital.

THIS IS
—enough people to populate an entire city as large as NEW ORLEANS.

THIS IS
—as much as the proposed strength of our NAVY and MARINE CORPS personnel.

From a national survey conducted by the Illinois Department of Finance, 1948

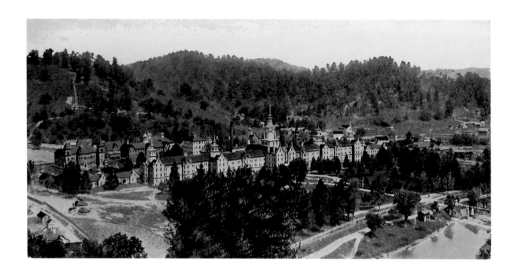
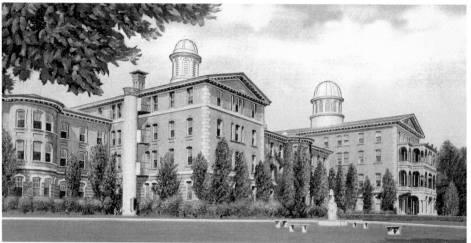
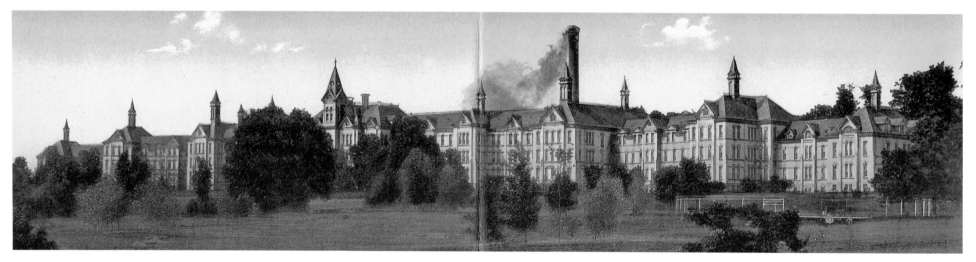
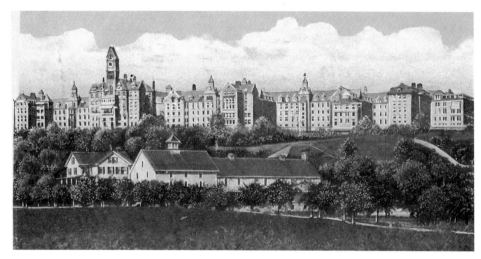
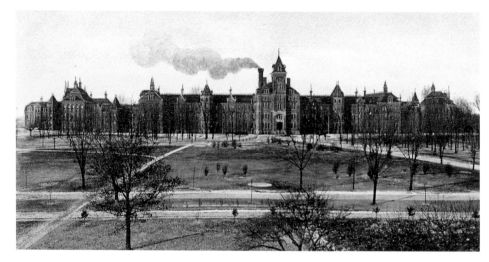

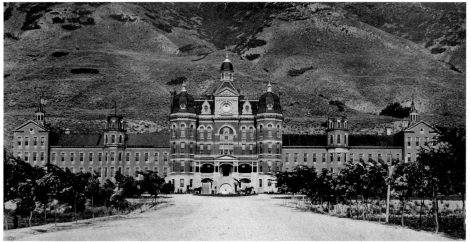

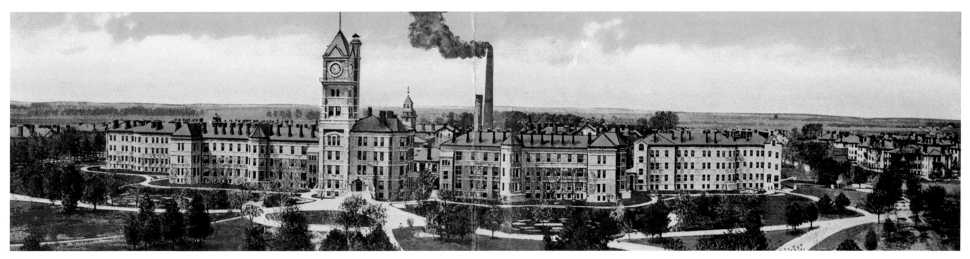

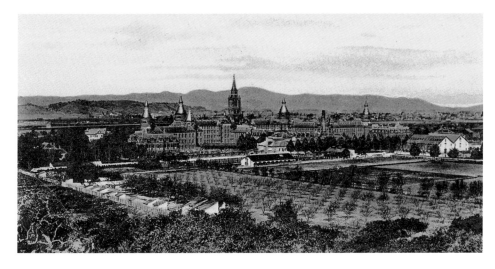

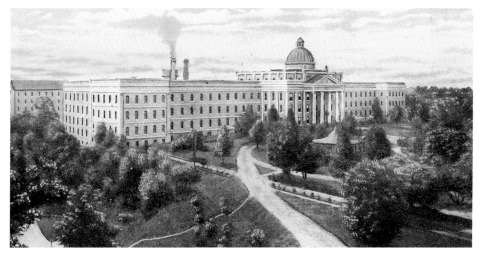

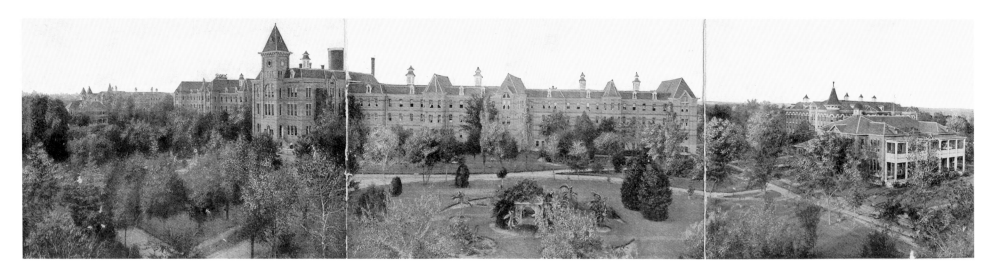

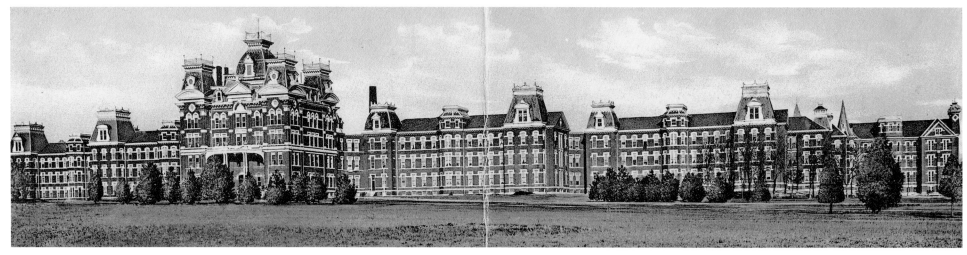

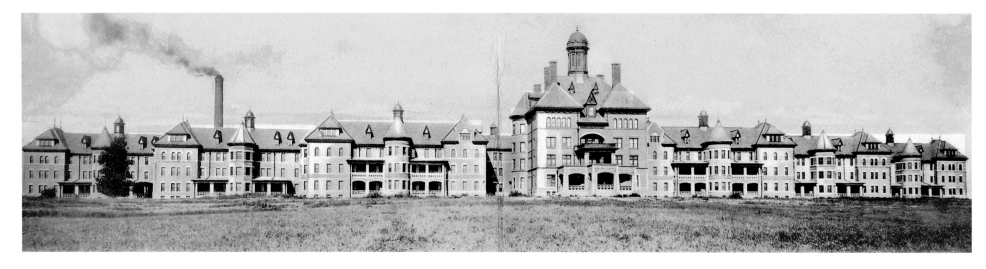

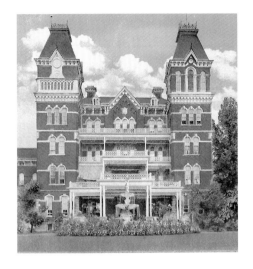
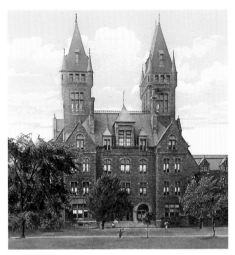
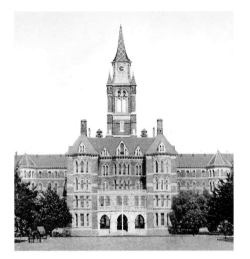
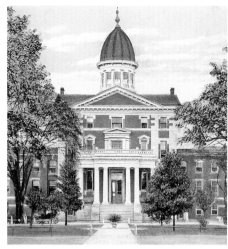
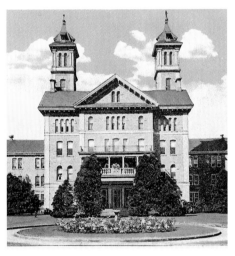
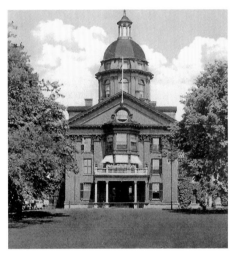
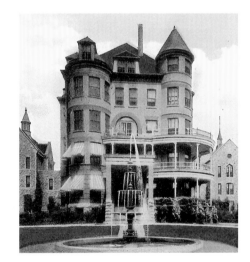
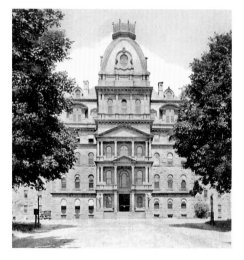
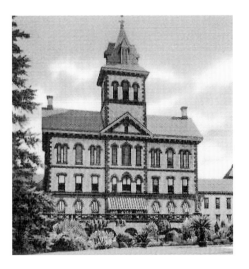
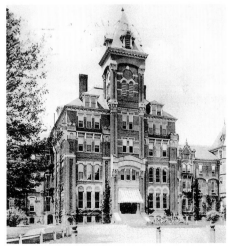
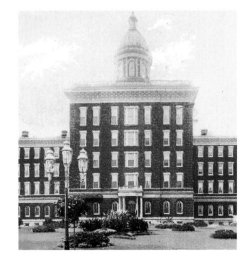
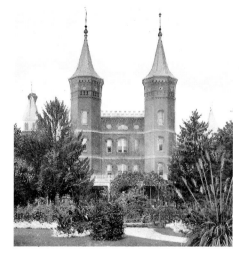

CREEDMOOR
CENSUS 3 — 1953

PATIENTS	MALE	FEMALE	TOTAL
CERTIFIED CAPACITY	1558	2584	4142
IN HOSPITAL	218	3612	5795
IN FAMILY CARE	2	2	4
CONV CARE	221	408	629
ESC PTS	10	2	12
TOTAL CENSUS	2416	4024	6440
EXCESS	625	1028	1653
3 6 1953			
BUDGET PERSONNEL	A 605	743	1348
MEDICAL SERVICE	A 33	4	37
PHYSICIANS ON DUTY	25	3	28
VACANCIES	8	1	9
WARD SERVICE	A 331	521	852
NURSE & ATTENDANTS ON DUTY	281	42	709
VACANCIES	50	93	143
ON PASS	36	54	90
SICK	3	19	22
OTHER DEPTS	A 241	218	459
ON DUTY	231	178	409
VACANCIES	10	40	50

Census, 1953, Creedmoor State Hospital, Queens, New York

THE PHOTOGRAPHS

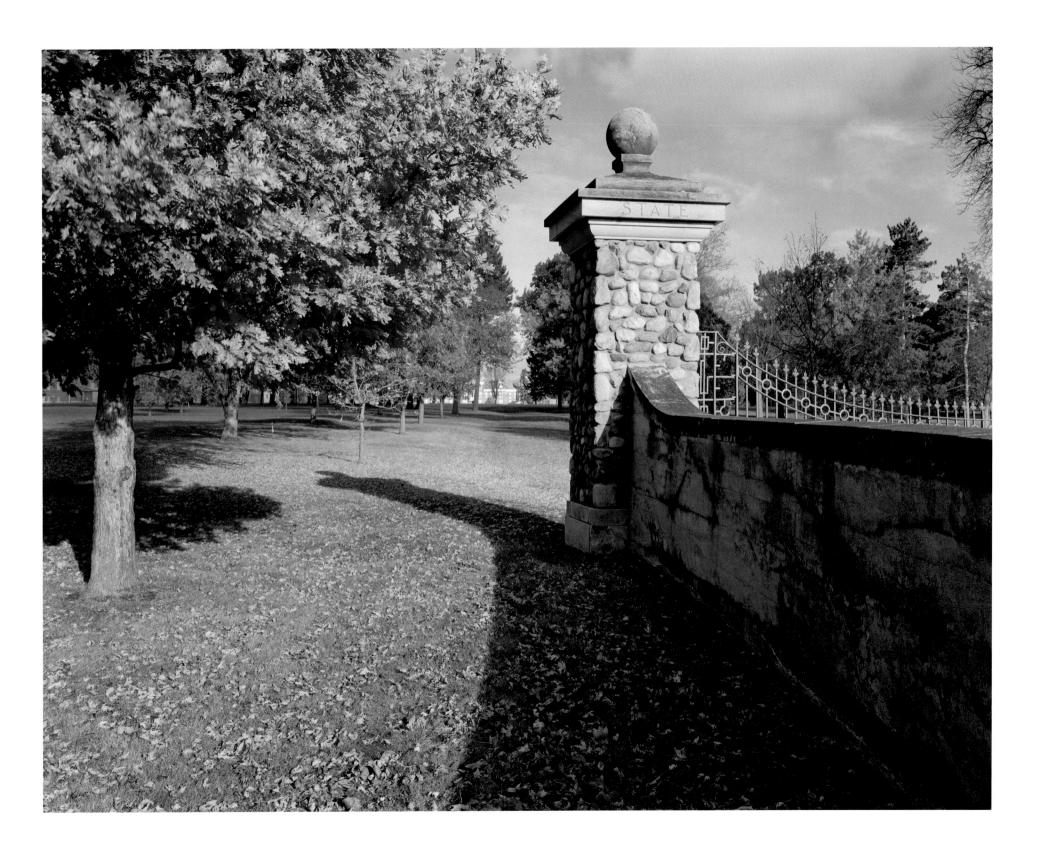

Original main entrance, Clarinda State Hospital, Clarinda, Iowa　21

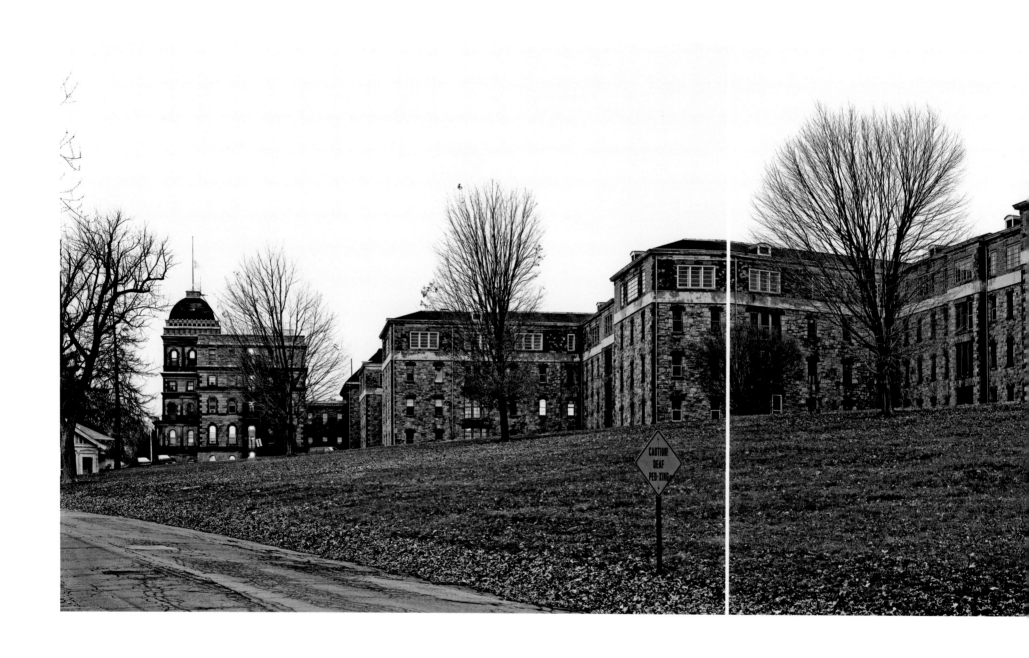

Greystone Park State Hospital, Morristown, New Jersey

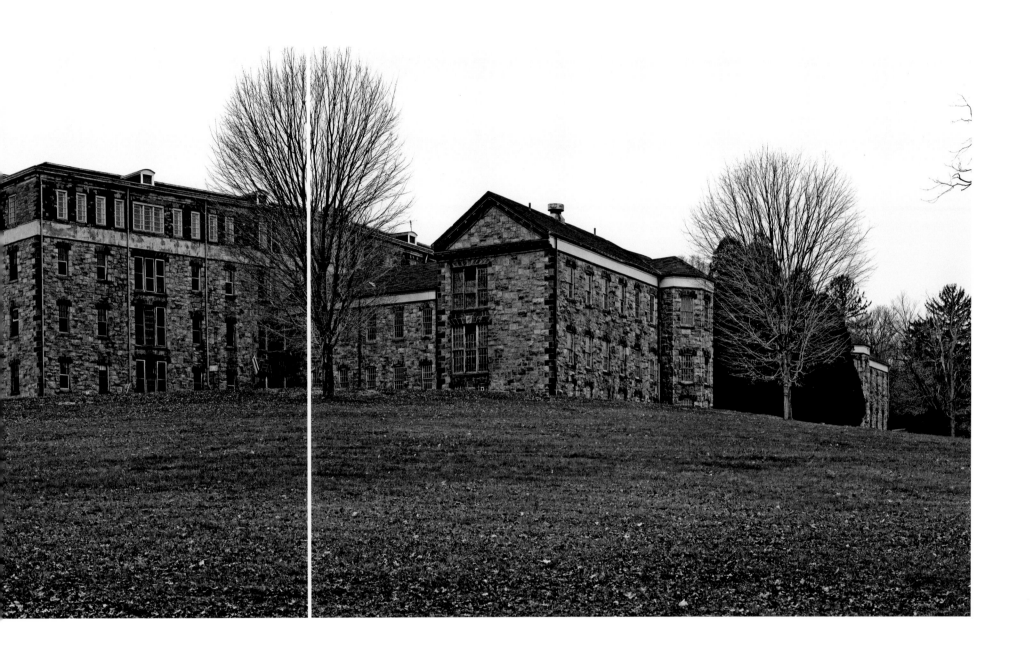

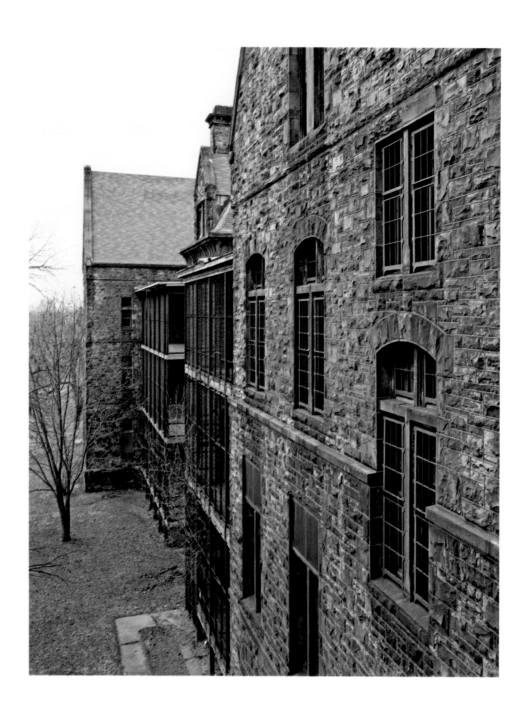

24 Buffalo State Hospital, Buffalo, New York (also facing page)

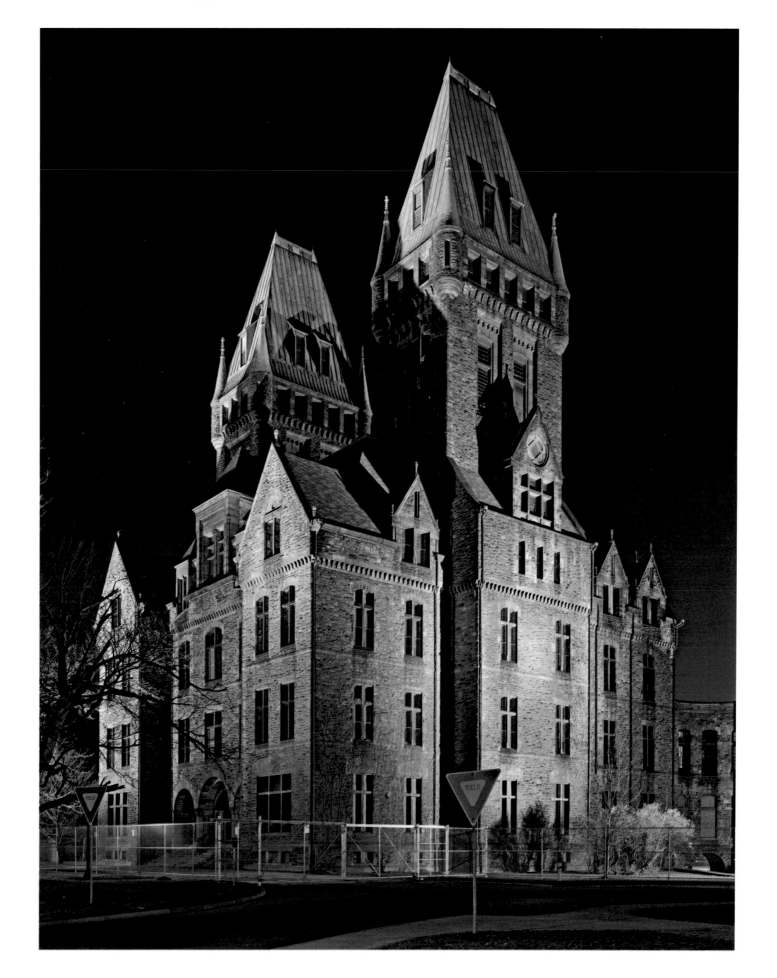

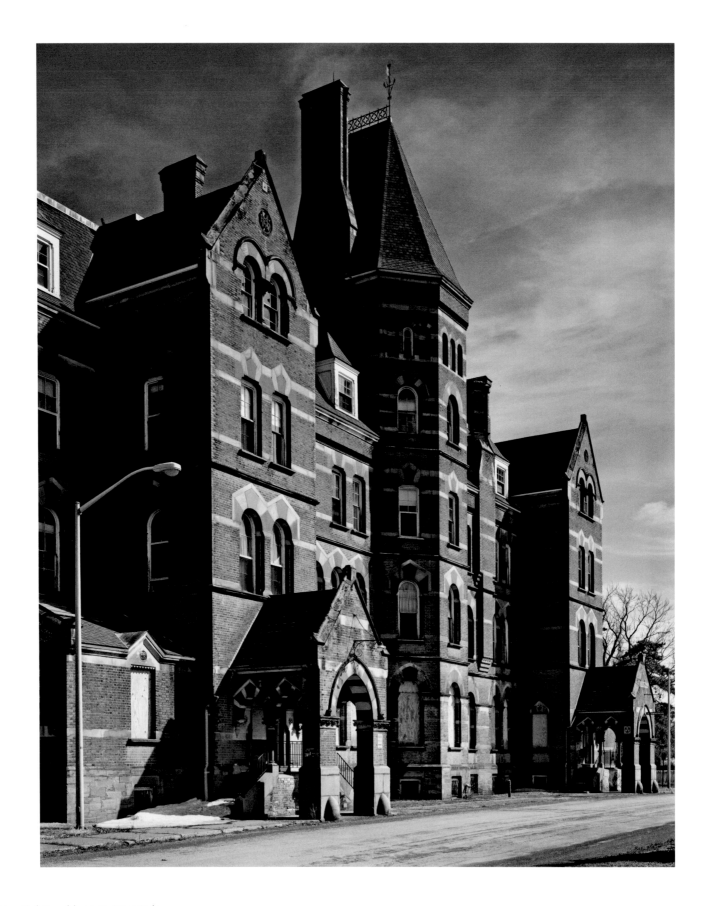

Hudson River State Hospital, Poughkeepsie, New York

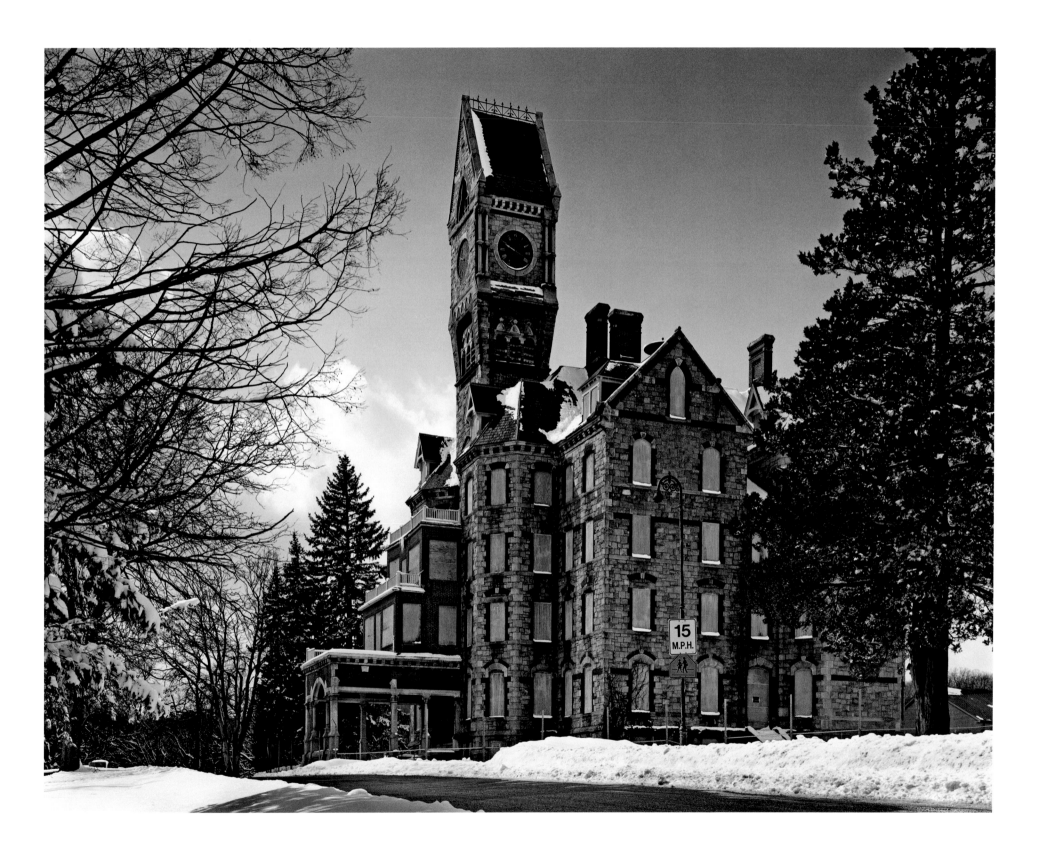

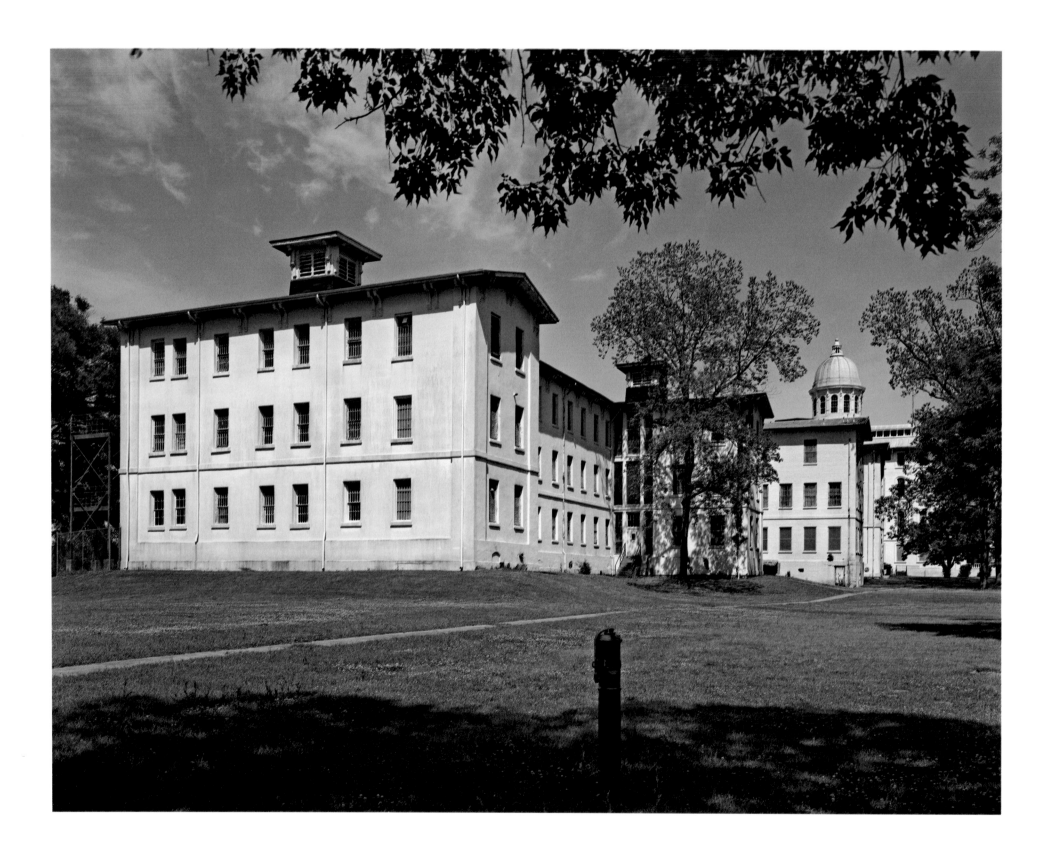

Bryce State Hospital, Tuscaloosa, Alabama

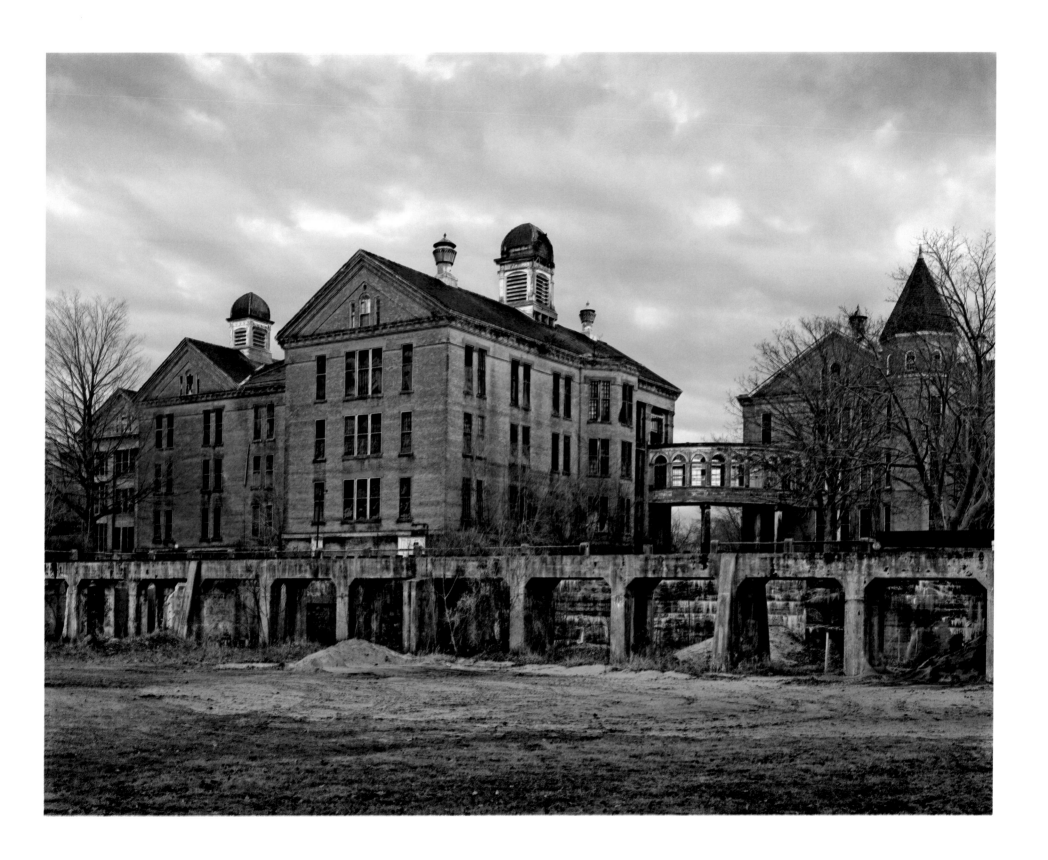

Taunton State Hospital, Taunton, Massachusetts 29

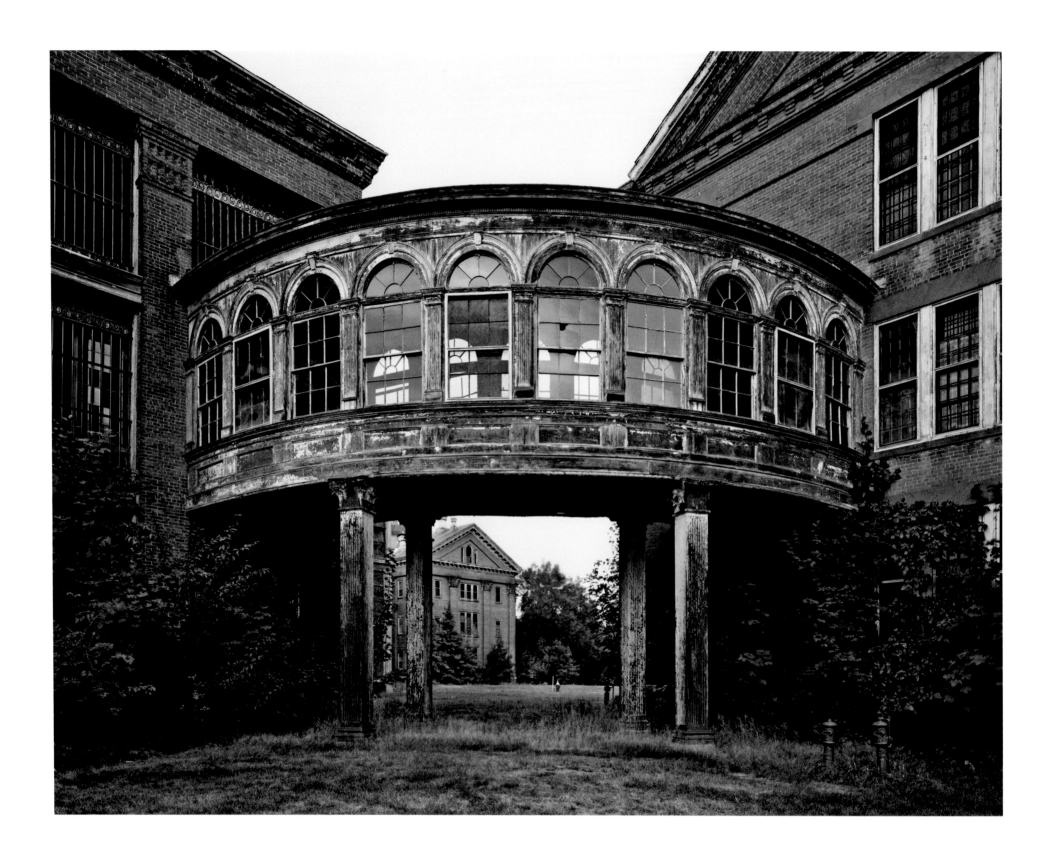

Breezeway to infirmary ward, Taunton State Hospital, Taunton, Massachusetts

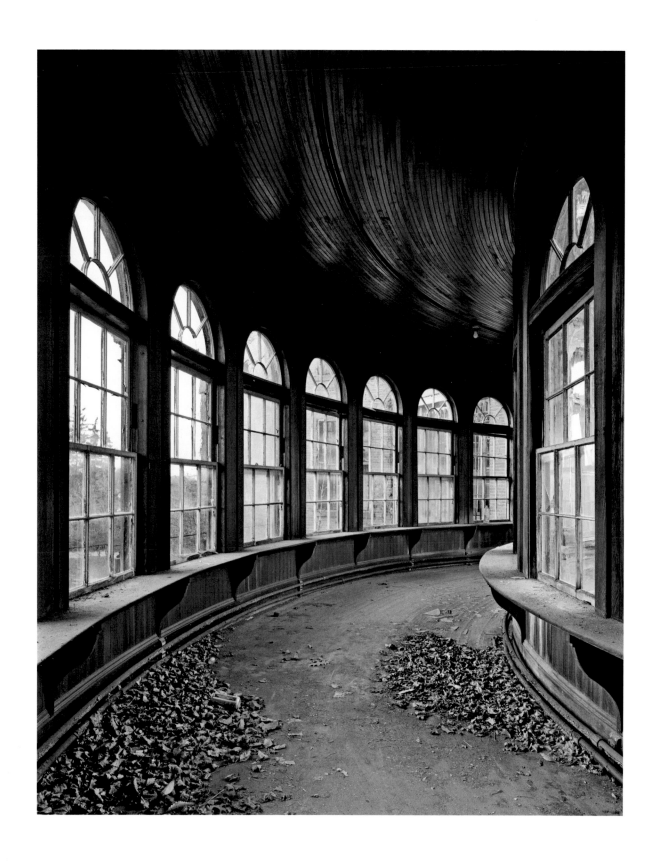

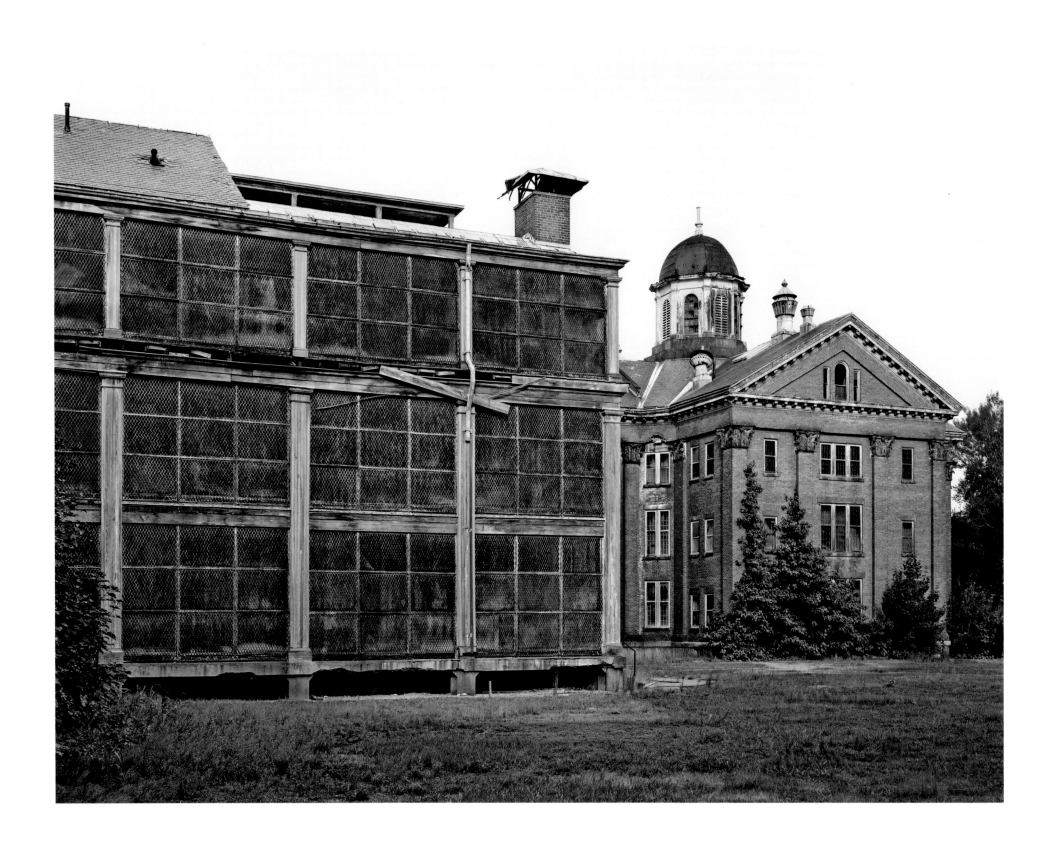

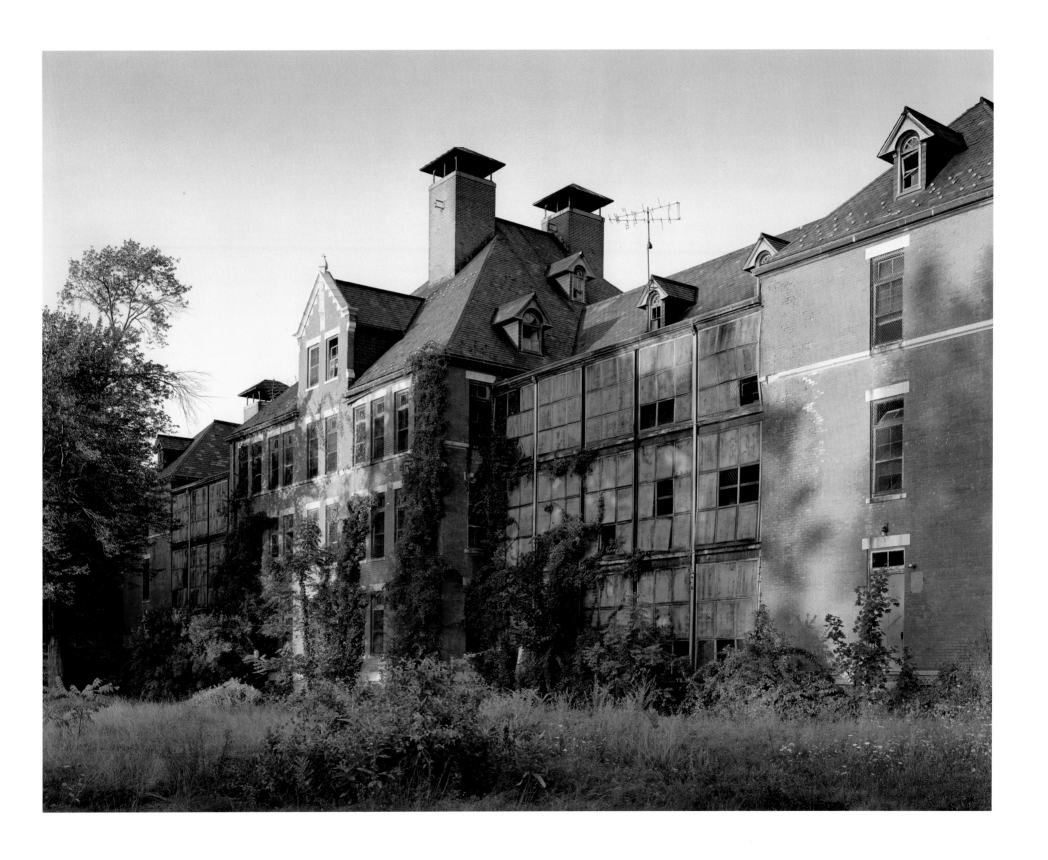

Norwich State Hospital, Preston, Connecticut 33

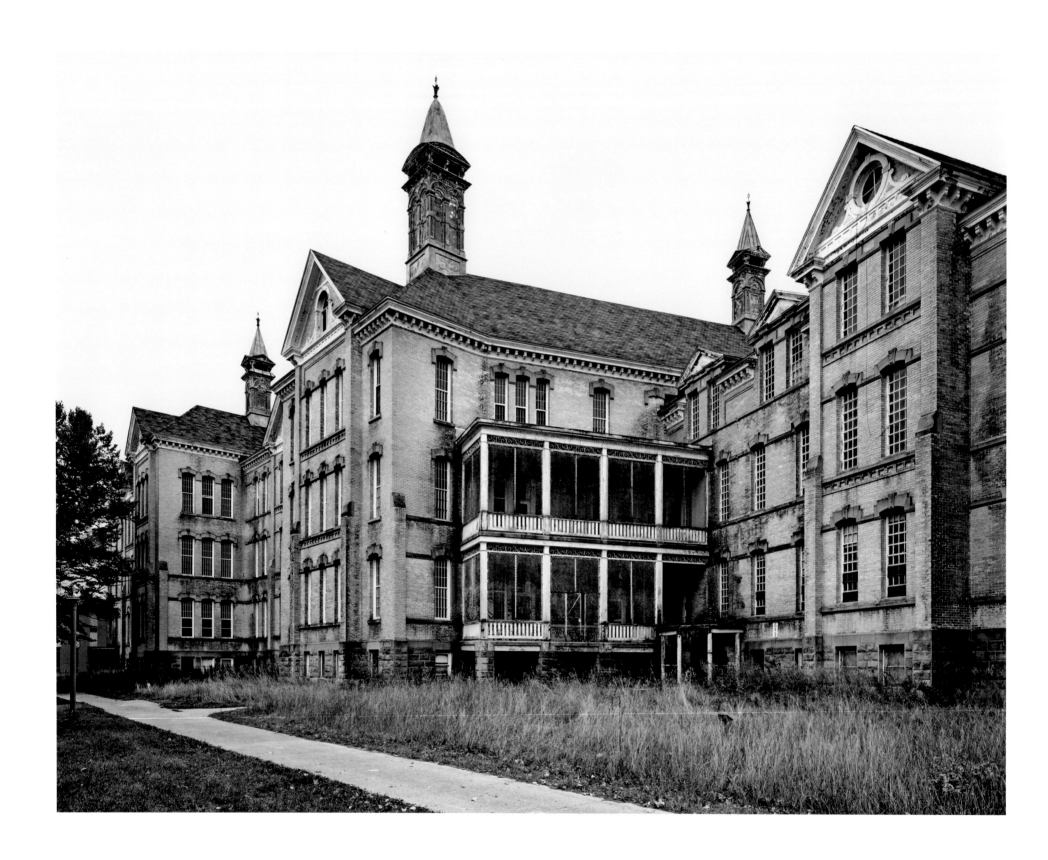

Traverse City State Hospital, Traverse City, Michigan

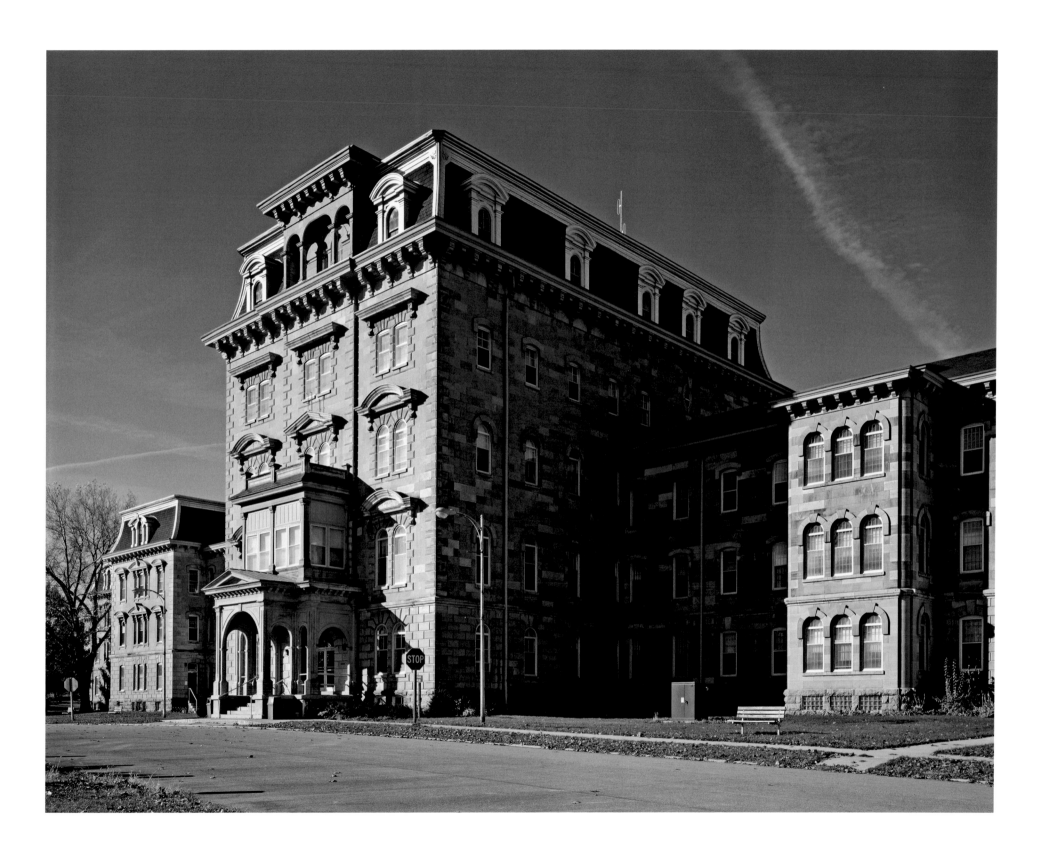

Independence State Hospital, Independence, Iowa 35

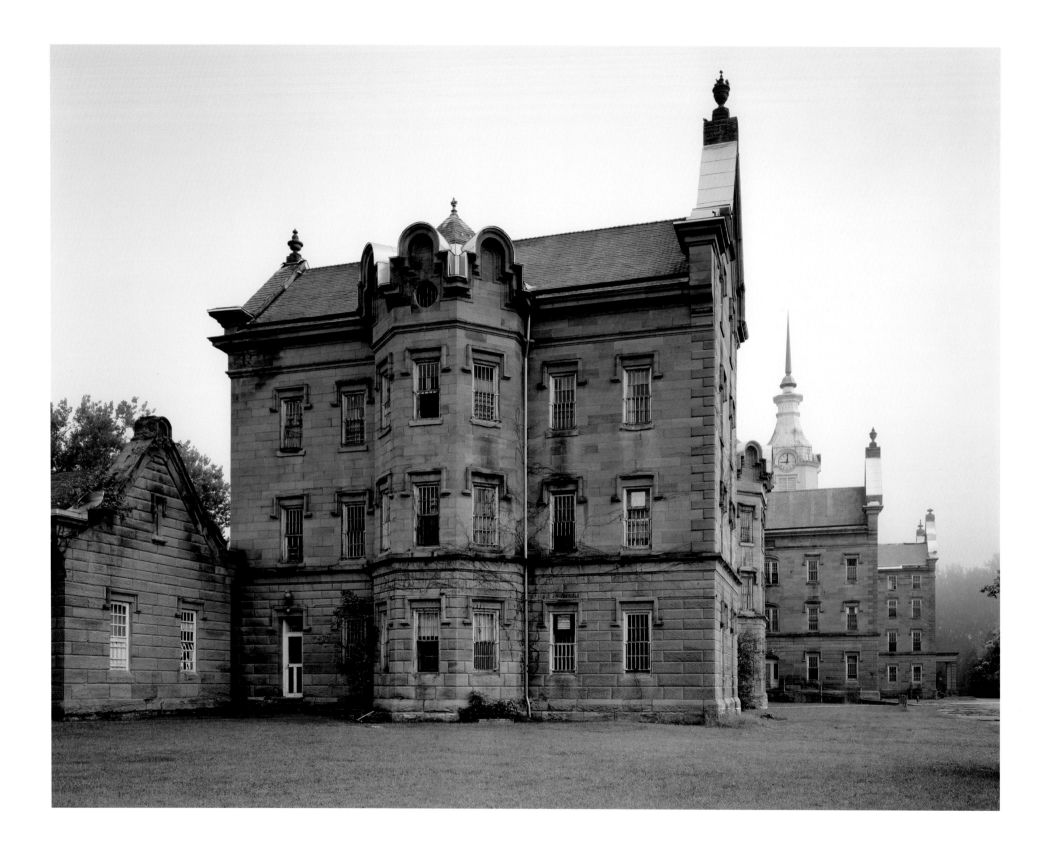

Weston State Hospital, Weston, West Virginia

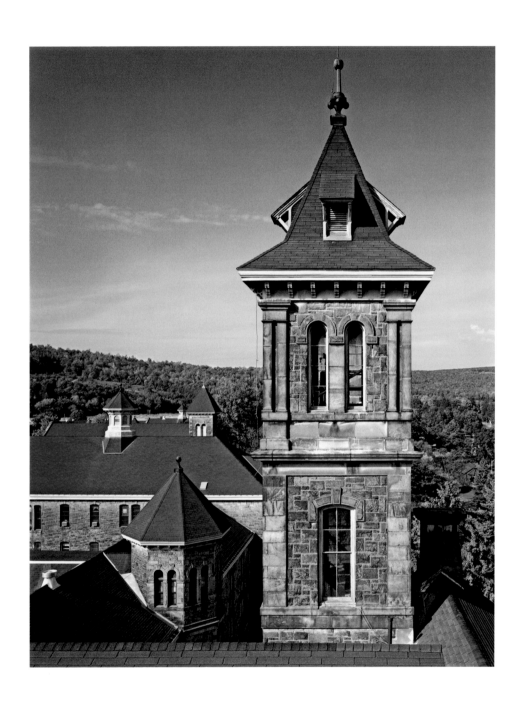

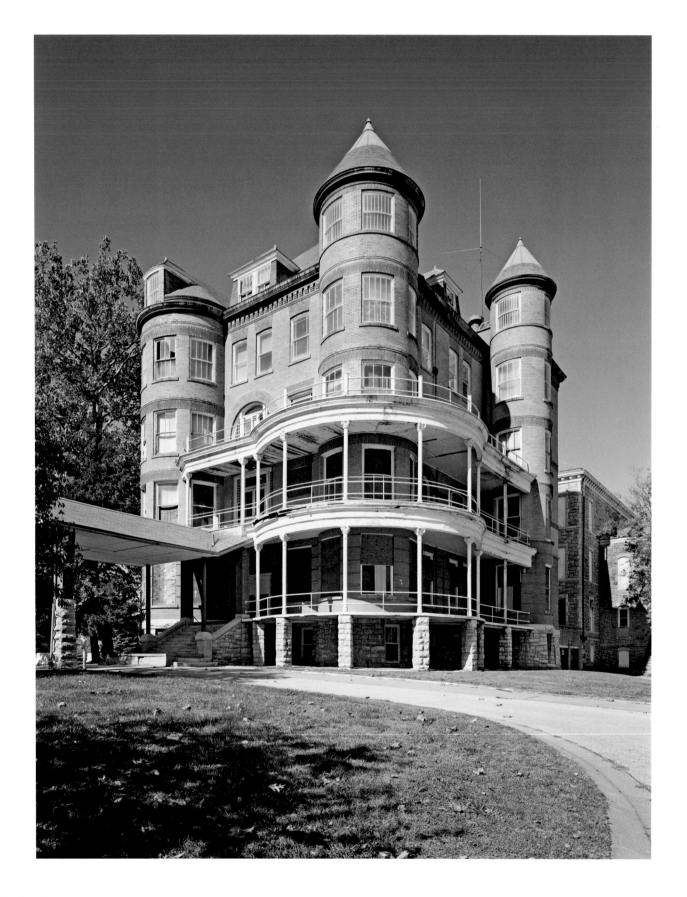

Topeka State Hospital, Topeka, Kansas

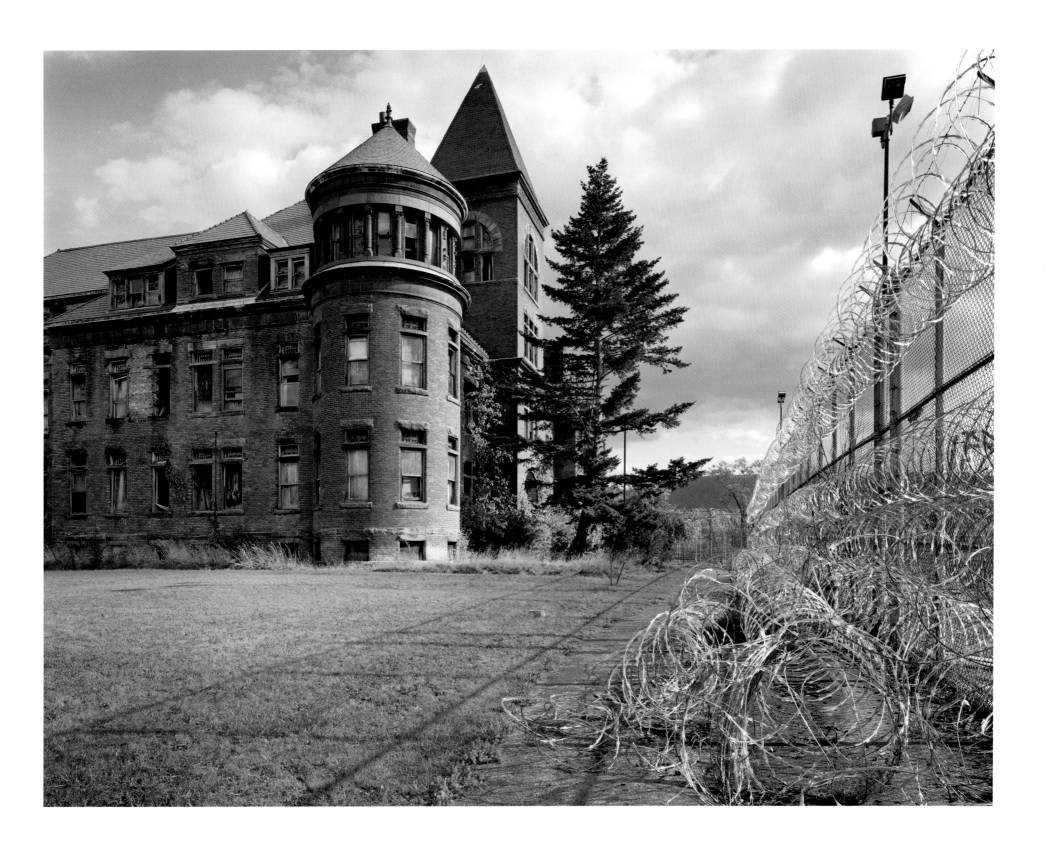

Matteawan State Hospital (now Fishkill Correctional Facility), Beacon, New York 39

The main building of Utica State Hospital was completed in 1843, and was one of the first asylums in the United States. Its monumental Greek Revival style predated the Kirkbride design.

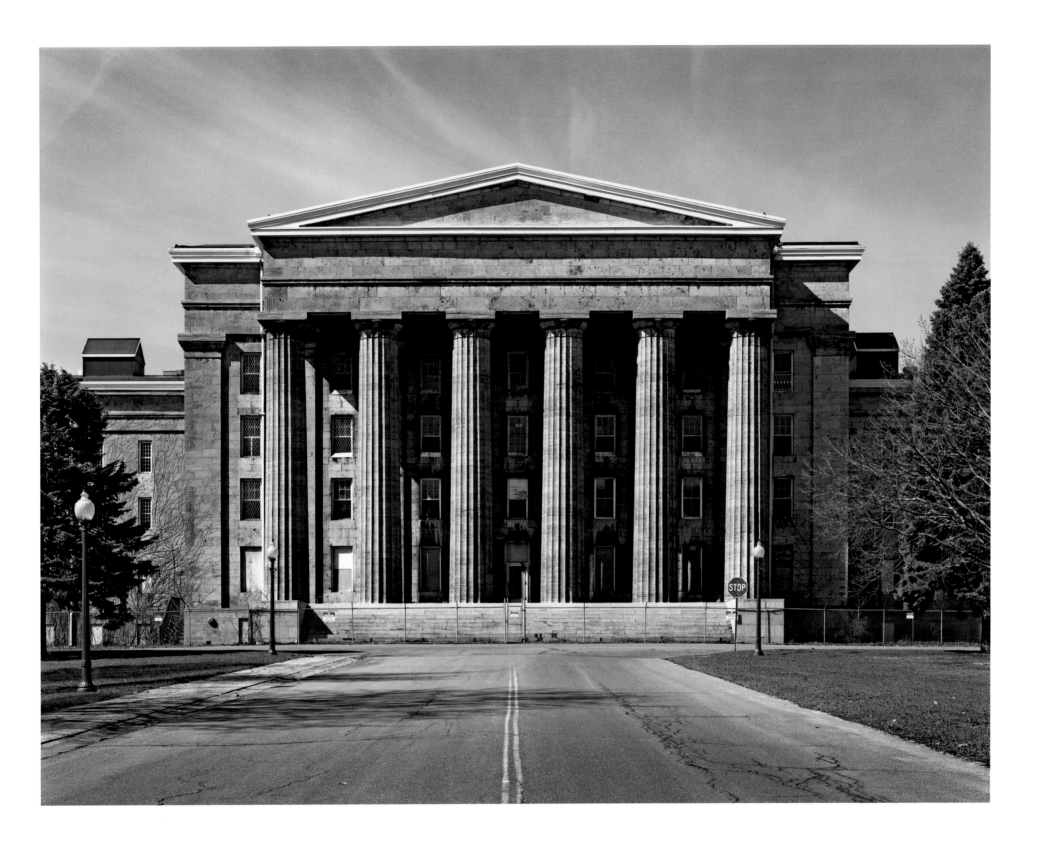

Utica State Hospital, Utica, New York 41

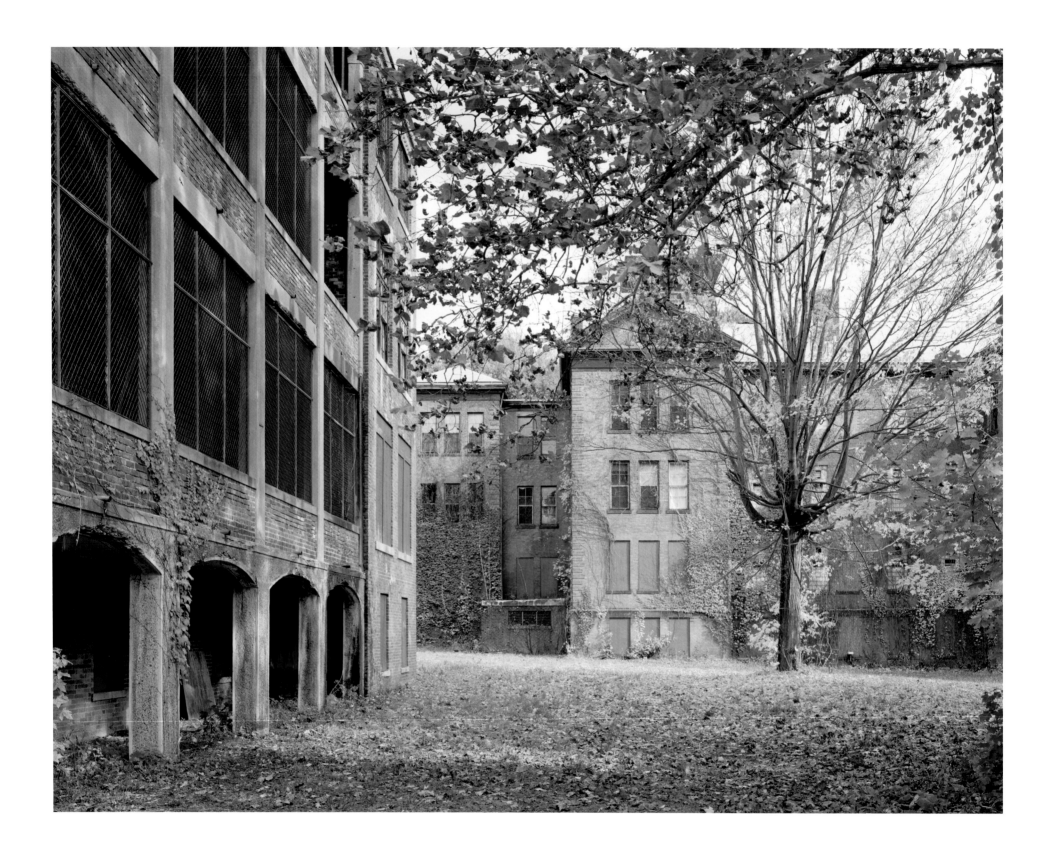

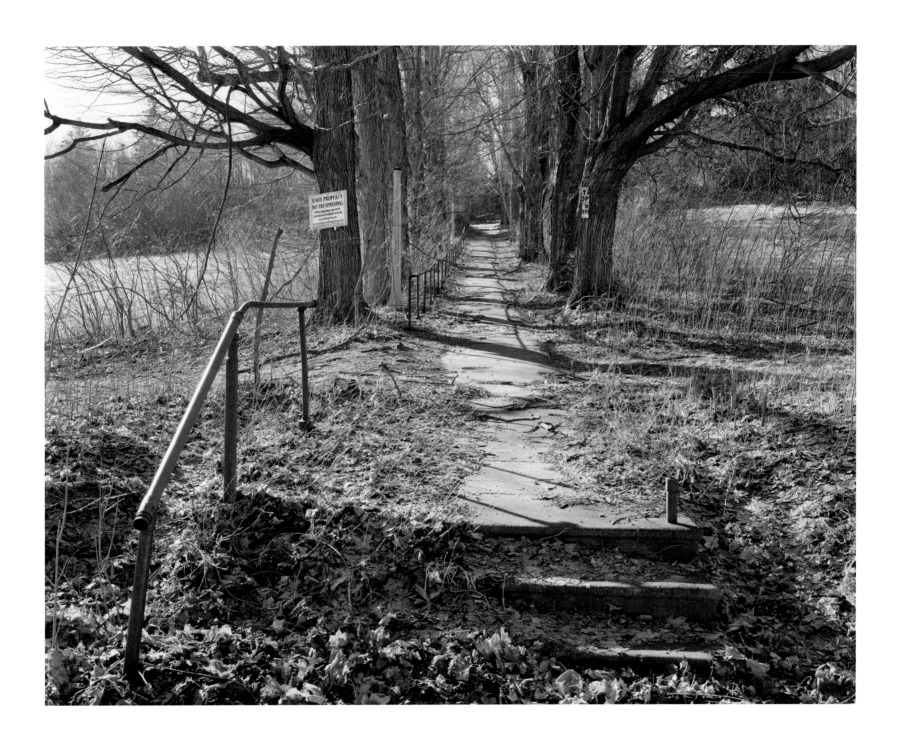

Path on the grounds of Danvers State Hospital, Danvers, Massachusetts 43

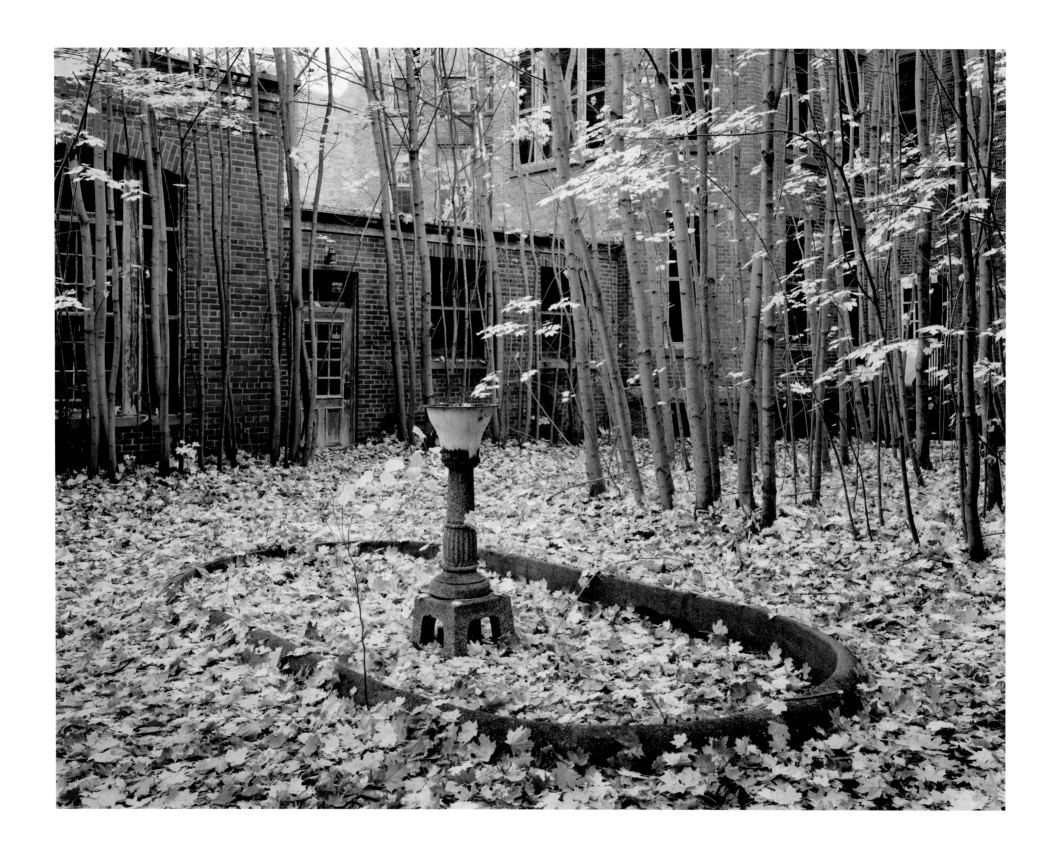

44 Enclosed courtyard, Taunton State Hospital, Taunton, Massachusetts

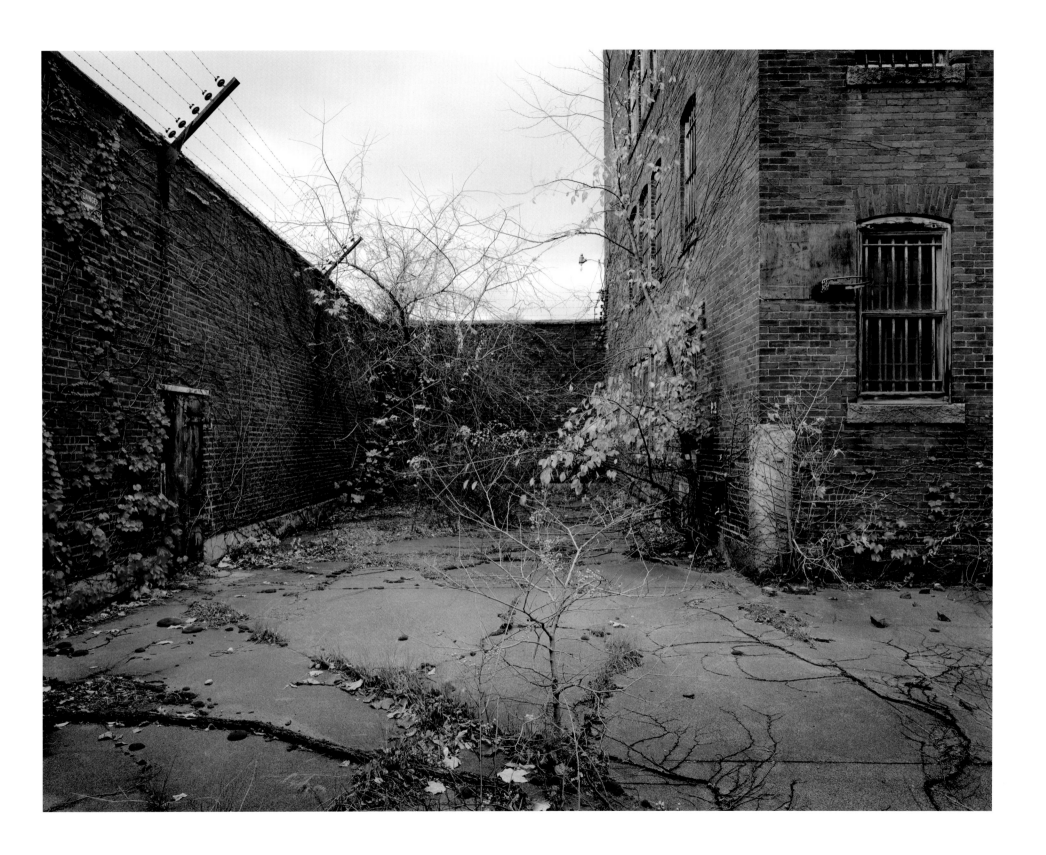

Recreation courtyard for criminally insane, Concord State Hospital, Concord, New Hampshire 45

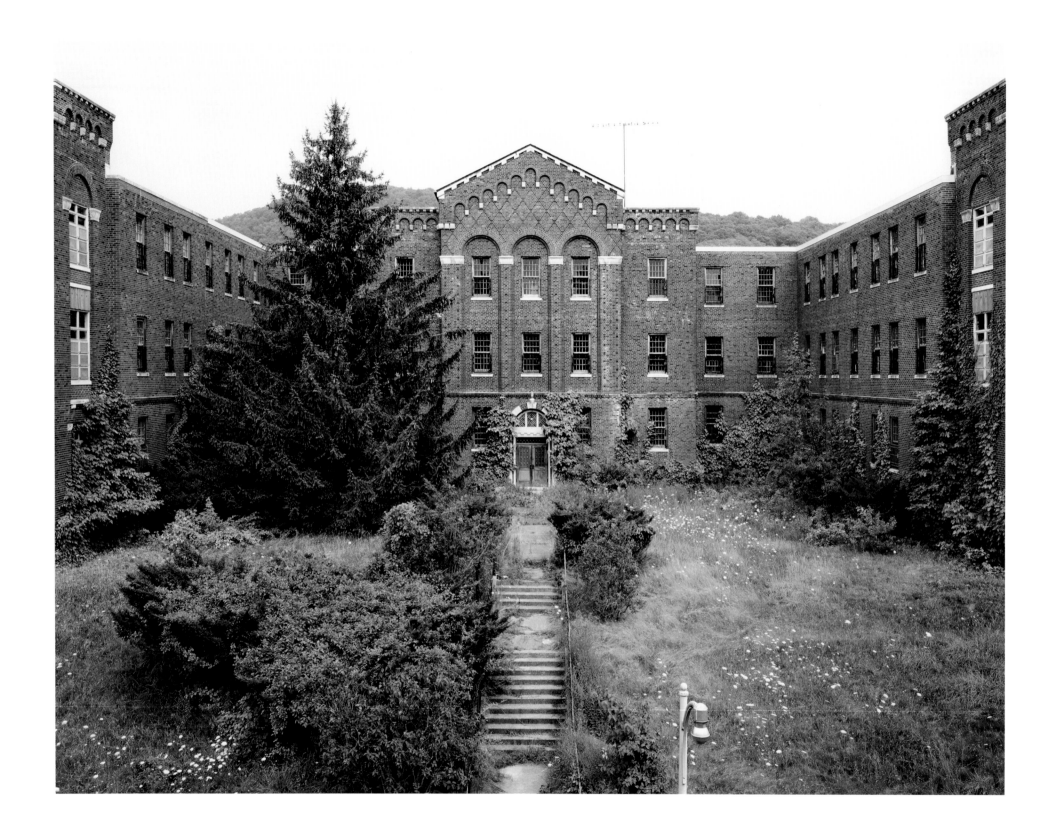

Harlem Valley State Hospital, Wingdale, New York

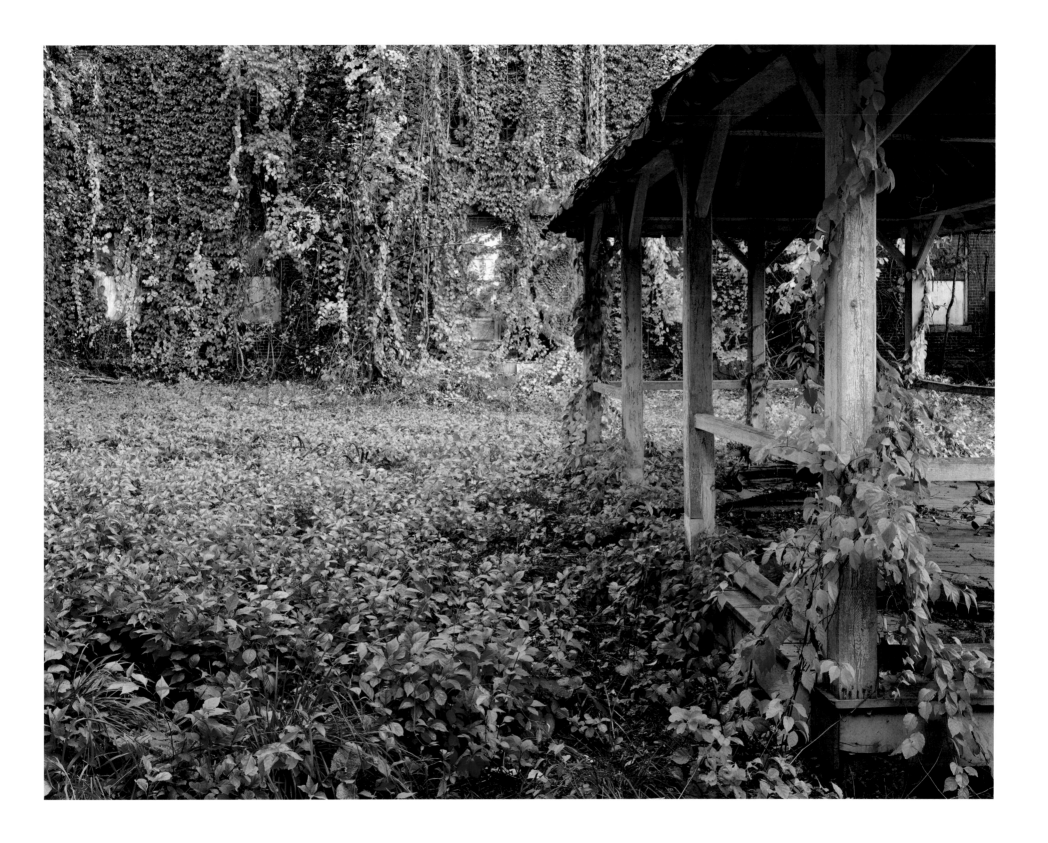

Courtyard gazebo, Concord State Hospital, Concord, New Hampshire 47

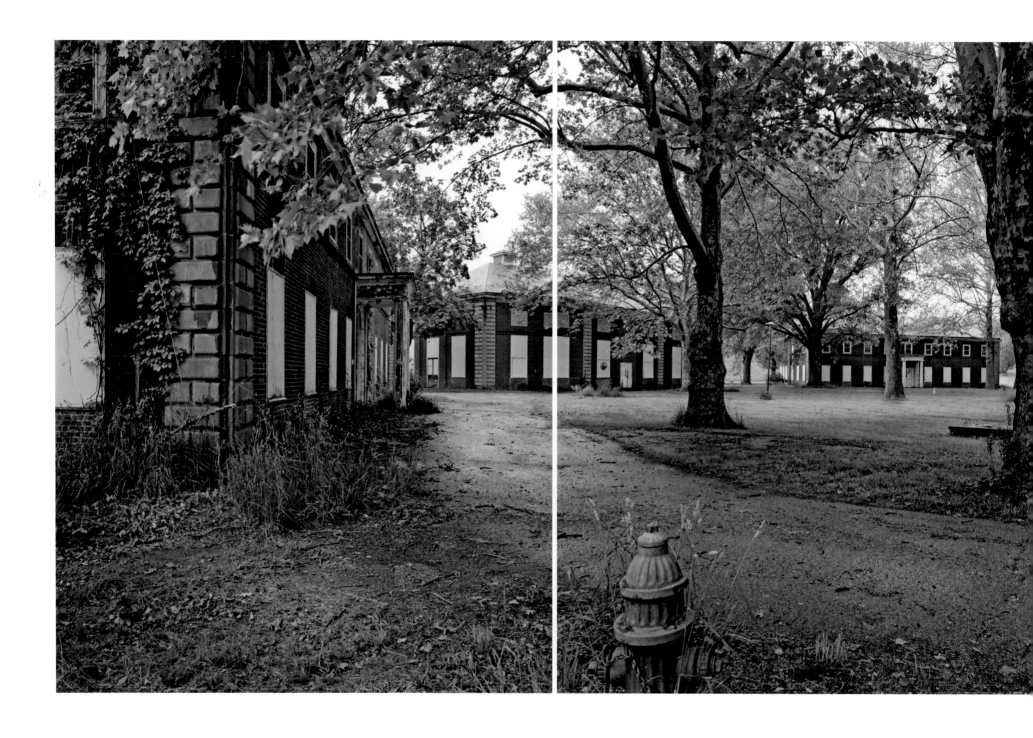

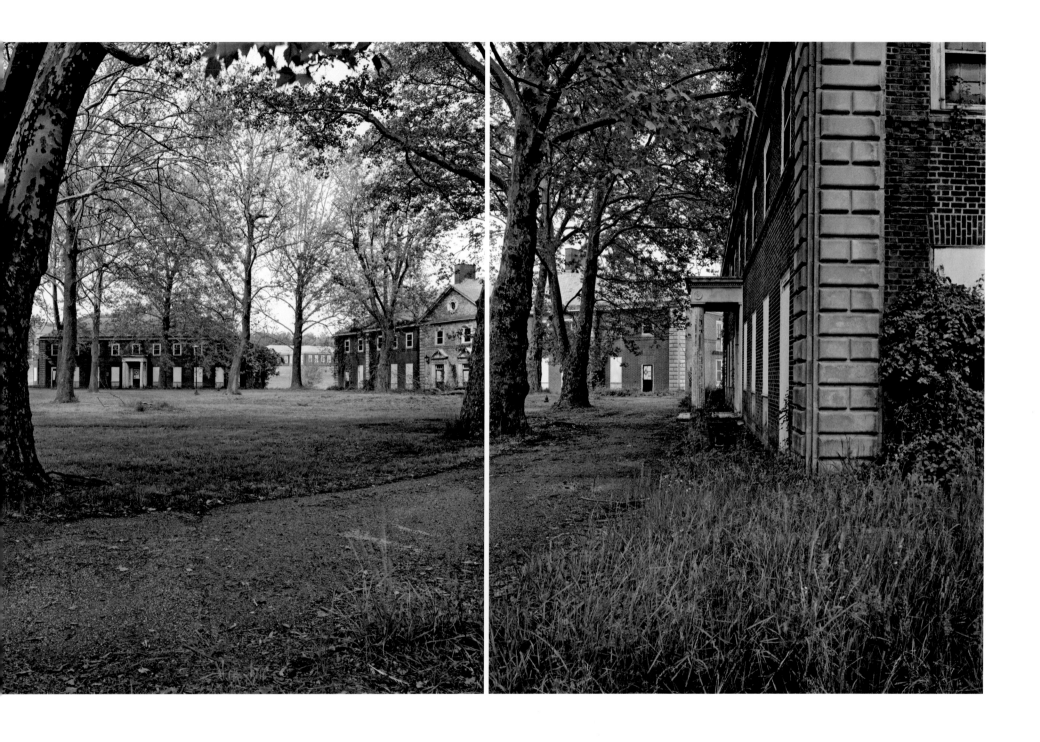

Clark Circle Colony for epileptics, Springfield State Hospital, Springfield, Maryland　　49

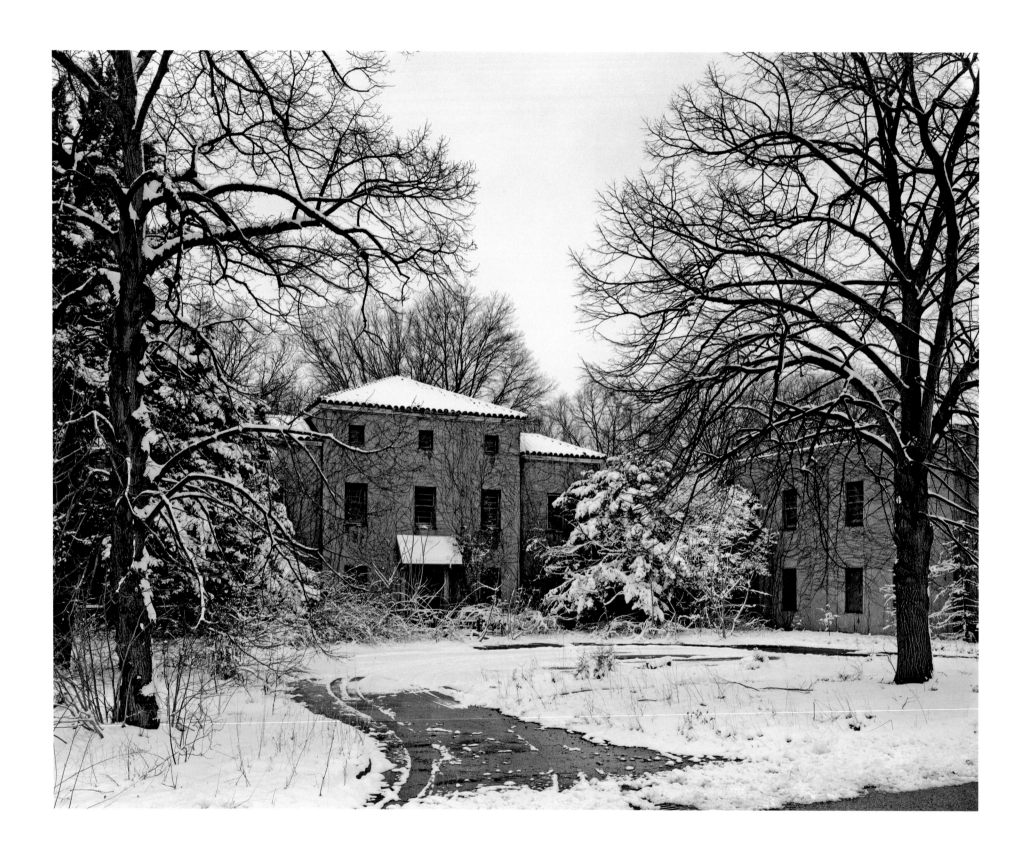

Rockland State Hospital, Orangeburg, New York

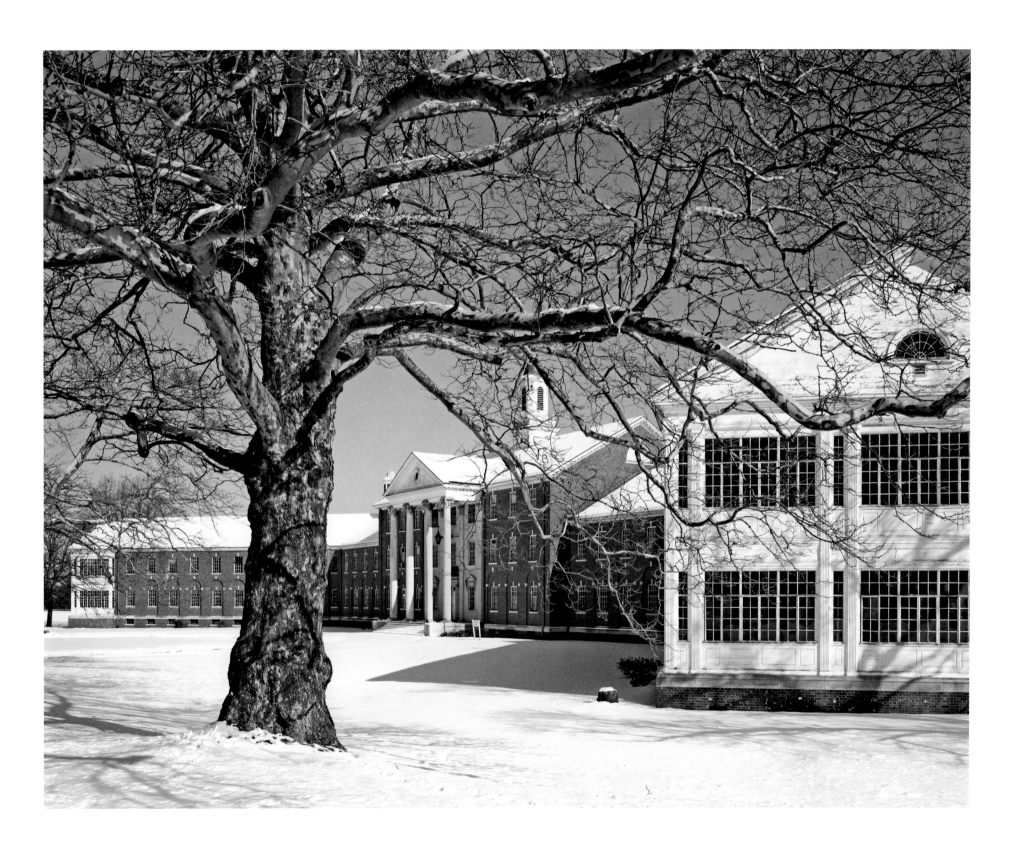

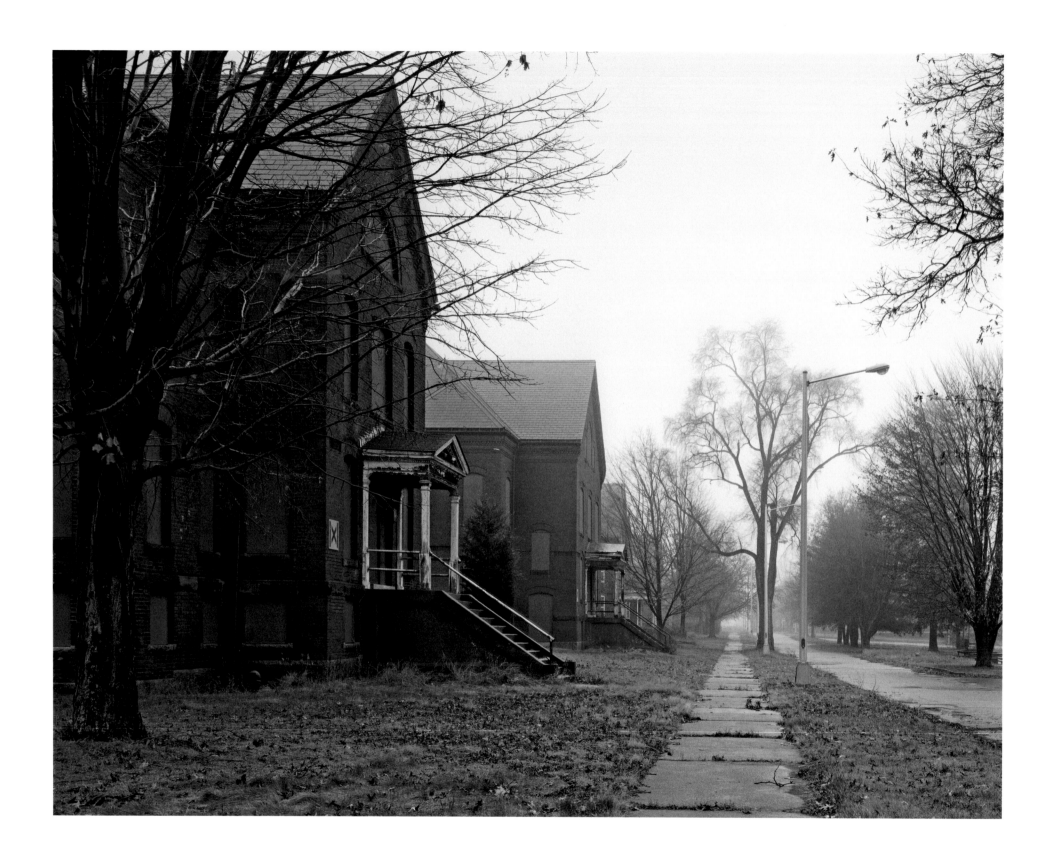

Medfield State Hospital, Medfield, Massachusetts

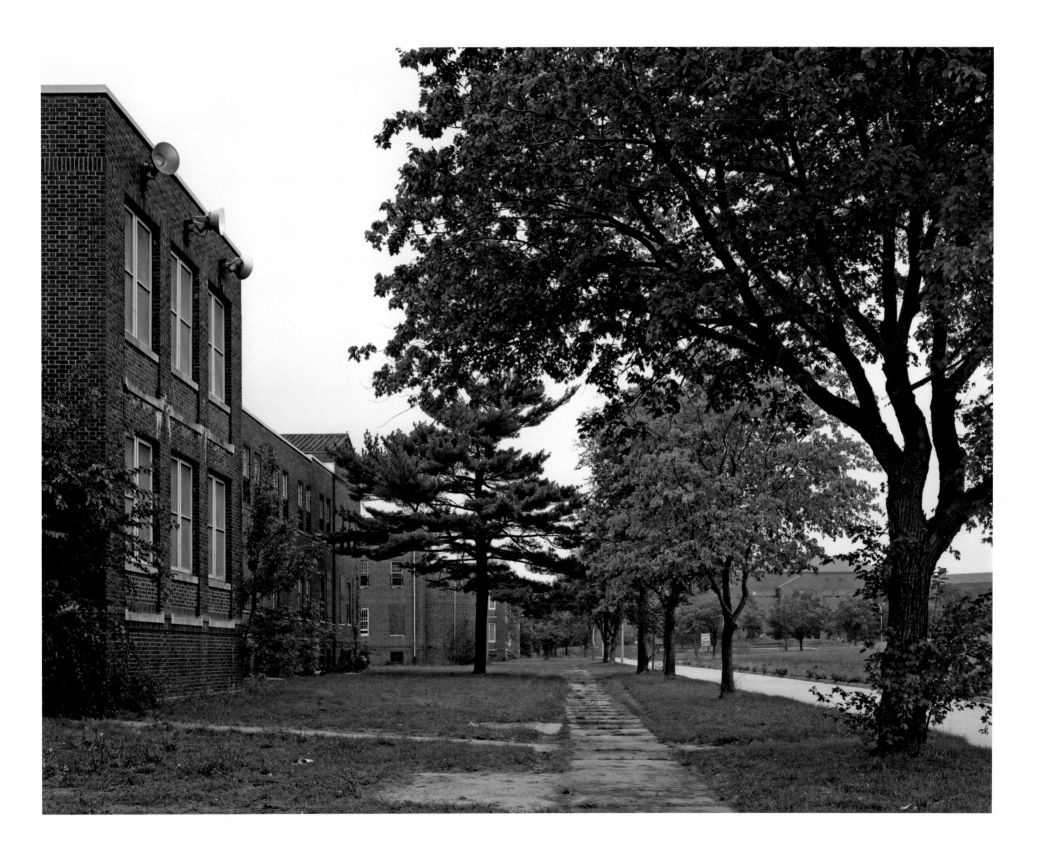

Pilgrim State Hospital, Brentwood, New York 53

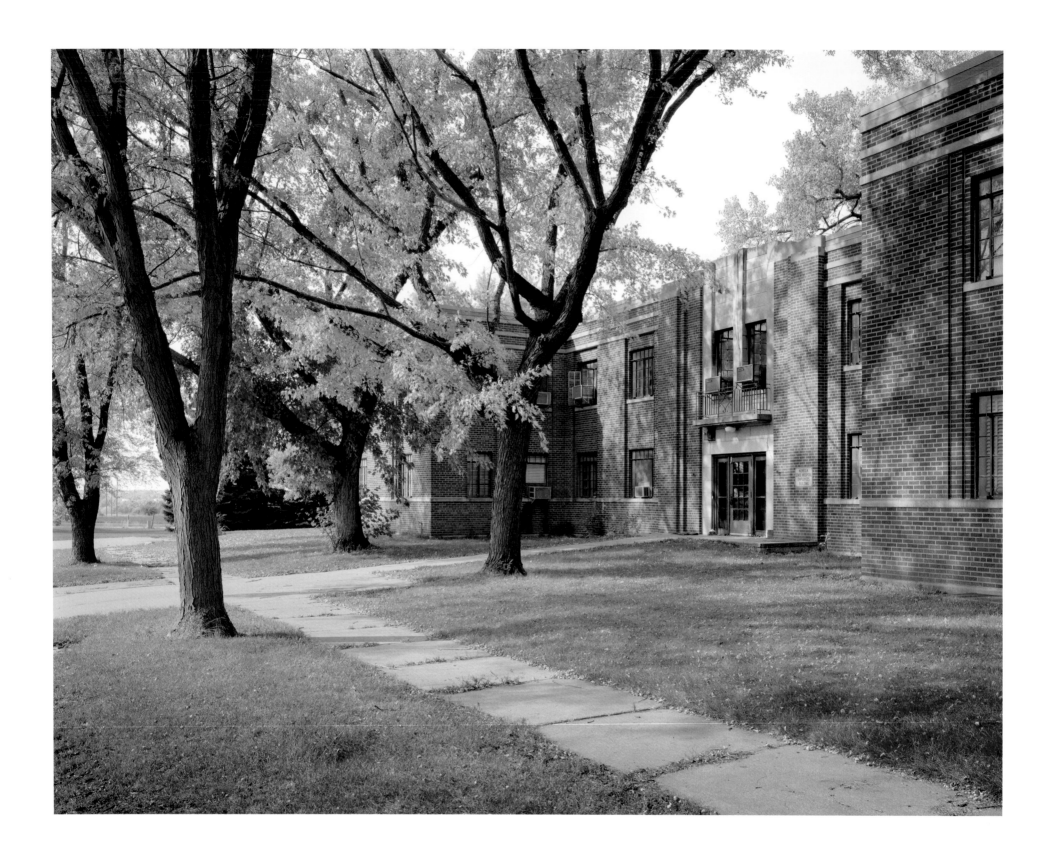

Employees' residence, Norfolk State Hospital, Norfolk, Nebraska

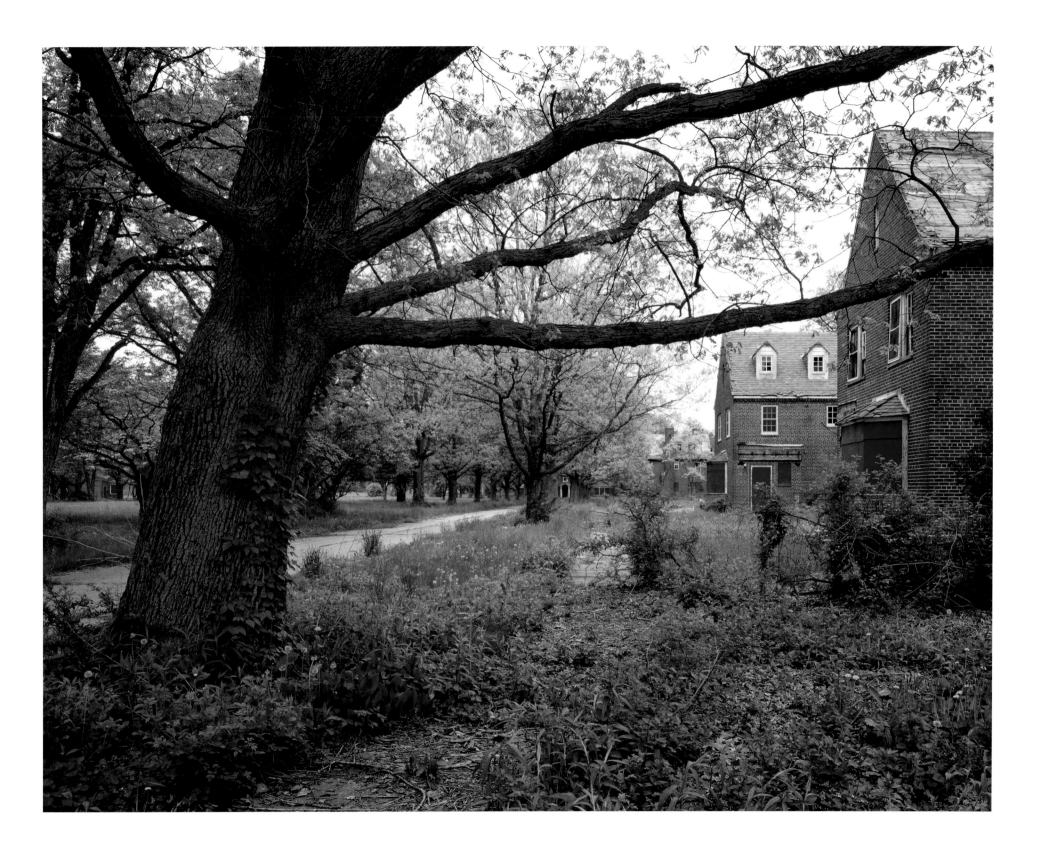

Doctors' village, Pilgrim State Hospital, Brentwood, New York 55

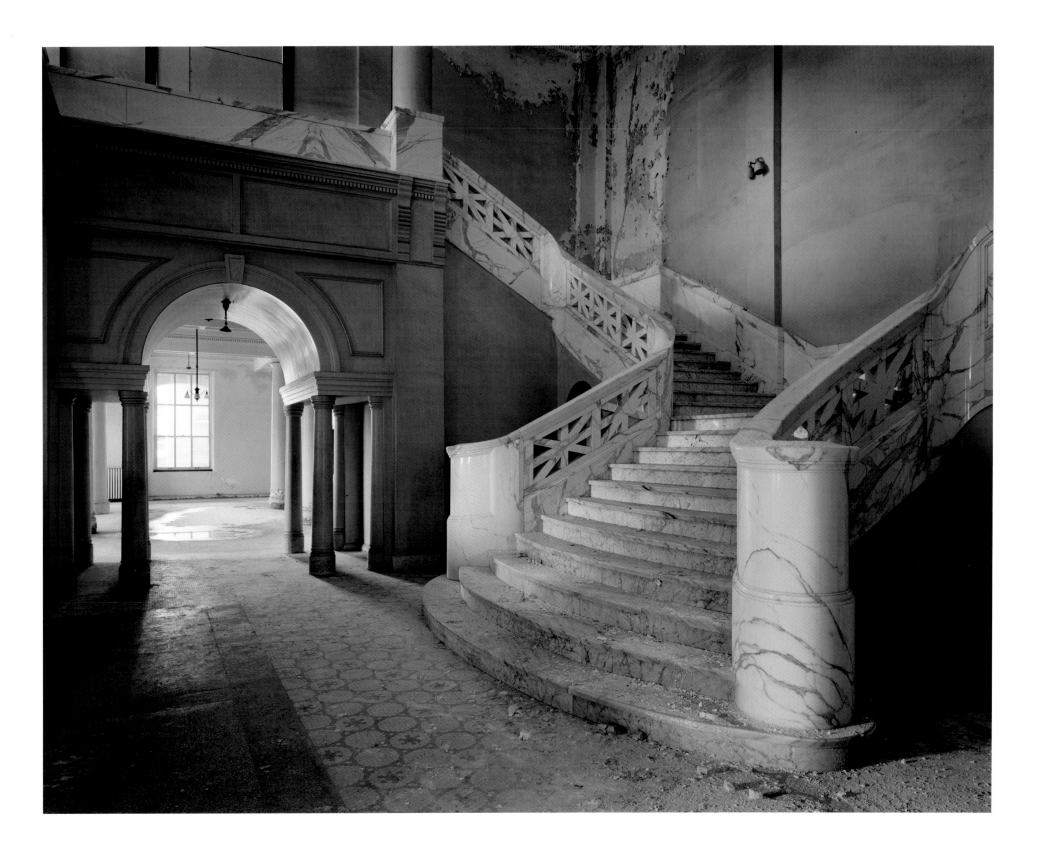

Lobby of Mead Building, Yankton State Hospital, Yankton, South Dakota 57

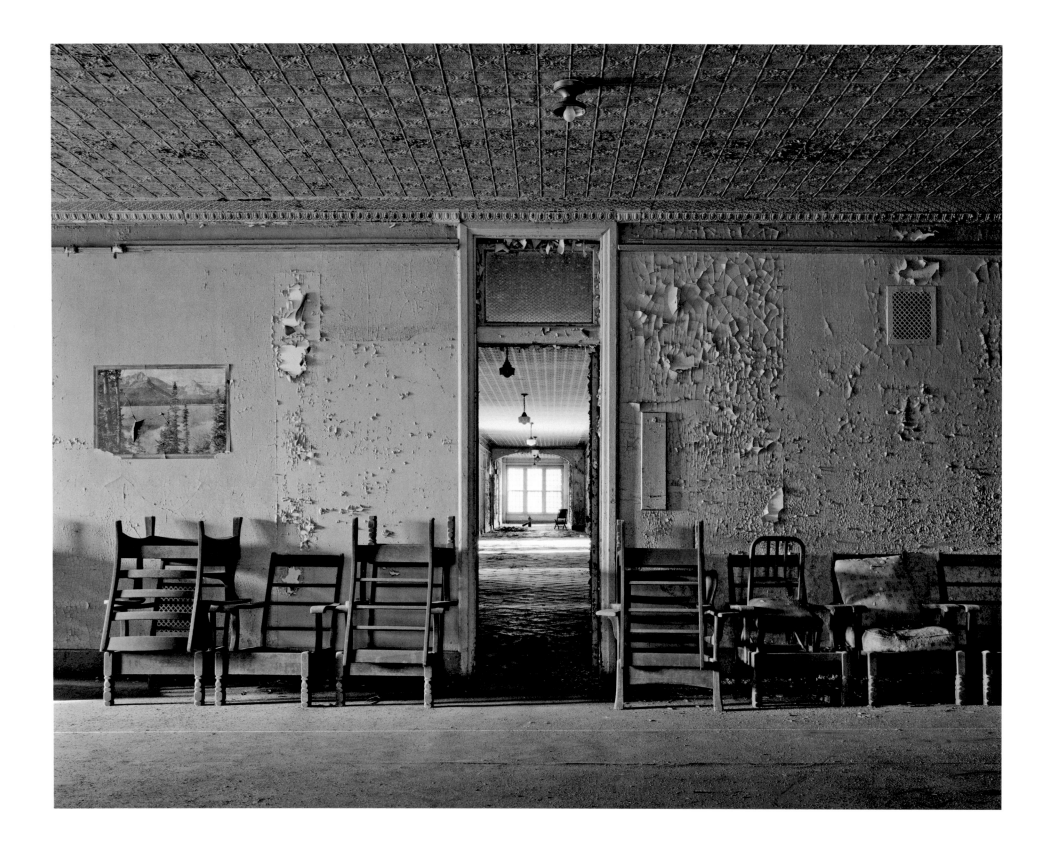

Ward entrance, Taunton State Hospital, Taunton, Massachusetts

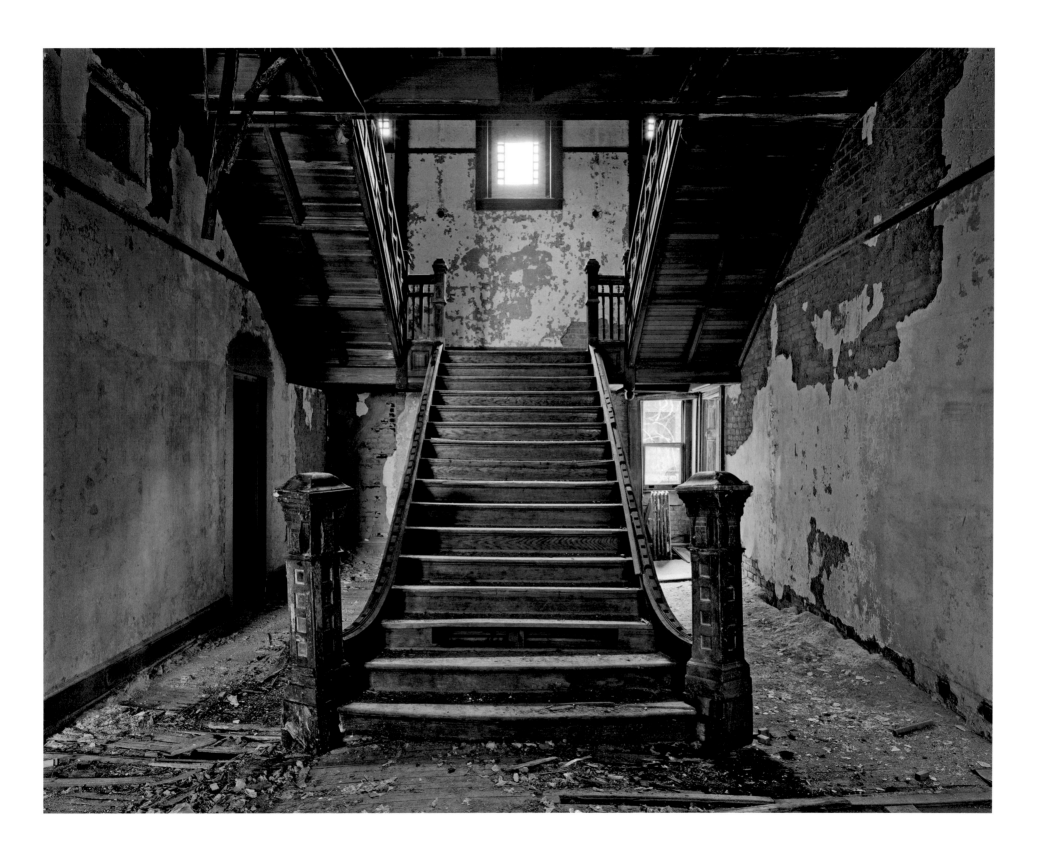

Administration building staircase, Matteawan State Hospital, Beacon, New York 59

THE QUINTESSENTIAL VIEW. The ward, the center of patient life, is the space that best typifies the mental hospitals. The view down the corridor, with its rigid symmetry and procession of identical bedroom doorways, speaks to the monotony of institutional life. In all the hospitals, the wards were fundamentally the same, sharing a plan driven by the need for efficiency and organization. On their own, they are just hallways, but together they are symbols of a closed and isolated world.

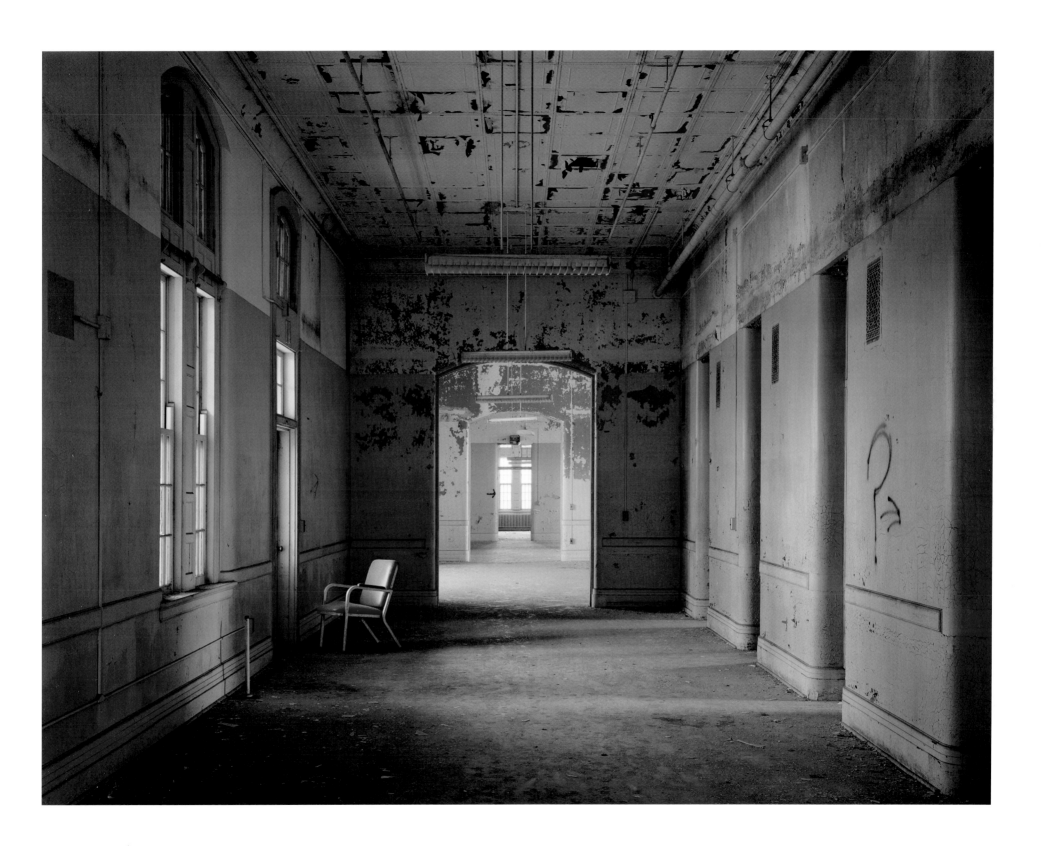

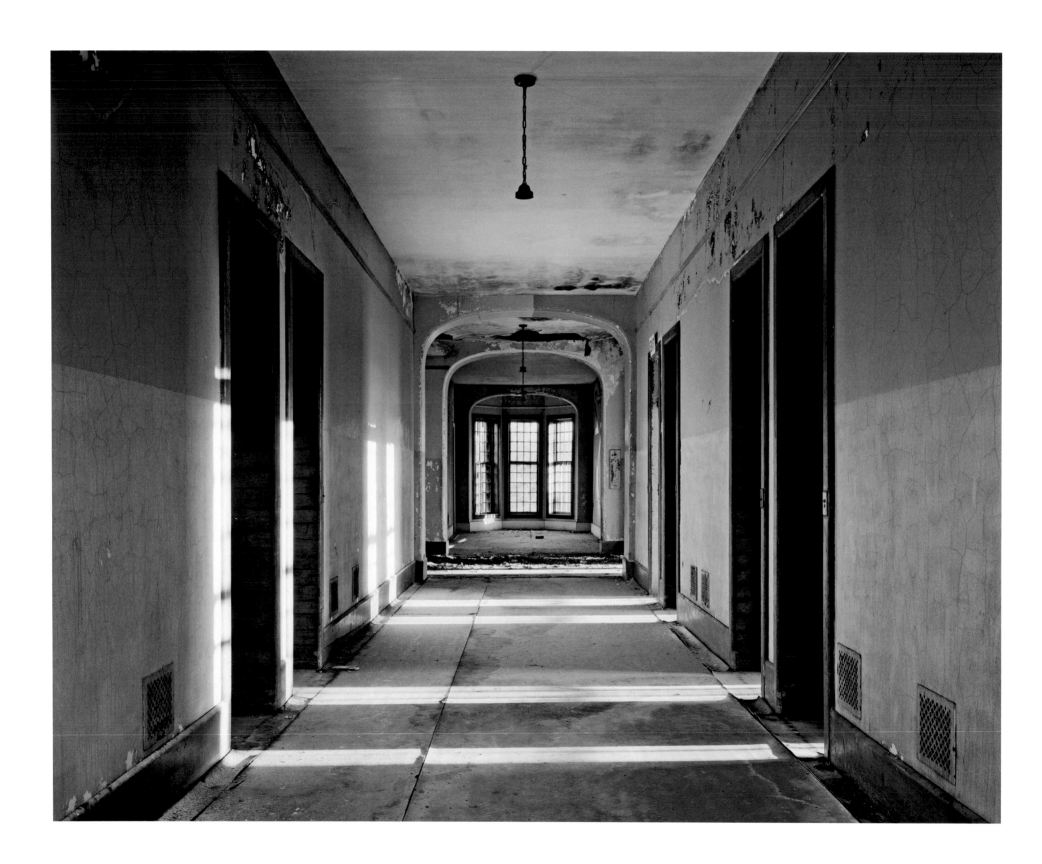

Typical ward, Taunton State Hospital, Taunton, Massachusetts

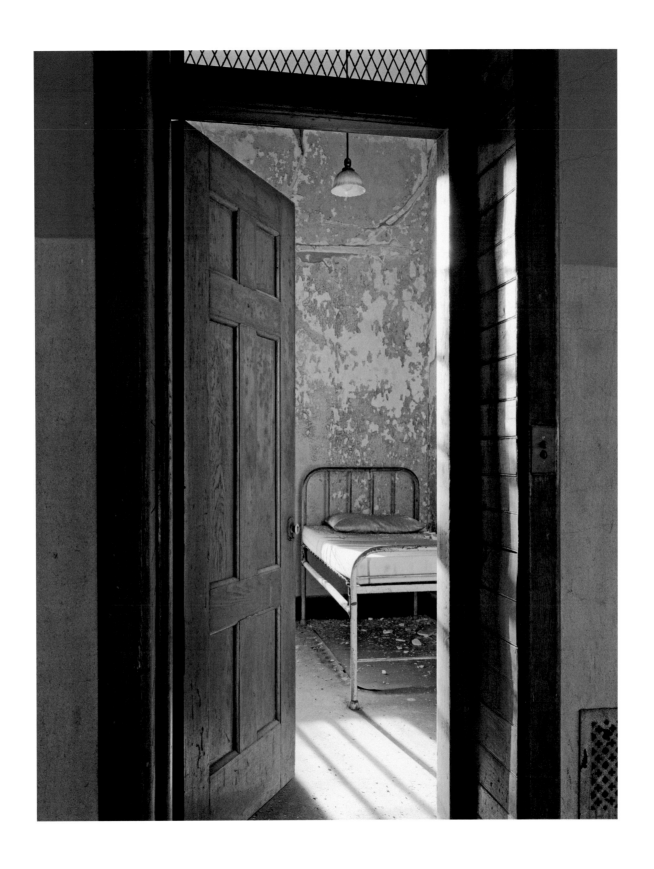

Patient bedroom, Taunton State Hospital, Taunton, Massachusetts 63

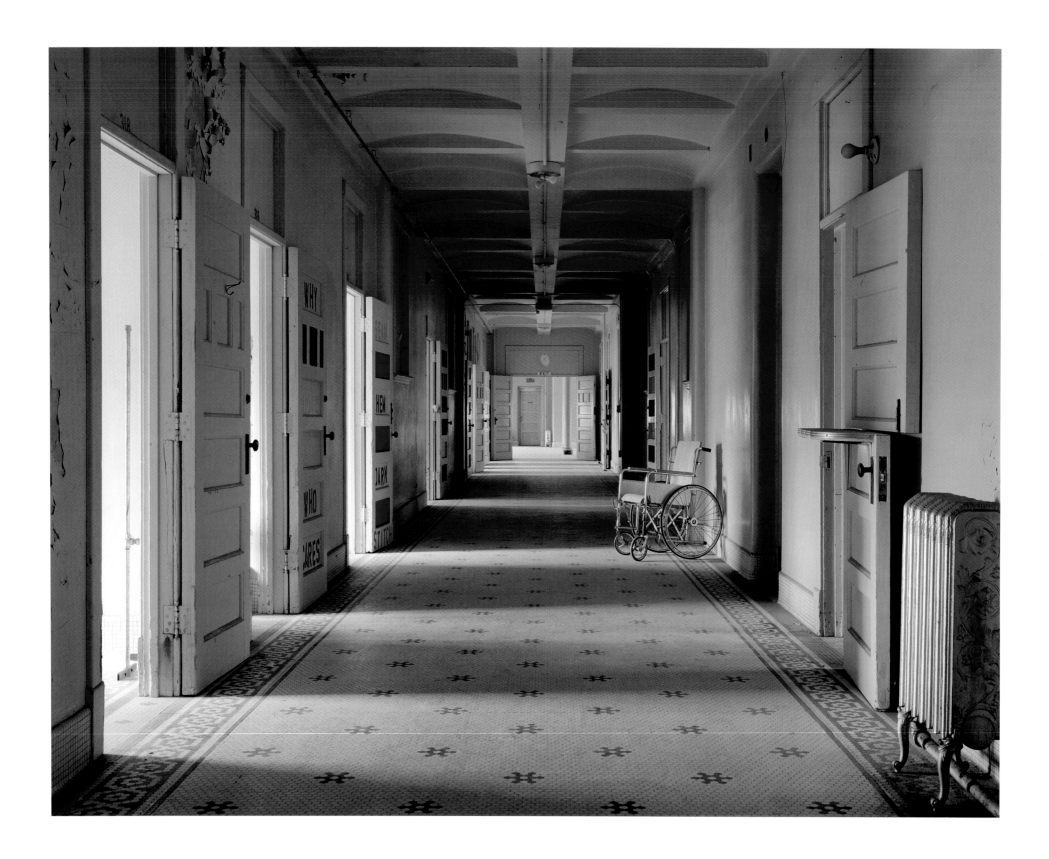

64 Typical ward, Fergus Falls State Hospital, Fergus Falls, Minnesota

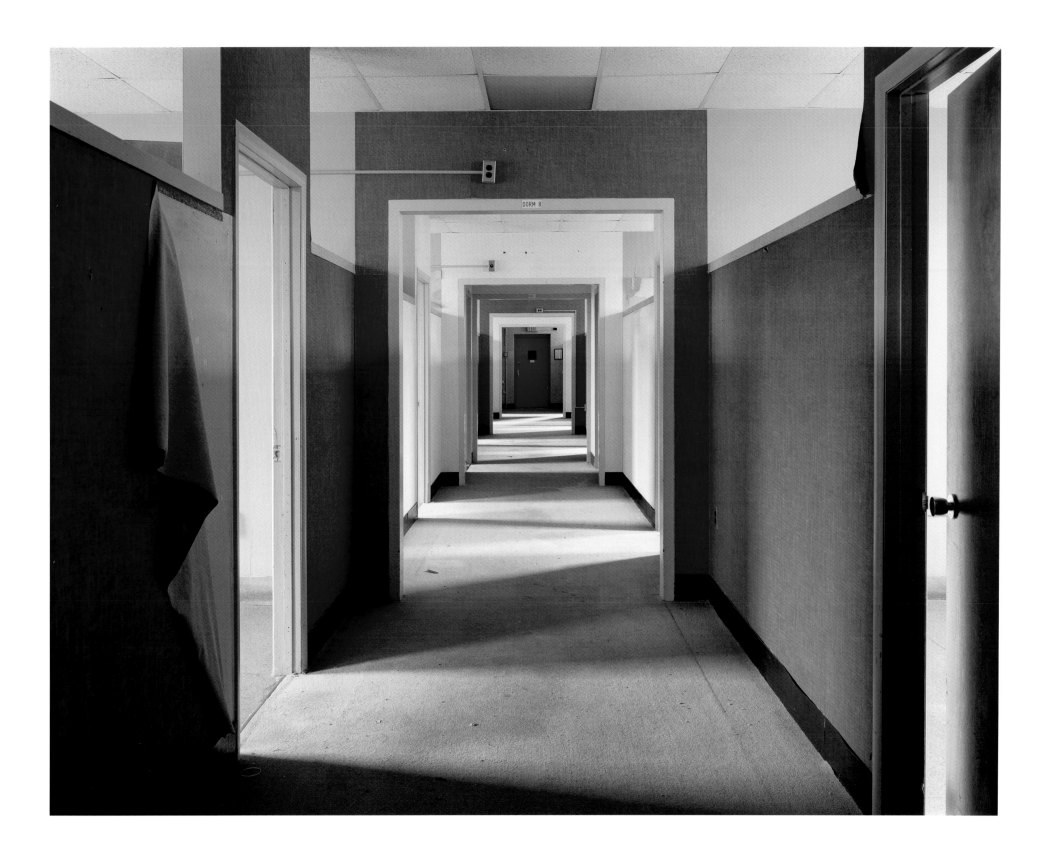

Remodeled dormitory ward, Harlem Valley State Hospital, Wingdale, New York 65

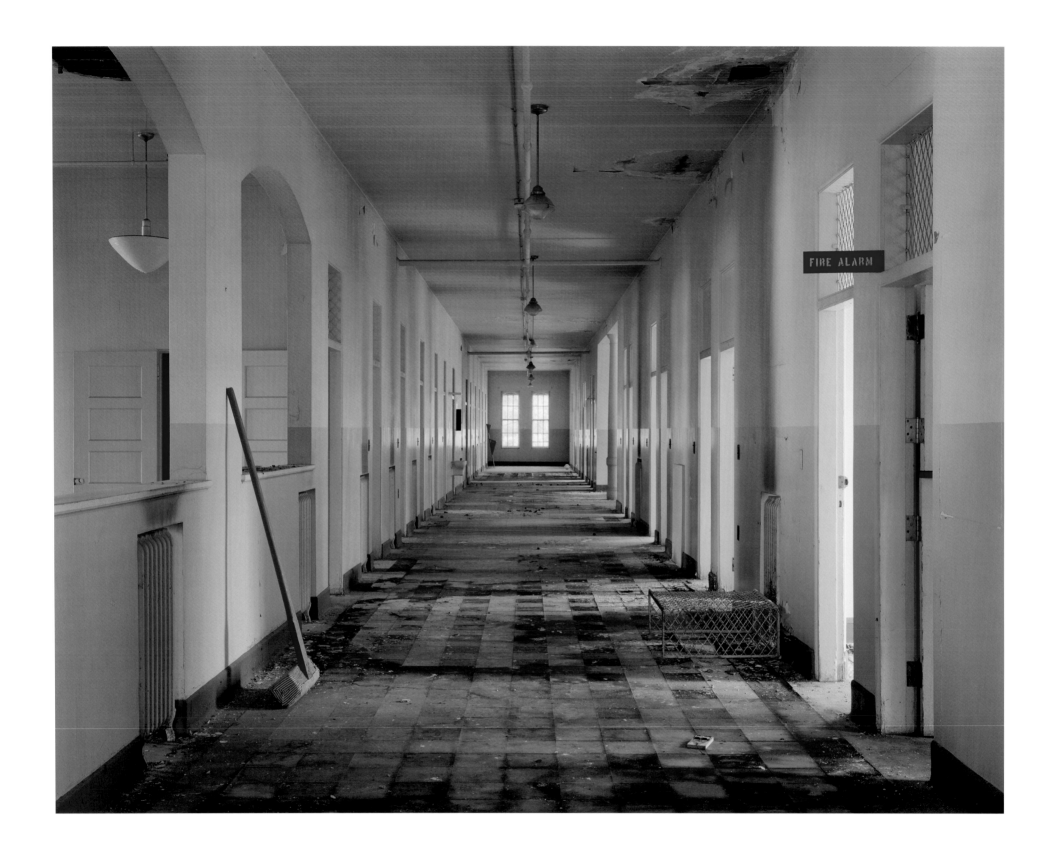

FIRE ALARM

Typical ward, Oregon State Hospital, Salem, Oregon

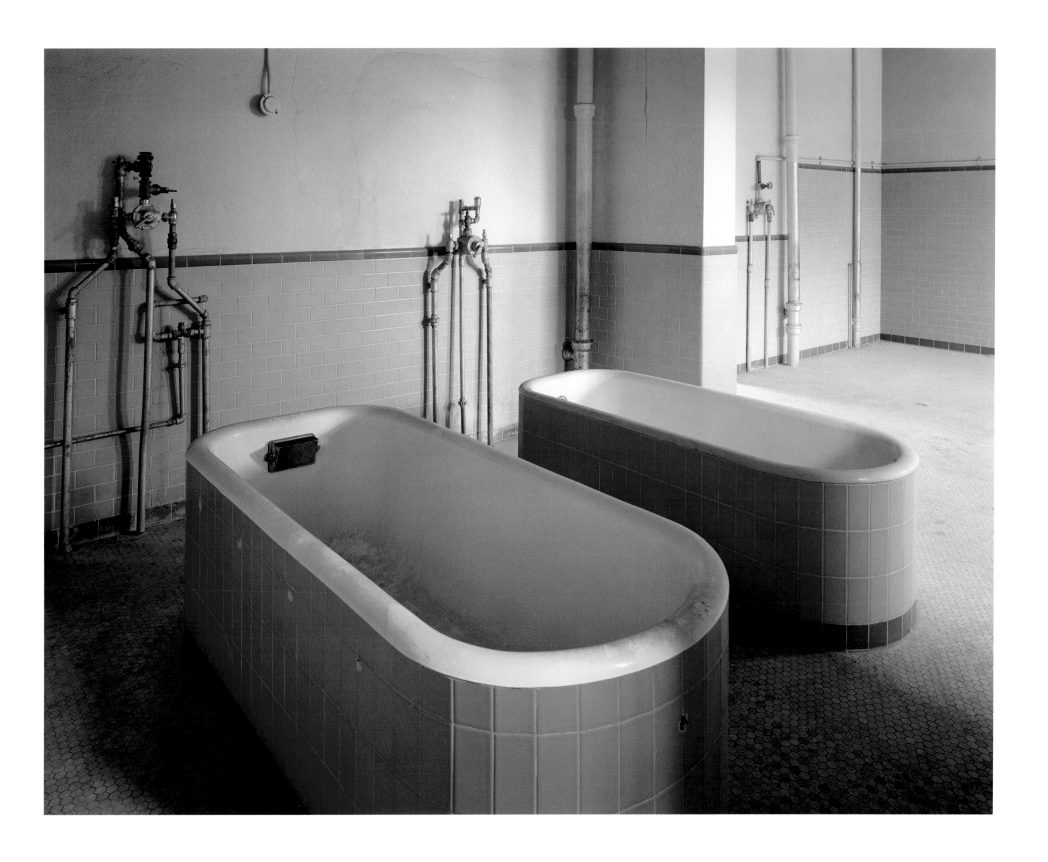

Patient bathtubs and showers, Oregon State Hospital, Salem, Oregon 67

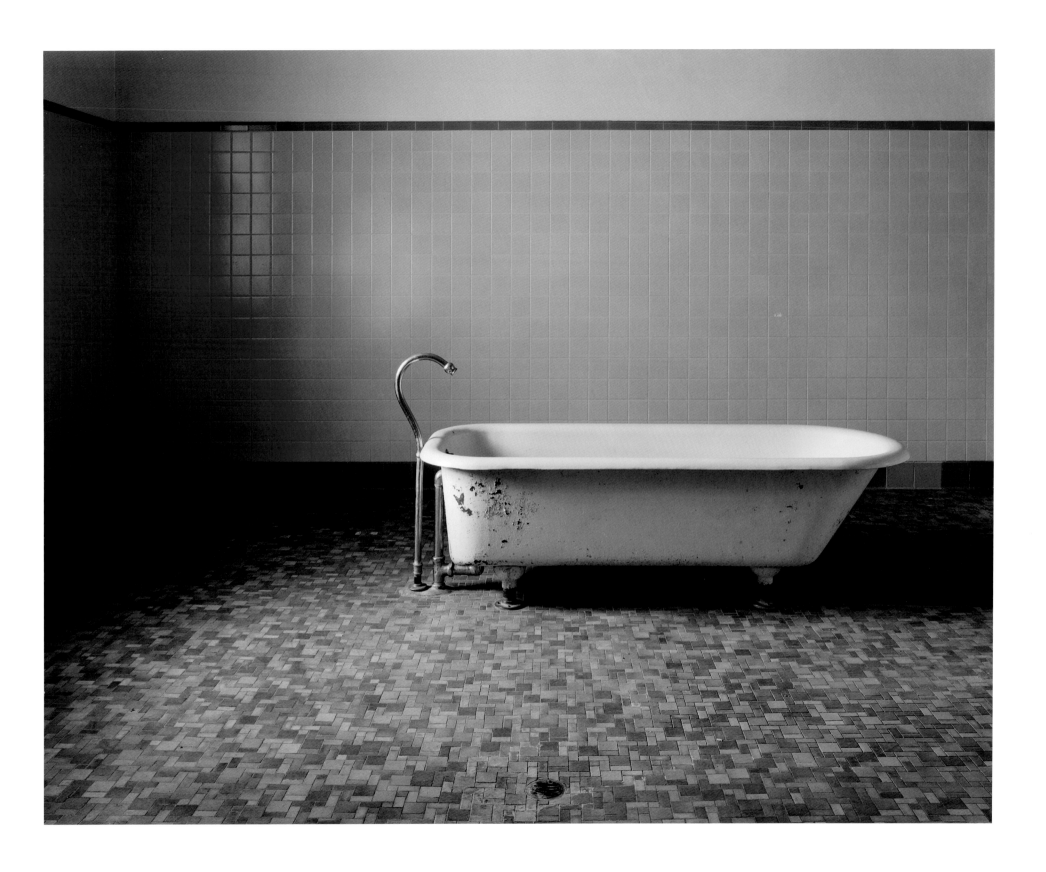

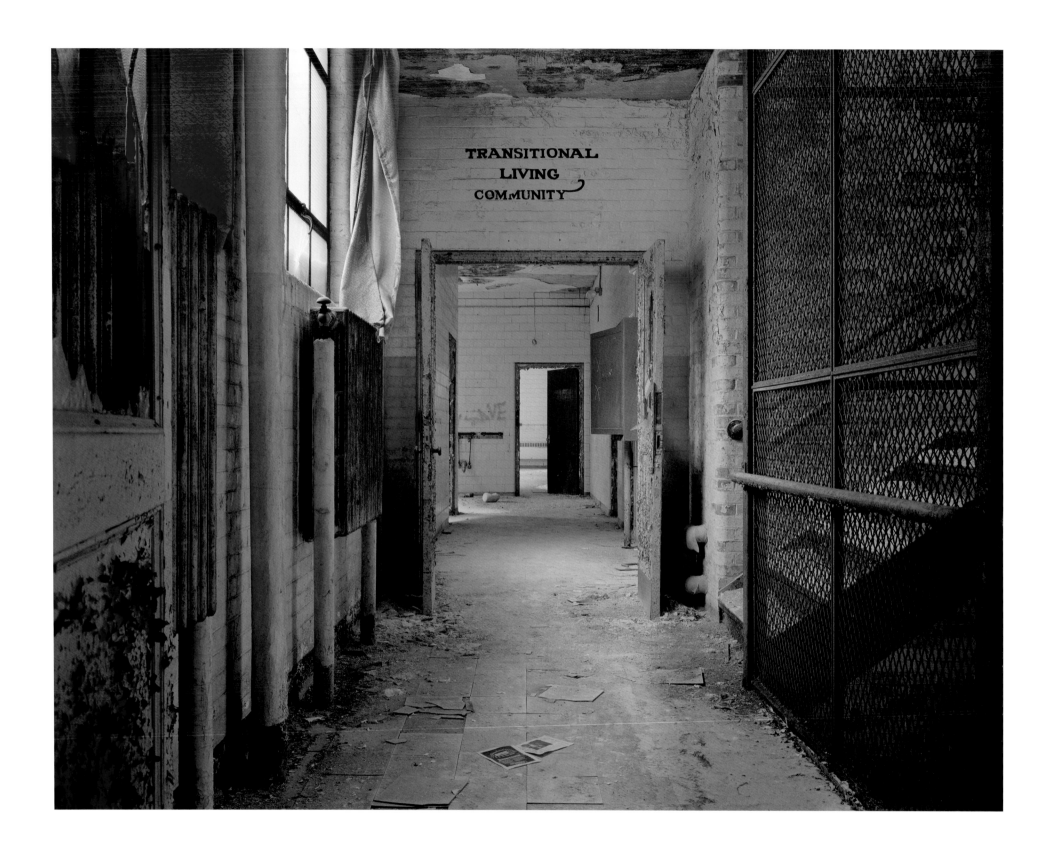

Danvers State Hospital, Danvers, Massachusetts

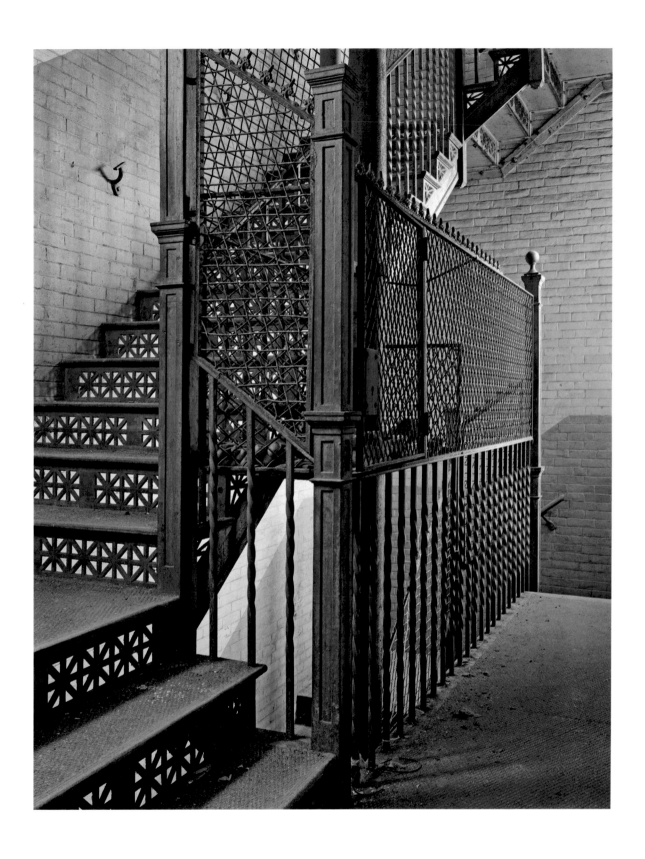

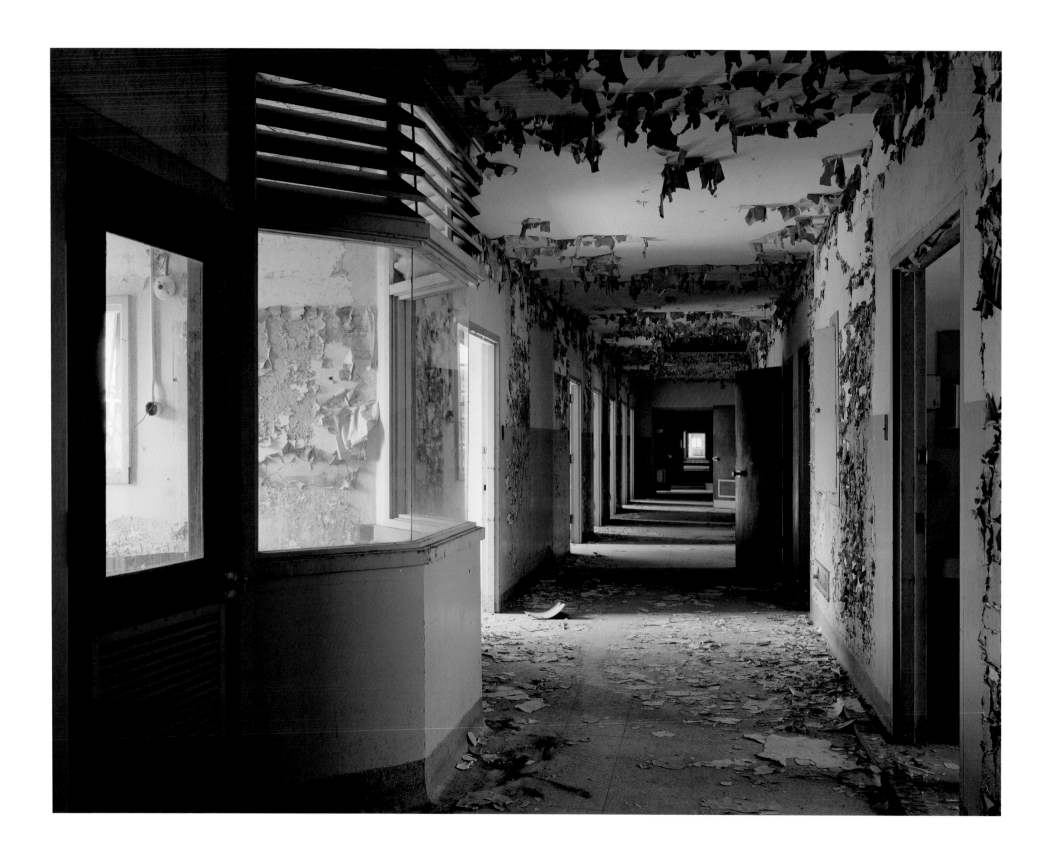

Nurses station, Bolivar State Hospital, Bolivar, Tennessee

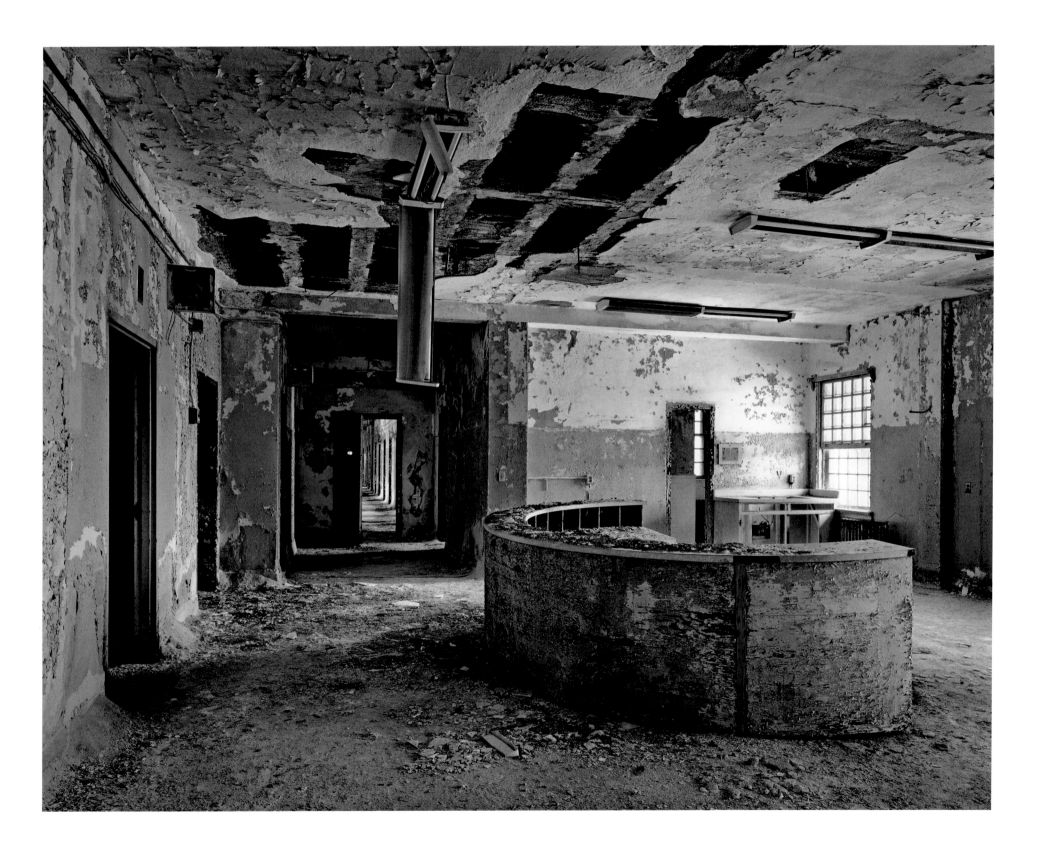

Nurses station, Central State Hospital, Milledgeville, Georgia 73

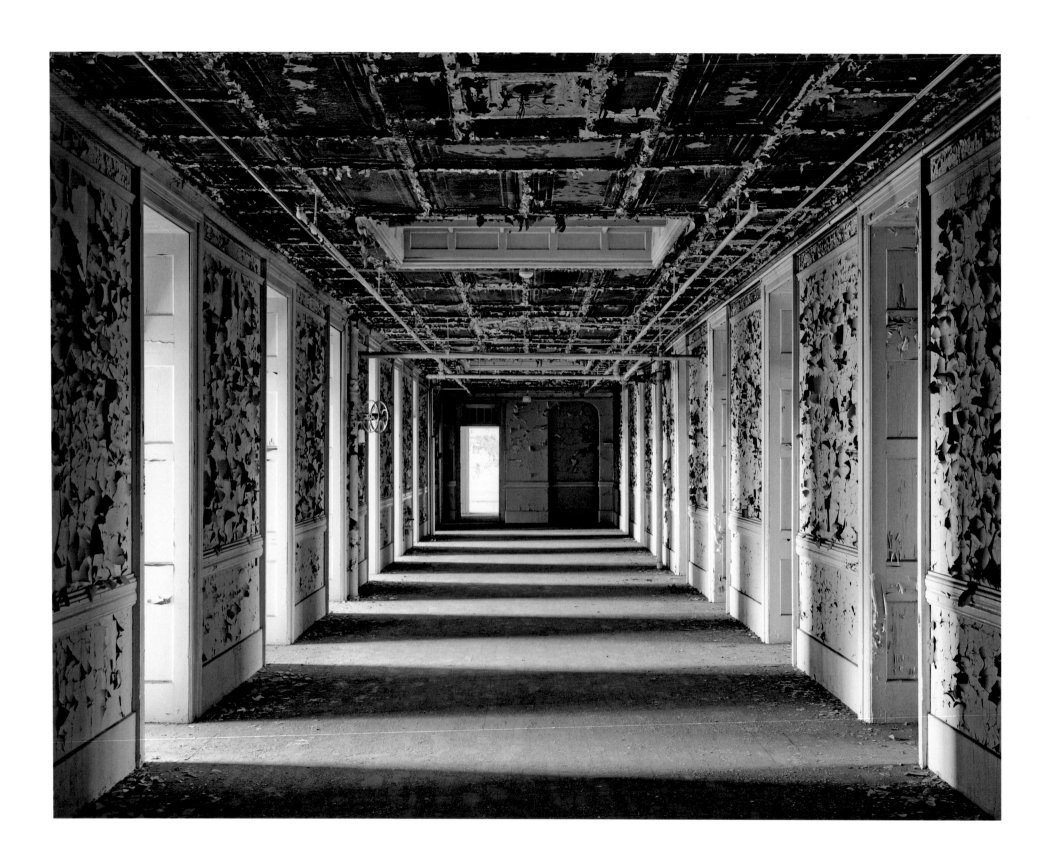

Typical ward, Utica State Hospital, Utica, New York

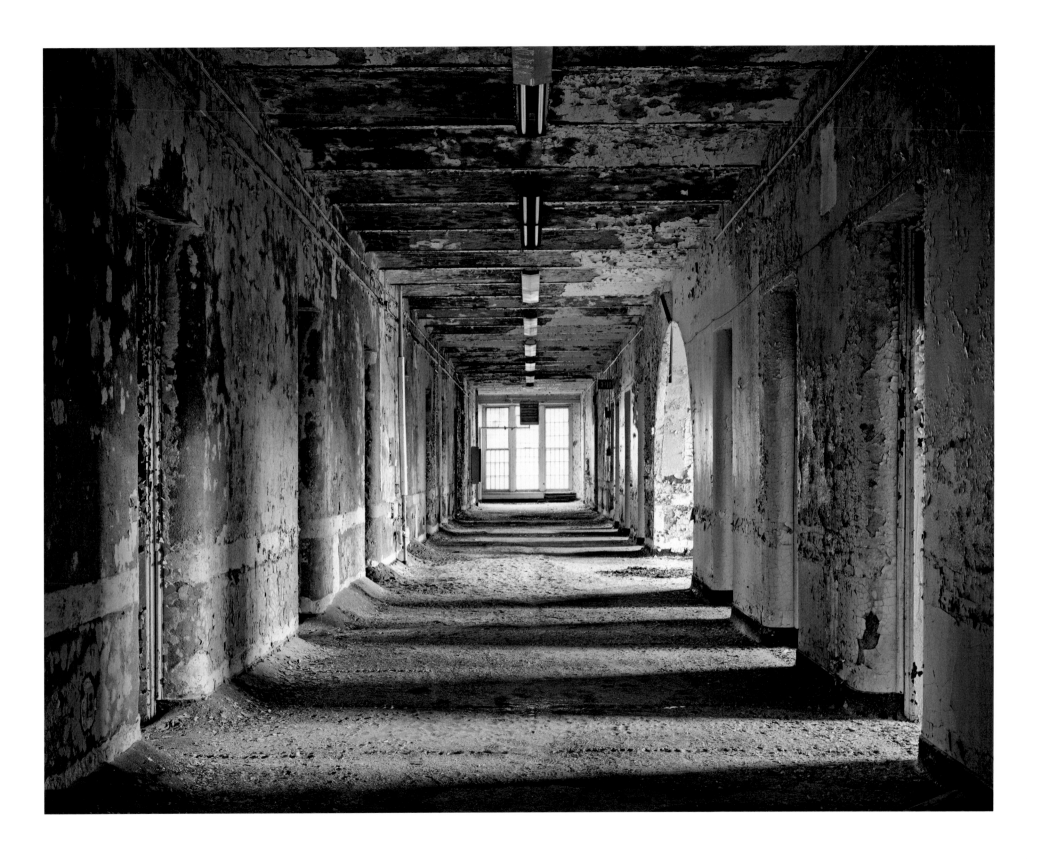

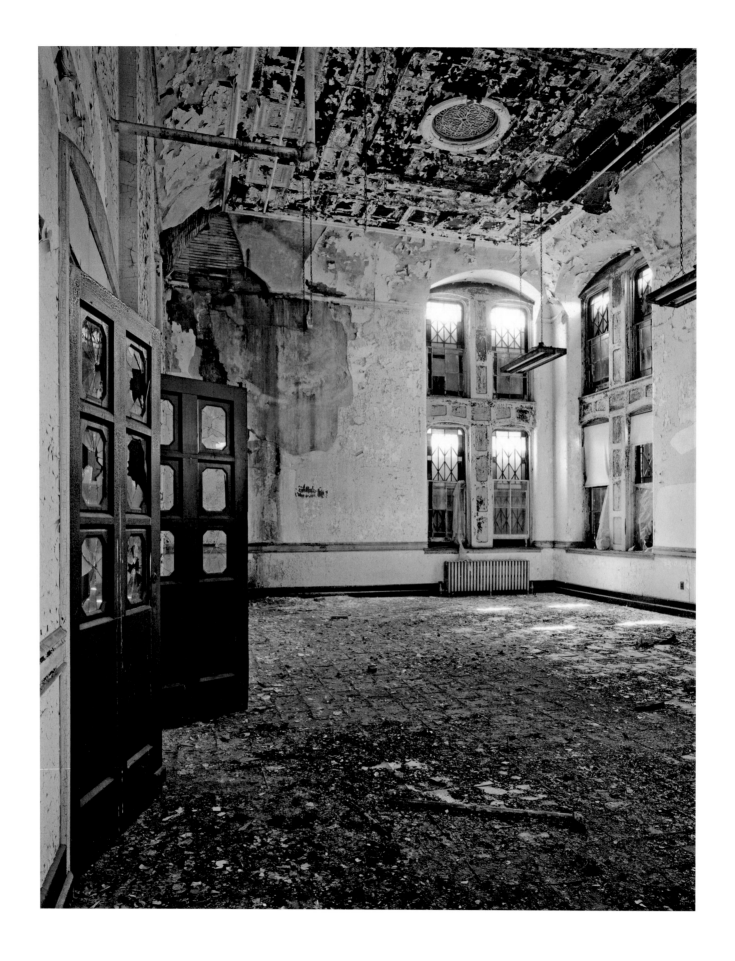

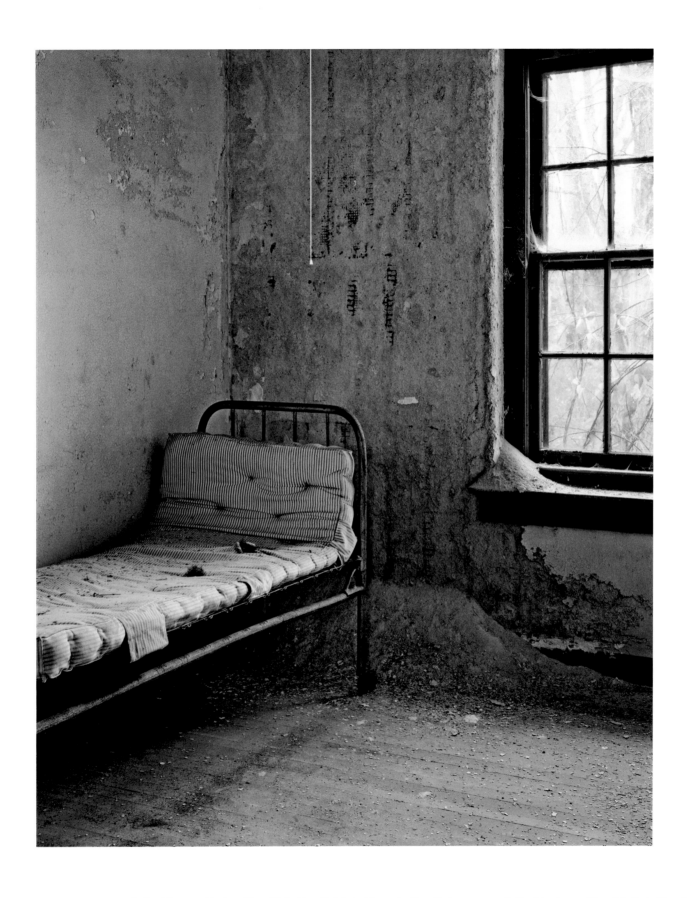

LEFT: Patient lounge, Hudson River State Hospital, Poughkeepsie, New York ABOVE: Patient bedroom, Norwich State Hospital, Preston, Connecticut 77

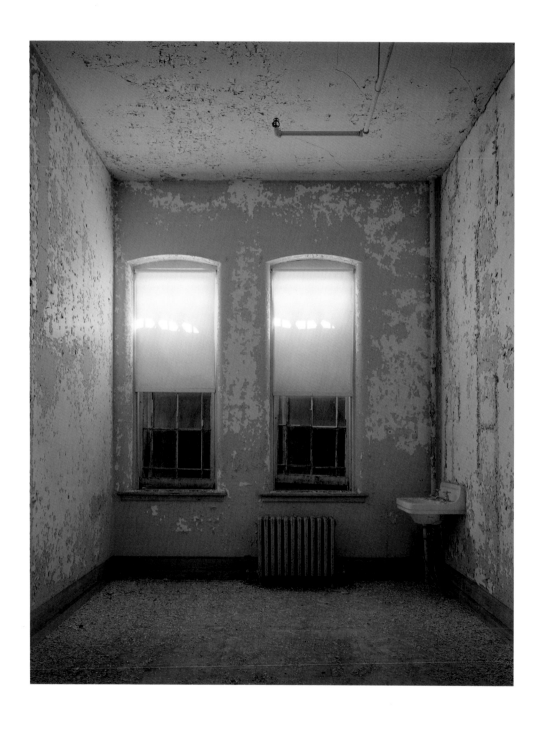

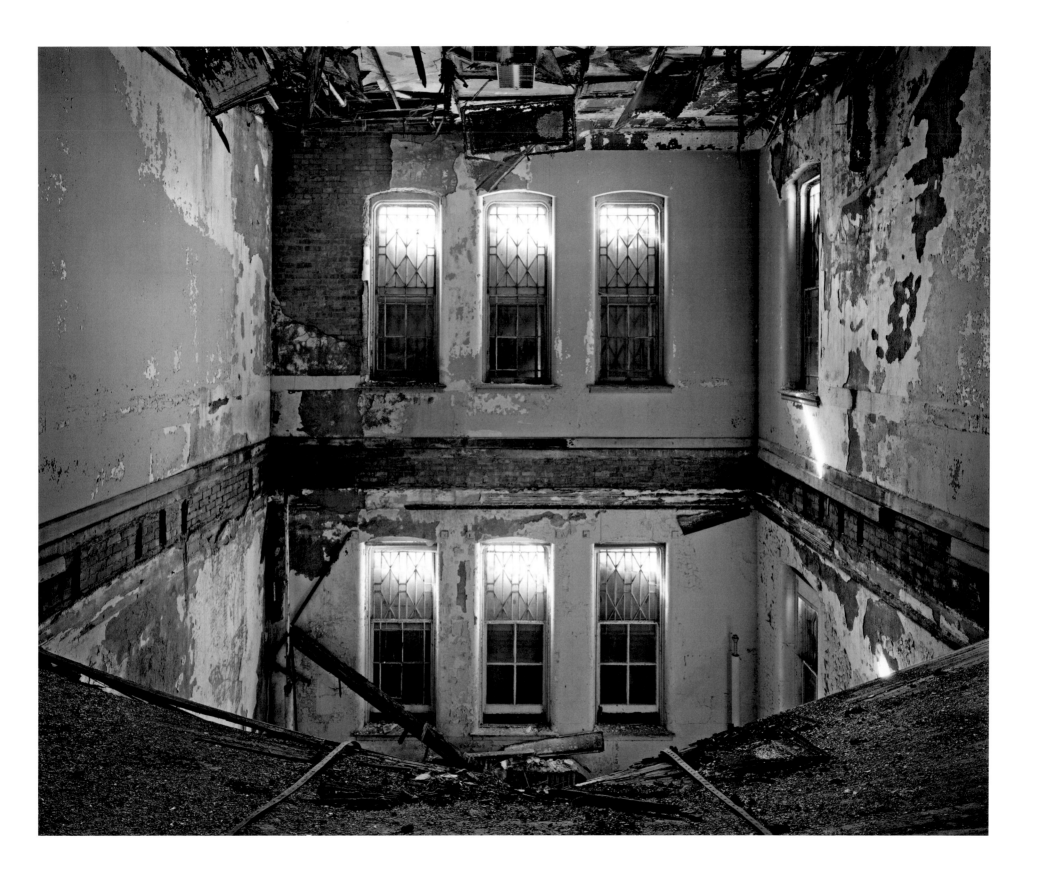

Two rooms, Hudson River State Hospital, Poughkeepsie, New York 79

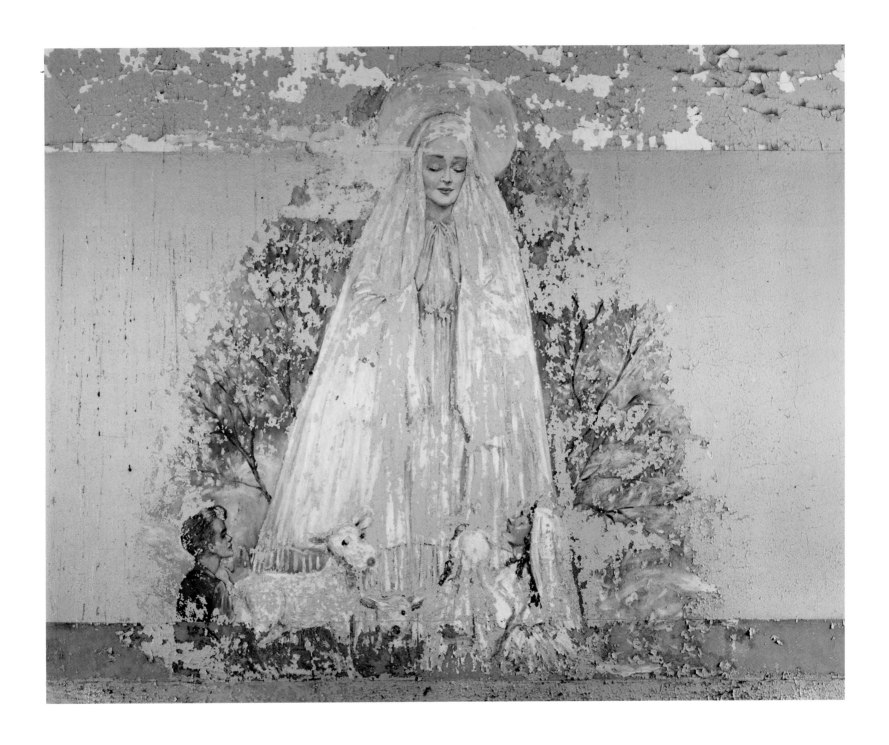

Ward mural, Creedmoor State Hospital, Queens, New York 81

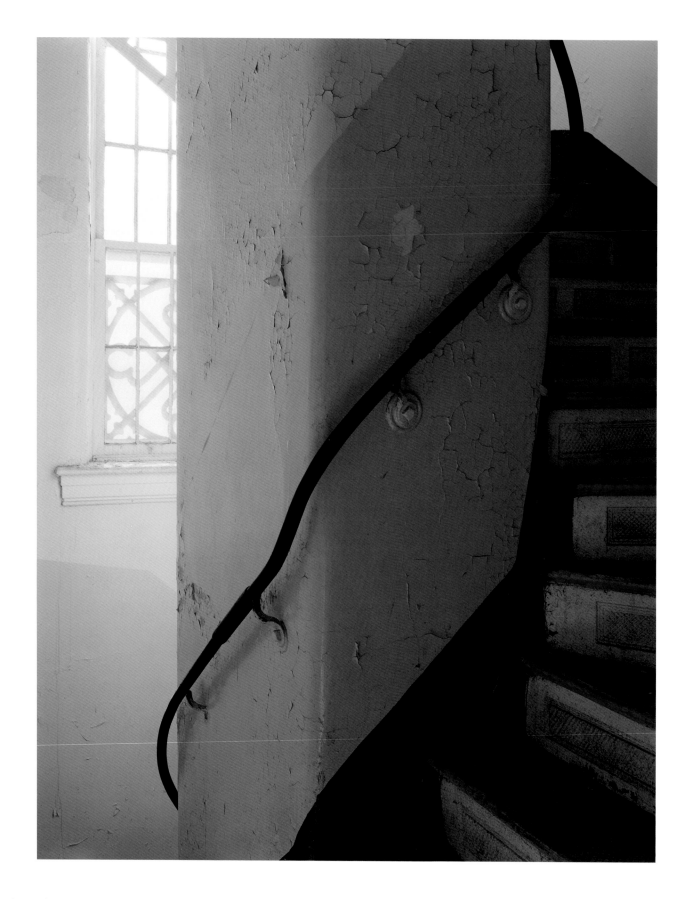

Athens State Hospital, Athens, Ohio

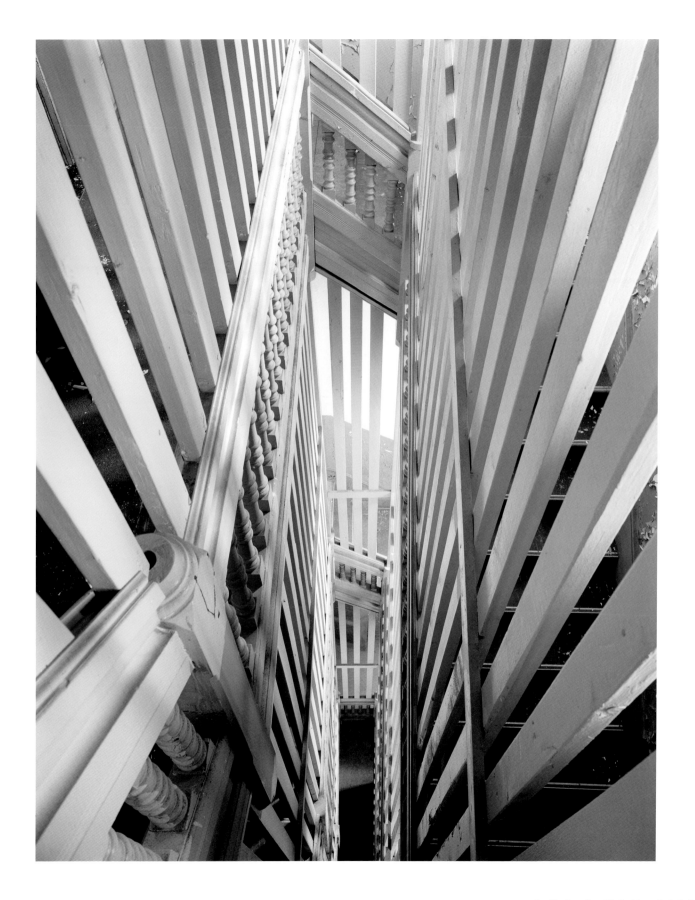

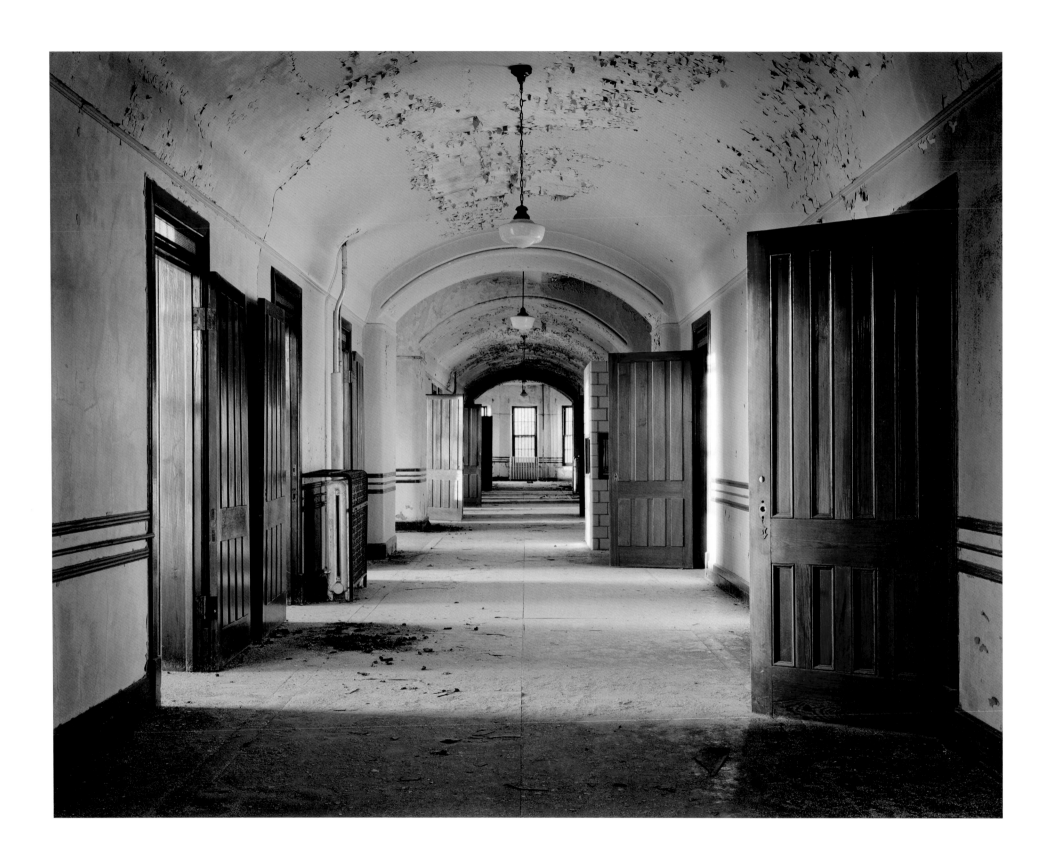

84 Typical ward, Kankakee State Hospital, Kankakee, Illinois

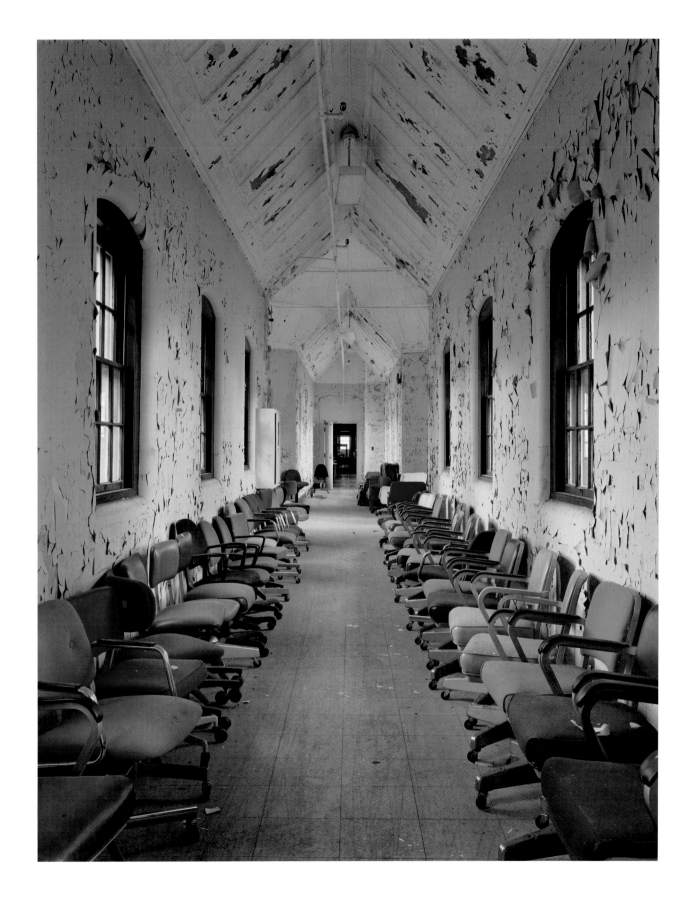

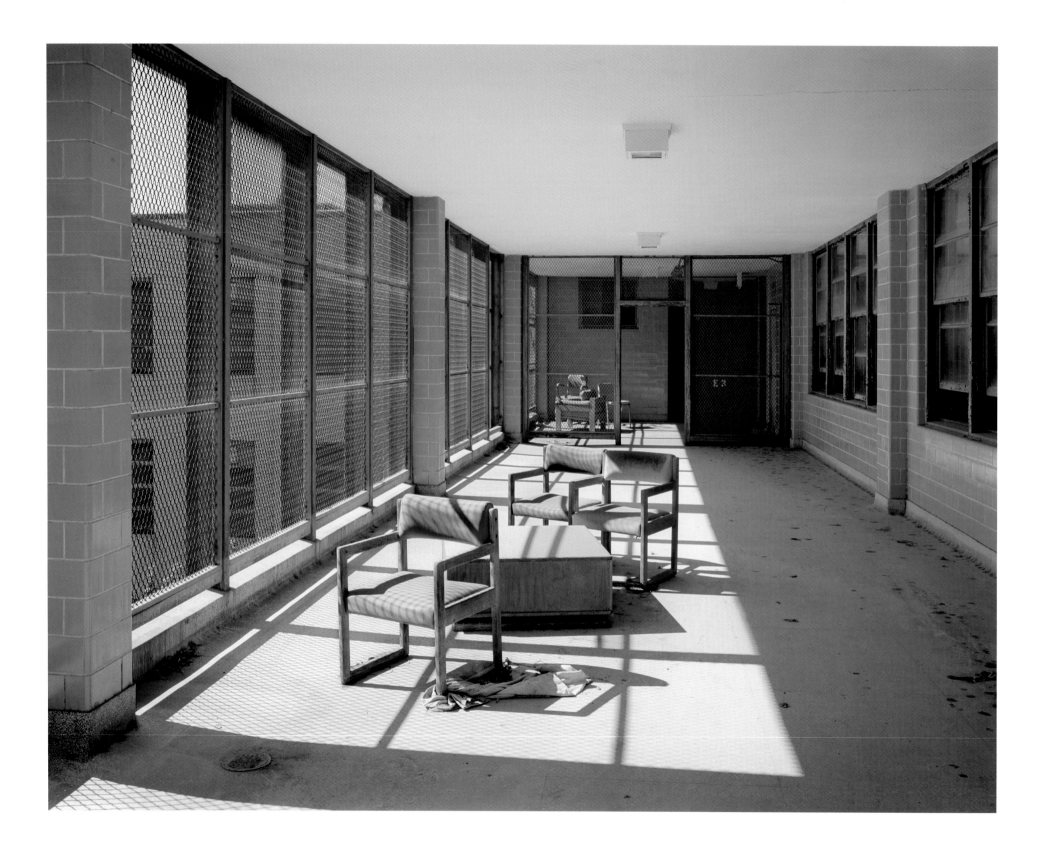

86 Ward porch, Terrell State Hospital, Terrell, Texas

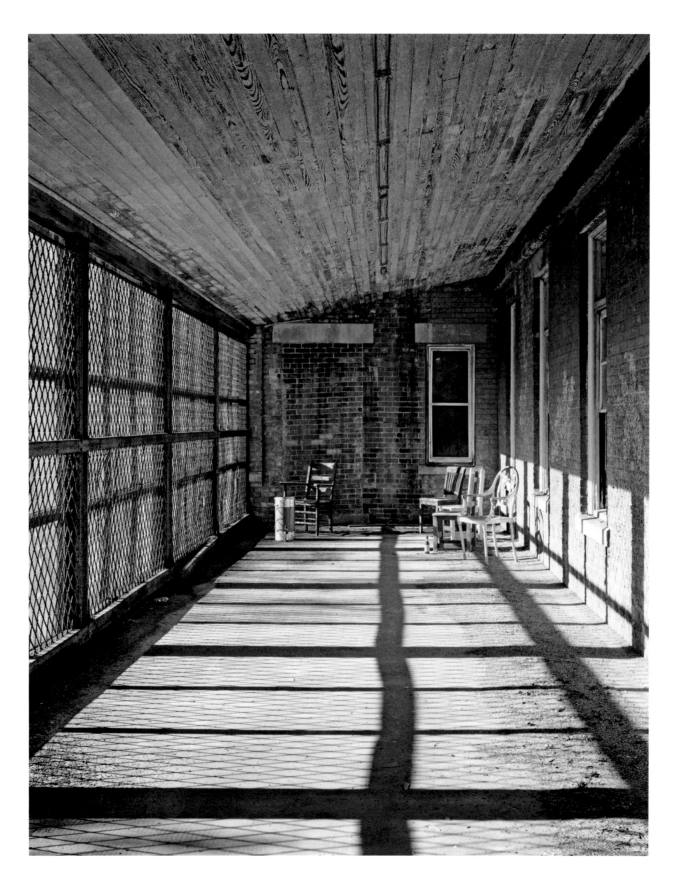

Ward porch, Norwich State Hospital, Preston, Connecticut 87

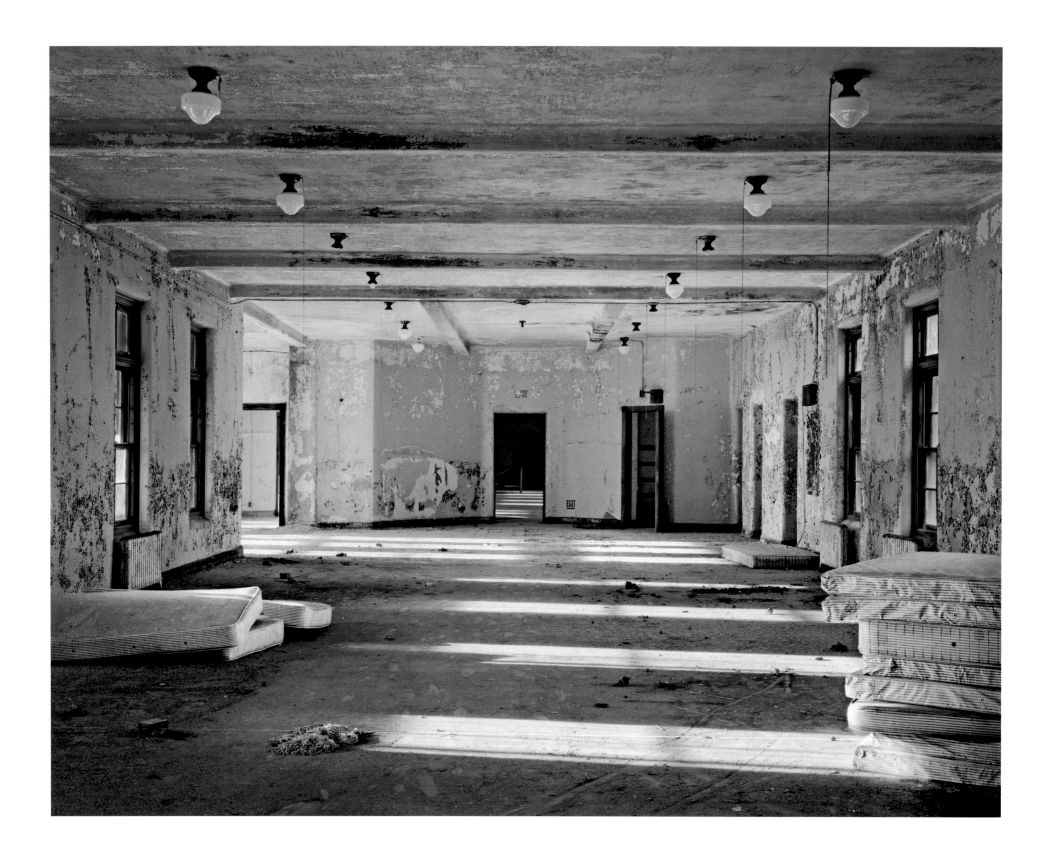

Dormitory ward, Norwich State Hospital, Preston, Connecticut

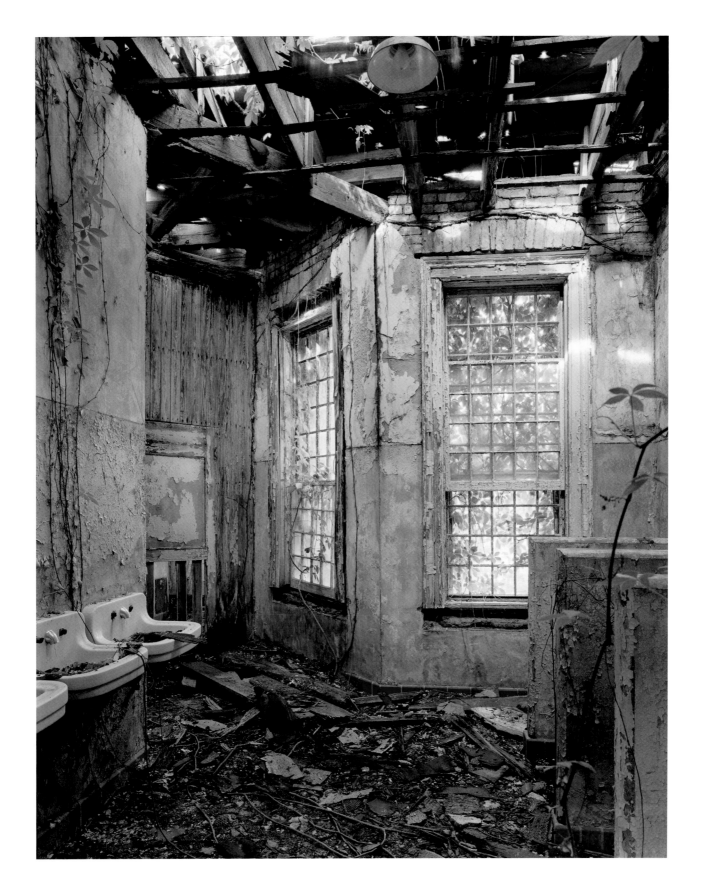

Ward bathroom, Central State Hospital, Milledgeville, Georgia 89

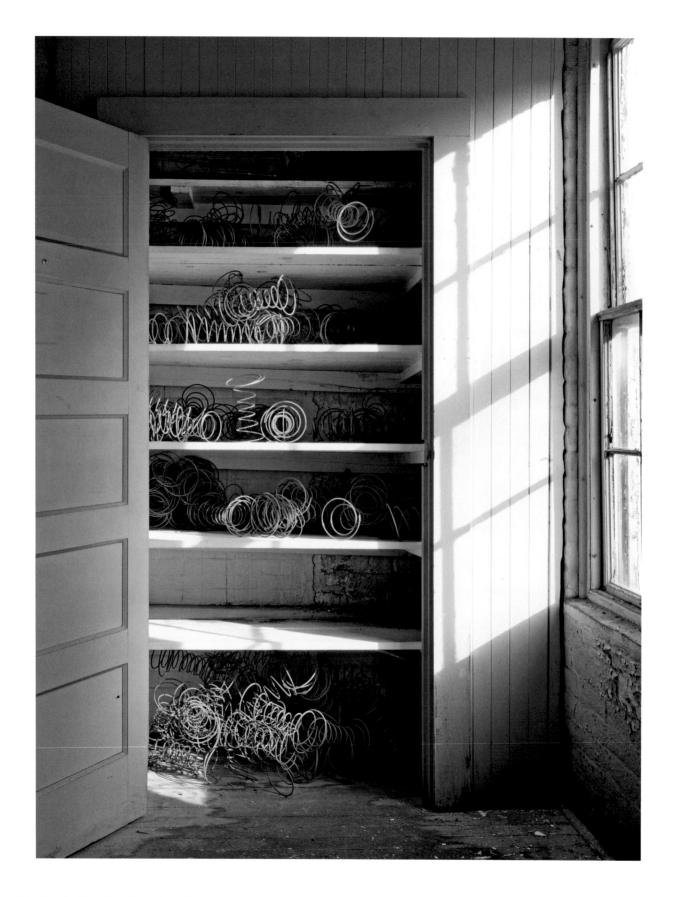

90 Mattress springs, Taunton State Hospital, Taunton, Massachusetts

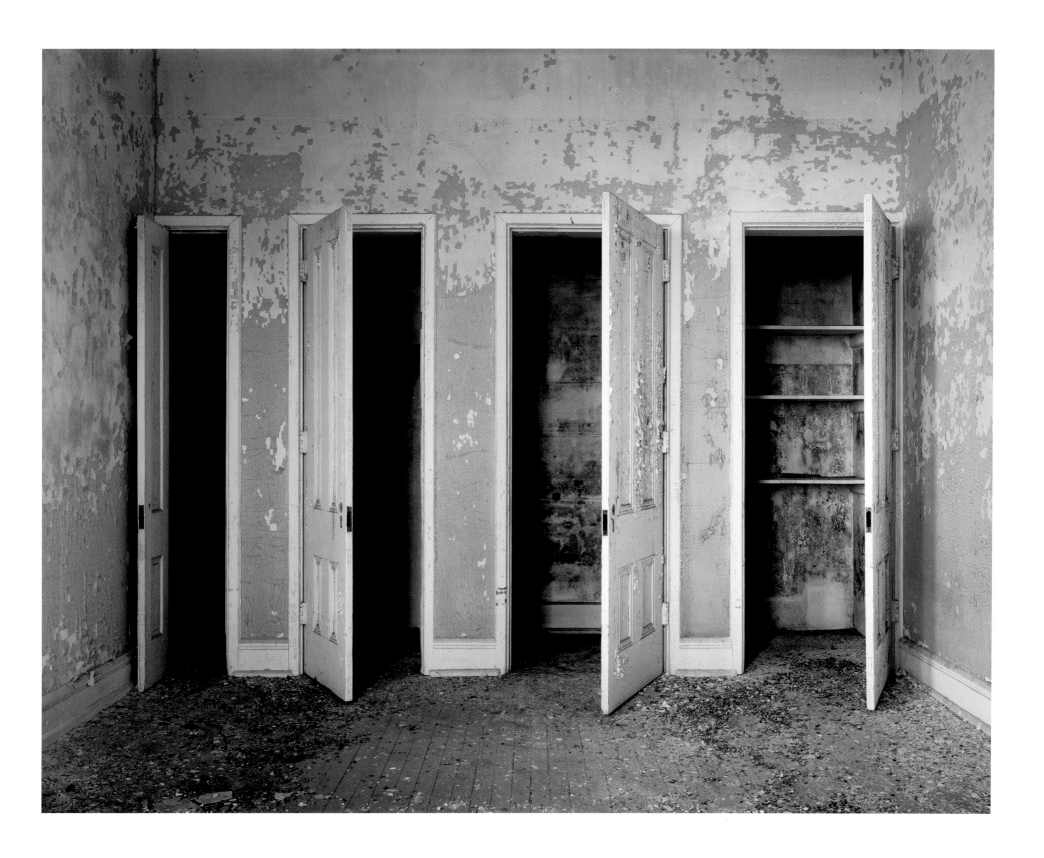

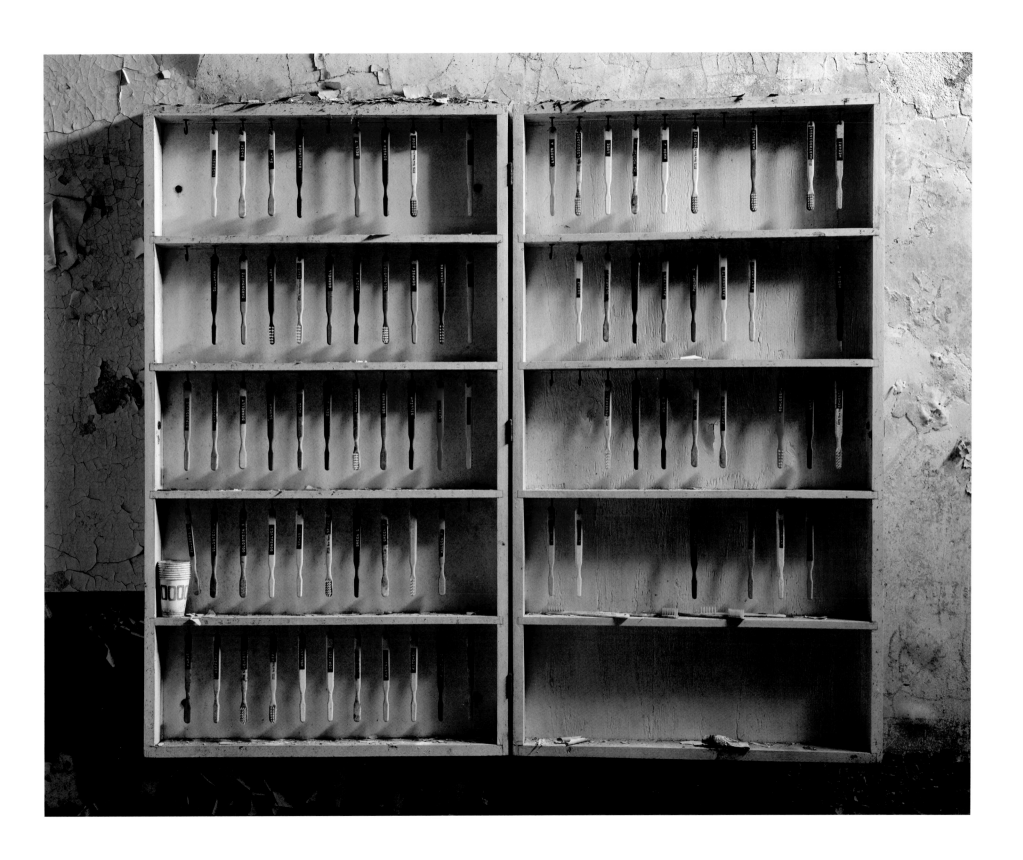

Patient toothbrushes, Hudson River State Hospital, Poughkeepsie, New York　93

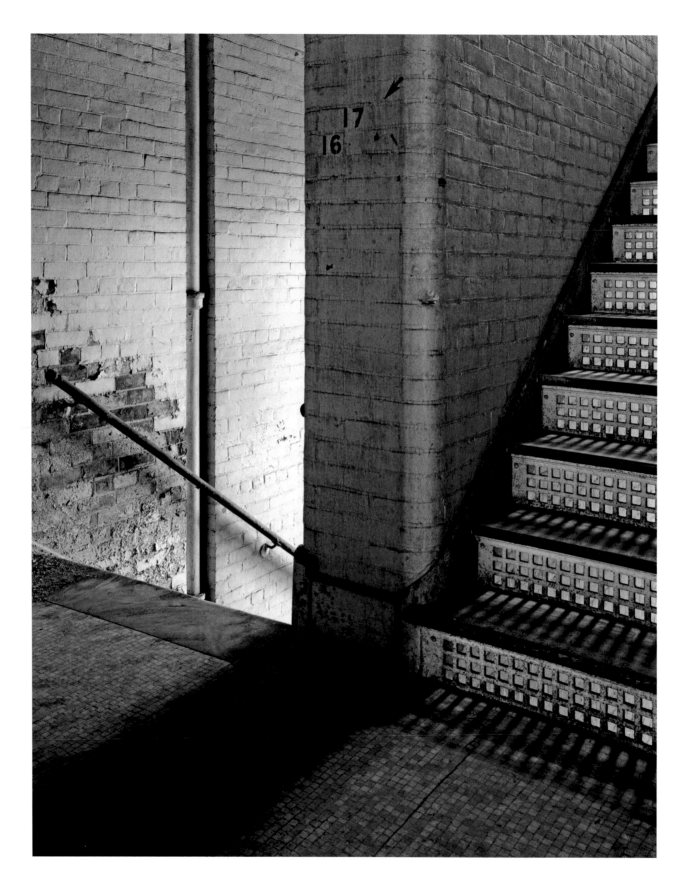

Buffalo State Hospital, Buffalo, New York

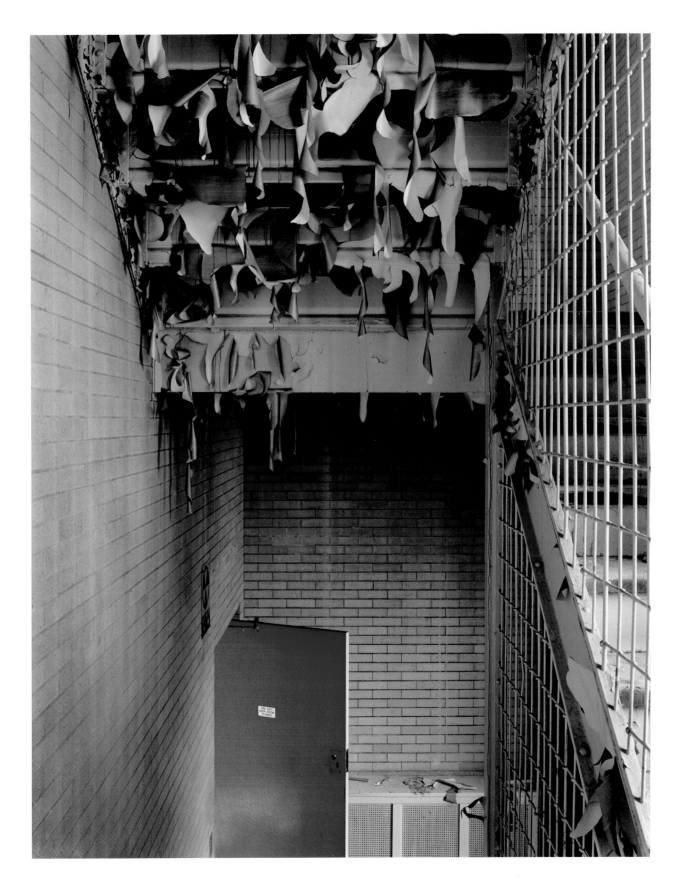

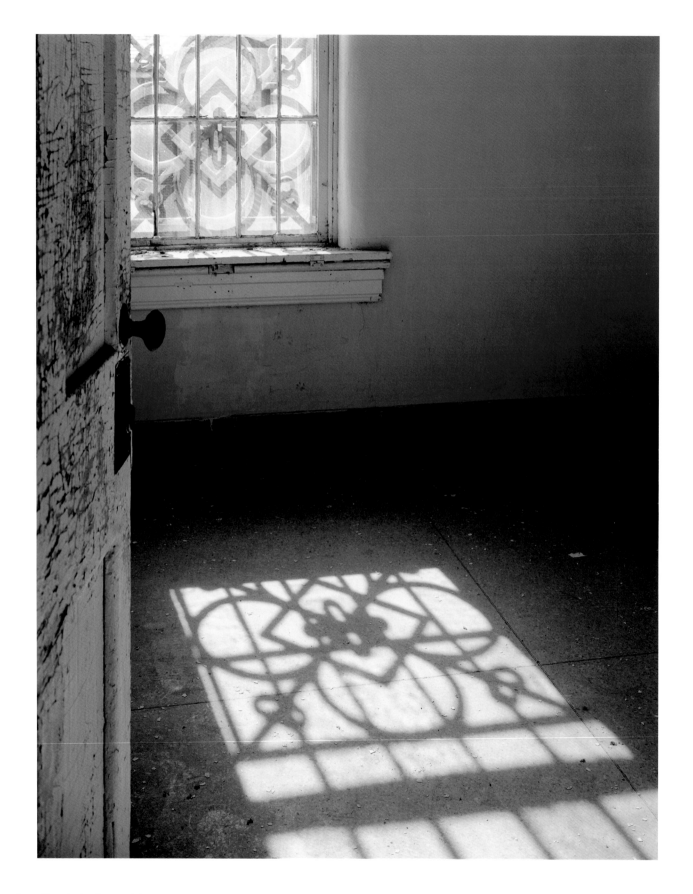

96 Patient bedroom, Athens State Hospital, Athens, Ohio

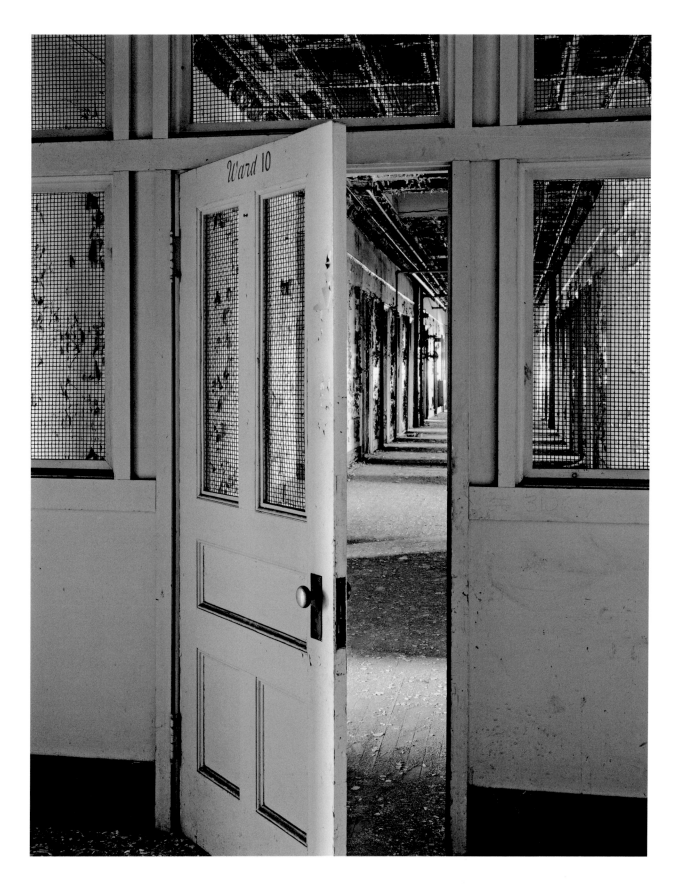

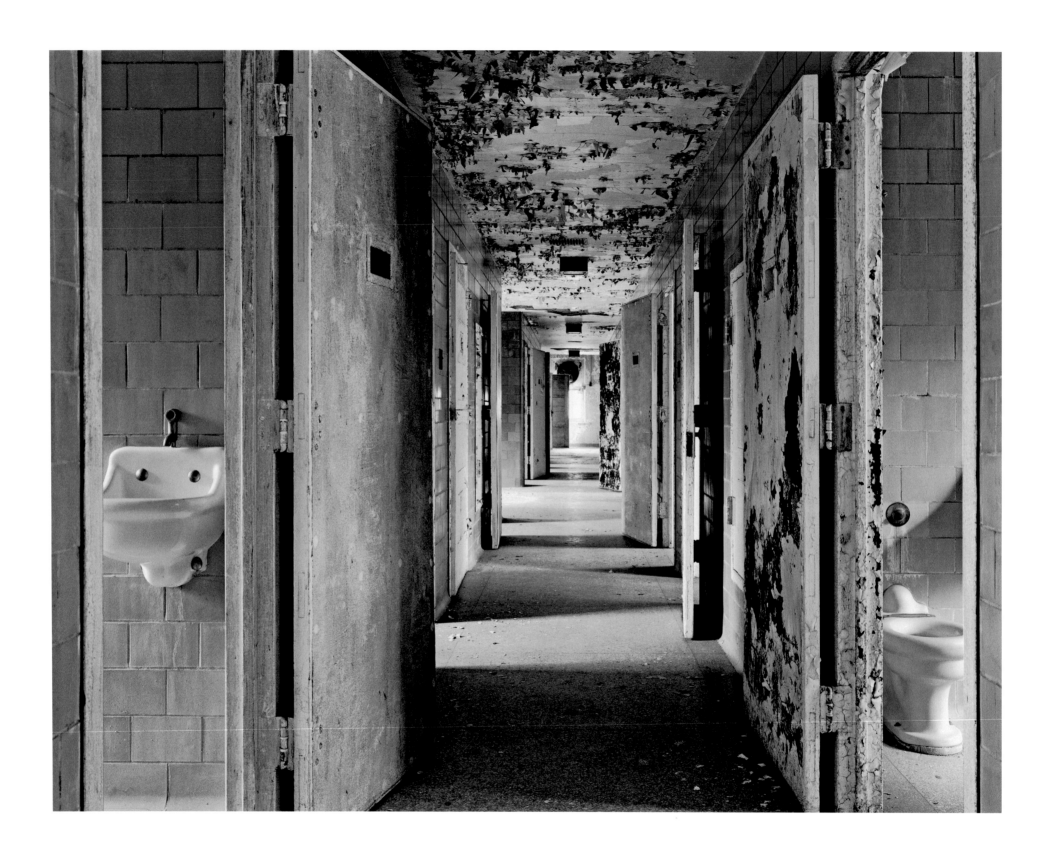

Ward for acute regressive patients, Trenton State Hospital, Trenton, New Jersey

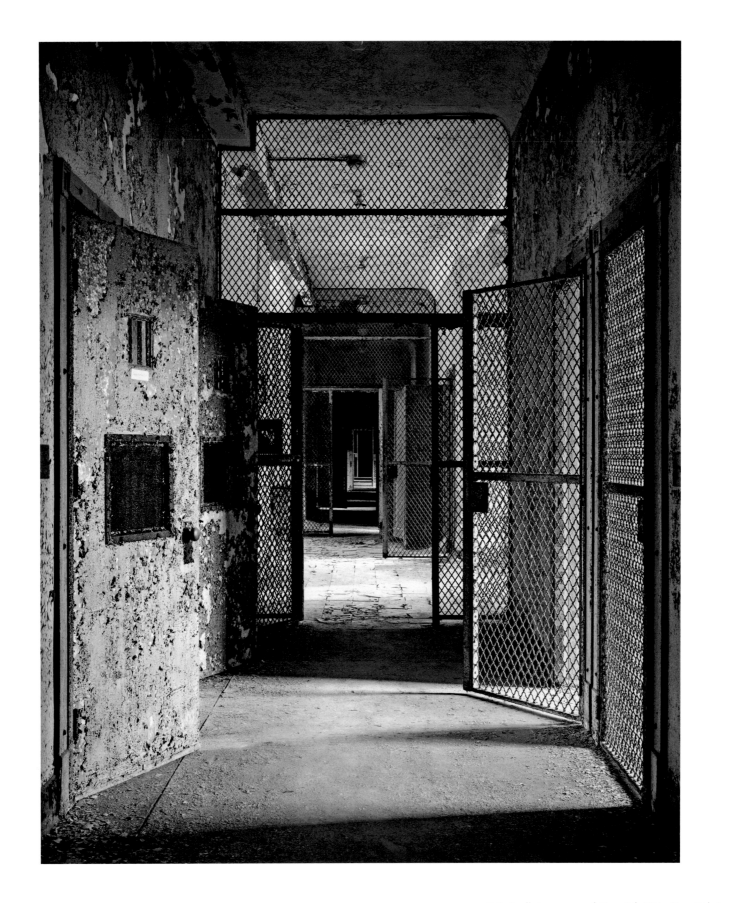

Criminally insane ward, Norwich State Hospital, Preston, Connecticut 99

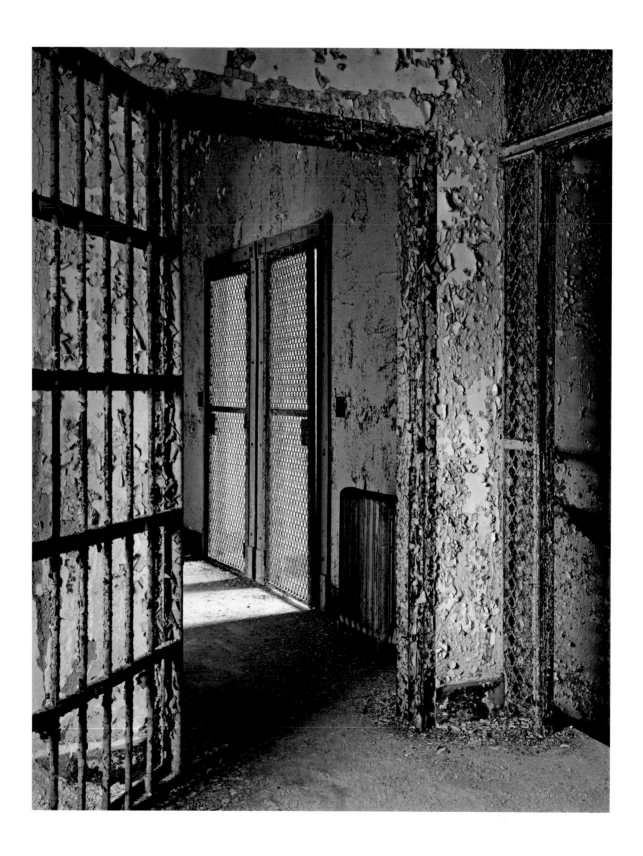

Entrance to criminally insane ward, Norwich State Hospital, Preston, Connecticut

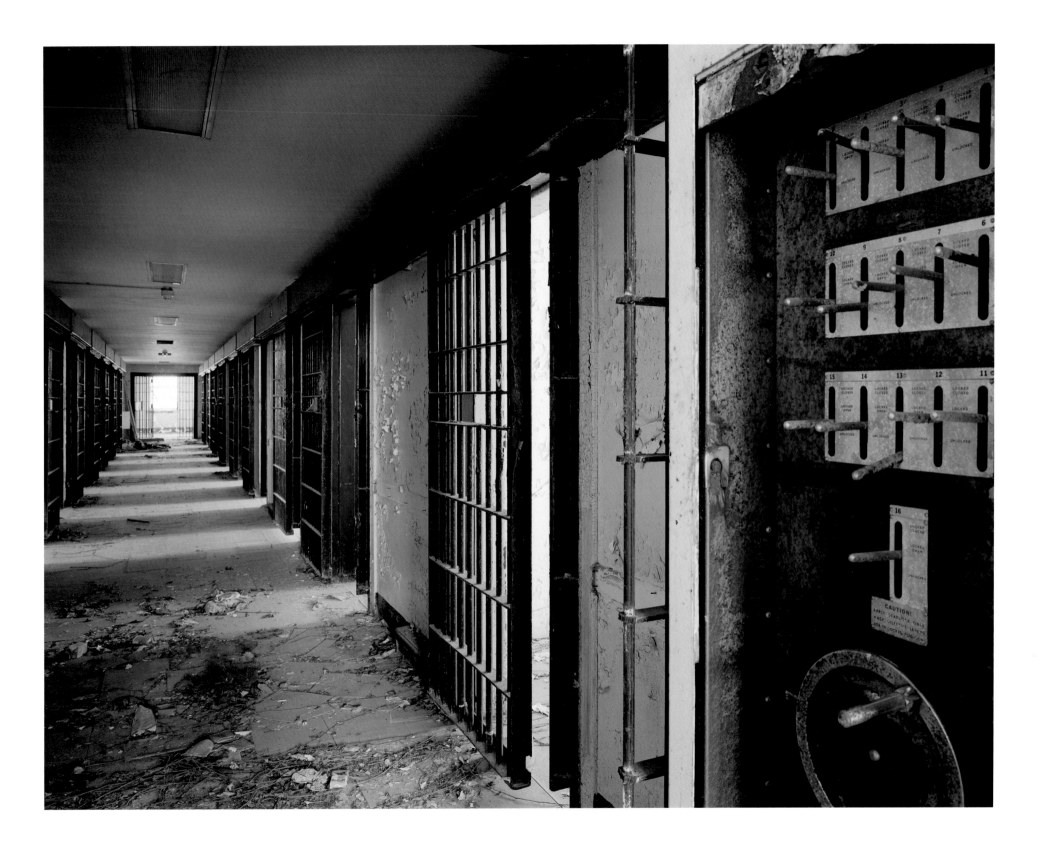

Forensic ward, East Louisiana State Hospital, Jackson, Louisiana 101

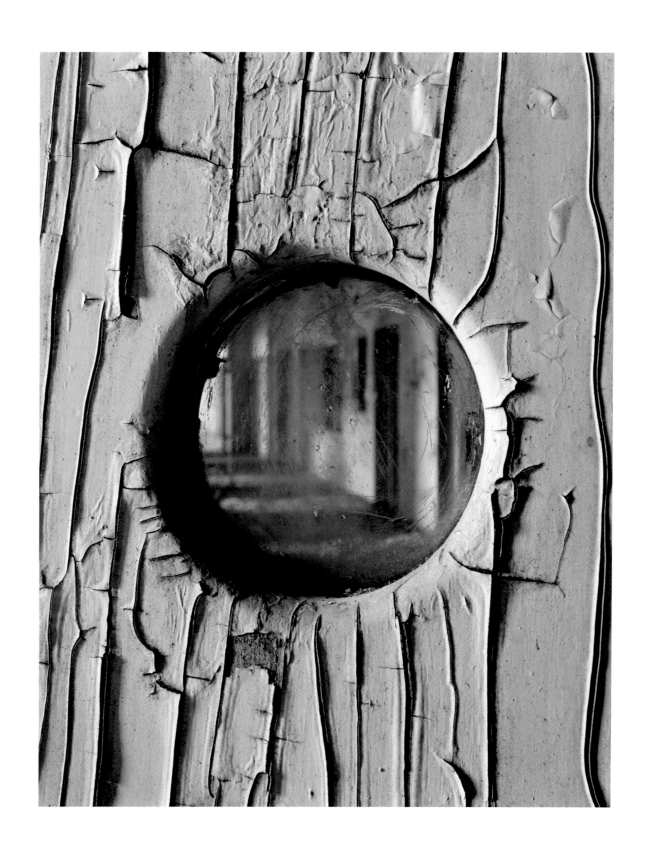

Observation window in door to seclusion room, Middletown State Hospital, Middletown, New York 103

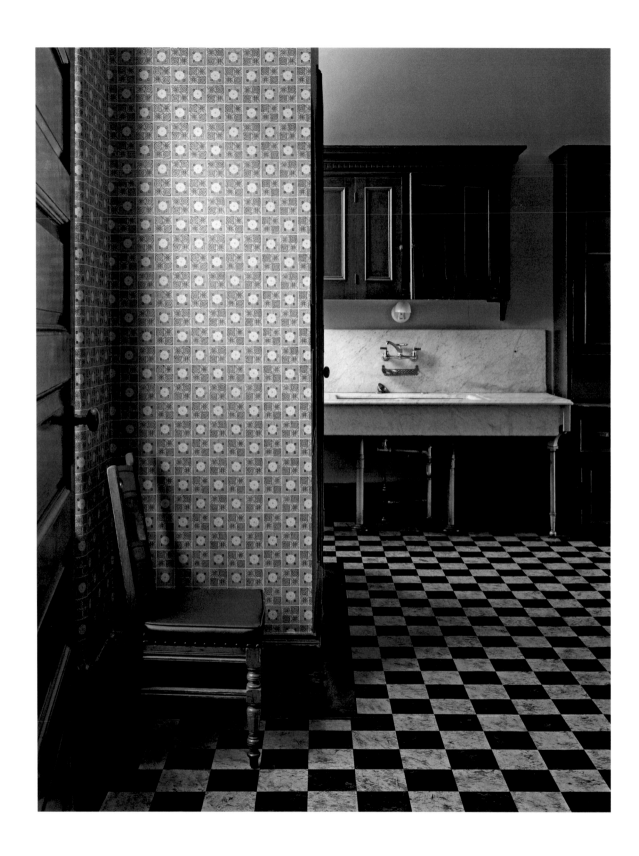

Superintendent's kitchen, Harrisburg State Hospital, Harrisburg, Pennsylvania

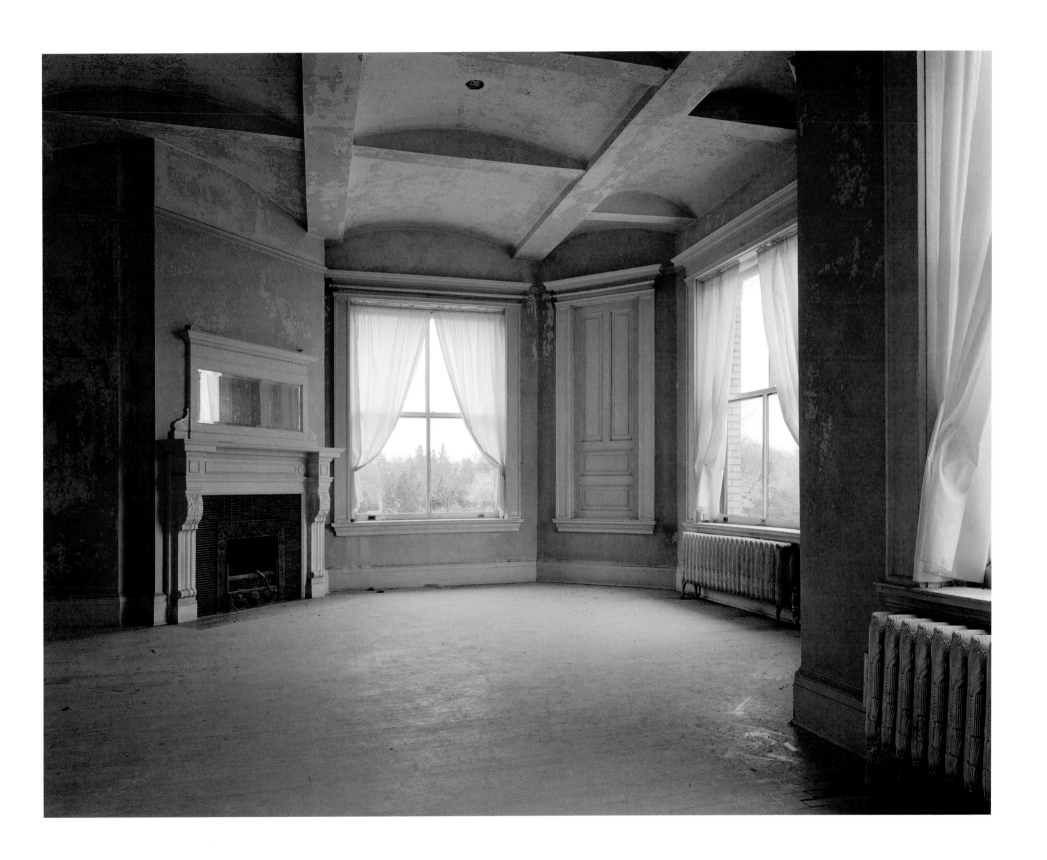

Superintendent's quarters, Fergus Falls State Hospital, Fergus Falls, Minnesota 105

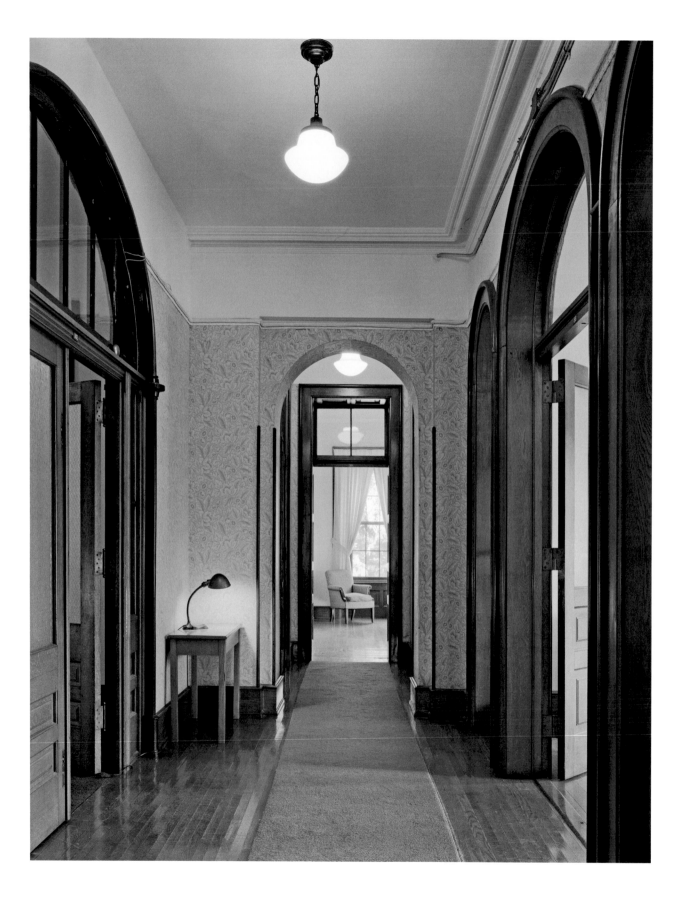

Visiting doctor's suite, Warren State Hospital, Warren, Pennsylvania

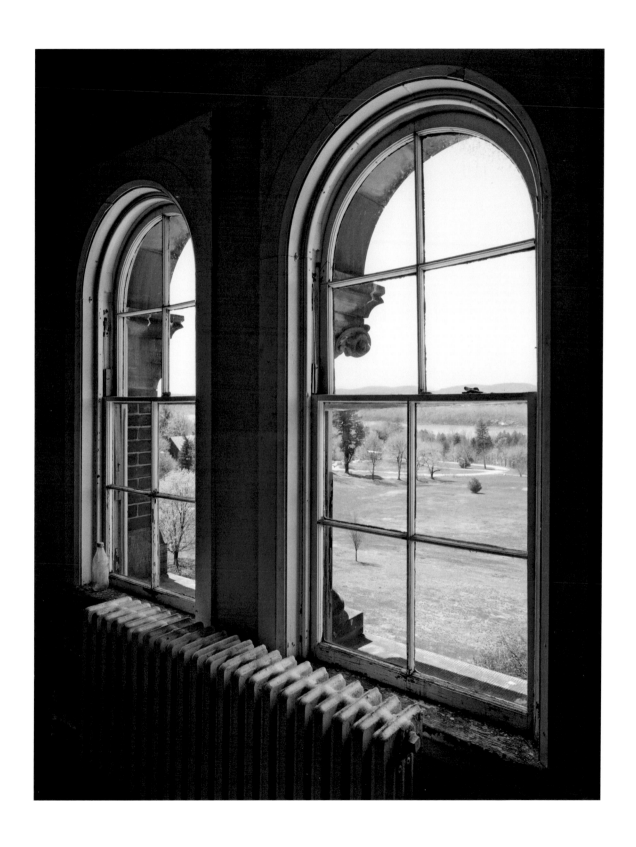

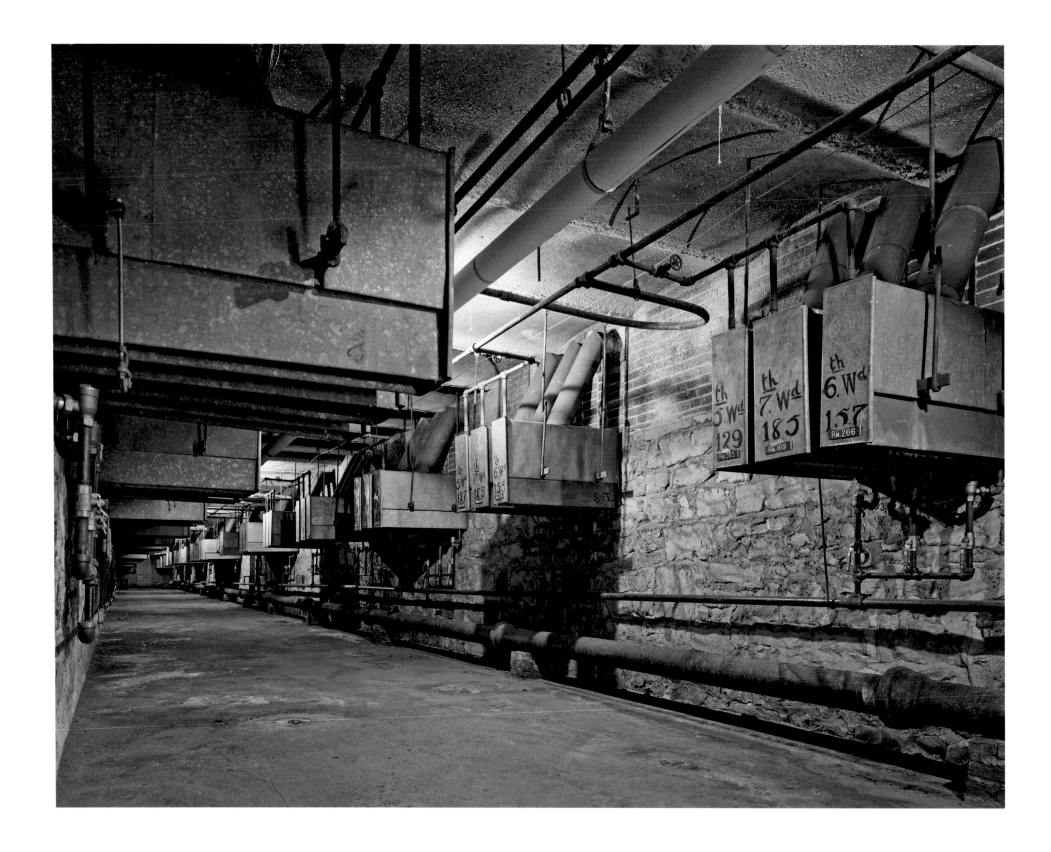

Heating ducts in basement, Warren State Hospital, Warren, Pennsylvania

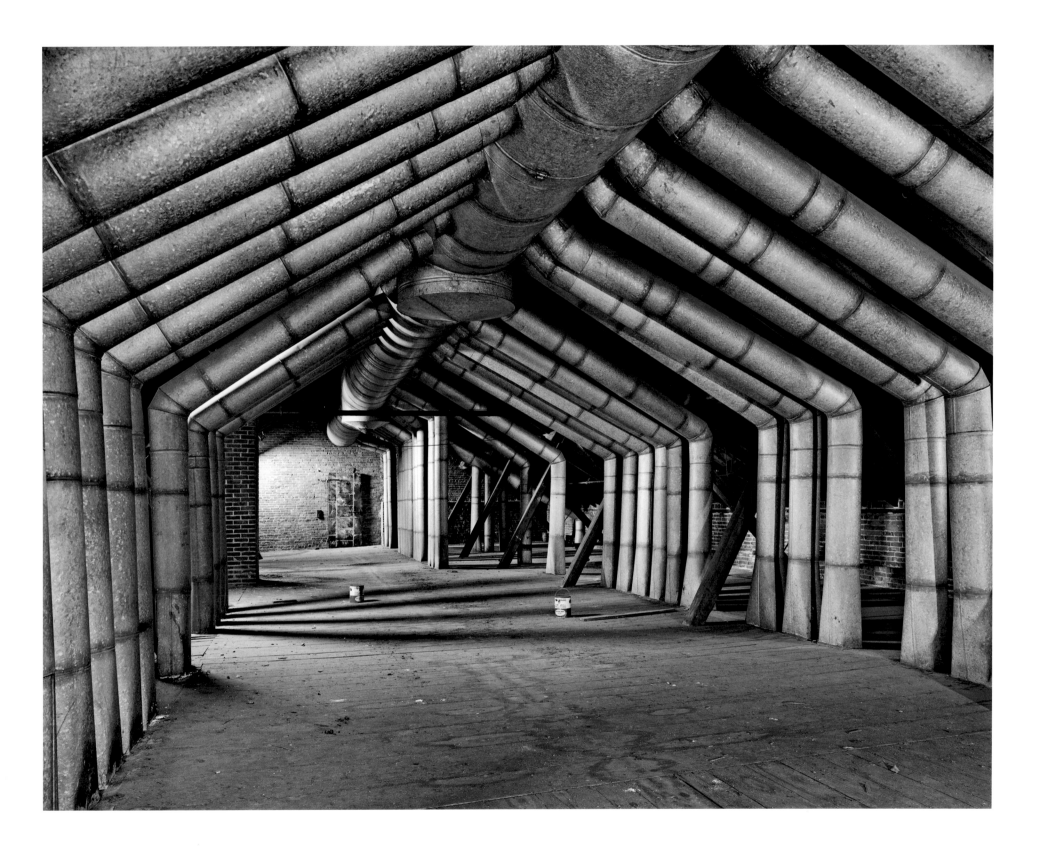

Exhaust flues in attic, Taunton State Hospital, Taunton, Massachusetts 109

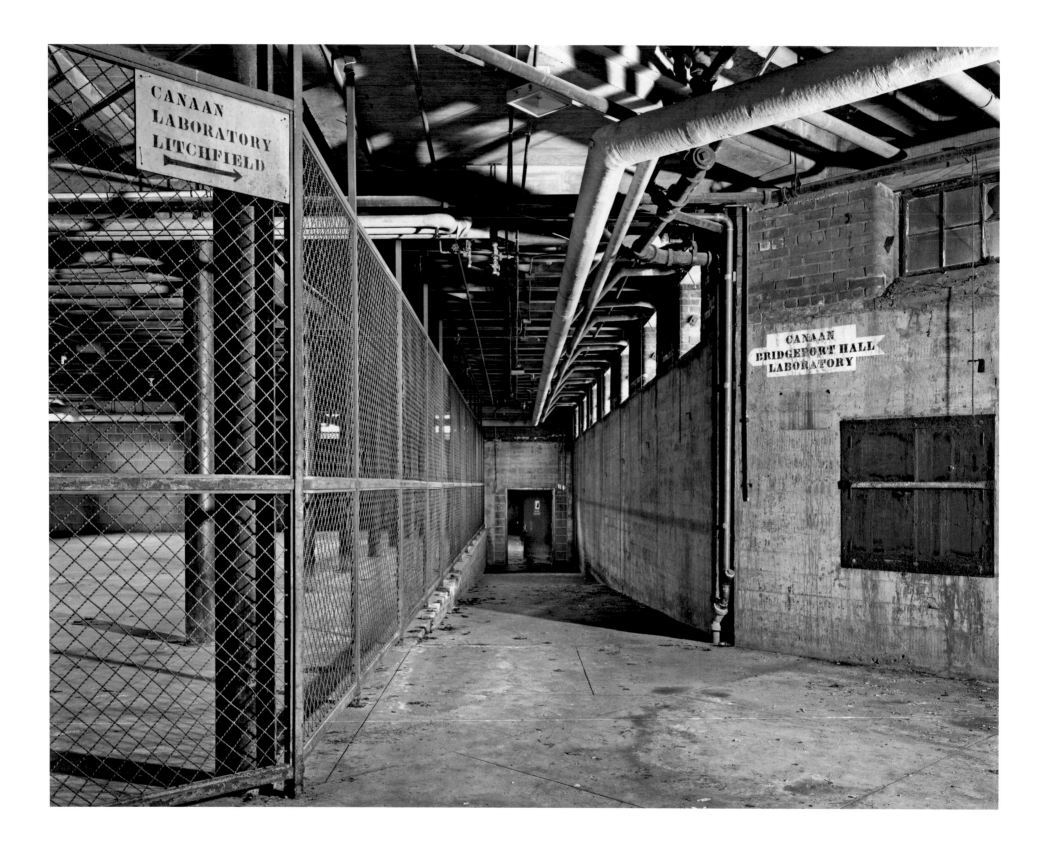

CANAAN
LABORATORY
LITCHFIELD

CANAAN
BRIDGEPORT HALL
LABORATORY

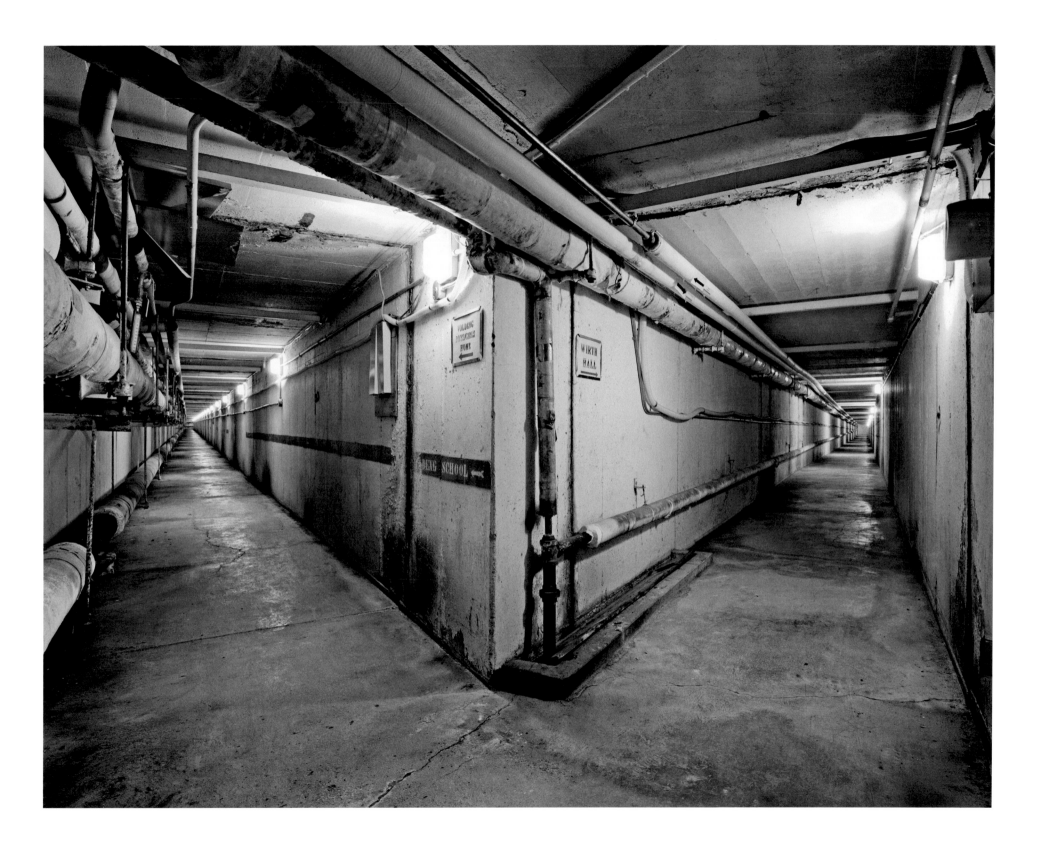

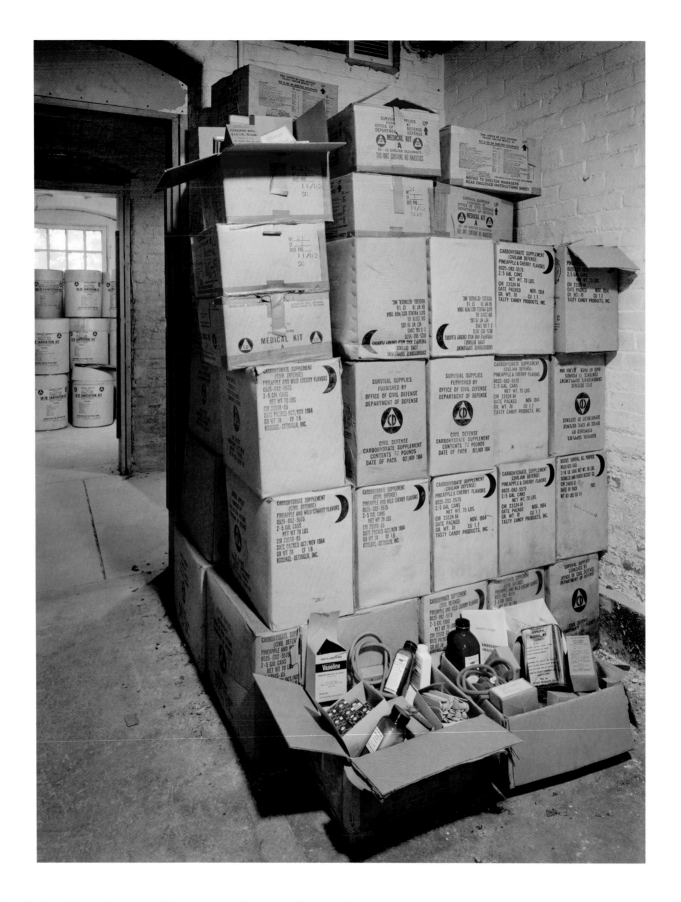

Civil defense rations and medical supplies, 1960s, Wernerville State Hospital, Wernersville, Pennsylvania

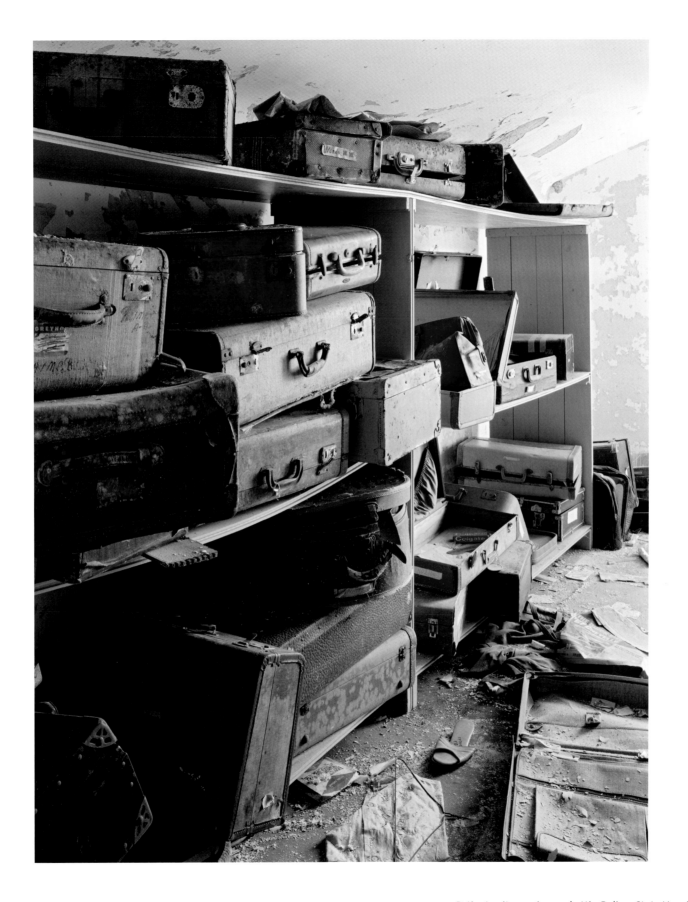

Patient suitcases in ward attic, Bolivar State Hospital, Bolivar, Tennessee 113

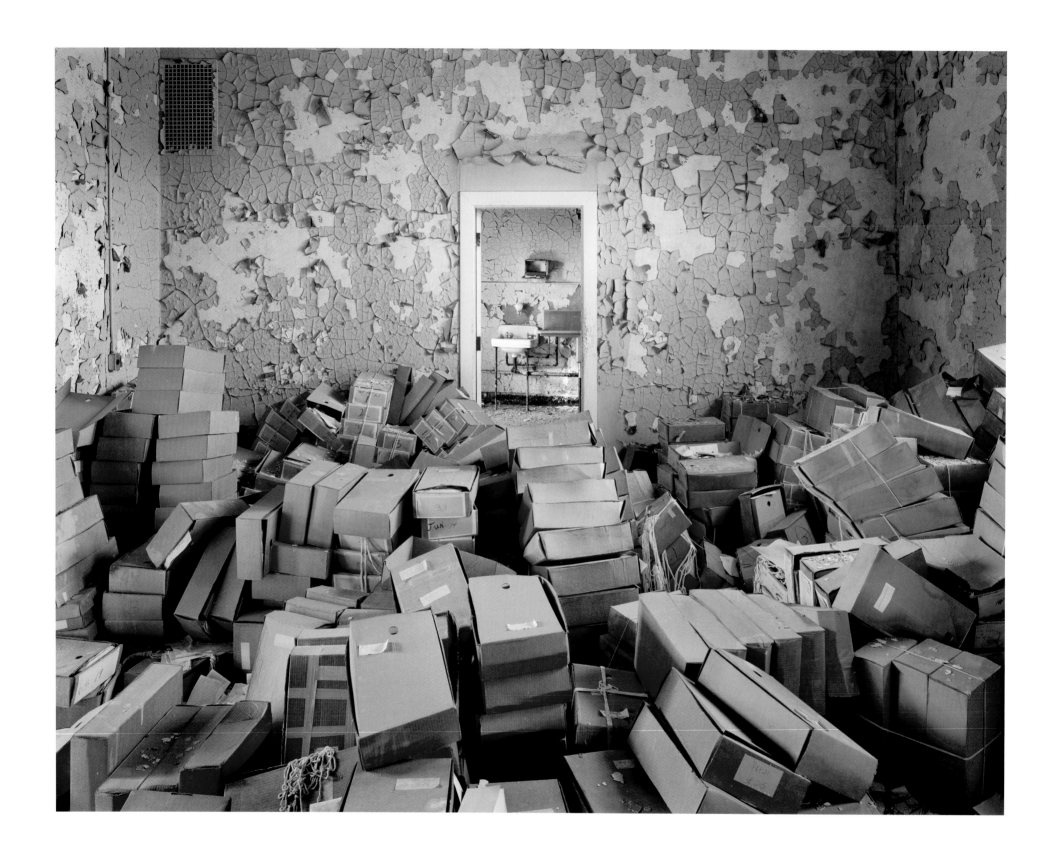

State records and files, Spring Grove State Hospital, Catonsville, Maryland

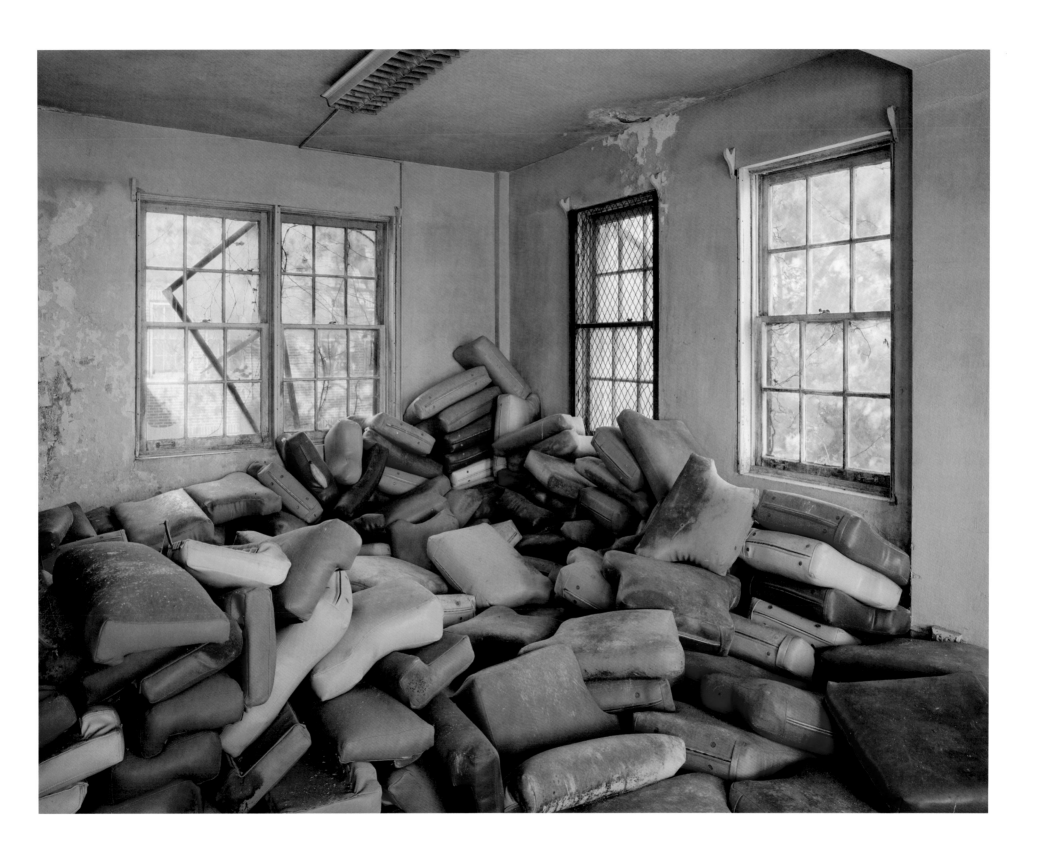

Seat cushions, Terrell State Hospital, Terrell, Texas

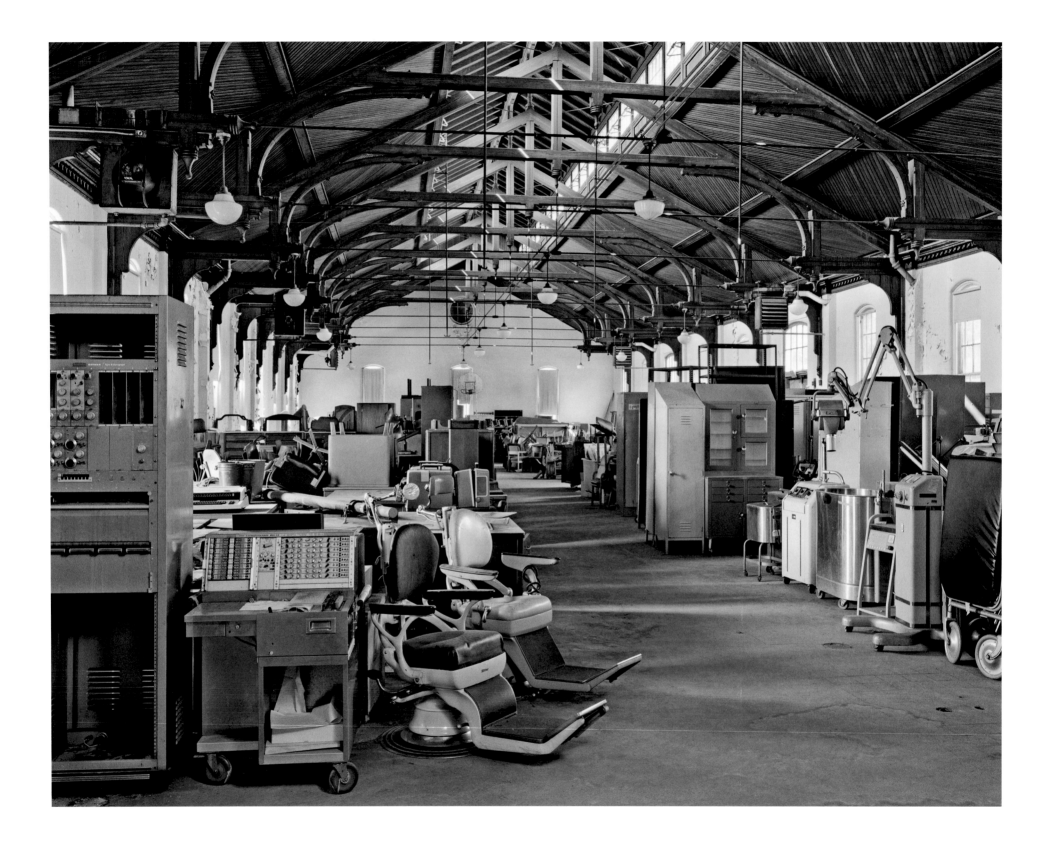

Storage in former dining hall, Norristown State Hospital, Norristown, Pennsylvania

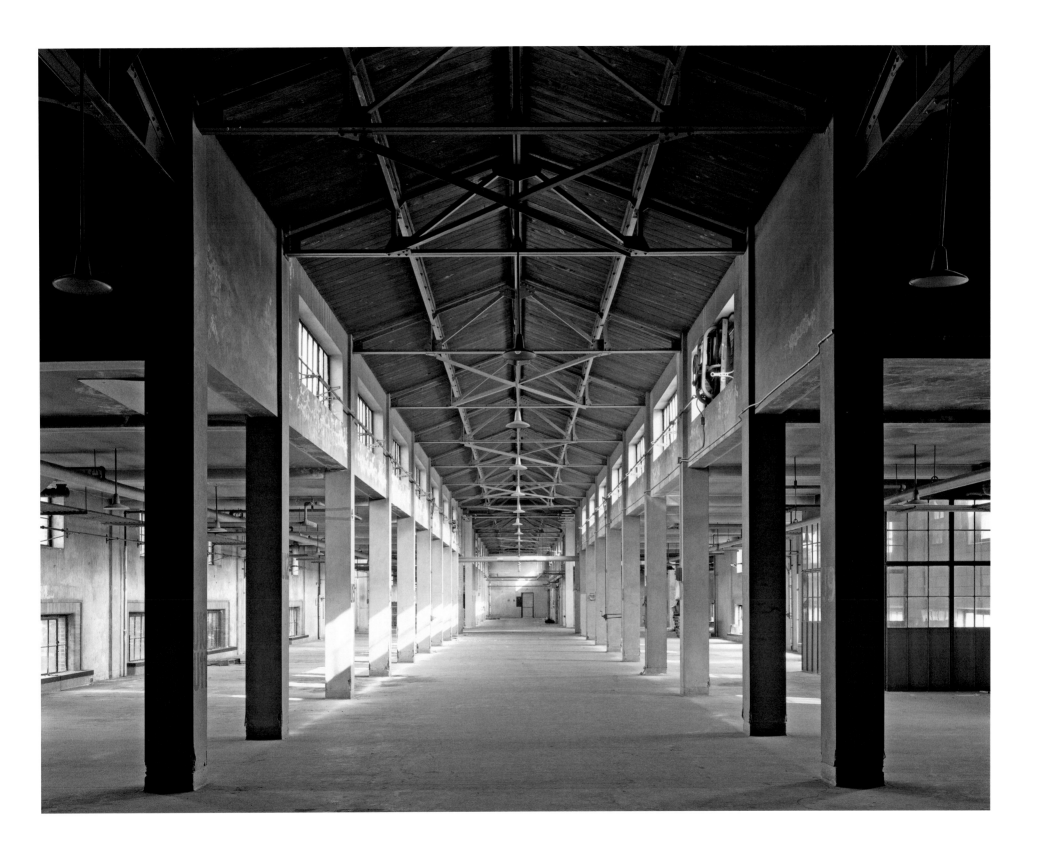

Dry goods storehouse, Pilgrim State Hospital, Brentwood, New York 117

The state hospitals were designed as self-sufficient communities, and virtually all consumable products were produced on the premises with patient labor.

Water tower and farm buildings, Independence State Hospital, Independence, Iowa

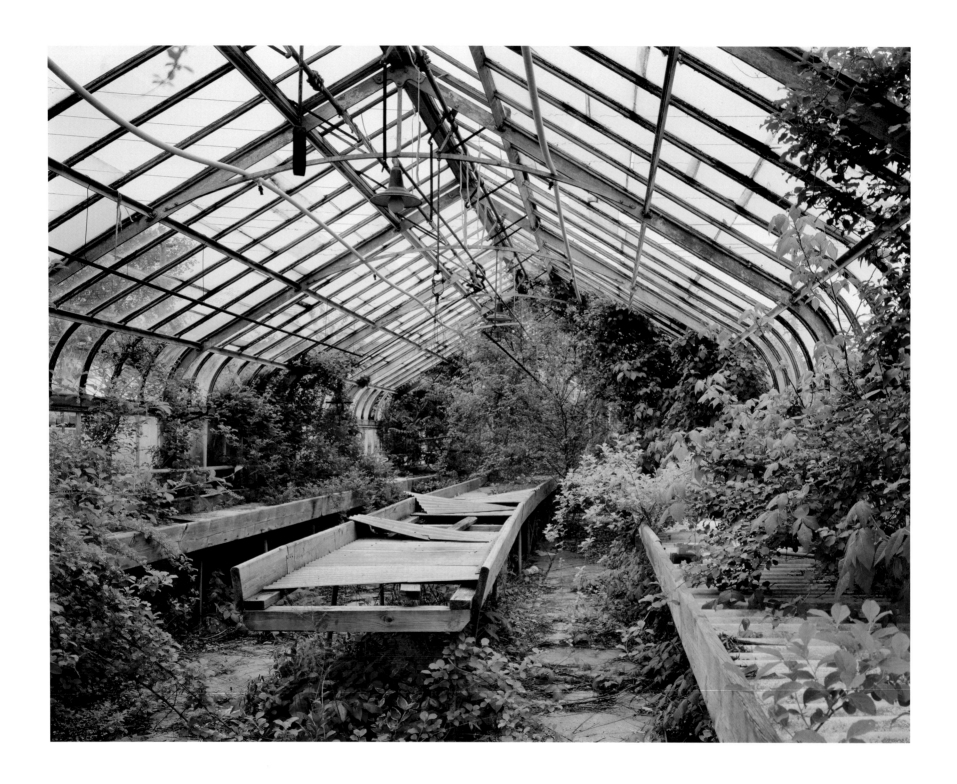

120 Greenhouse, Pilgrim State Hospital, Brentwood, New York

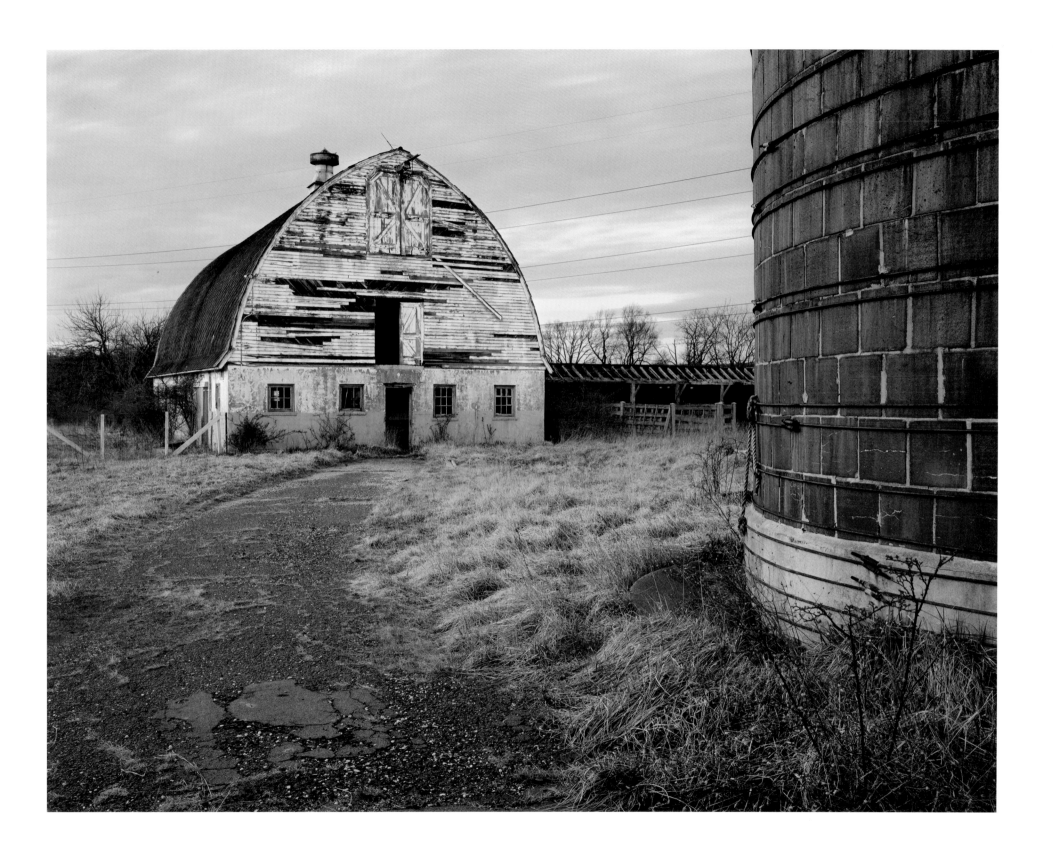

Dairy barn, Marlboro State Hospital, Marlboro, New Jersey

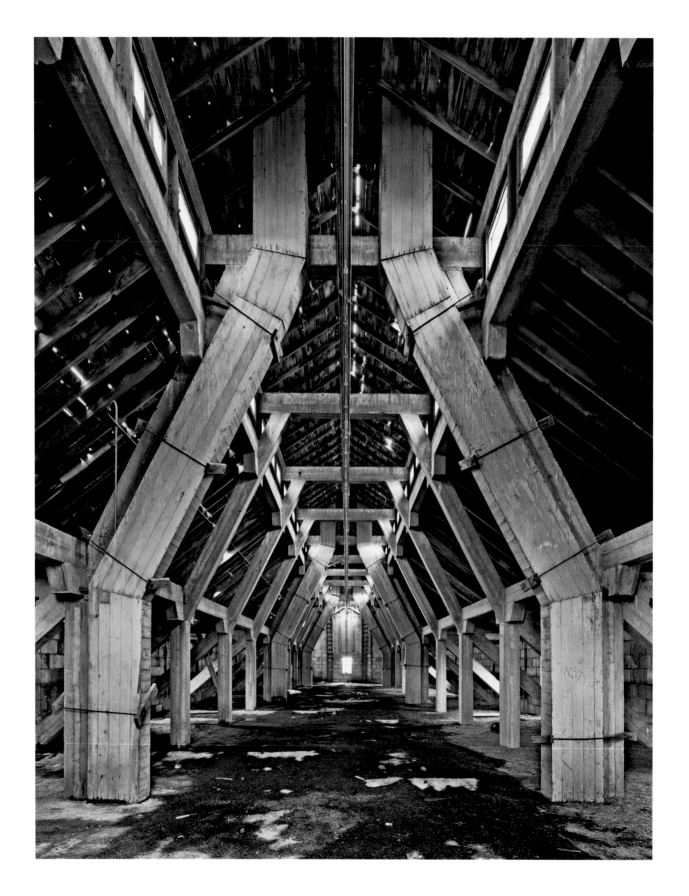

122 Calf barn hay loft, Yankton State Hospital, Yankton, South Dakota

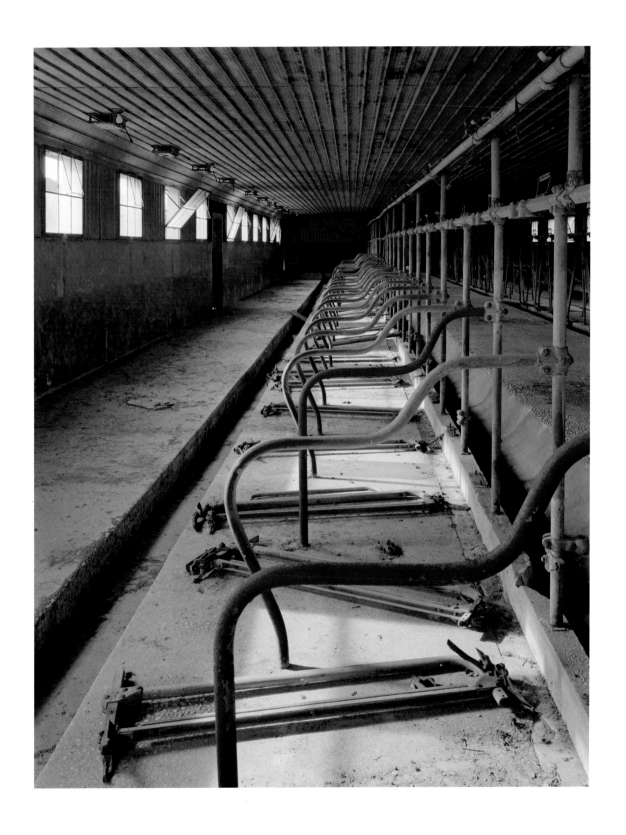

Dairy cow stalls, Marlboro State Hospital, Marlboro, New Jersey 123

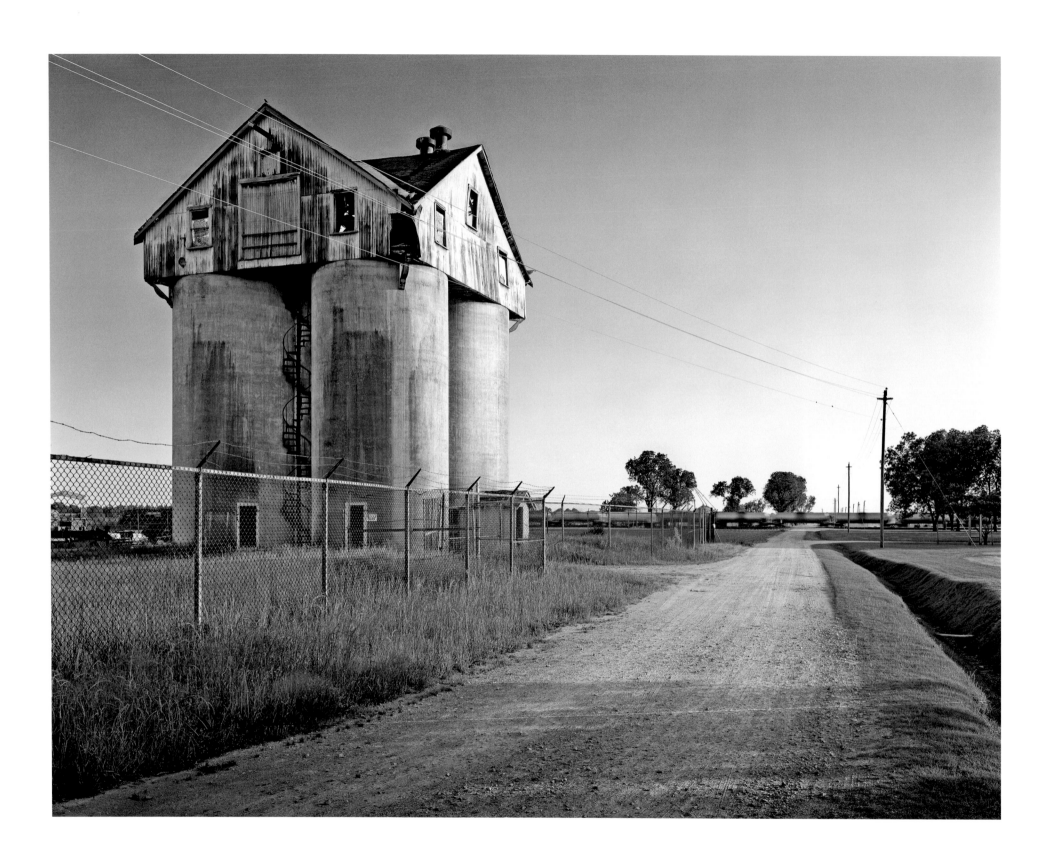

124 Farm silos, Cherry State Hospital, Goldsboro, North Carolina

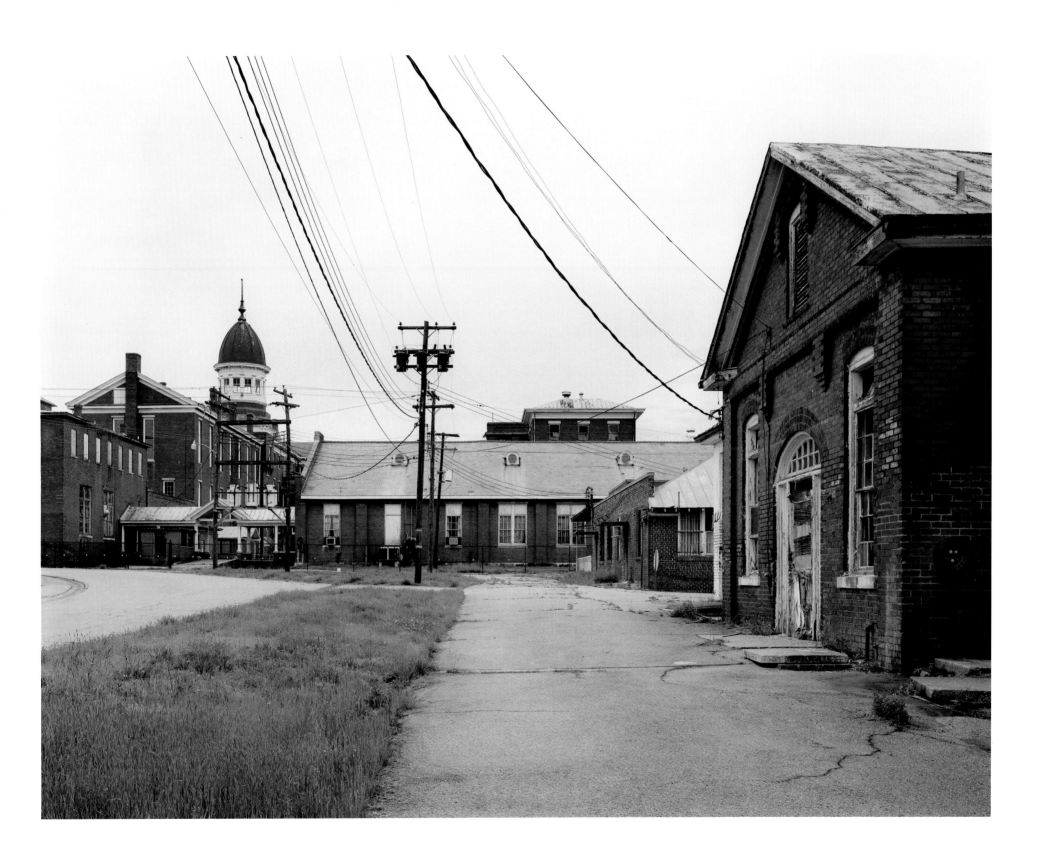

Workshops, South Carolina State Hospital, Columbia, South Carolina 125

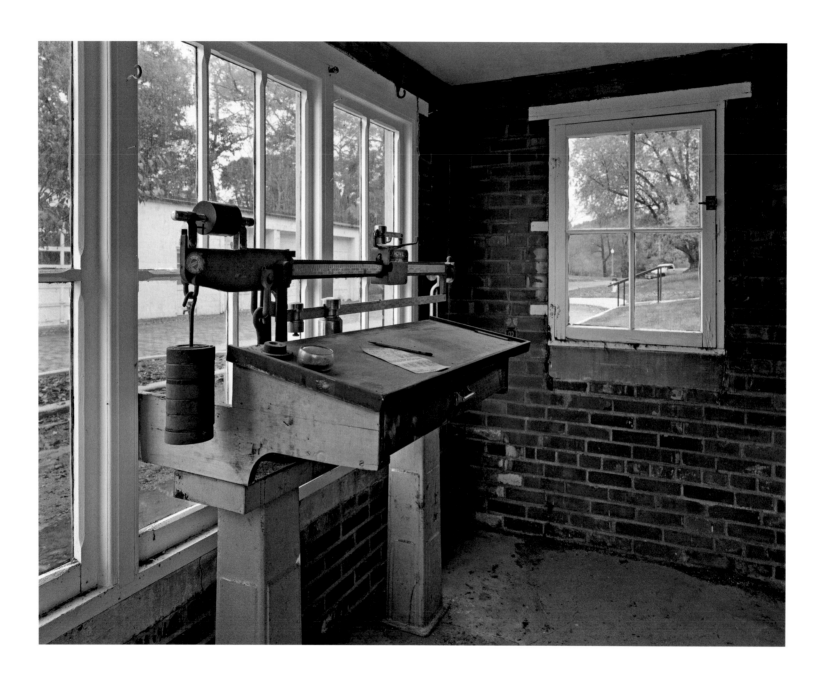

Truck scale, Athens State Hospital, Athens, Ohio

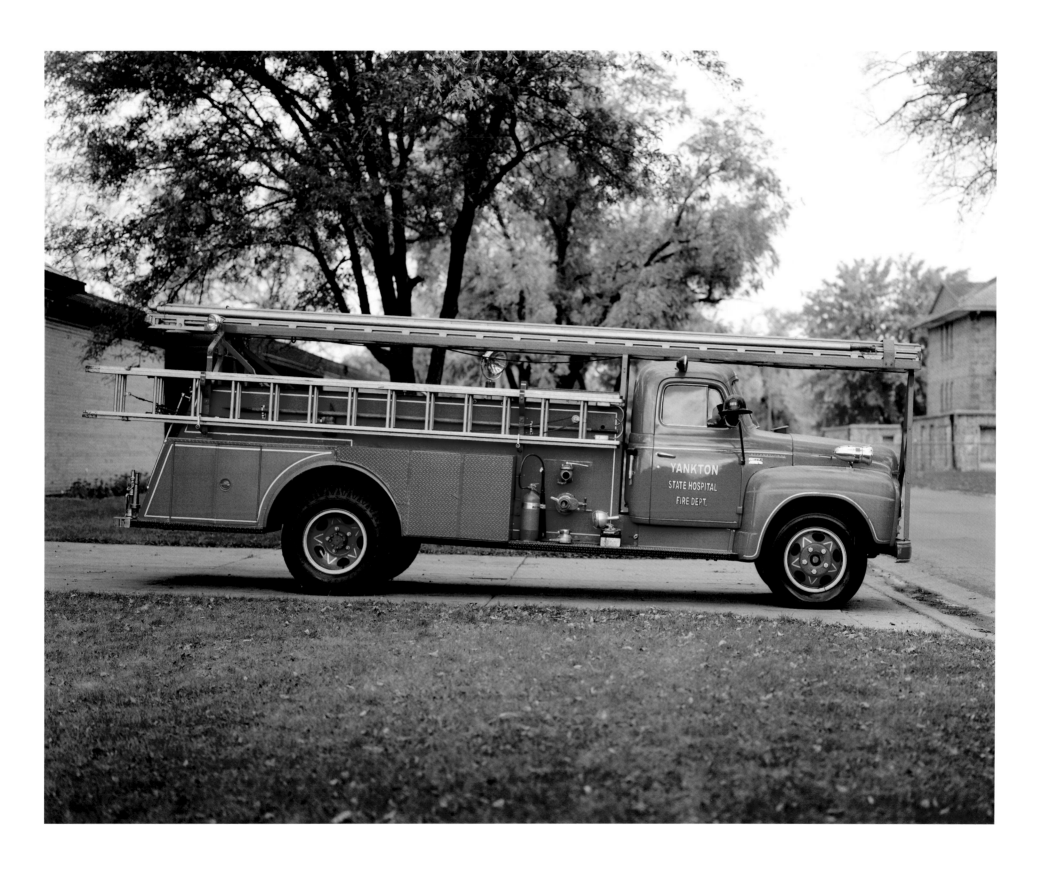

Fire truck, Yankton State Hospital, Yankton, South Dakota 127

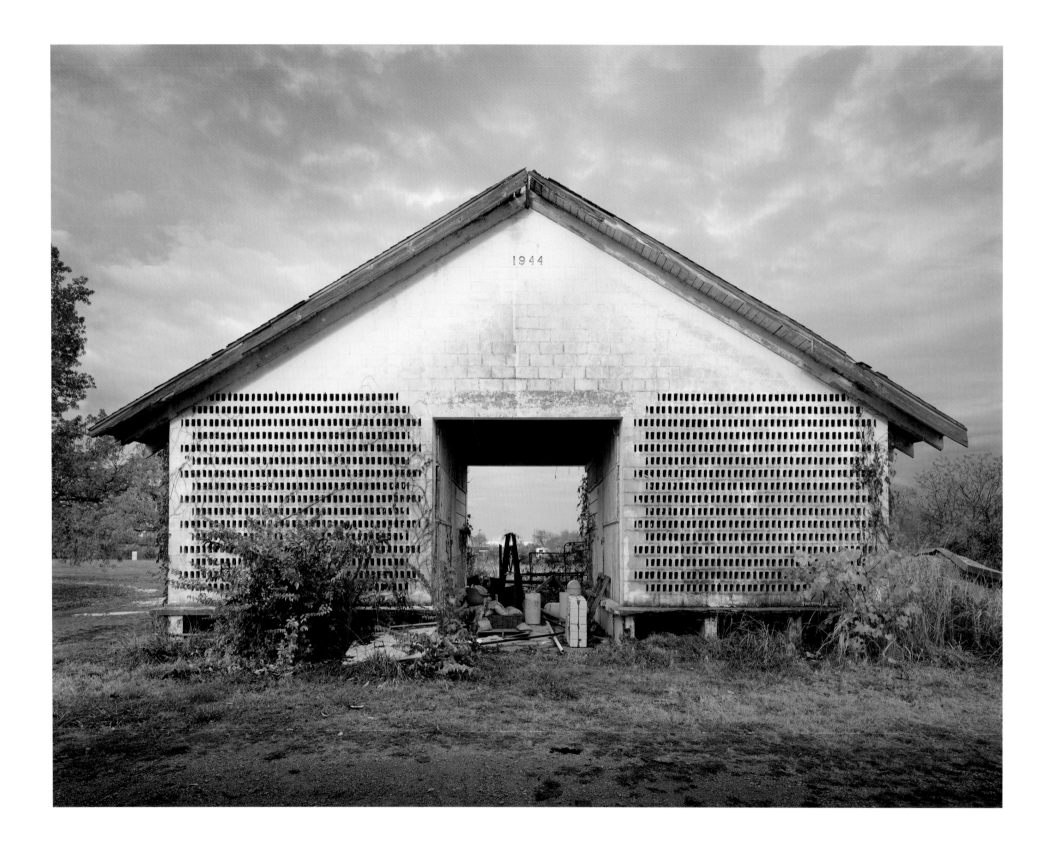

Corn crib, Eastern State Hospital, Lexington, Kentucky

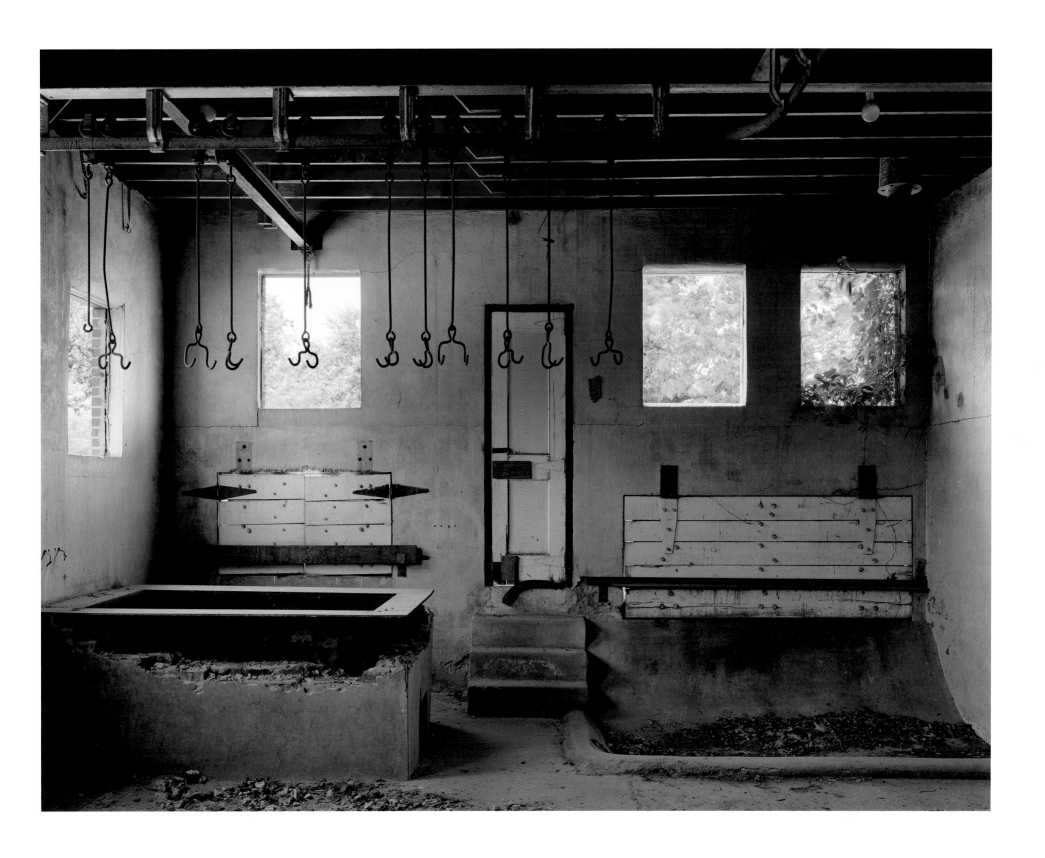

Slaughterhouse, Broughton State Hospital, Morganton, North Carolina 129

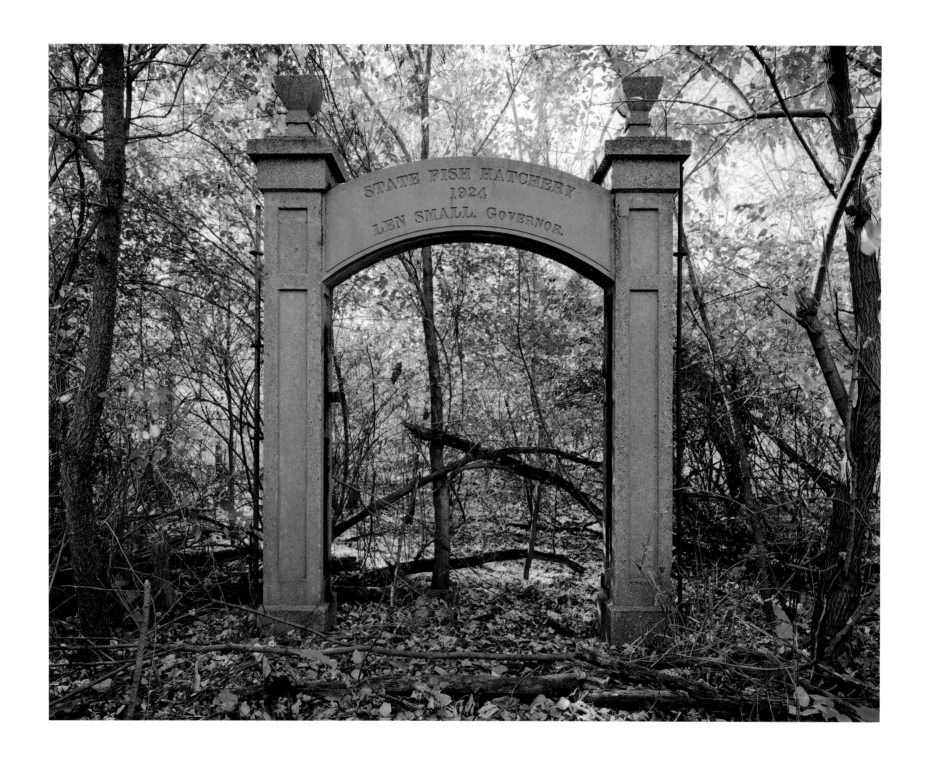

Fish hatchery entrance, Kankakee State Hospital, Kankakee, Illinois

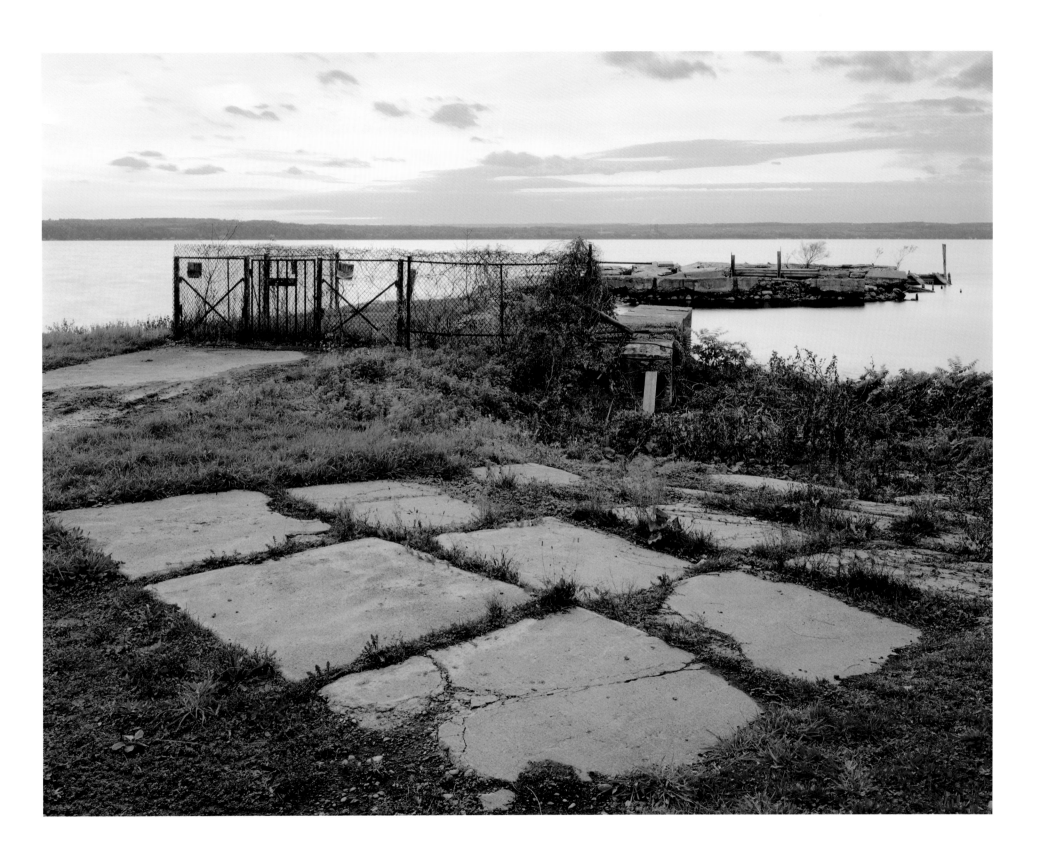

Dock on Lake Geneva, Willard State Hospital, Willard, New York

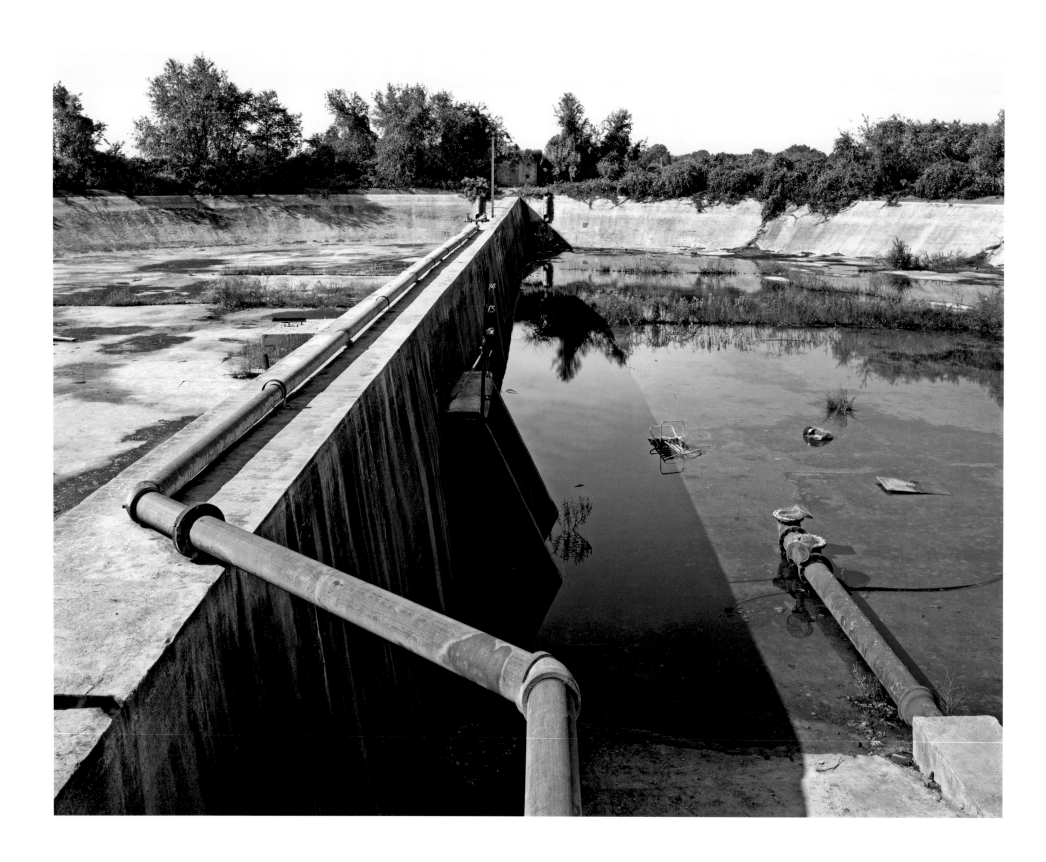

132 Reservoir, Norristown State Hospital, Norristown, Pennsylvania

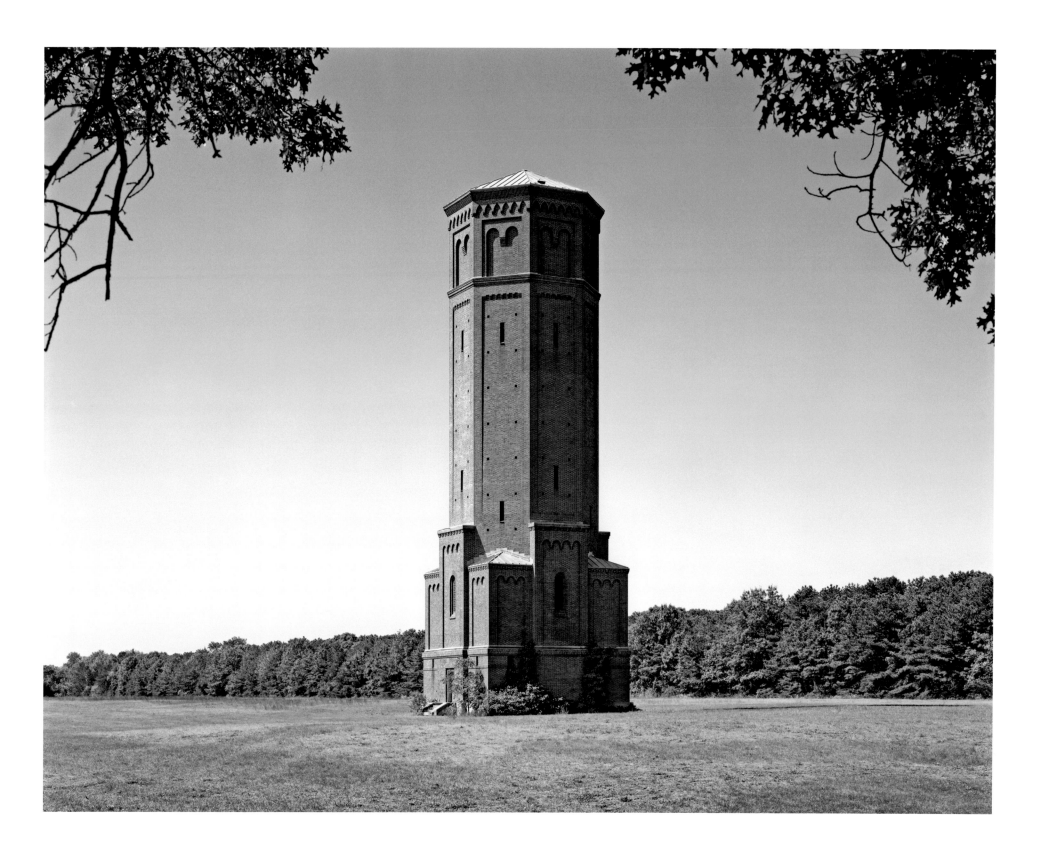

Water tower, Pilgrim State Hospital, Brentwood, New York 133

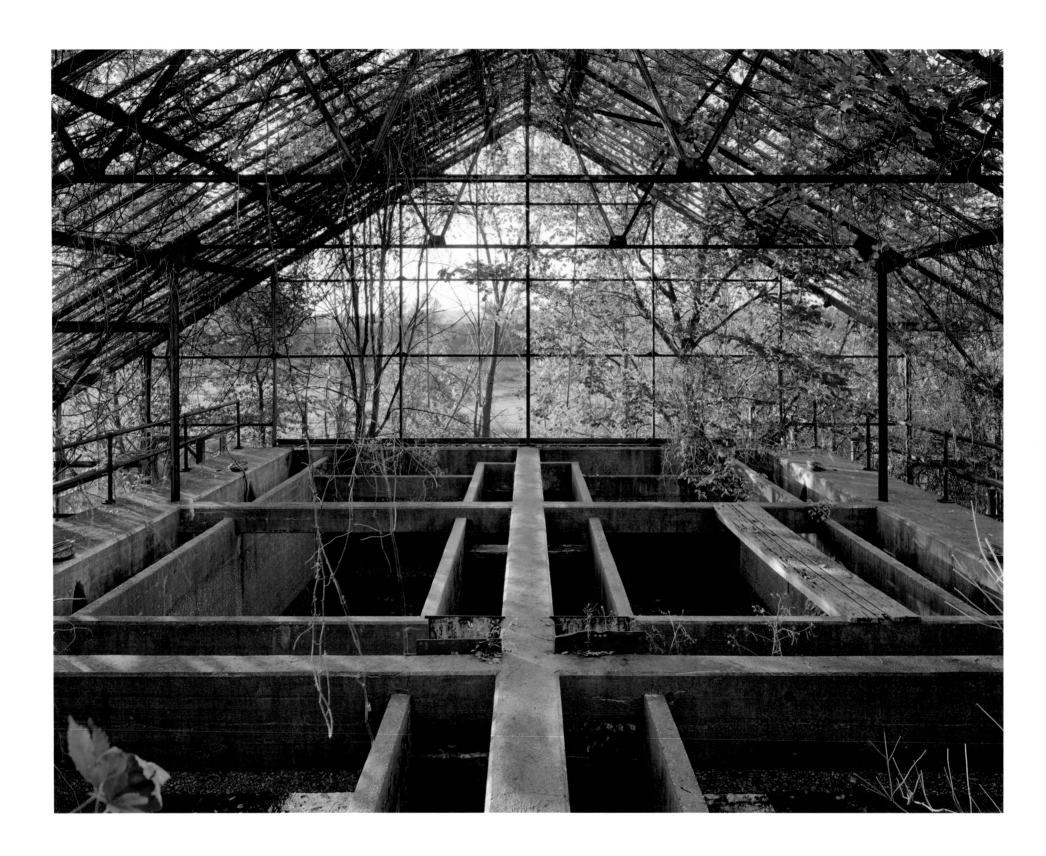

Water treatment settling tanks, Matteawan State Hospital, Beacon, New York

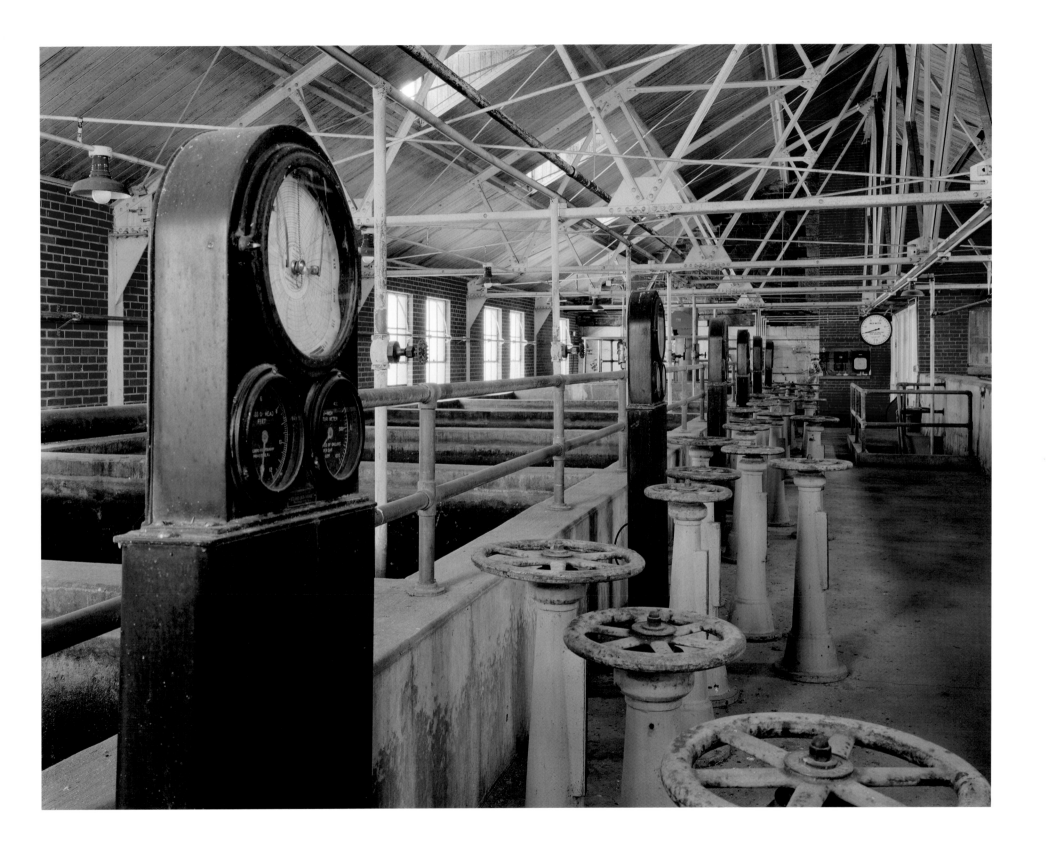

Water treatment plant, Danville State Hospital, Danville, Pennsylvania 135

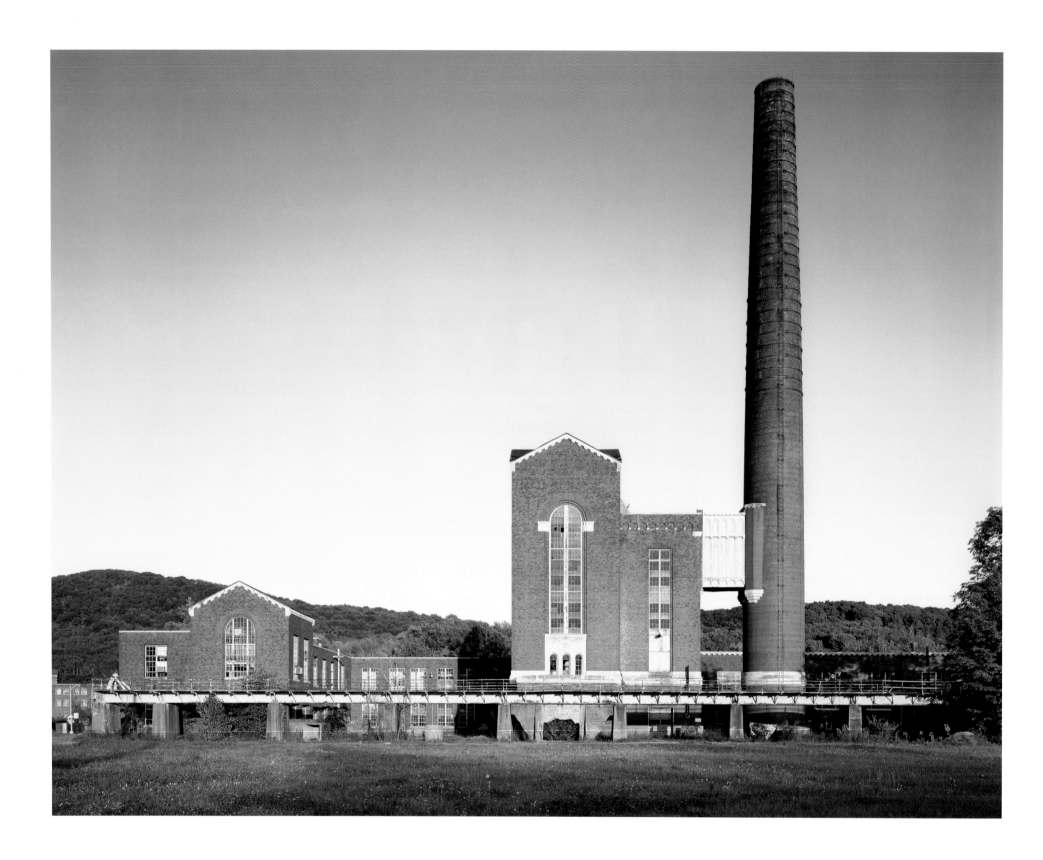

Power plant, Harlem Valley State Hospital, Wingdale, New York

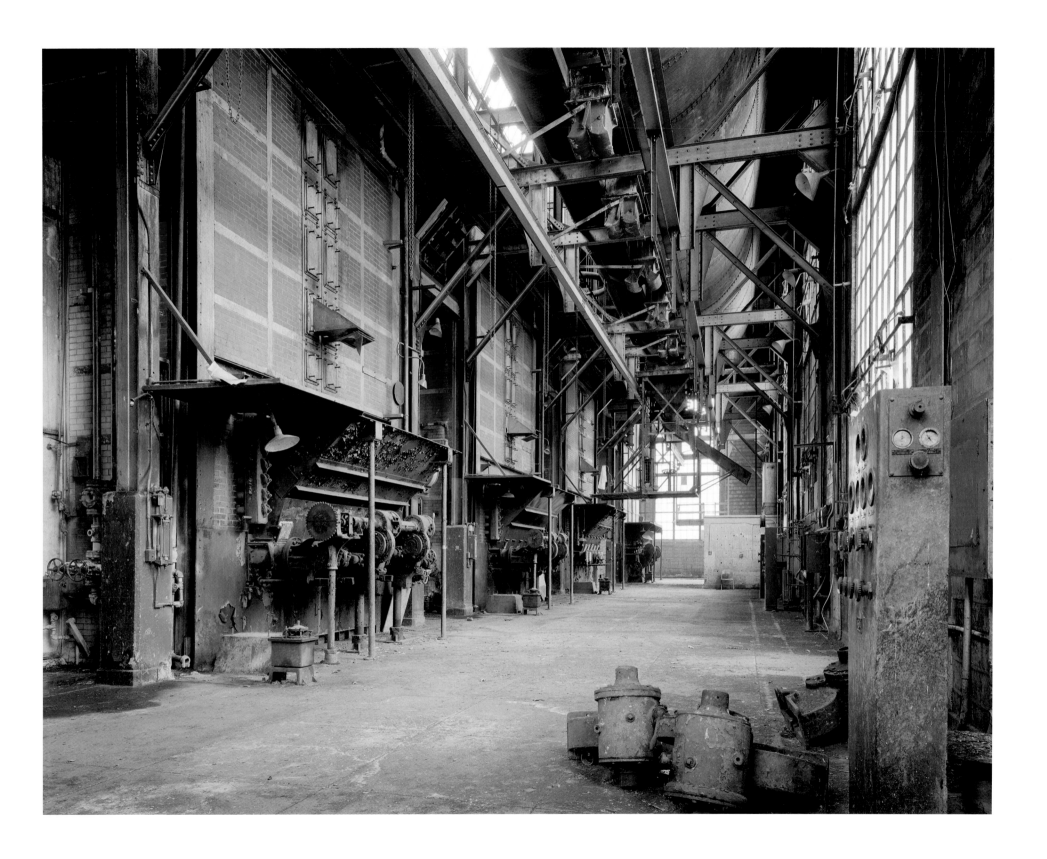

Boilers in power plant, Hudson River State Hospital, Poughkeepsie, New York 137

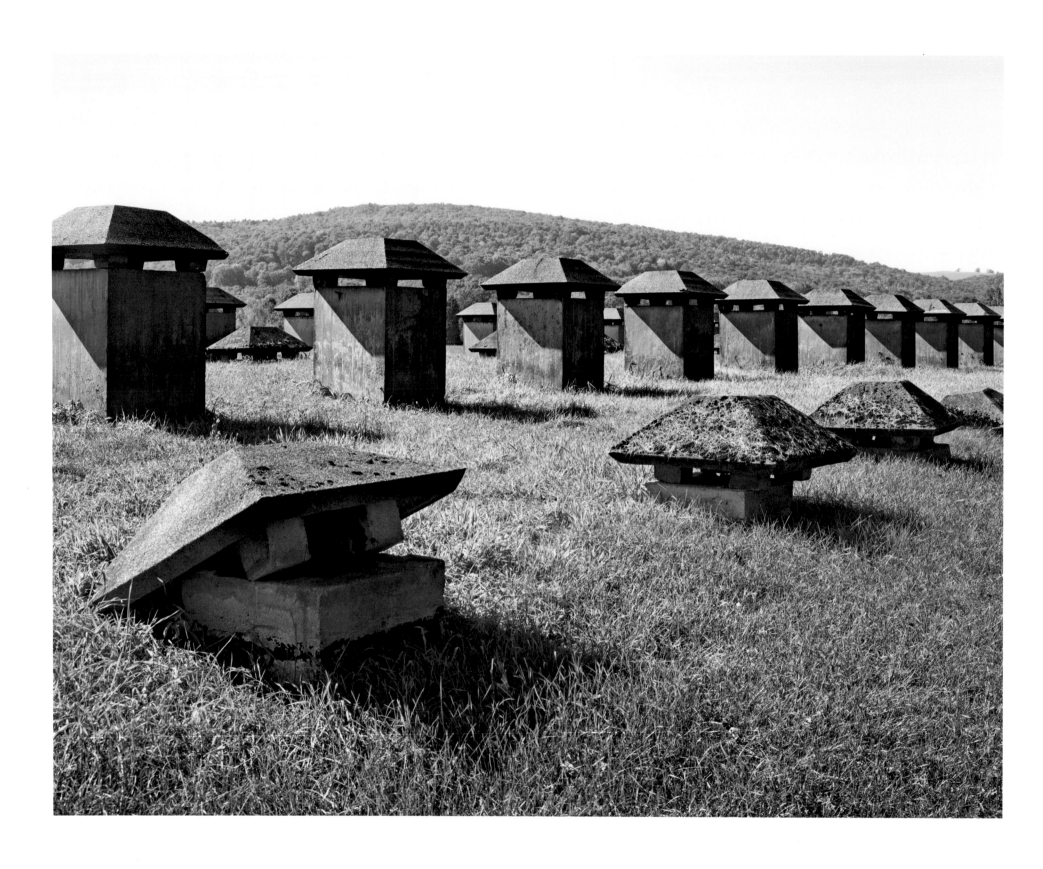

138 Root cellar vents, Warren State Hospital, Warren, Pennsylvania

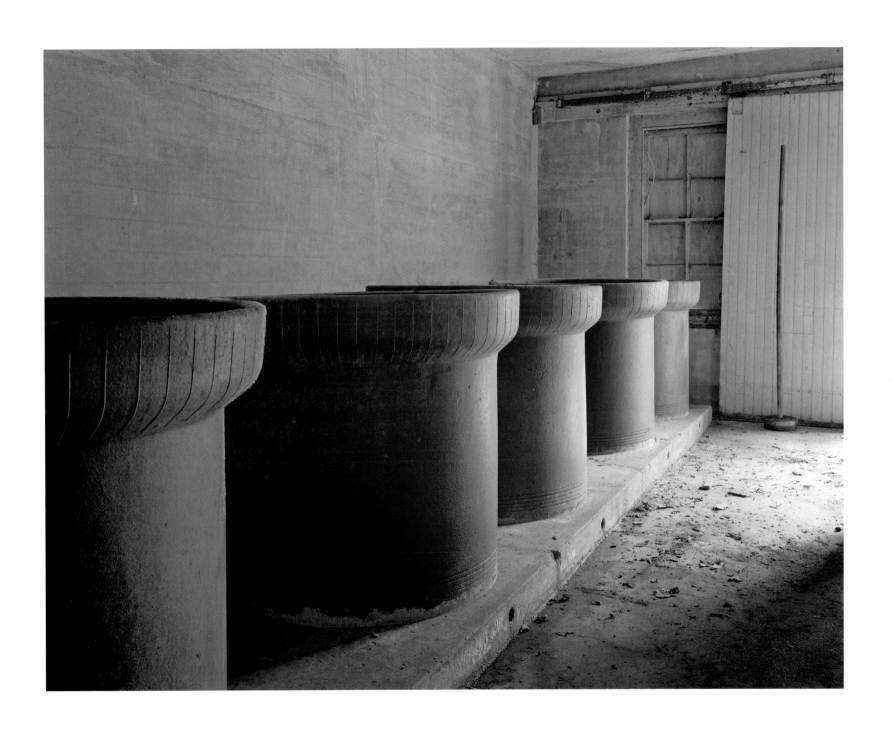

Sauerkraut vats, Danville State Hospital, Danville, Pennsylvania 139

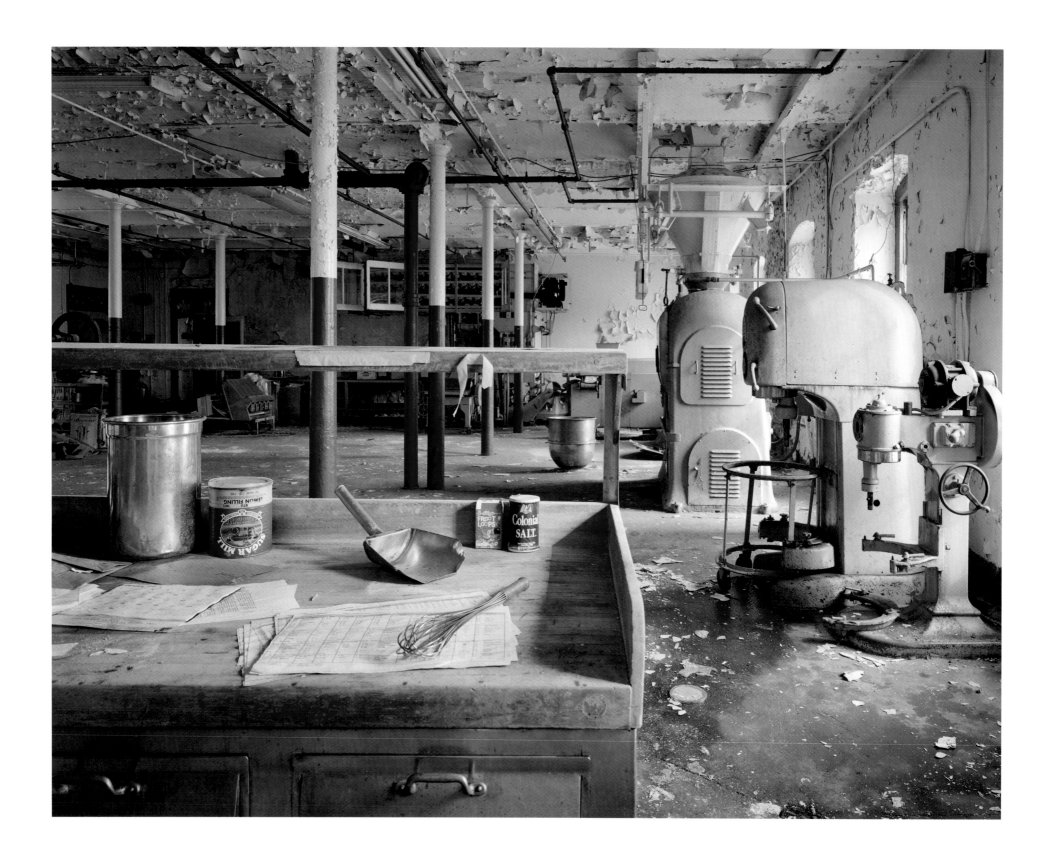

Bakery, Greystone Park State Hospital, Morristown, New Jersey

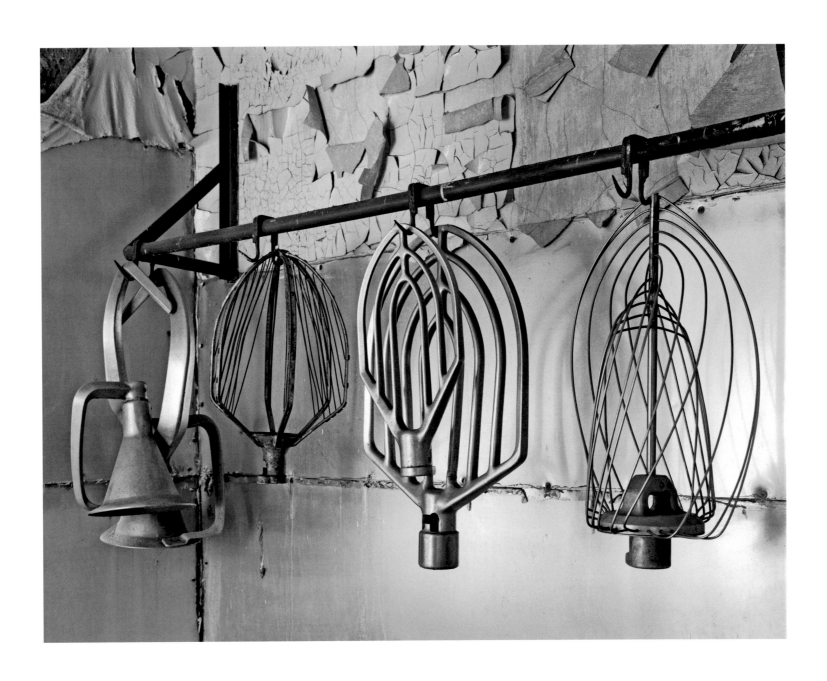

Bakery mixer attachments, Greystone Park State Hospital, Morristown, New Jersey

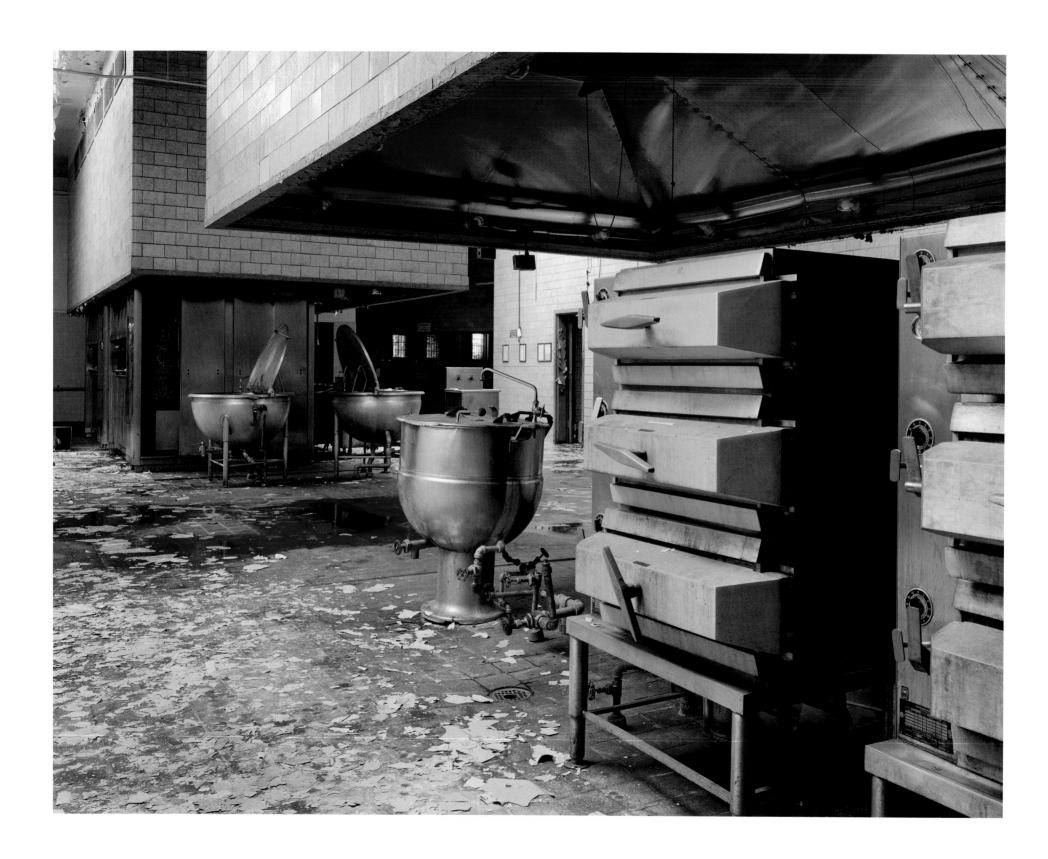

142 Central kitchen, Harlem Valley State Hospital, Wingdale, New York

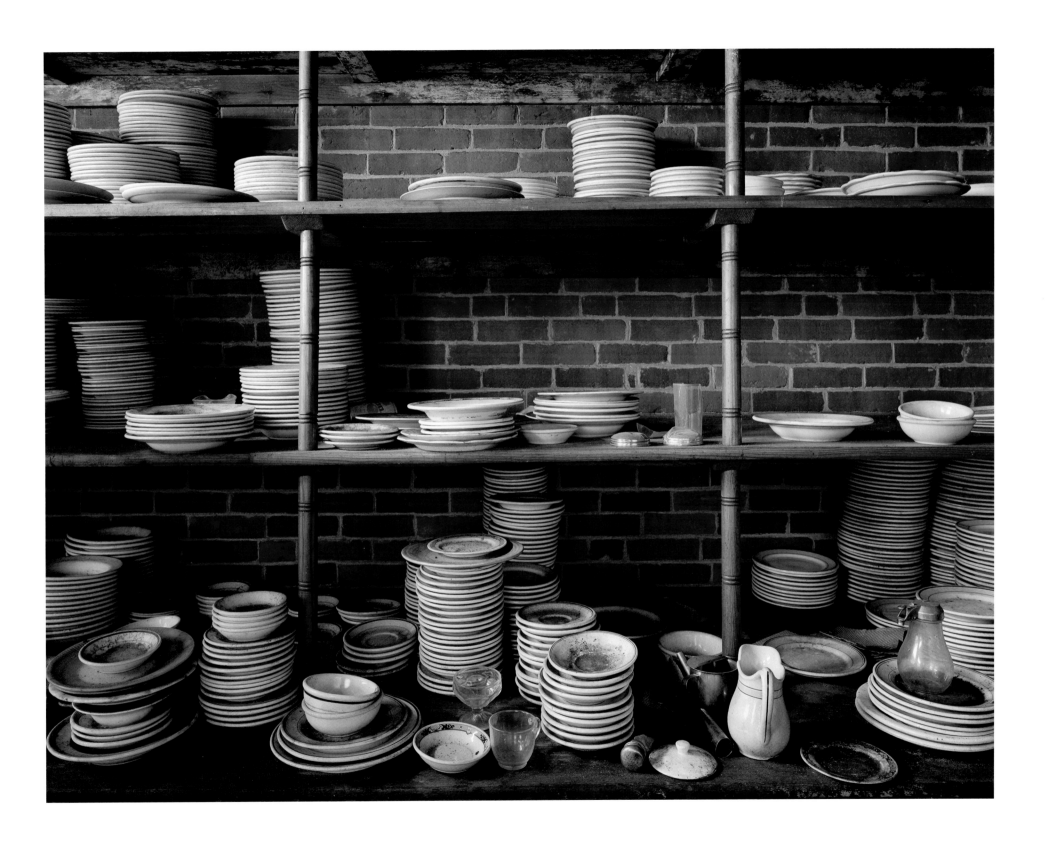

Dishes, Concord State Hospital, Concord, New Hampshire 143

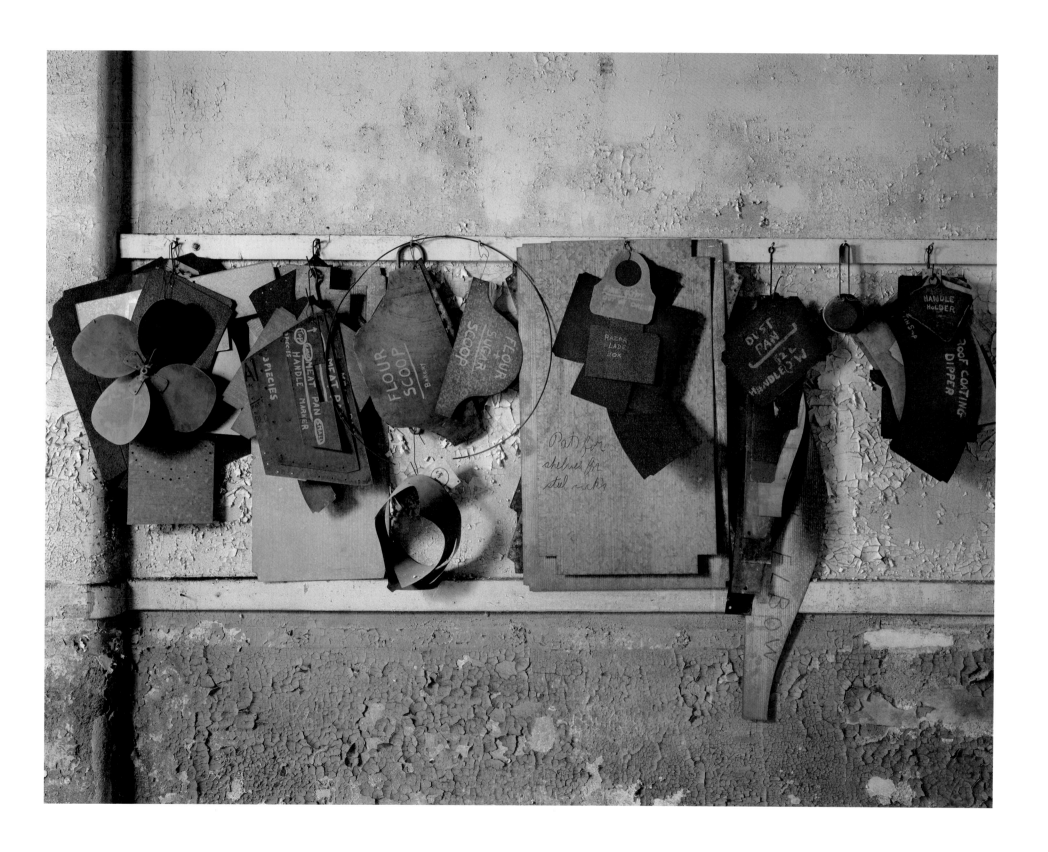

Sheet metal forms, Willard State Hospital, Willard, New York 145

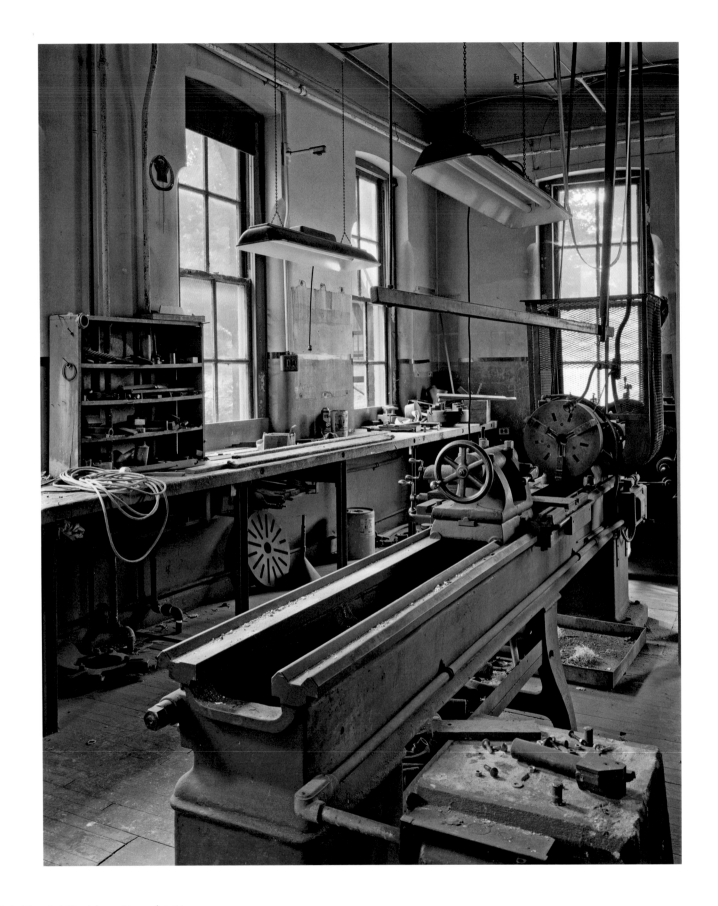

146 Lathe, Harrisburg State Hospital, Harrisburg, Pennsylvania

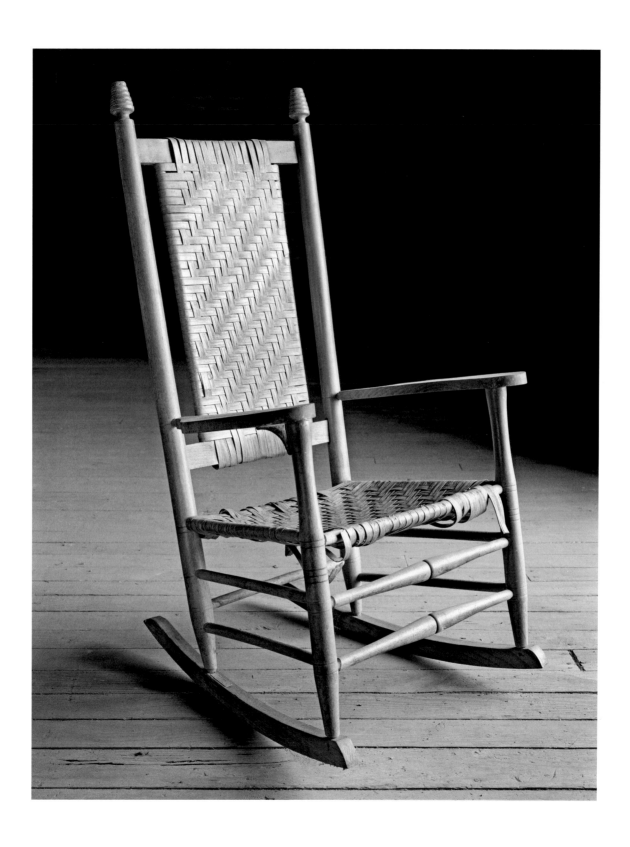

Chair made at Eastern State Hospital, Lexington, Kentucky 147

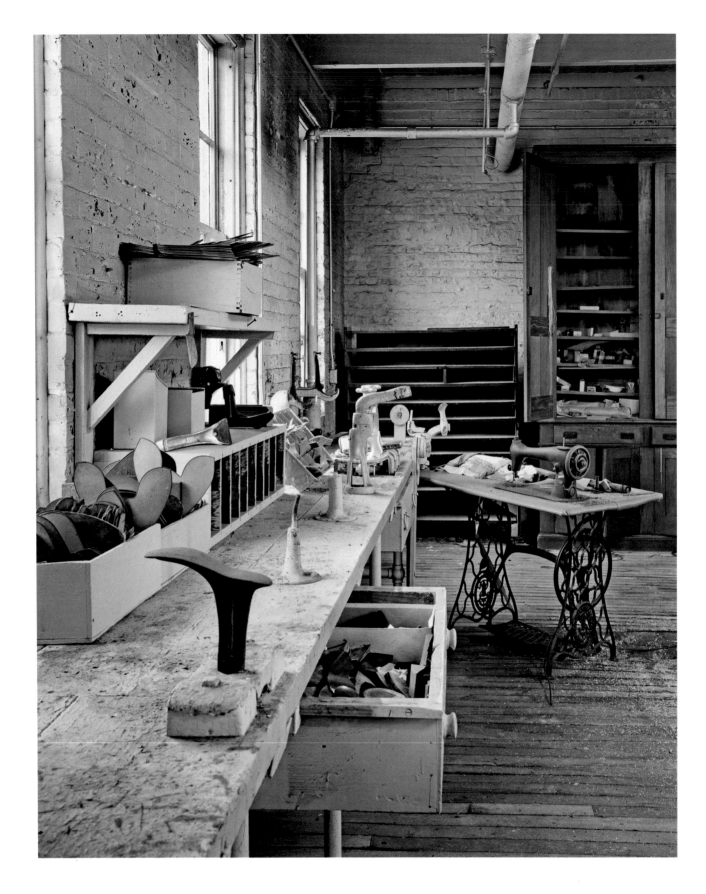

148 Shoe shop, Taunton State Hospital, Taunton, Massachusetts

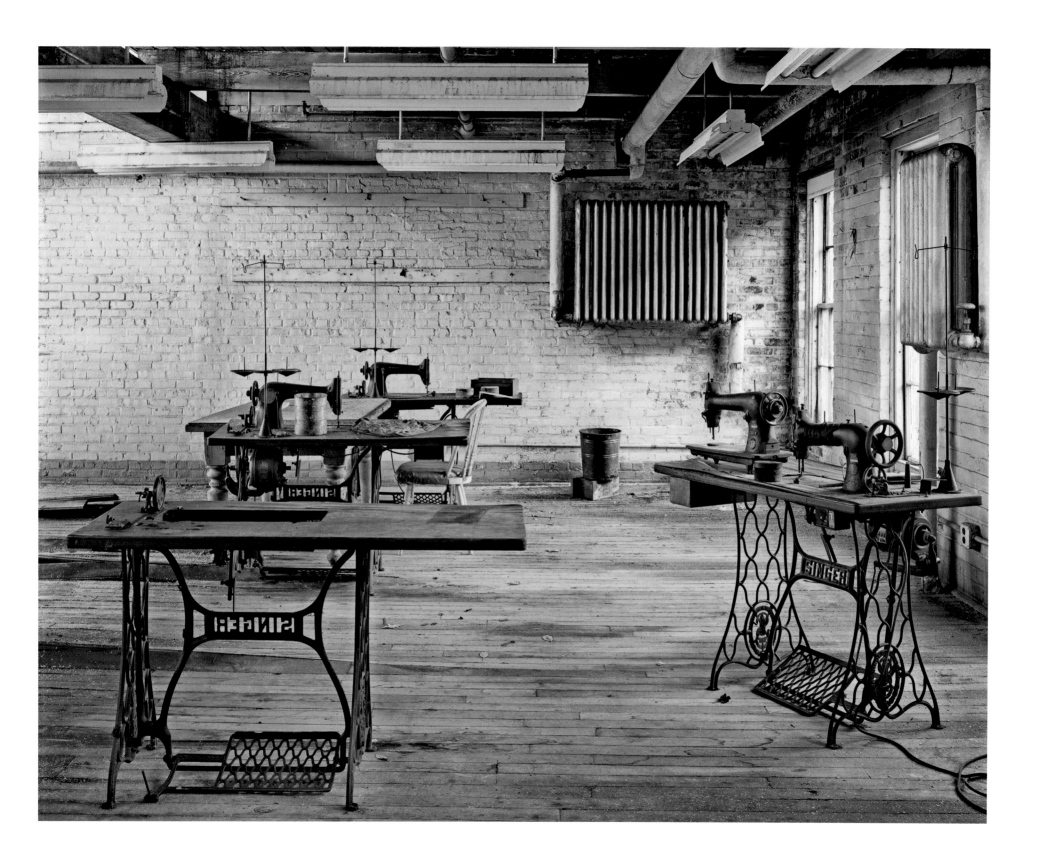

Sewing shop, Taunton State Hospital, Taunton, Massachusetts 149

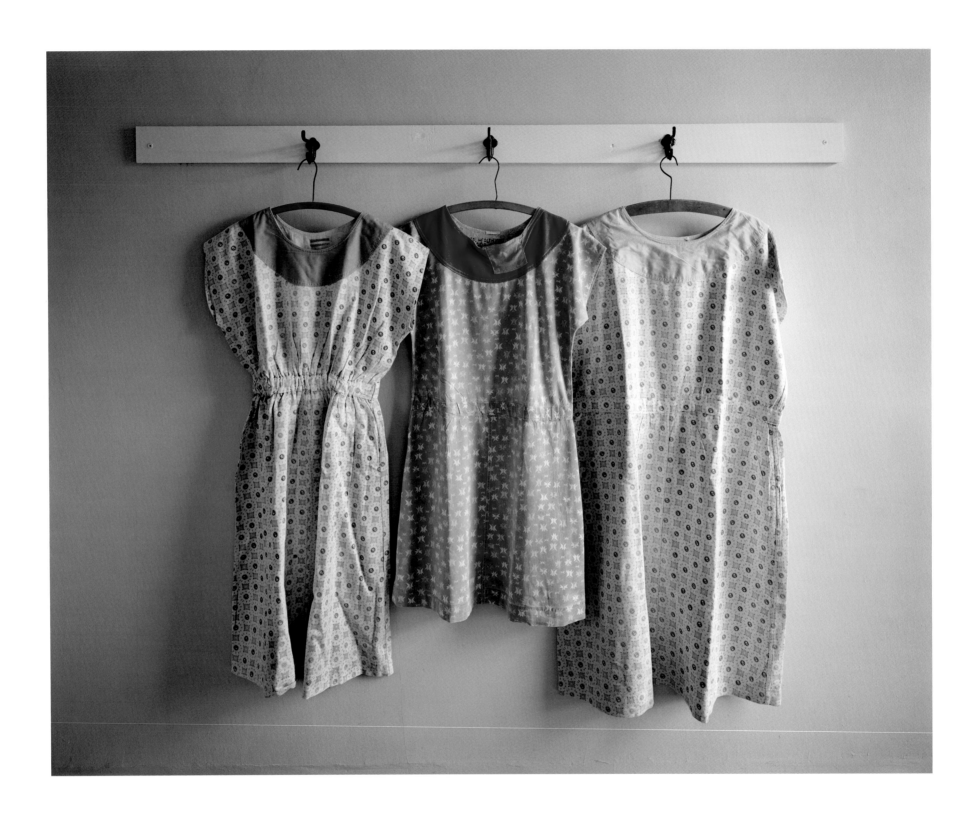

Patient dresses made at Clarinda State Hospital, Clarinda, Iowa

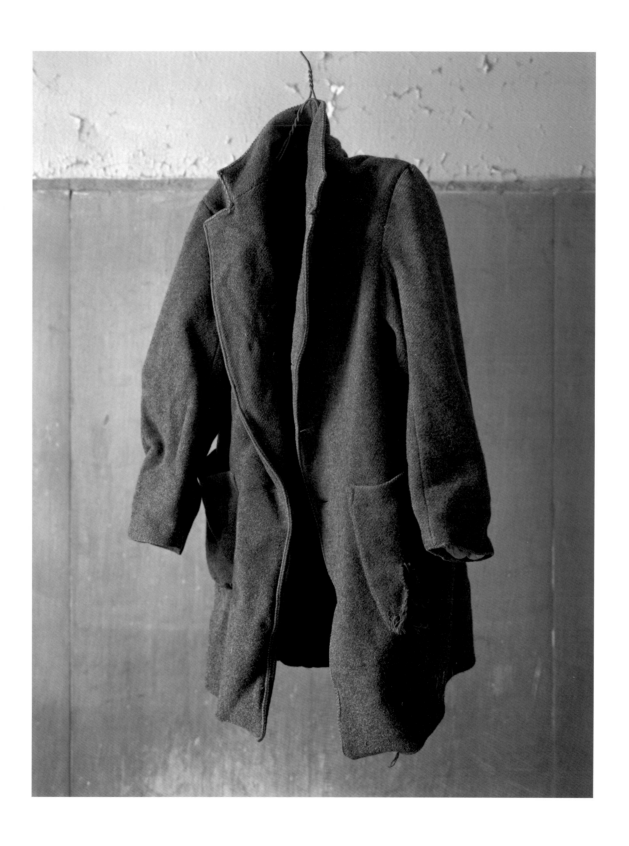

Patient coat, Willard State Hospital, Willard, New York 151

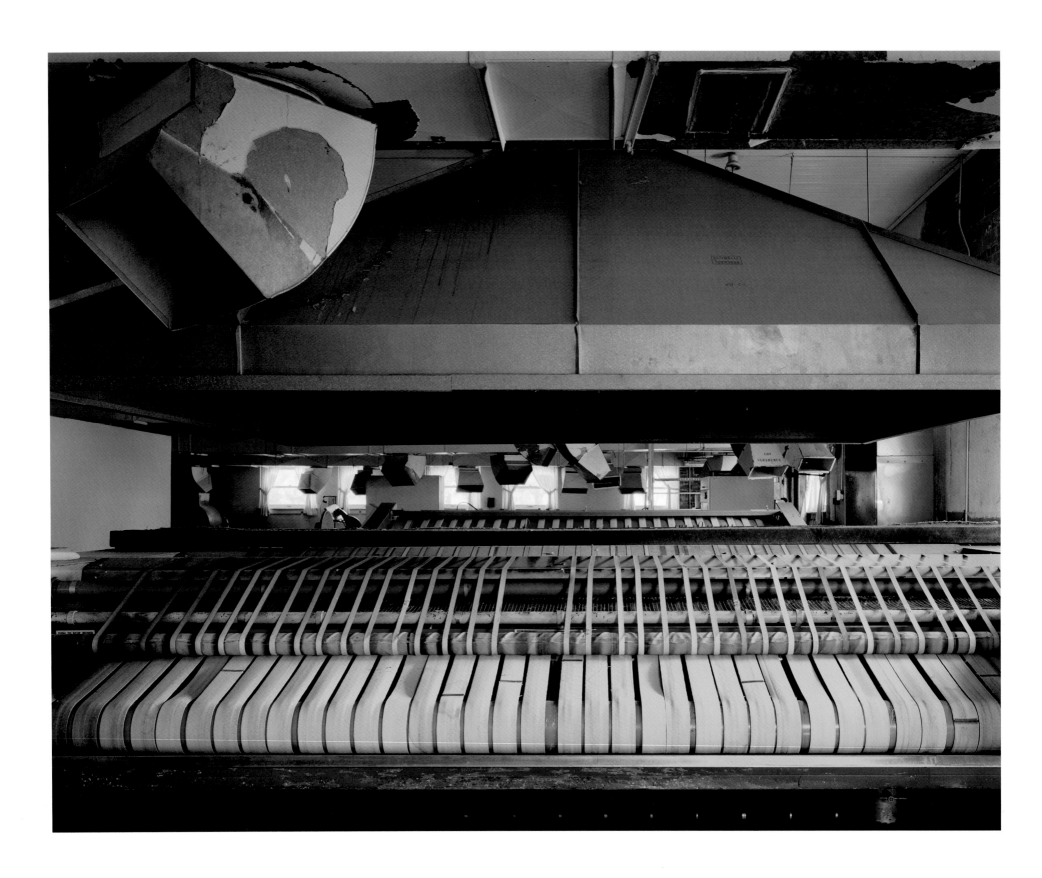

Laundry sheet folder, Hastings State Hospital, Hastings, Nebraska

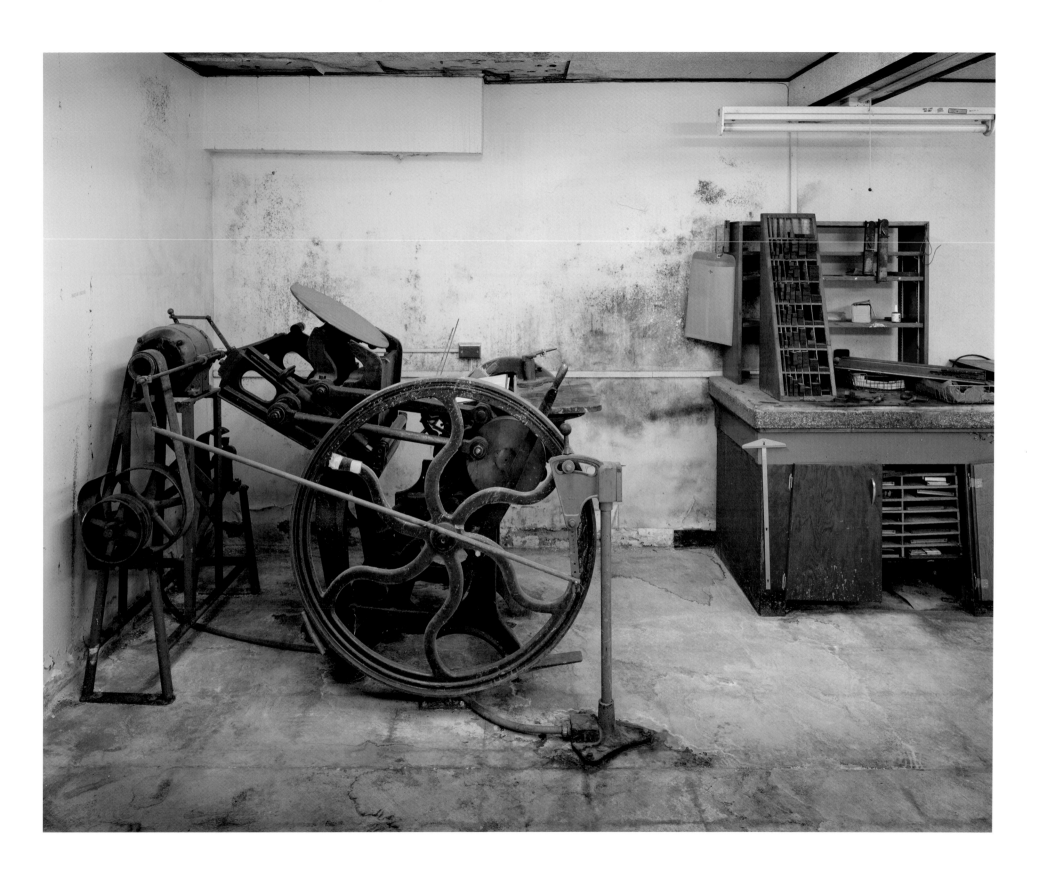

Printing shop, Yankton State Hospital, Yankton, South Dakota 153

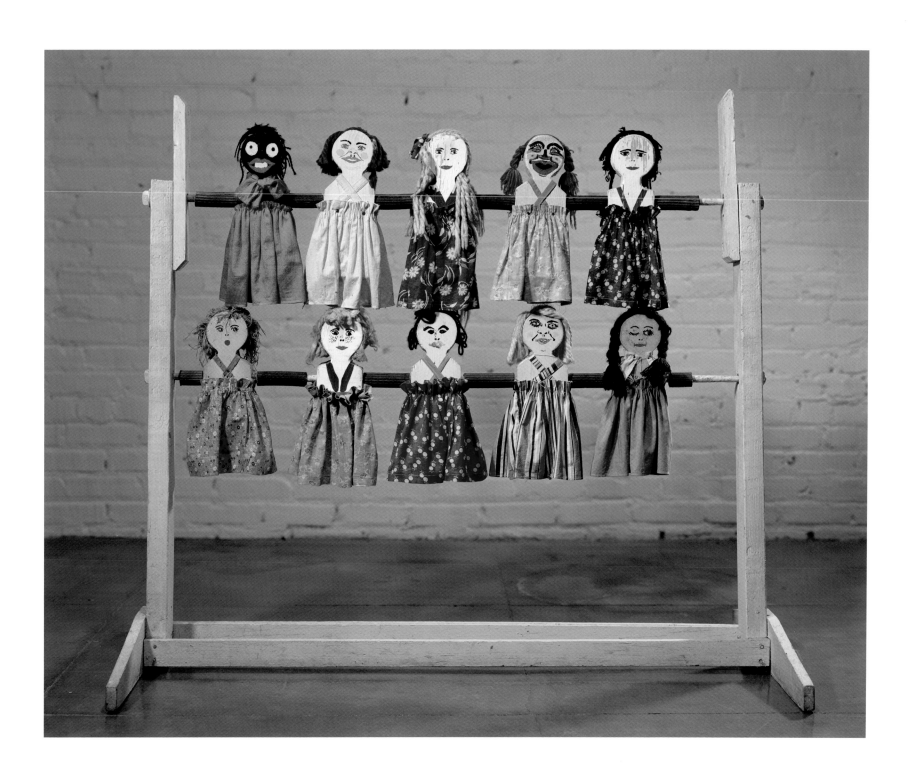

Patient-made game, Cherokee State Hospital, Cherokee, Iowa　155

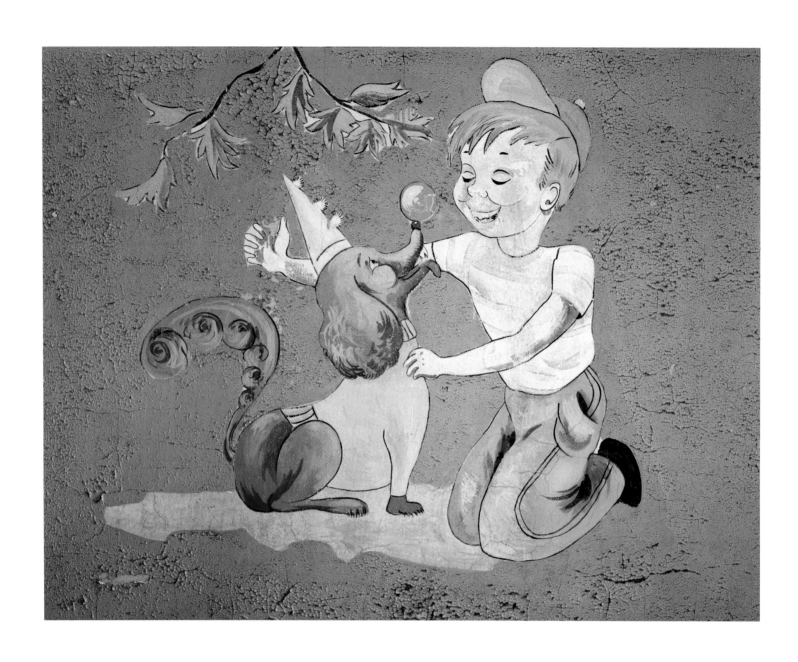

Patient art, Creedmoor State Hospital, Queens, New York

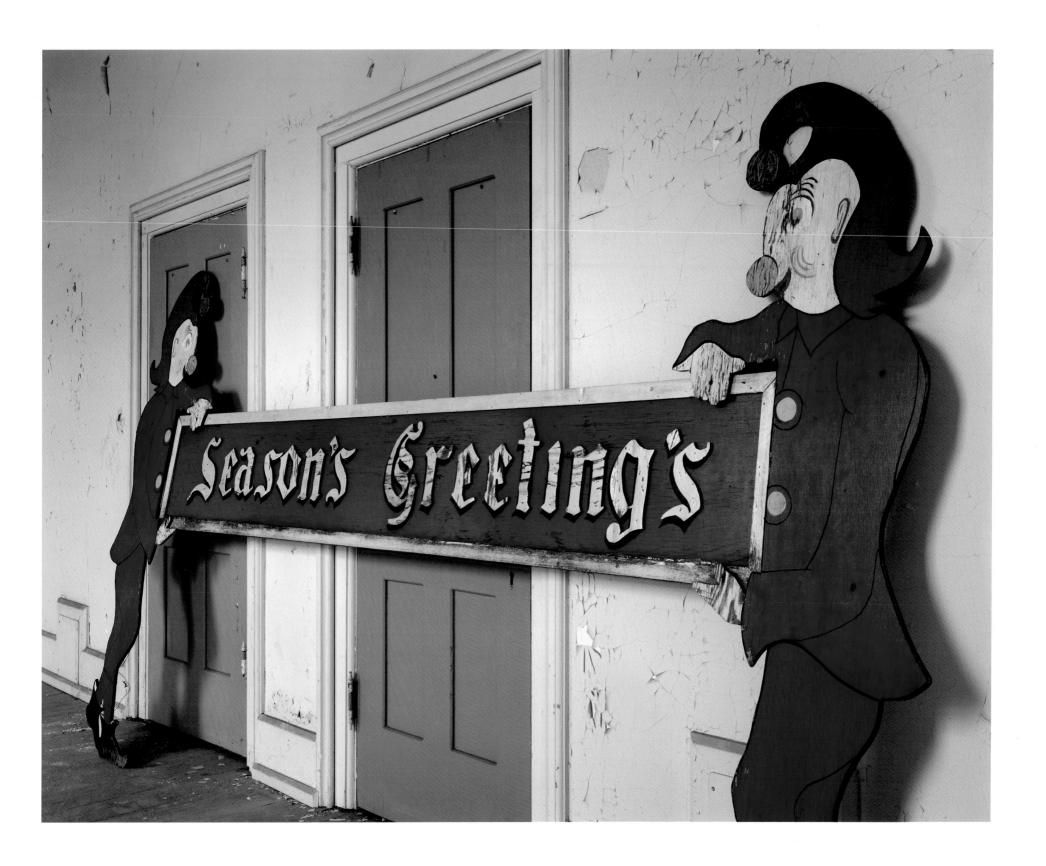

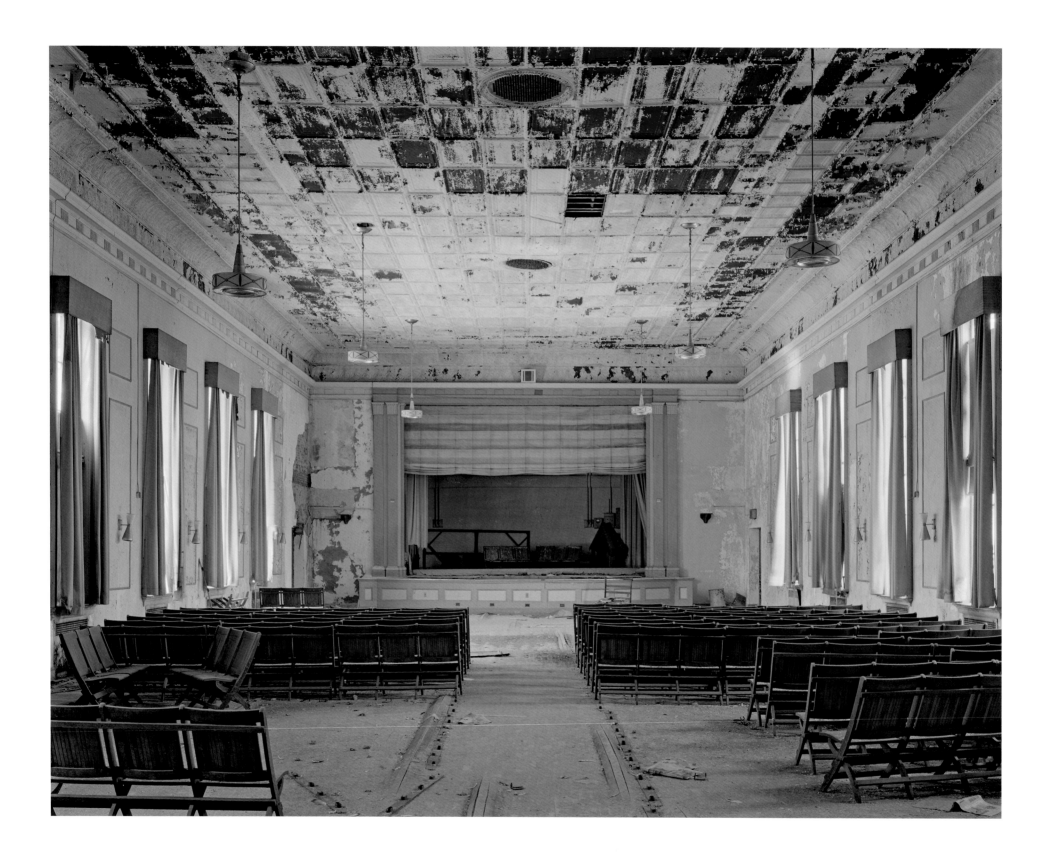

Auditorium, Taunton State Hospital, Taunton, Massachusetts

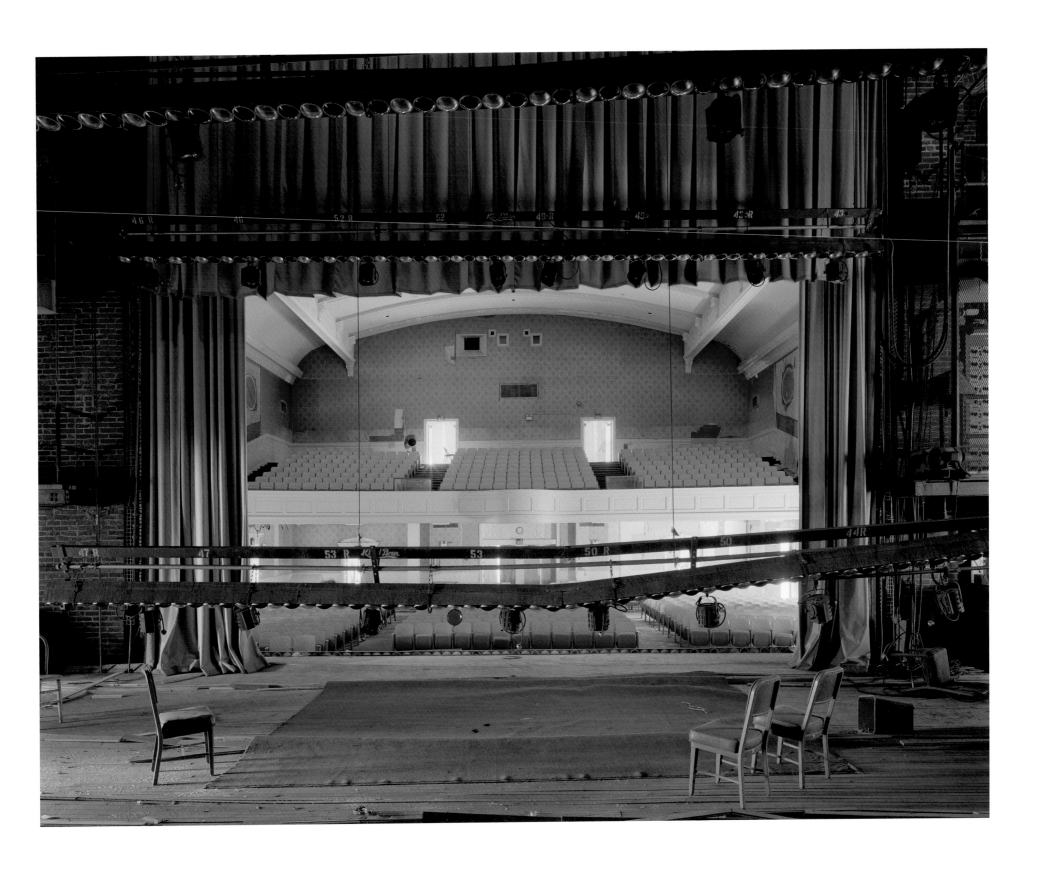

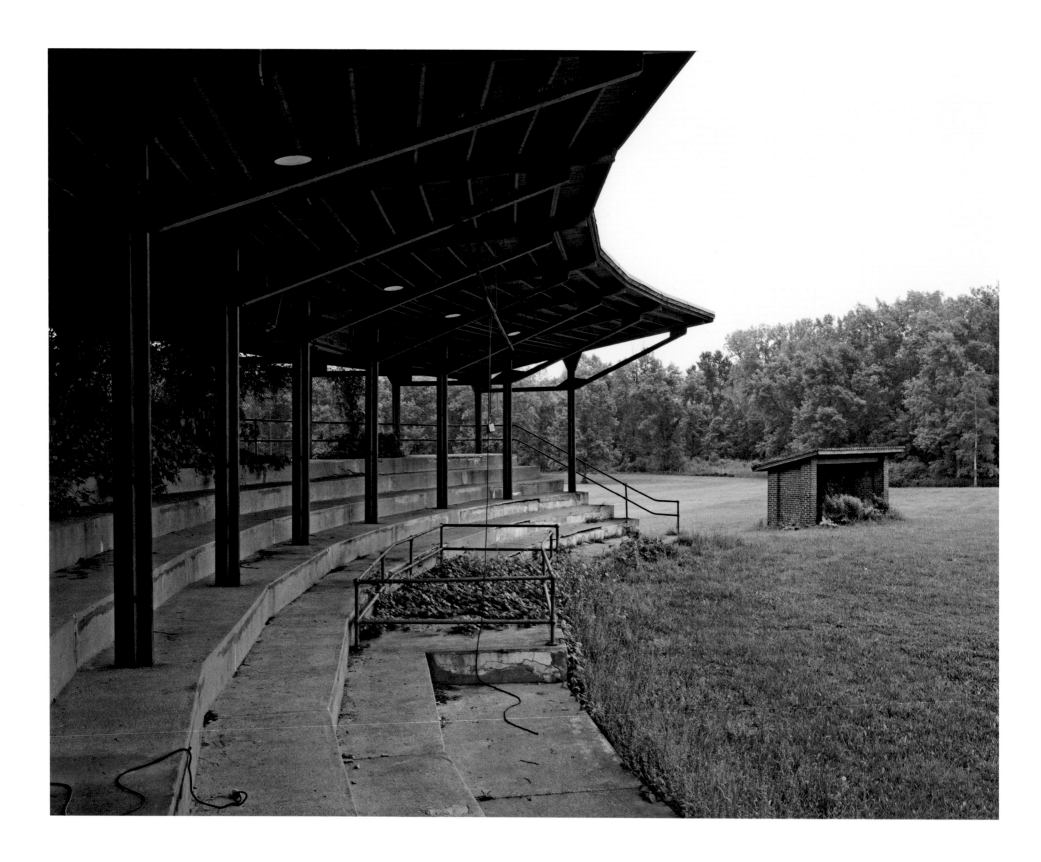

Grandstand, Harlem Valley State Hospital, Wingdale, New York

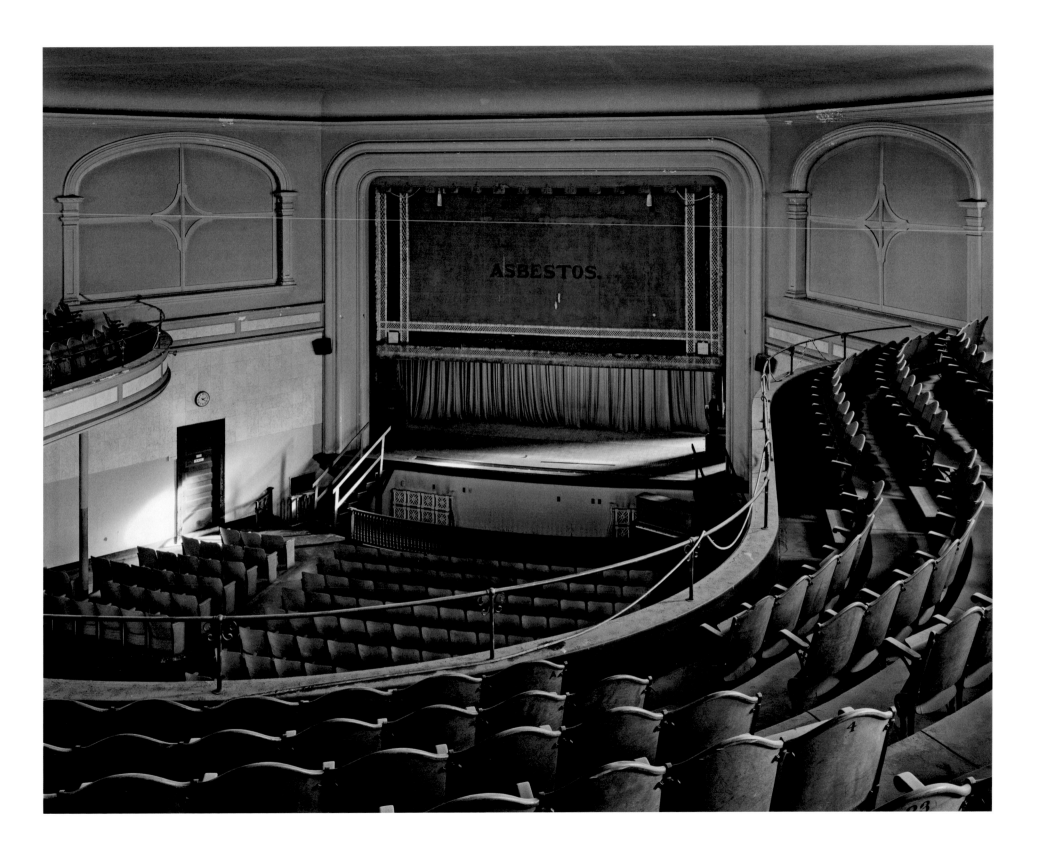

Noble Hall, Connecticut Valley State Hospital, Middletown, Connecticut 161

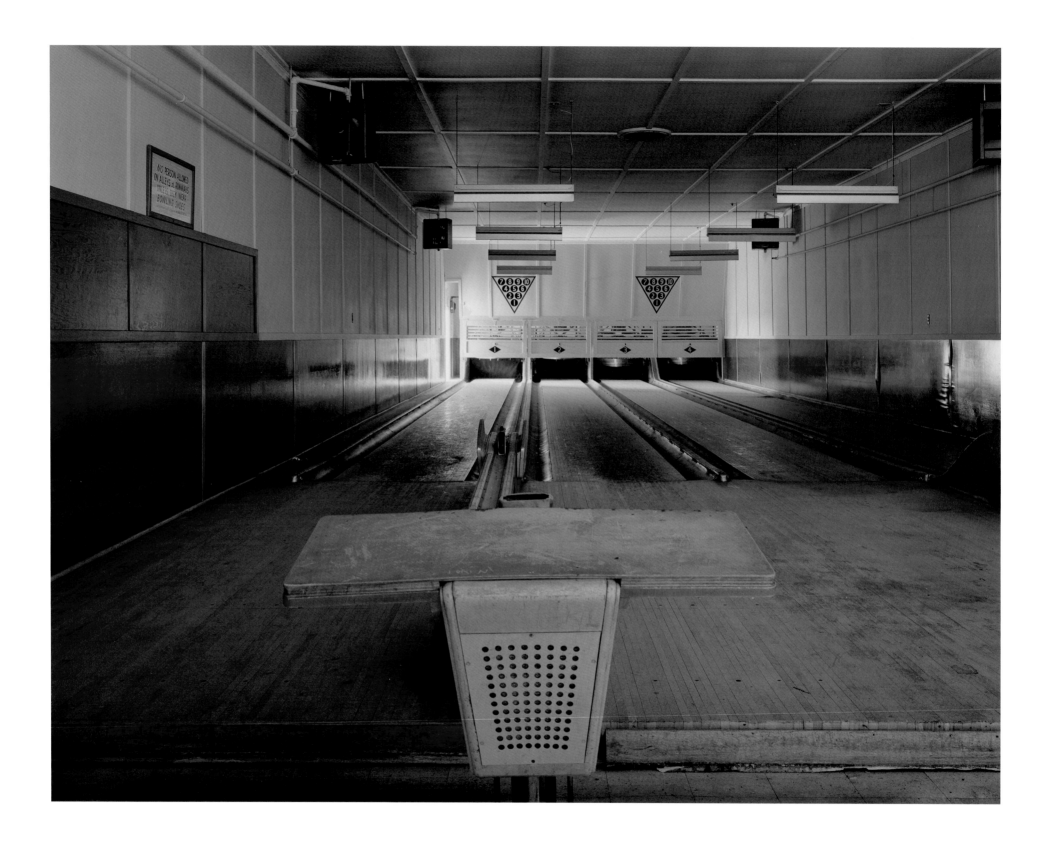

162 Bowling alley, St. Lawrence State Hospital, Ogdensburg, New York

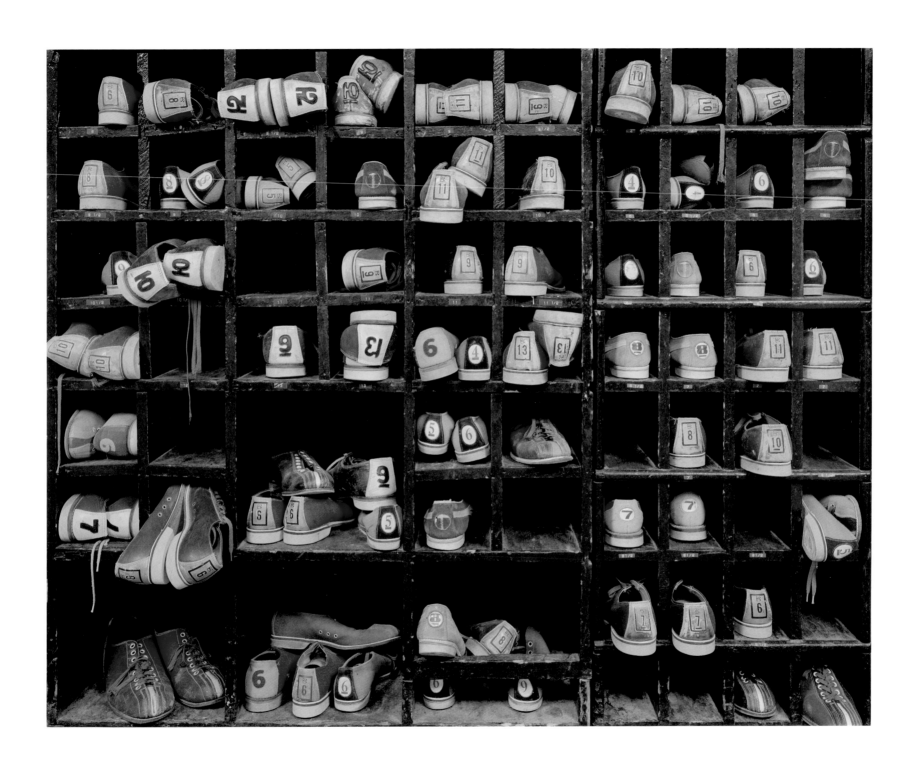

Bowling shoes, Rockland State Hospital, Organgeburg, New York 163

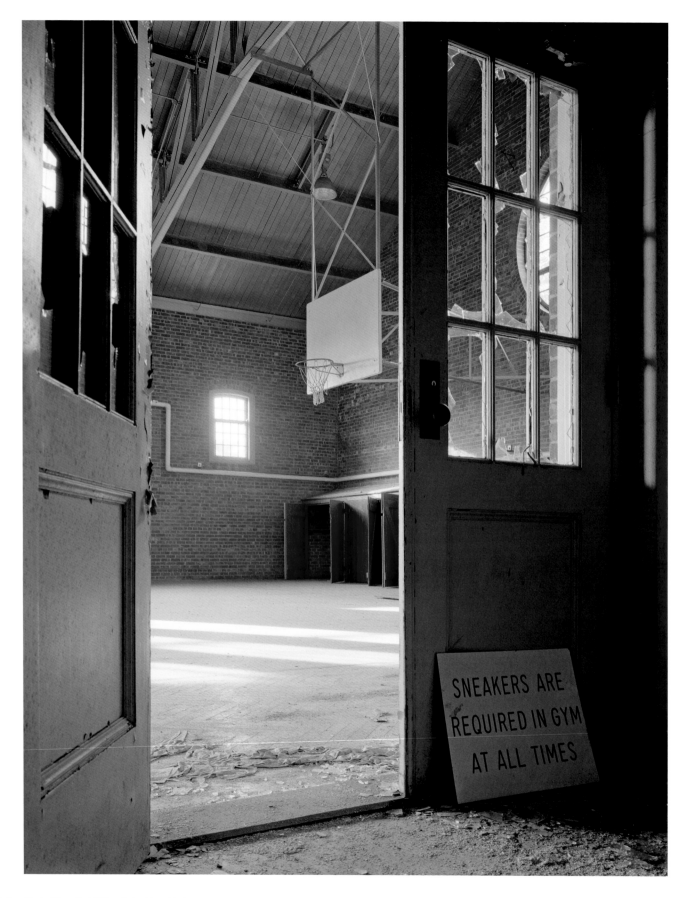

Gymnasium, Harlem Valley State Hospital, Wingdale, New York

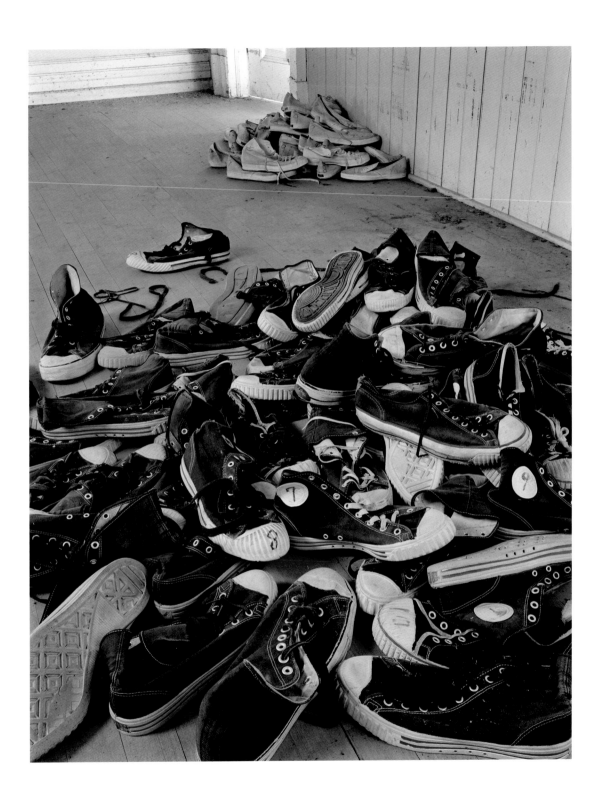

Men's and women's gym sneakers, Wernersville State Hospital, Wernersville, Pennsylvania 165

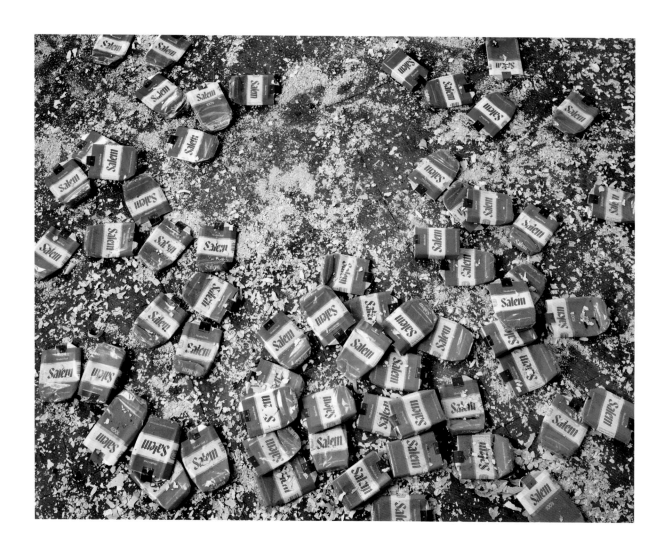

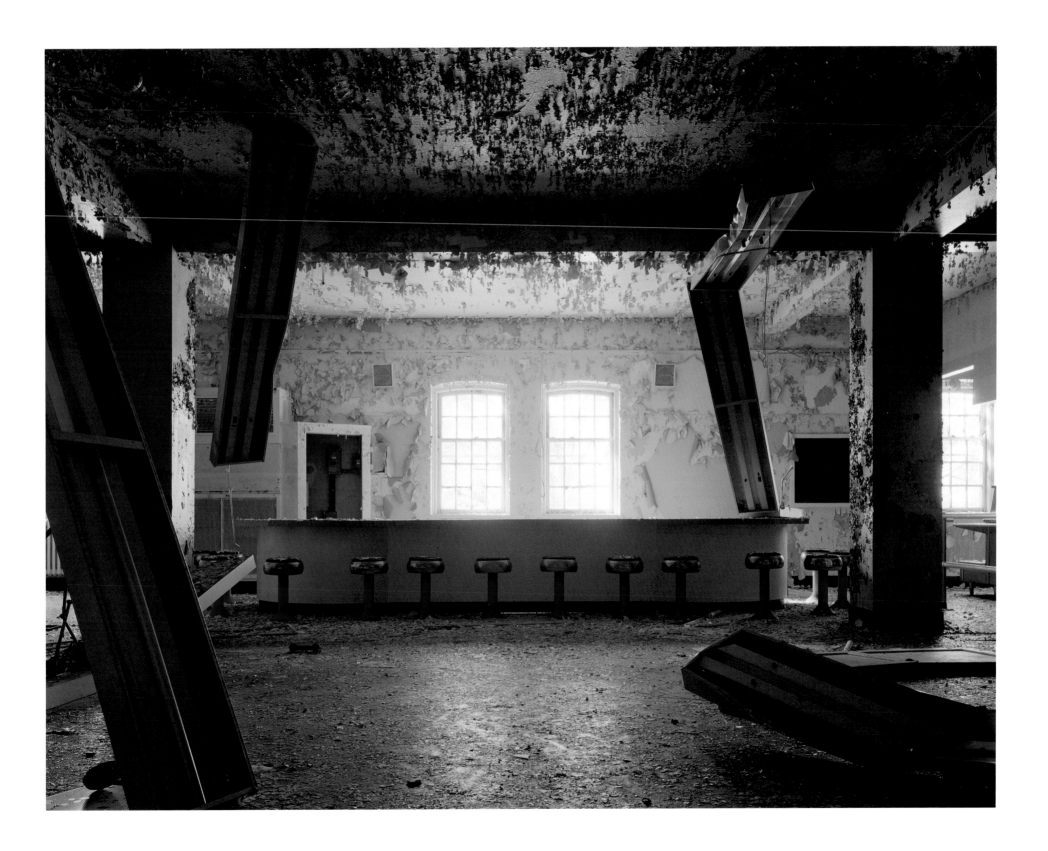

Patient café, Harlem Valley State Hospital, Wingdale, New York 167

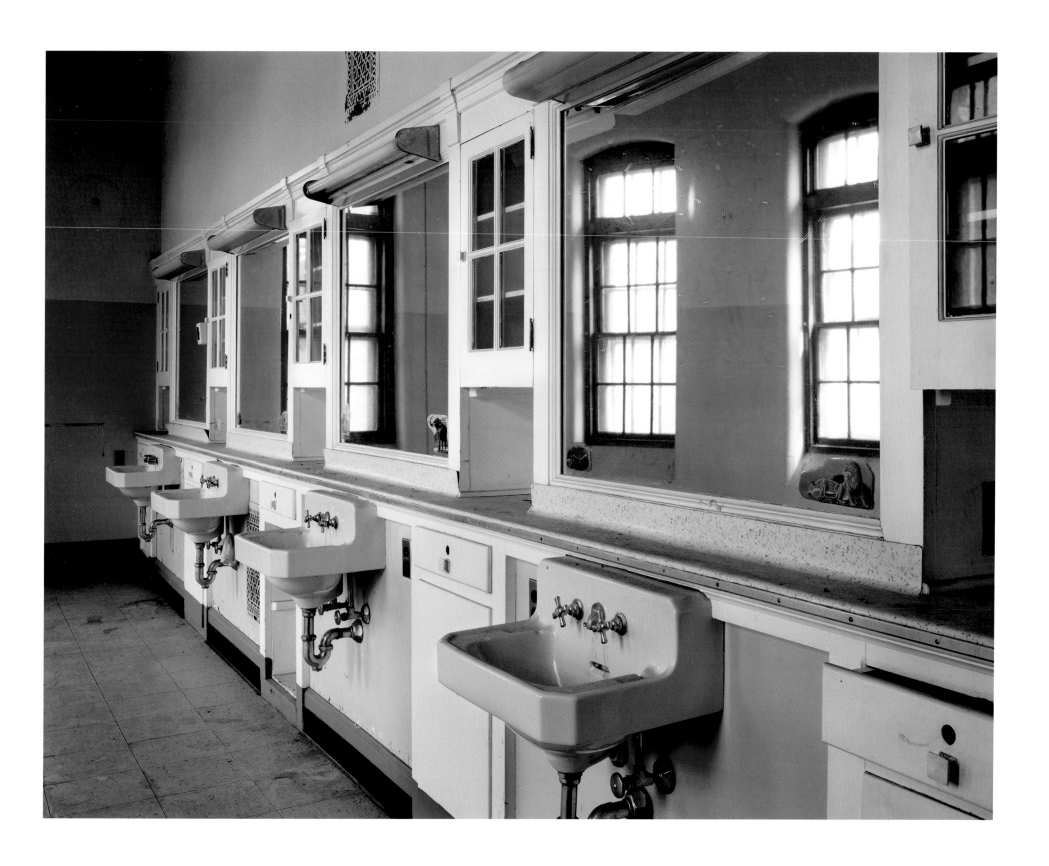

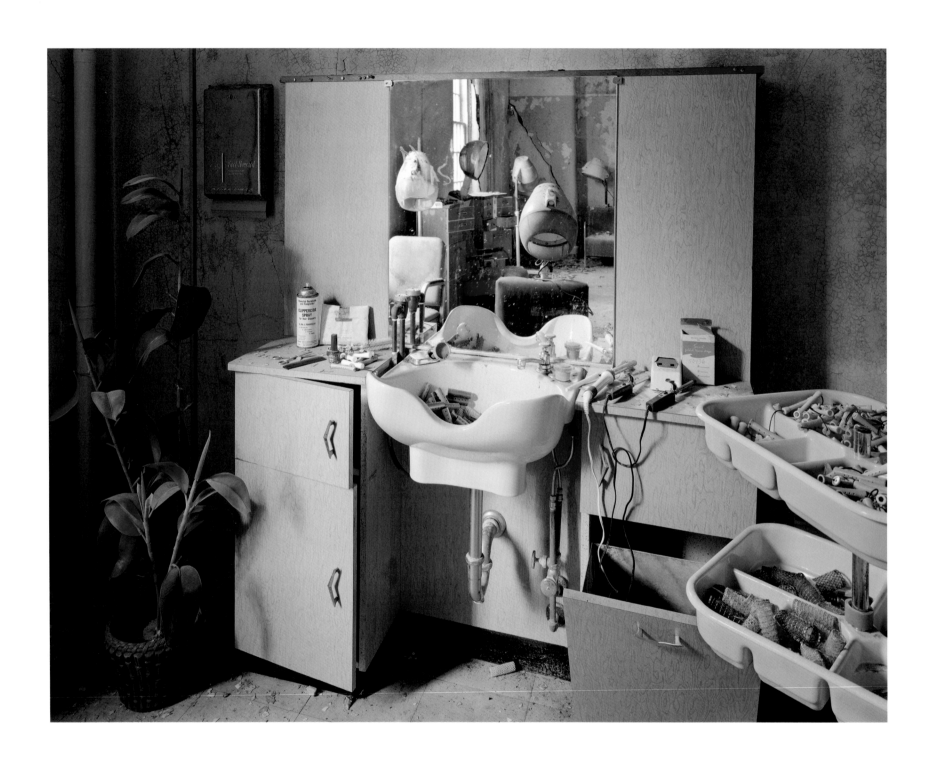

Beauty salon, Willard State Hospital, Willard, New York

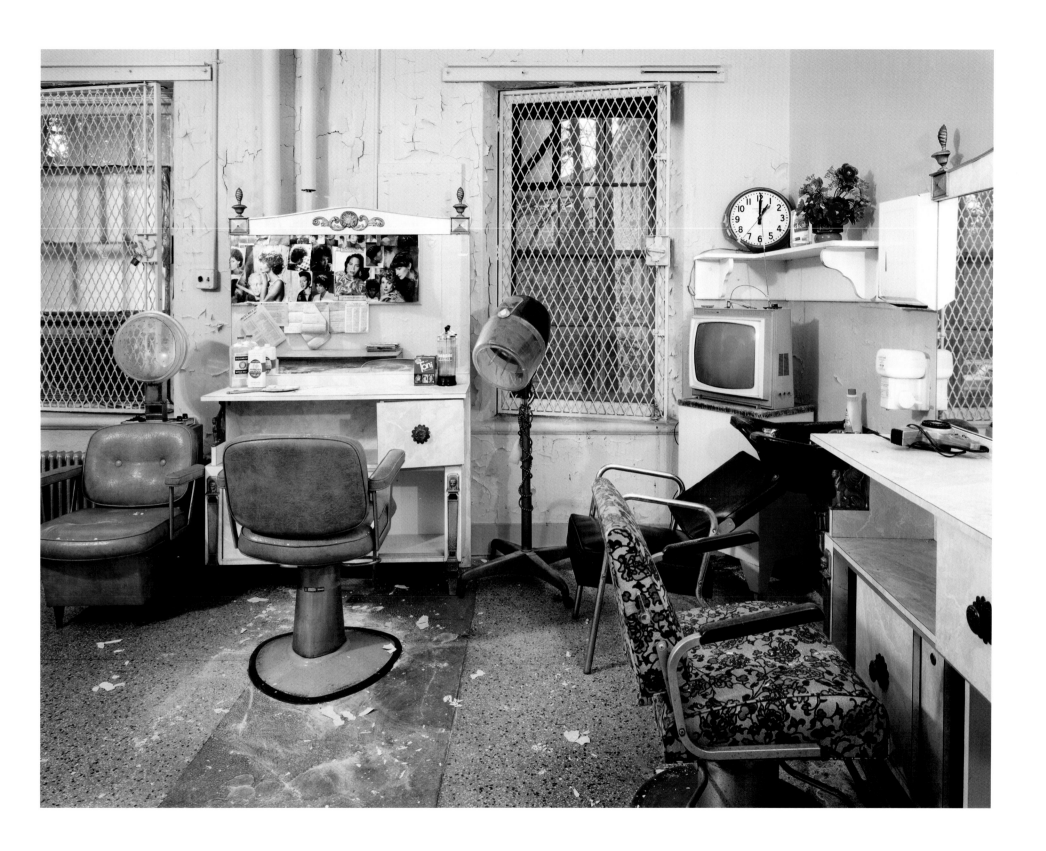

Beauty salon, Trenton State Hospital, Trenton, New Jersey

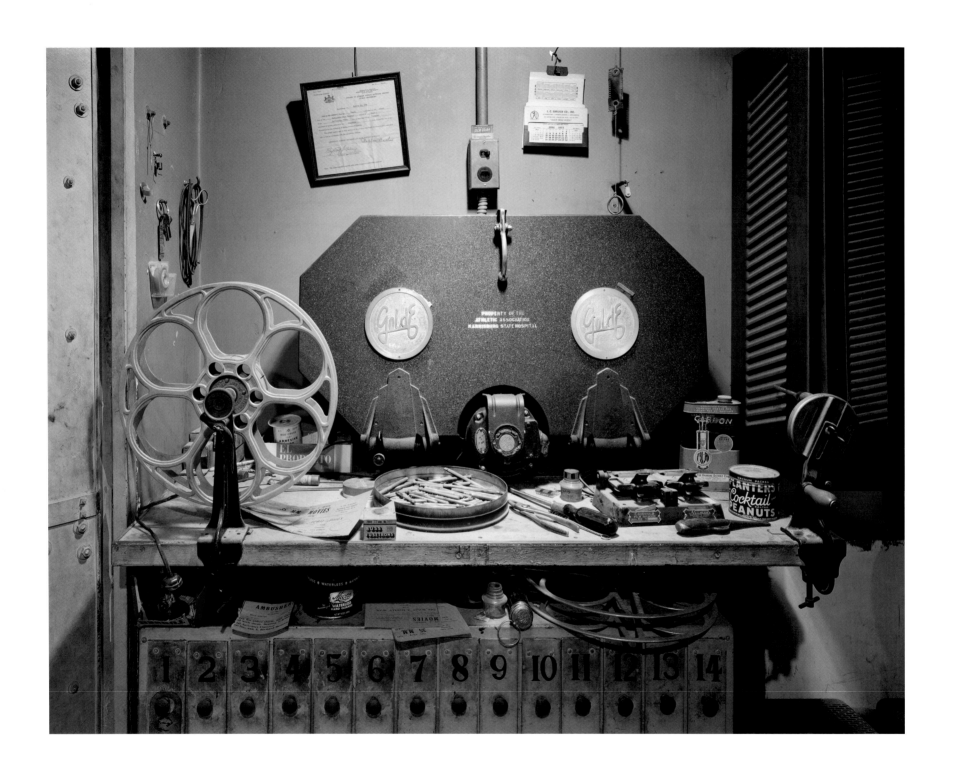

Film projection equipment, Harrisburg State Hospital, Harrisburg, Pennsylvania

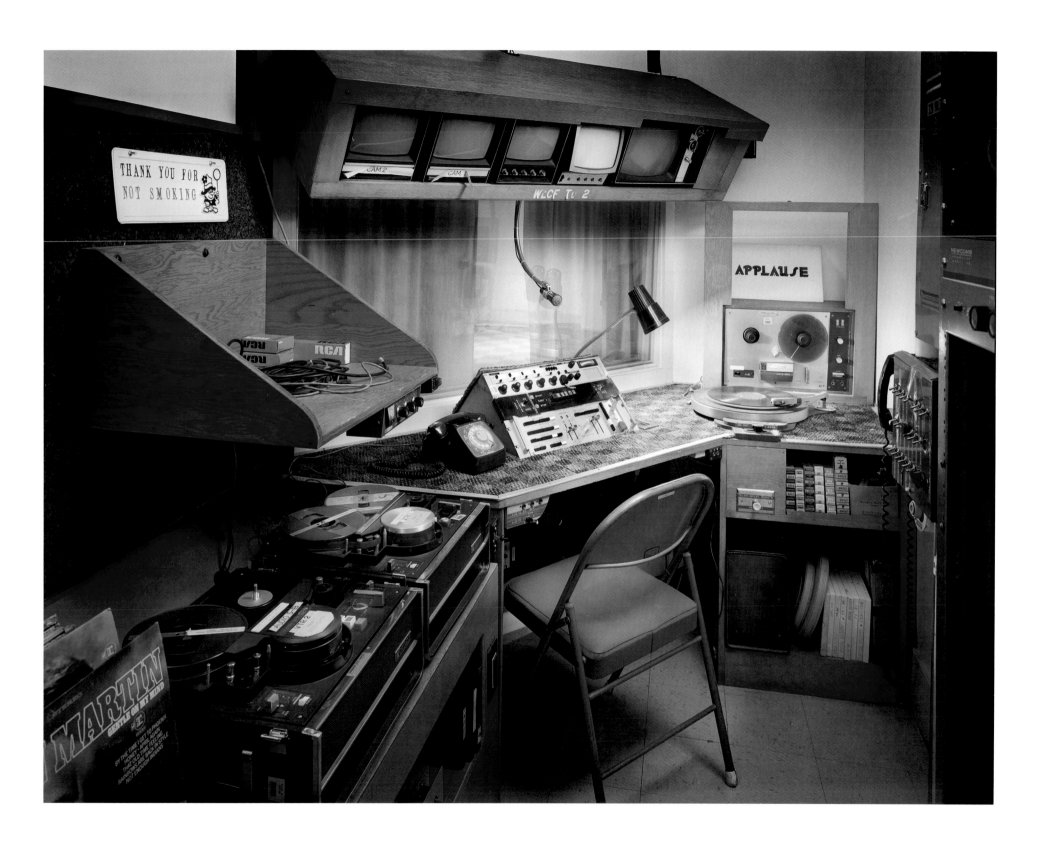

TV studio, Logansport State Hospital, Logansport, Indiana 173

State hospitals were equipped with facilities for acute care and surgical procedures. They were also centers for clinical research, and some had their own nursing schools. As the hospitals downsized, these services and programs were most often eliminated.

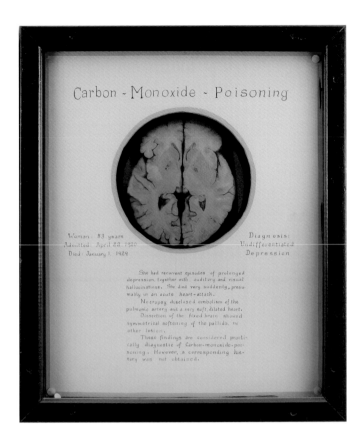

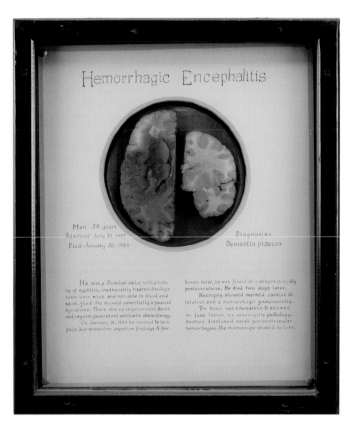

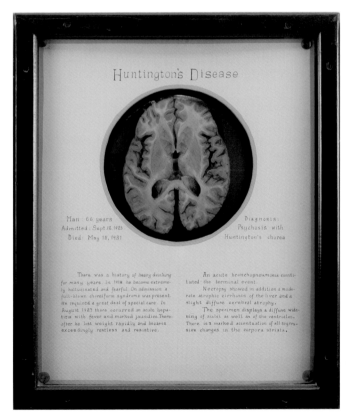

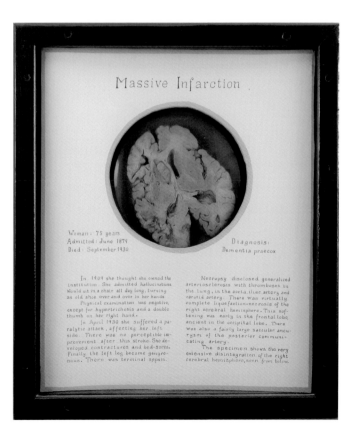

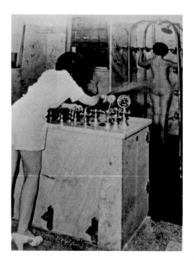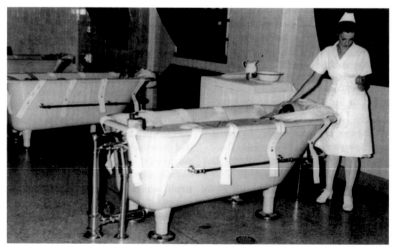

LEFT: Mississippi State Hospital from Baxter and Hathcox, *America's Care of the Mentally Ill: A Photographic History*, 1994. RIGHT: Mayview State Hospital from Morrison, *The Physician, the Philanthropist, and the Politician: A History of Public Mental Health Care in Pennsylvania*, 2001.

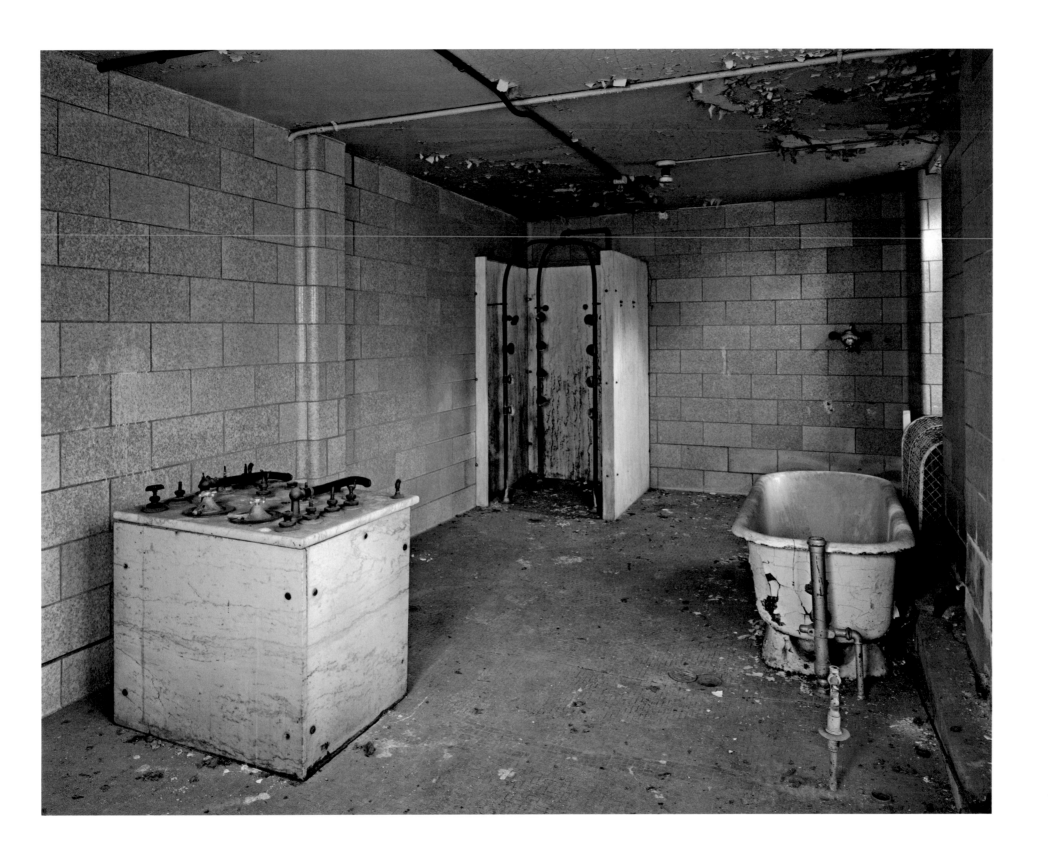

Hydrotherapy room, with control panel, needle shower, and continuous flow bath, Greystone Park State Hospital, Morristown, New Jersey 177

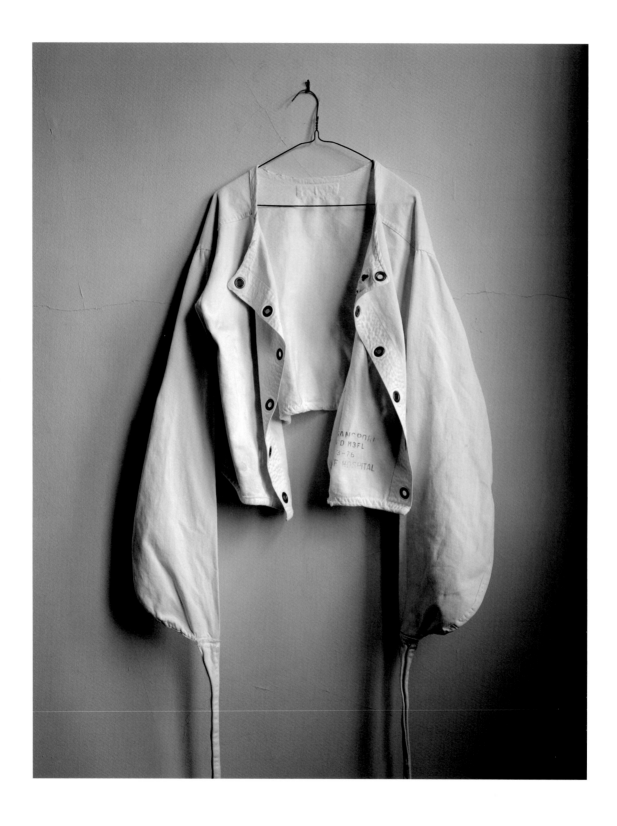

Straightjacket, Logansport State Hospital, Logansport, Indiana

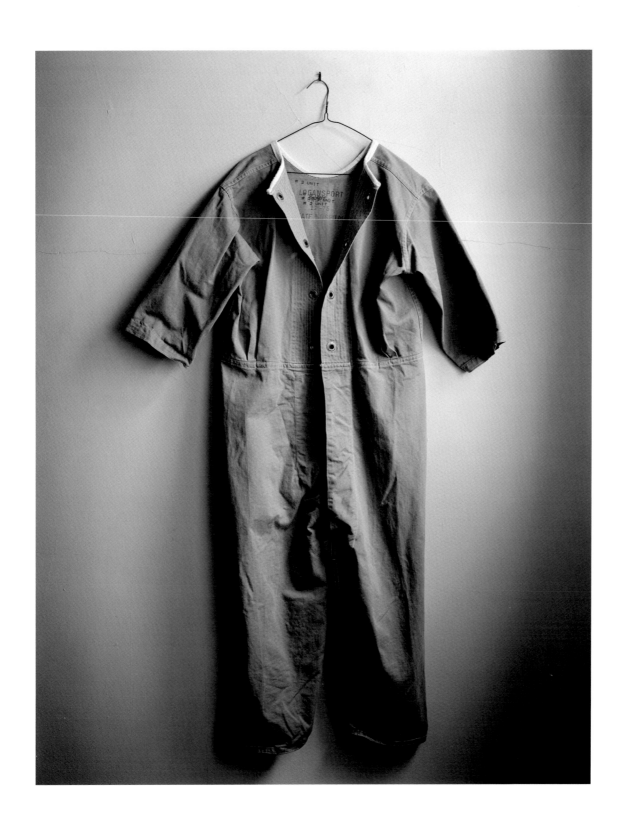

"Strong" jacket, Logansport State Hospital, Logansport, Indiana 179

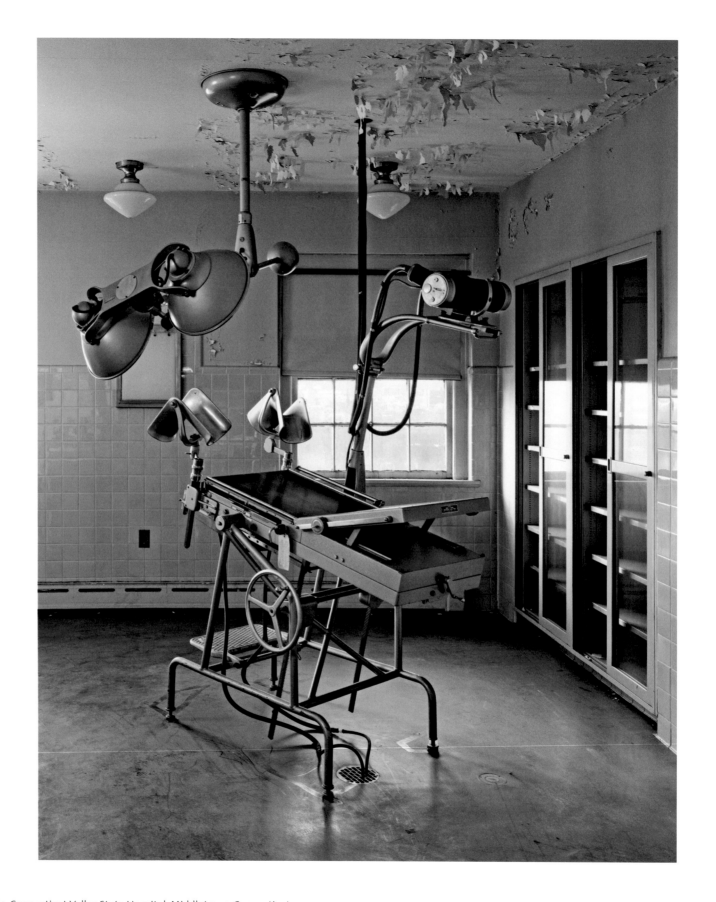

180 Urological x-ray suite, Connecticut Valley State Hospital, Middletown, Connecticut

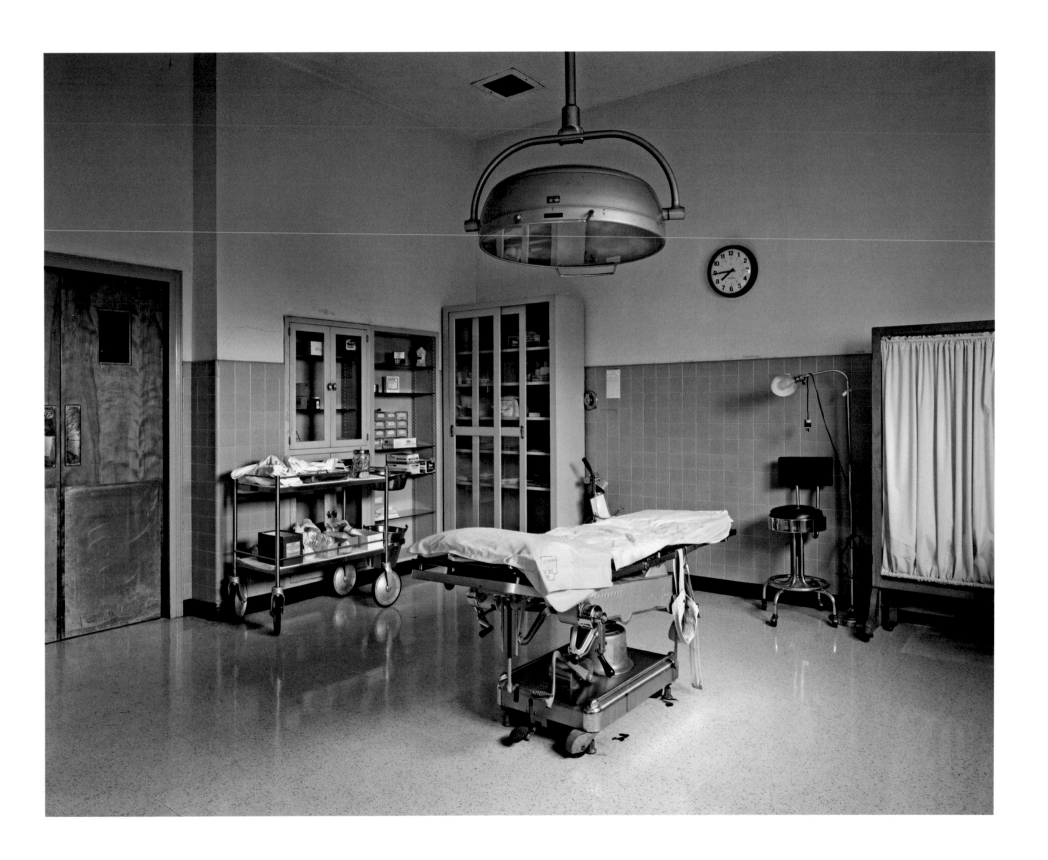

Operating room, Norristown State Hospital, Norristown, Pennsylvania

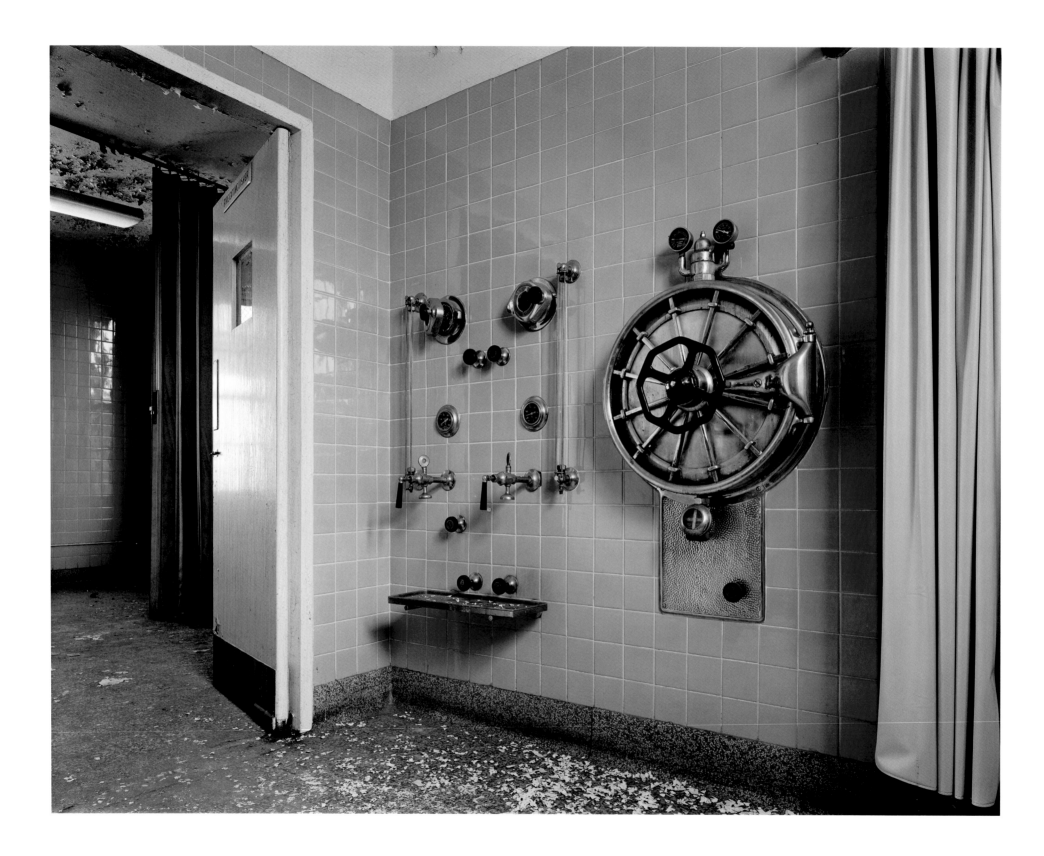

Surgical autoclave, Bryce State Hospital, Tuscaloosa, Alabama

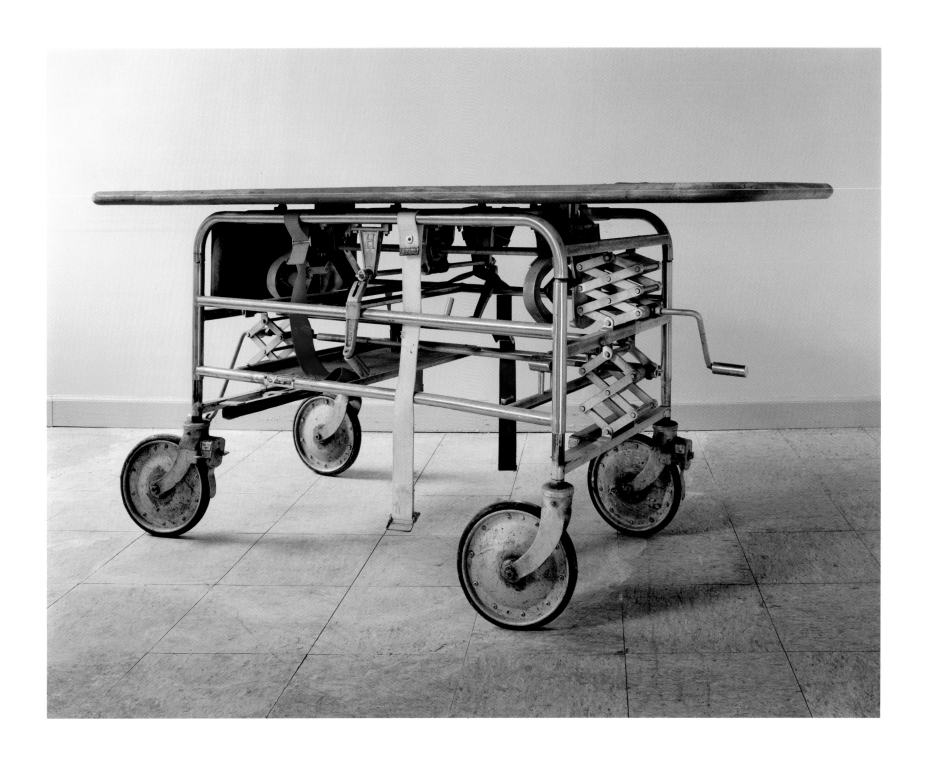

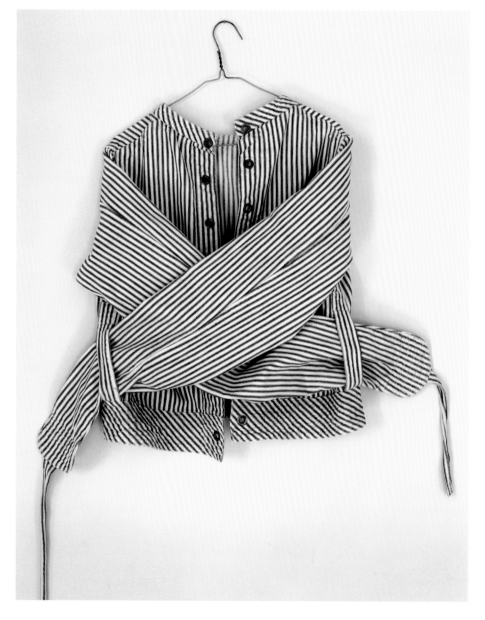

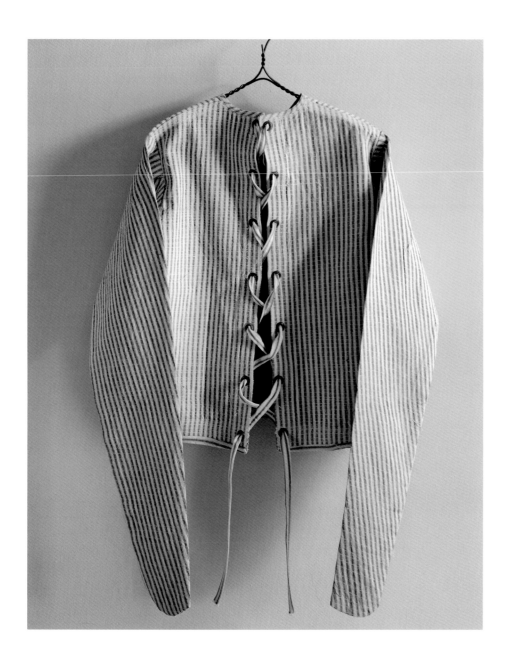

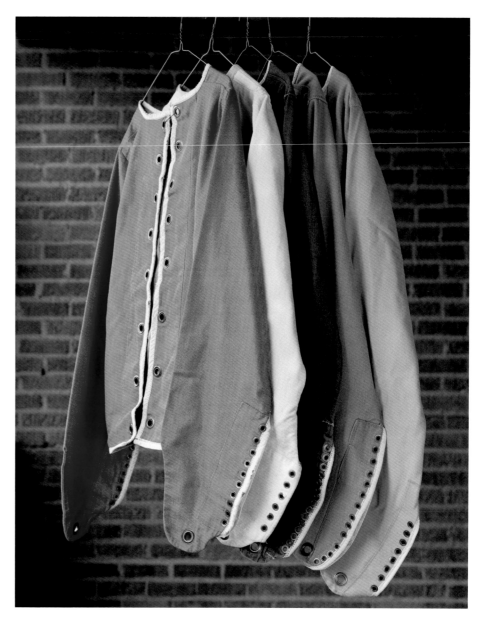

Straightjackets from Iowa and North Dakota state hospitals 185

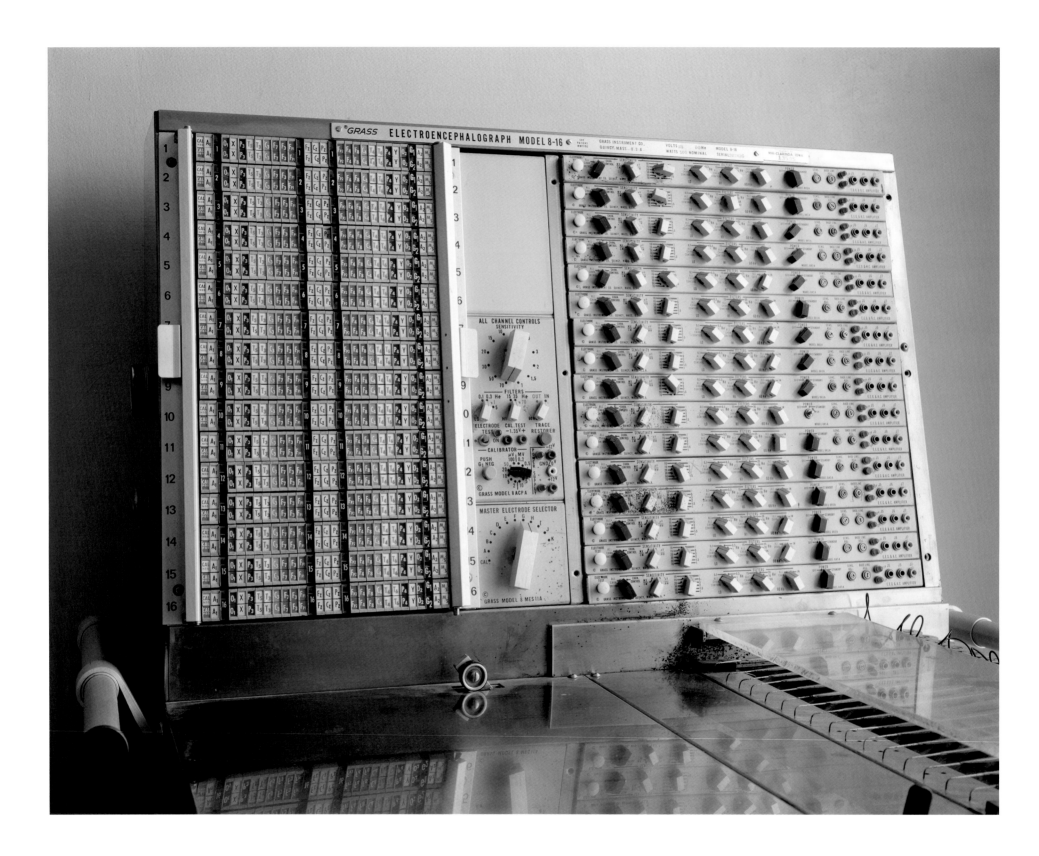

Electroencephalograph, Clarinda State Hospital, Clarinda, Iowa

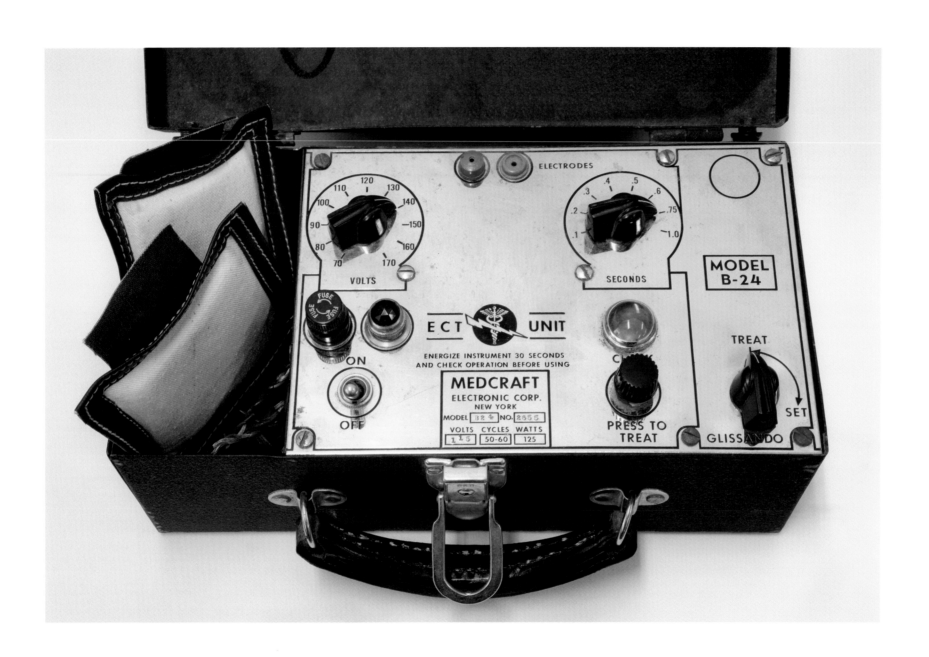

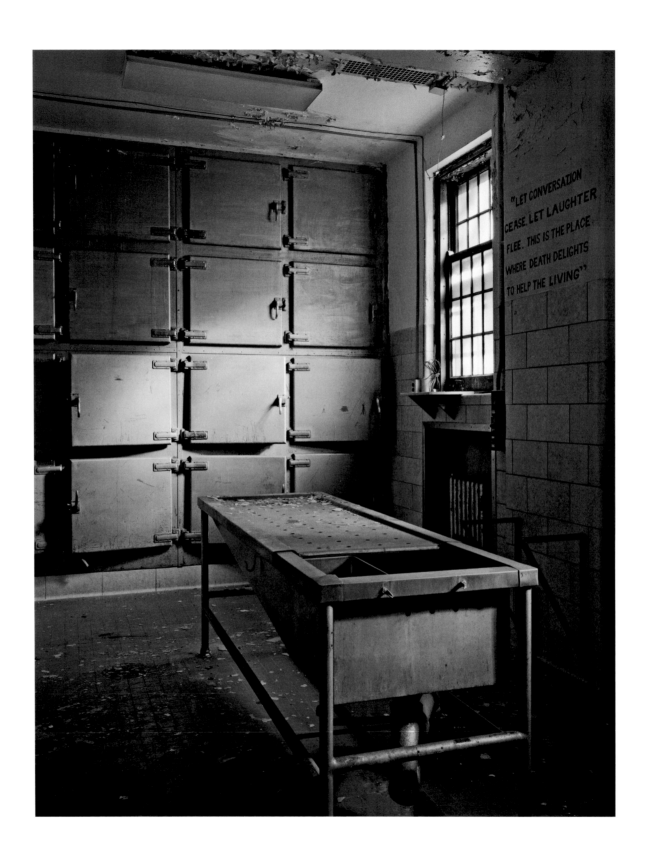

Morgue, Pilgrim State Hospital, Brentwood, New York

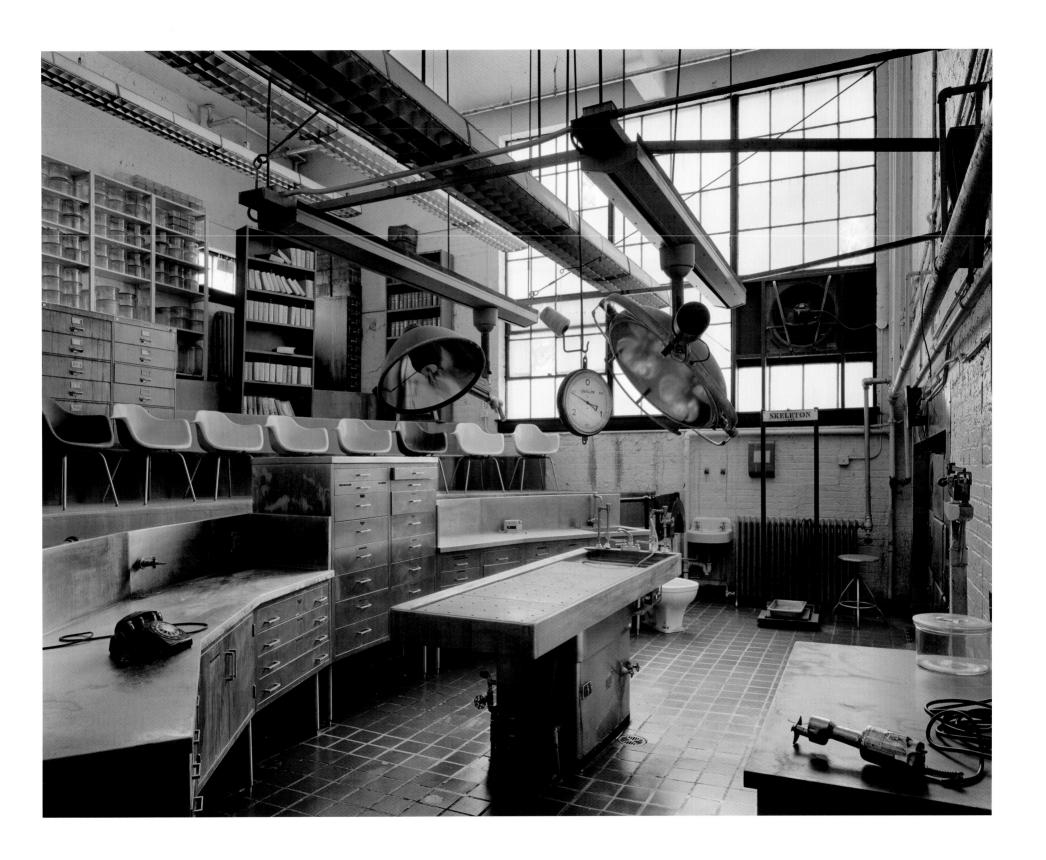

Autopsy theater, St. Elizabeth's Hospital, Washington D. C. 189

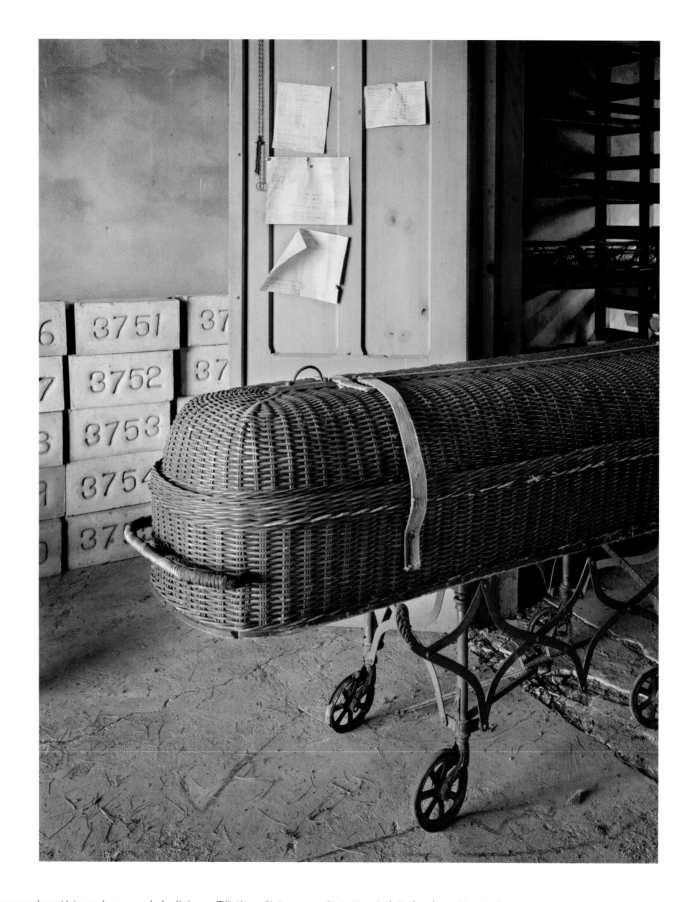

190 Casket and unused grave markers. Lists on door recorded religious affiliations. St. Lawrence State Hospital, Ogdensburg, New York

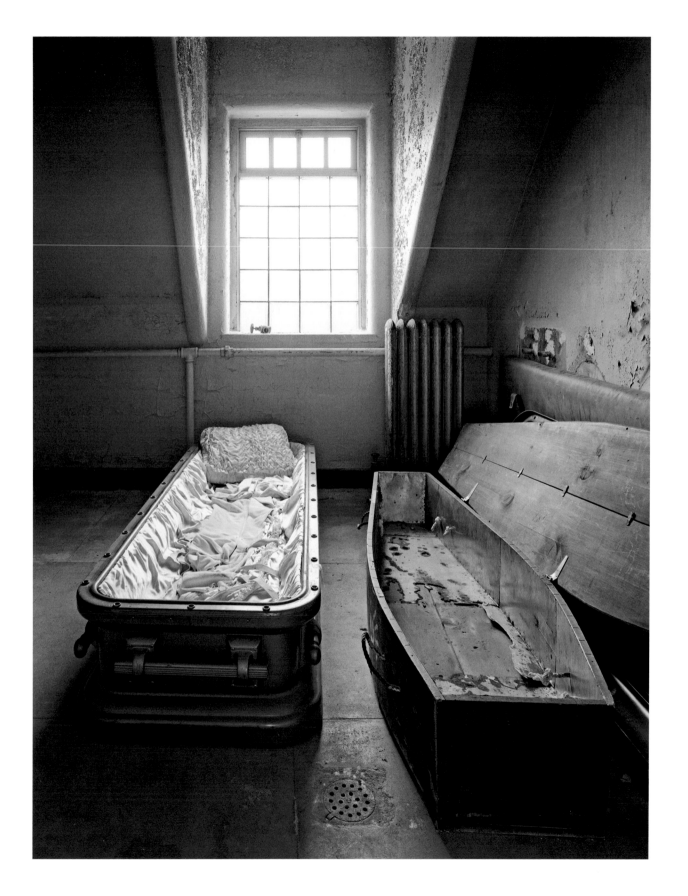

Coffins in attic, Fergus Falls State Hospital, Fergus Falls, Minnesota

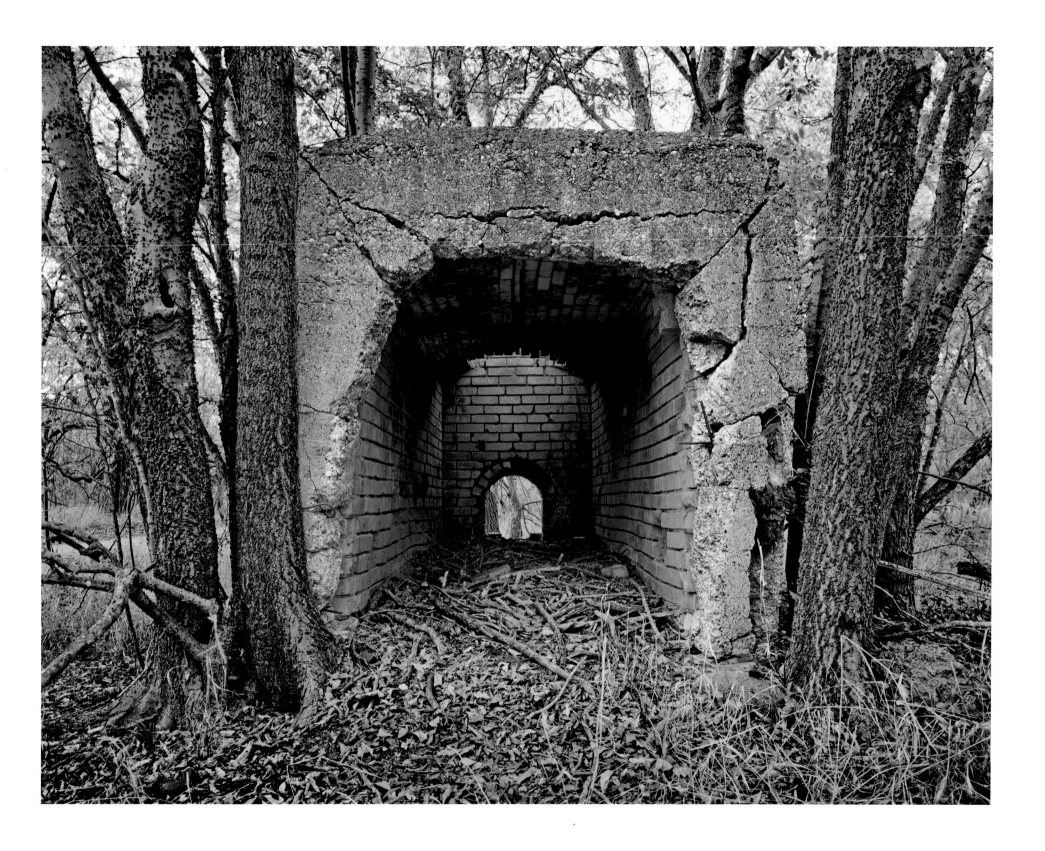

Crematorium, Terrell State Hospital, Terrell, Texas 193

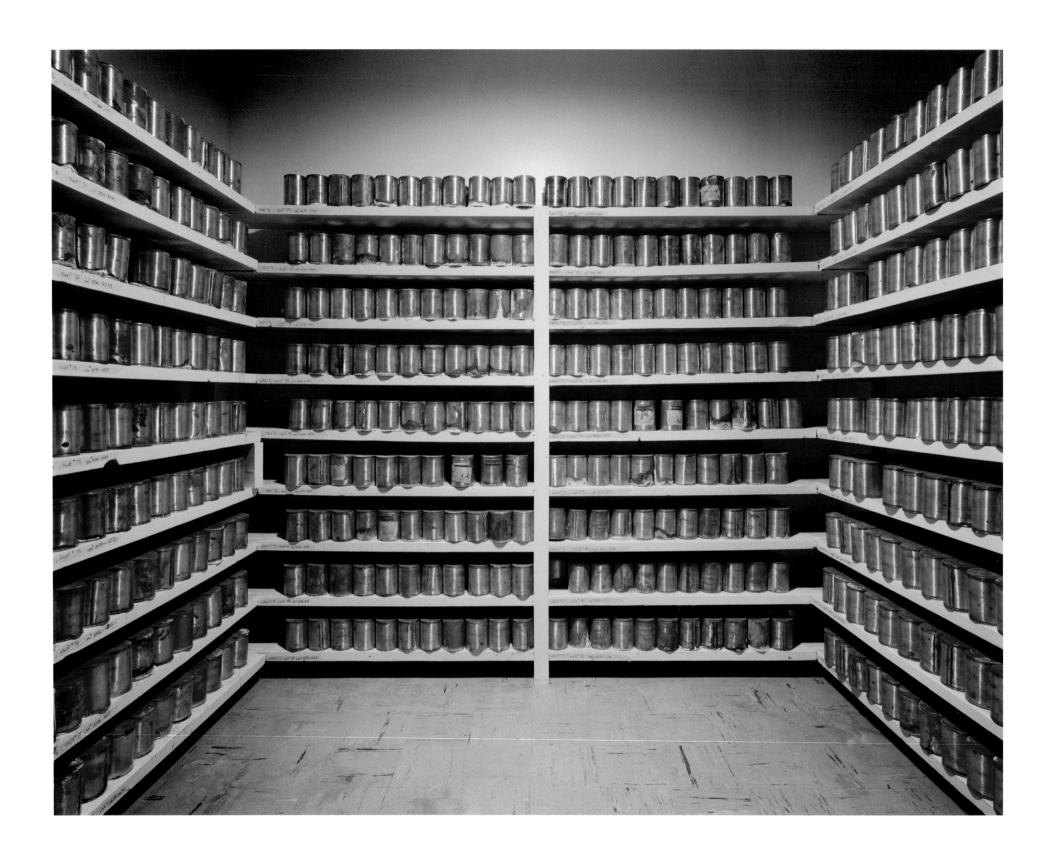

Unclaimed copper cremation urns, Oregon State Hospital, Salem, Oregon

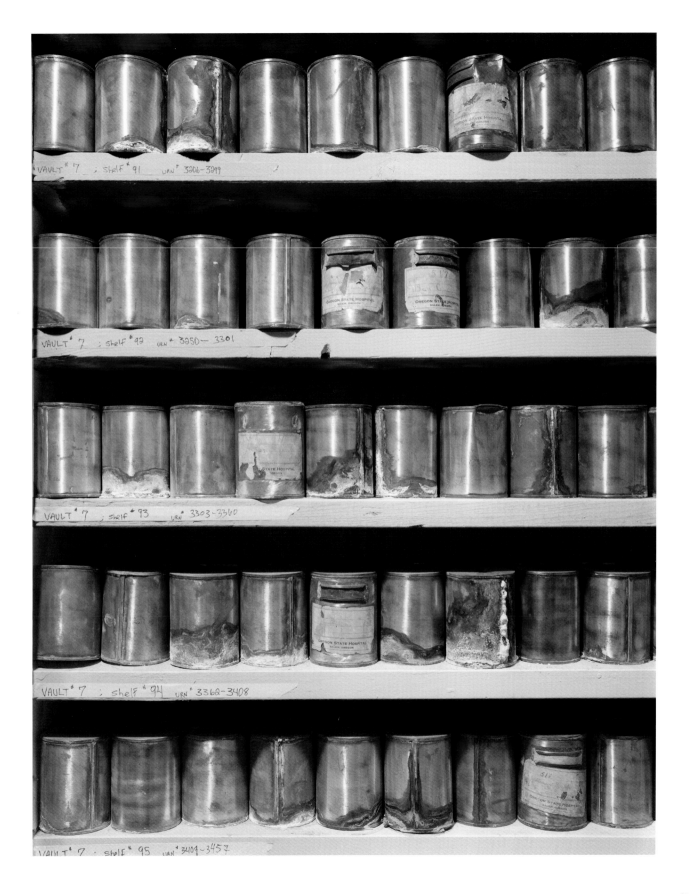

Detail of cremation urns 195

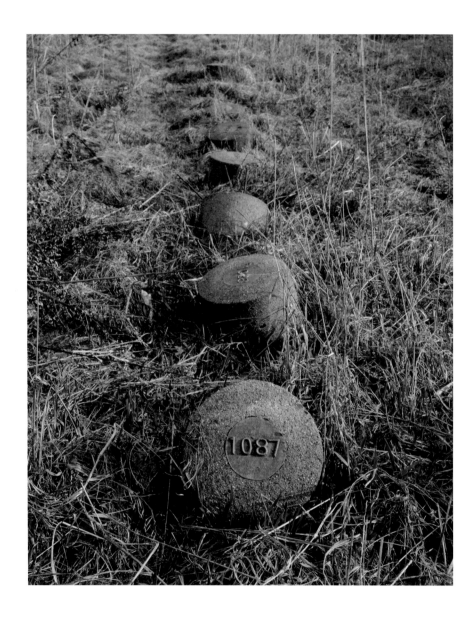

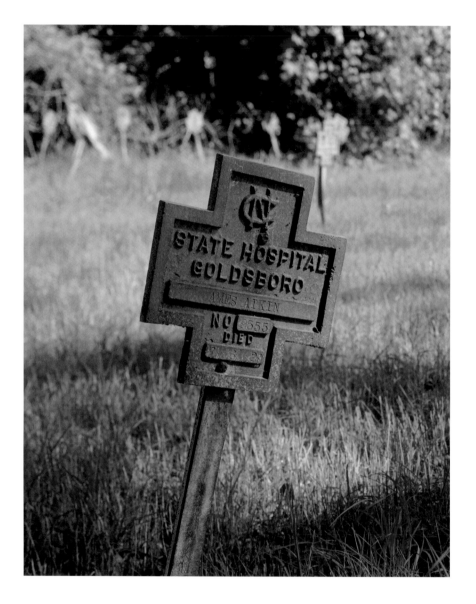

LEFT: Grave markers, Harlem Valley State Hospital, Wingdale, New York. RIGHT: African-American cemetery grave marker, Cherry State Hospital, Goldsboro, North Carolina

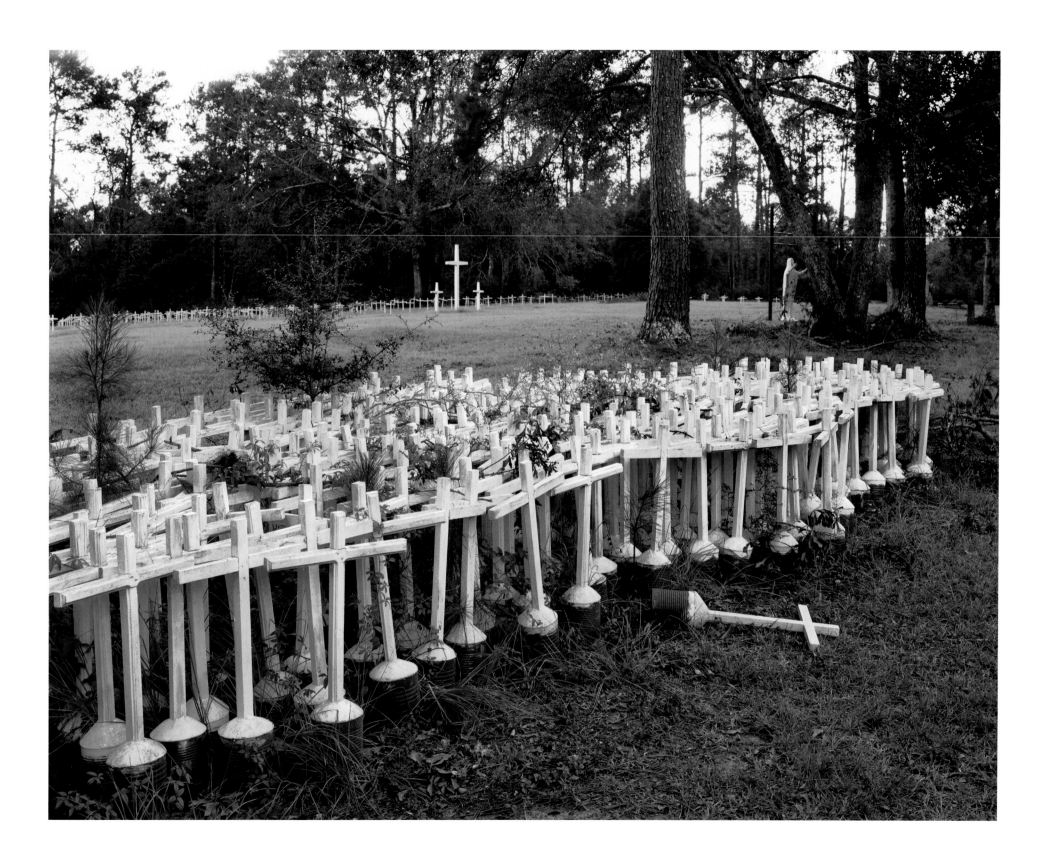

Unused grave markers, East Louisiana State Hospital, Jackson, Louisiana 197

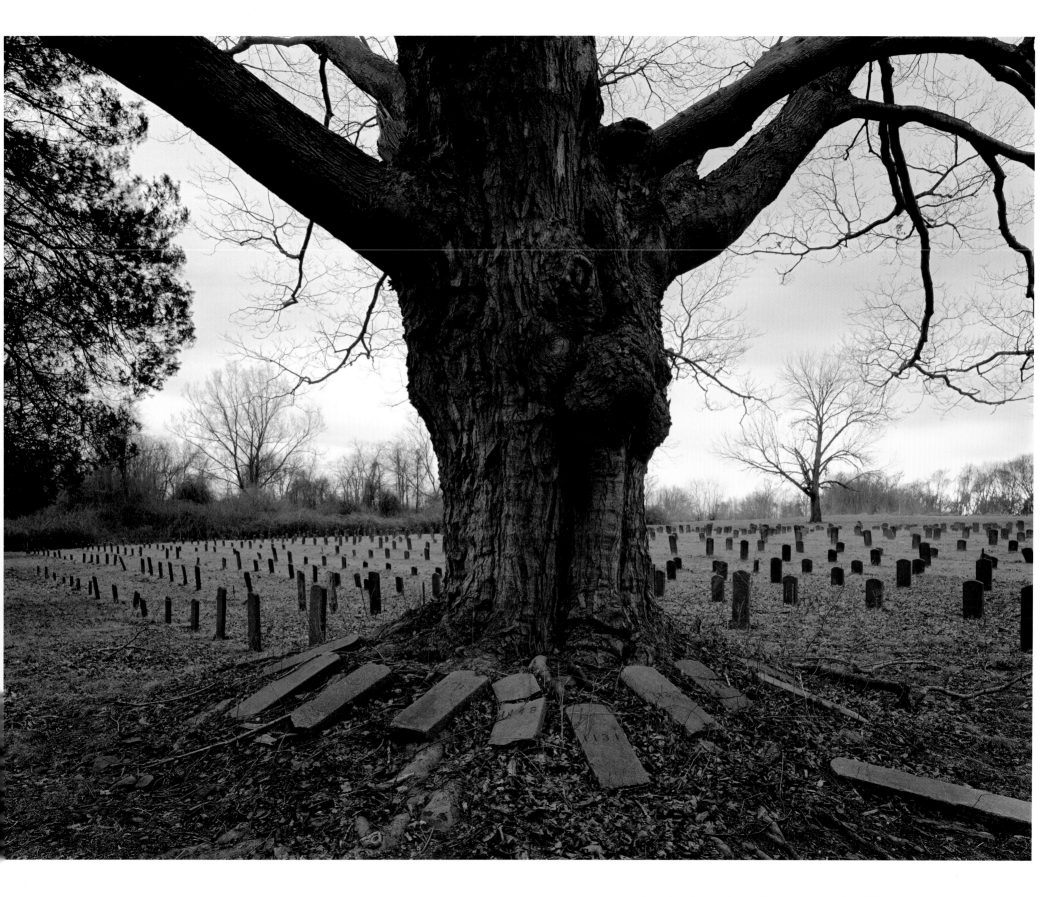

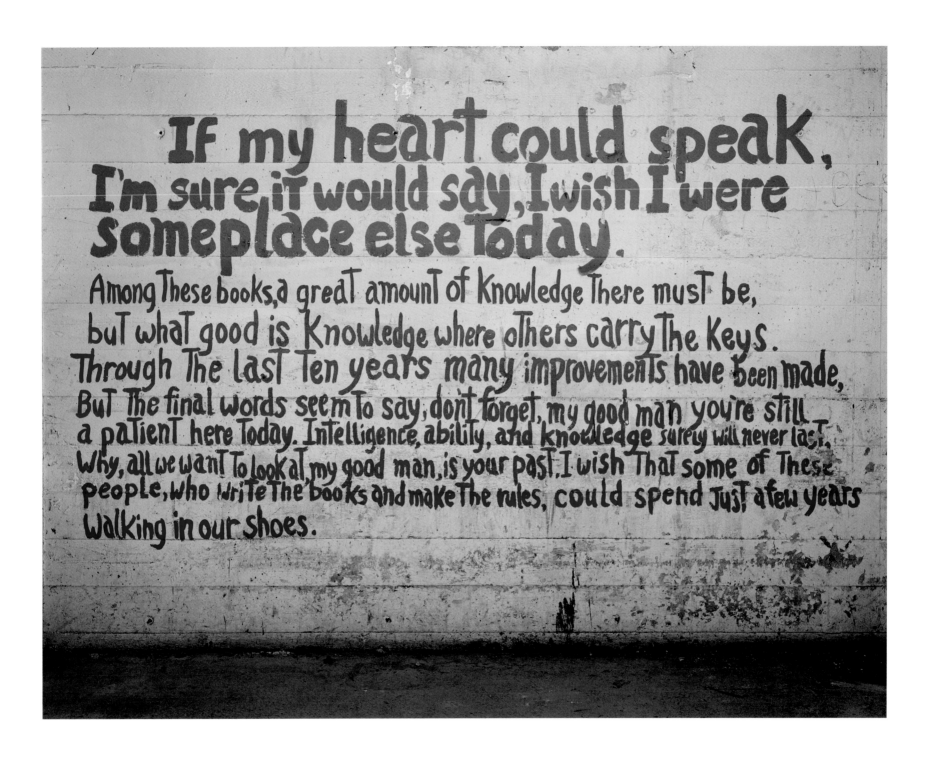

If my heart could speak,
I'm sure it would say, I wish I were
someplace else Today.

Among These books, a great amount of Knowledge There must be,
but what good is Knowledge where others carry The Keys.
Through The last Ten years many improvements have been made,
But The final words seem To say, don't forget, my good man you're still
a patient here Today. Intelligence, ability, and knowledge surely will never last.
Why, all we want To look at my good man, is your past. I wish That some of These
people, who write The books and make The rules, could spend Just a few years
walking in our shoes.

Before I began this project in the summer of 2002, I had never visited a state mental hospital. A friend, who knew my interest in forgotten architecture and industrial archeology, told me about one on Long Island he thought might interest me. It was Pilgrim State, the largest facility of its kind in the world when it was built in the 1930s. I drove there and was immediately astounded by its size and dumbfounded by its desolation. Only a small part of it was still in use. I wondered how a place so big, easily larger than any number of towns or major universities, could be so forsaken.

I left that day with an overwhelming desire to know more, and in the weeks following, I discovered more state hospitals in the New York area, all of which resembled ghost towns. By the end of 2008, I had visited over 70 hospitals in 30 states. The majority of them were still functioning, albeit at a fraction of their original capacity. The farms were long gone and the hospitals no longer engaged in any manufacturing or food processing. Still, touring the grounds and empty buildings, it was not difficult to imagine these enormous complexes in full operation, and to appreciate the tremendous effort it took to keep them going by the thousands of people who lived and worked there. The idea of self-contained communities that grew their own food and made their own shoes fascinated me and seemed to speak to a more environmentally sensible way of life.

I anticipated my greatest challenge would be access. Given the negative public opinion these hospitals had long engendered, I expected my requests to be denied. In fact, I encountered little resistance and met many administrators and workers who were proud of the hospital's history and eager to see it documented. Many of them had worked at the hospitals for most of their lives, as had family members before them. Some were puzzled as to why I had driven hundreds of miles to photograph a decrepit old building. When I mentioned my interest in these places as examples of institutional self-sufficiency, where food, clothing, energy, and other necessities were produced on the premises, they inevitably nodded with understanding. I never grew tired of hearing their stories, no matter how similar they were. Nearly everyone told me emphatically that the court decisions of the 1970s, which ended patient labor practically overnight and forced closure of the shops and farms, did as much damage to the patients as it did to the hospitals. Oliver Sacks drew the same conclusion from his clinical observations.

In discussing the project with friends, I heard the usual superstitions and third-hand horror stories. What I did not expect were the number of people who had a personal connection to these institutions, the stories of an aunt or grandfather who had spent years in a state hospital. A musician friend remembered playing in a band hired to give concerts for the patients; others recalled summer jobs and volunteer work. Conflicting emotions were inevitable as I learned about the original, noble intent of the asylums and the harsh reality of court-directed social control and severely overcrowded conditions. But coming from a generation that was less burdened by stereotypes, when the hospitals were no longer haven or threat, I was

CHRISTOPHER PAYNE
AFTERWORD

Rooftop, Danvers State Hospital, Danvers, Massachusetts

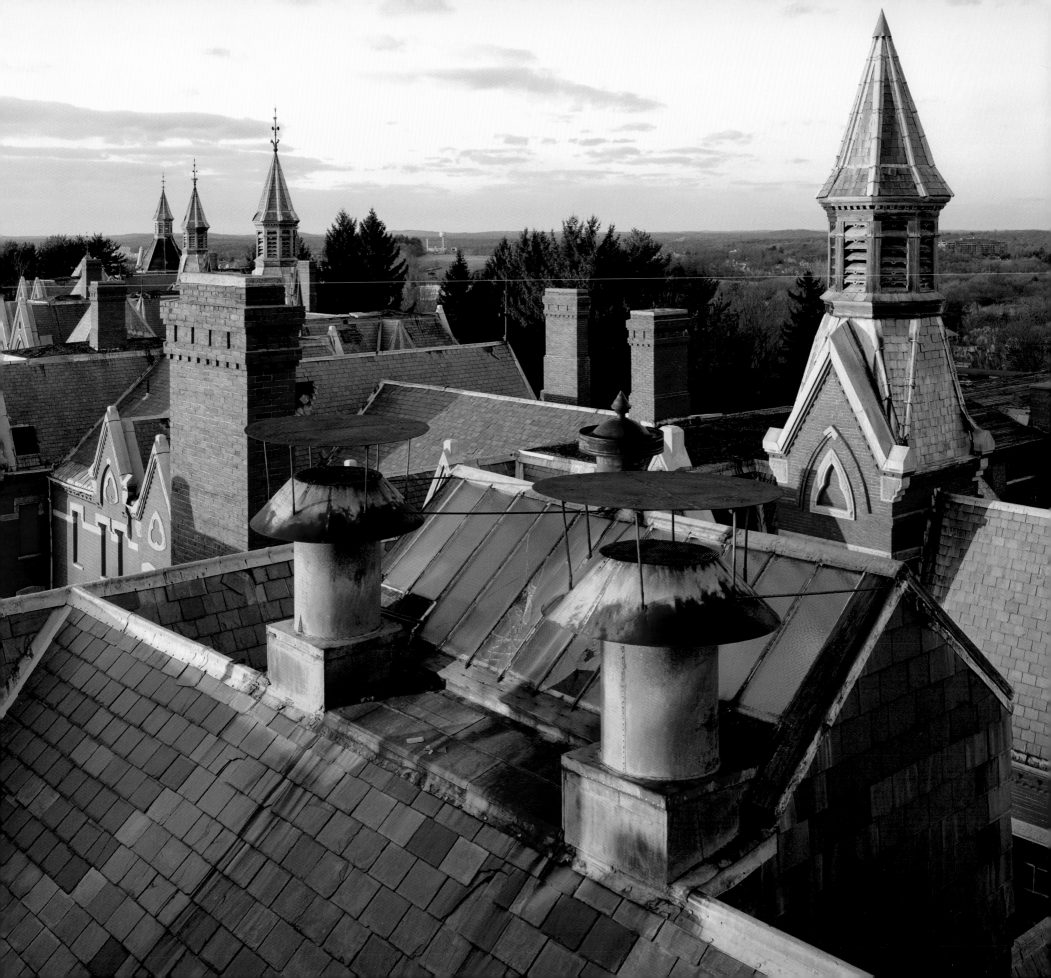

able to look more objectively and show how they functioned, and how grand was their architecture.

While the monumental architecture of the hospitals impressed me greatly, my deeper imagination was captured by the more utilitarian structures: the agricultural buildings where food was processed, the shops where clothing was made, the informal places where patients socialized. Almost every hospital had something special to offer: an extraordinarily well-made building that had been abandoned for years or, perhaps, a locked room whose contents were an unintended time capsule. It was no longer possible to find one hospital with all its parts intact, but by juxtaposing a photograph of a theater from one hospital, a morgue from another, a bowling alley from a third, and so on, an entire model hospital could be recreated.

The physical condition of the hospitals varied from building to building, and even from room to room; one might be extremely well-preserved while another's ceiling was caved in, exposing its contents to the sky. The "Kirkbrides" were particularly prone to decay because of their size. Typically, as the patients left, the outer wards were abandoned until only the central administration building remained in use. Here the line between past and present—between a modern, heated, occupied office and a cold, dilapidated ward—was sharply drawn, separated by no more than a locked door.

The collapse of the structures was ongoing, but exactly how it happened was a mystery. Was it gradual and natural, the way wind and water smooth stones? Or was it sudden, as when years of silence are interrupted by a violent shift—a board gives way, a brick comes loose, a wall falls, and a new order is created? Perhaps it was both. Now everything seemed still, as if a balance had been struck just long enough to take a picture. Standing in these spaces, I could feel the heaviness of air laden with dust beginning to coat my skin. Polaroid wrappers left behind from my earlier shoots were quickly absorbed, like fossils in a new layer of sediment. (There was no obligation to take out the trash, as the buildings themselves were discards, and yet I found myself doing so out of respect.) Gravity was constantly tugging on these structures, just as it does to people, returning them back to the earth.

THE INSIDES OF THE BUILDINGS were not as mysterious as they appeared on the outside; their division of space inevitably followed an established syntax with which I had become fluent. I found no ghosts inhabiting the hallways, and yet, the spaces conveyed their own emotion, a sadness at having been abandoned so abruptly and having stood empty for so long. Being alone in the buildings, I couldn't help but feel a certain intimacy with them, and a strong sense of protectorship and responsibility as, perhaps, their final documenter. One week I might have had a place all to myself; the next I might be barred from the property by a new owner, usually a real estate developer fearing negative publicity as a destroyer of landmarks.

The destruction of one hospital in particular affected me deeply: Danvers State

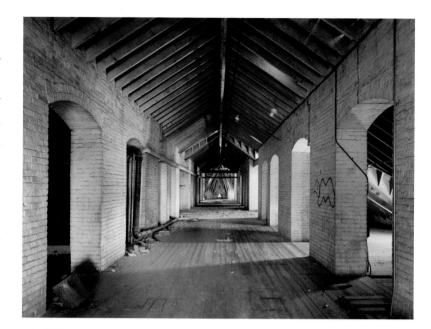
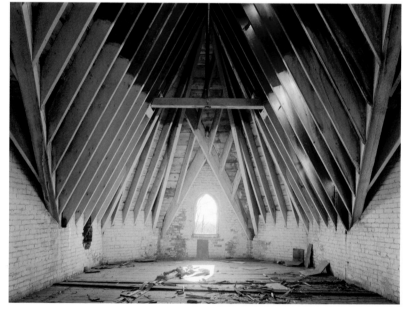
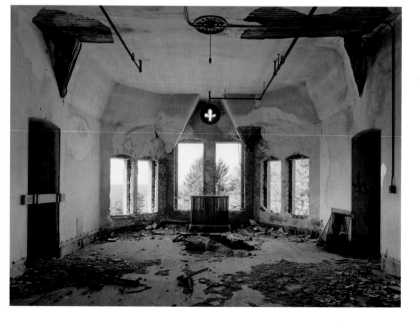

Demolition, Danvers State Hospital, Danvers, Massachusetts

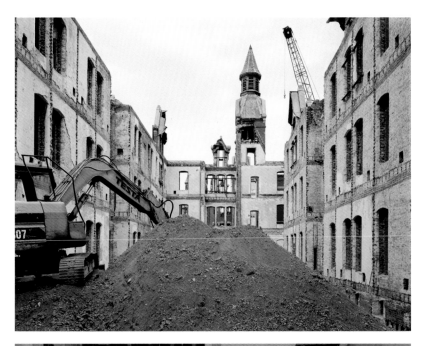

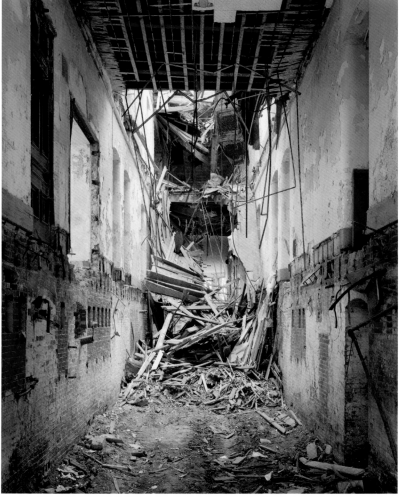

Hospital in Massachusetts. It was one of the last hospitals I photographed, and one that I had been trying to get inside since my project began. I had grown up in Boston and had cousins who lived in Danvers. Long before I knew it existed, the hospital had been part of the trip to see my family, and it became retroactively linked to my happy memories of those drives.

From Interstate 95, Danvers State Hospital could be seen looming in the distance high on top of a hill. It looked like an ancient, far-away castle, with towers poking above the trees, forming a long string of peaks that hinted of its monumental size. While the world below had changed, the hospital had remained isolated and frozen in time, completely at odds with the surrounding suburban sprawl. It had been built between 1873 and 1877, designed by the well-regarded architect Nathaniel Jeremiah Bradlee, whose work is still very much in evidence in Boston and throughout New England. Its classic Victorian haunted-house architecture had become part of local mythology and perhaps the national mythology: Danvers State is believed to have been the inspiration for the Arkham Sanitarium in several H. P. Lovecraft stories (and, by homage, Arkham Asylum for the Criminally Insane in the *Batman* comics series). With its closing, in 1992, its enigmatic reputation had only grown. When I first visited it, the hospital had been for sale for a few years, though no serious plans for its reuse had been proposed; neither the town nor the state was interested in its preservation. The land had become prime real estate. Rumors of demolition circulated and were finally confirmed by the hospital's sale to a local developer. I thought I would never gain access, but after weeks of persistence, the new owners finally agreed to my request.

I had photographed the exterior two years earlier, when it was still owned by the state. At that time, not a soul was around and it was completely silent, except for the wind. Now it was a different scene entirely: uprooted trees and the entire apparatus of modern demolition covering its lawns. The boards covering the hospital's windows had been pulled off, allowing light inside for the first time in more than a decade. As part of the demolition process, everything of value had been removed, except those items deemed too large and heavy. The interior shell was mostly intact, however, and still retained stamped tin ceilings and varnished oak millwork. Despite the destruction, the hospital's grandeur was undiminished, and in this emptiness I saw the interiors as they were originally intended: large, open, full of light and air.

As Danvers was torn apart, material beneath the surface became visible for the first time in more than a century. Intricate plaster laths, heavy beams and timbers, layers of brick and stone all spoke of the painstaking preparation required to assemble a building of such complexity. Concealed from the environment for so long, these raw, humble materials still bore the fresh imprint of human hands, as if the space of 130 years was compressed instantly into one precious moment. How ironic it was that so much care and effort was put into a structure intended solely for society's outcasts.

I returned to Danvers several times, and each time more of it had vanished. At

a certain point, it was no longer what it had once been. Half full had become half empty, and then even less. Mountains of rubble separated into stone, metal, and brick (materials that could be salvaged and sold) grew higher as the building receded. Interiors I photographed a week earlier no longer existed, and I struggled to orient myself as to where they had been. From the highway, the peaks disappeared, one by one, as did the large trees that had grown up alongside them. The center building and two wings were retained as a facade for the new housing development. As if to cleanse the past, these sections were completely gutted, leaving only the exterior shell. Before, these walls looked impenetrable; now they had to be propped up to be kept from toppling over.

I hesitated to tell the site manager how disturbing it was to watch this happen, since he represented the developer's interests. But as we spoke, he echoed the same sense of loss I felt and added soberly: "When I first saw this place, I fell in love with it. Now without the building, it's just a place, like any other."

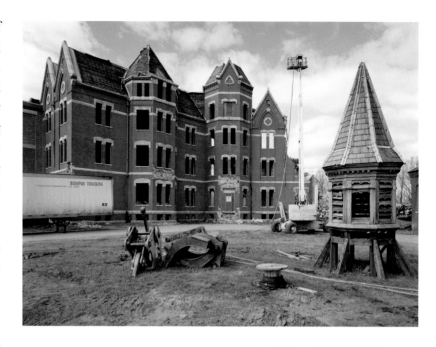

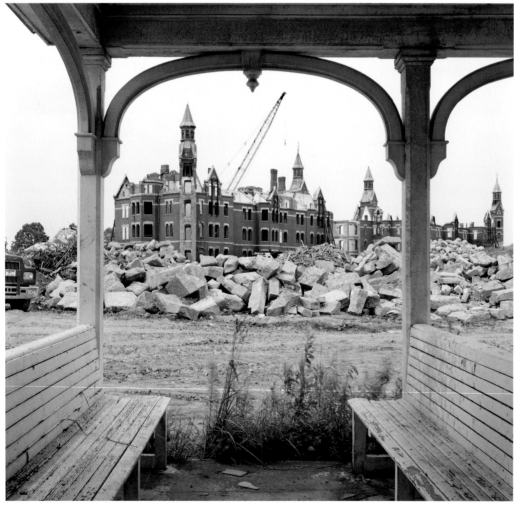

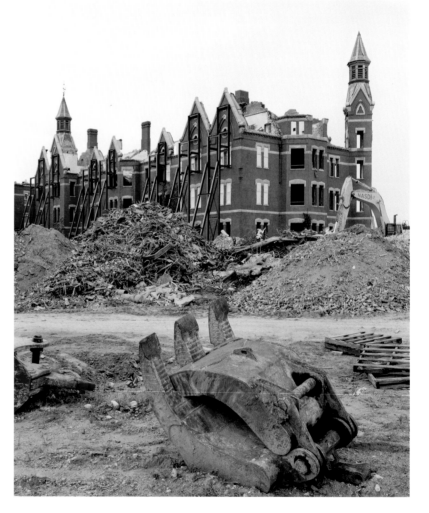

Demolition, Danvers State Hospital, Danvers, Massachusetts

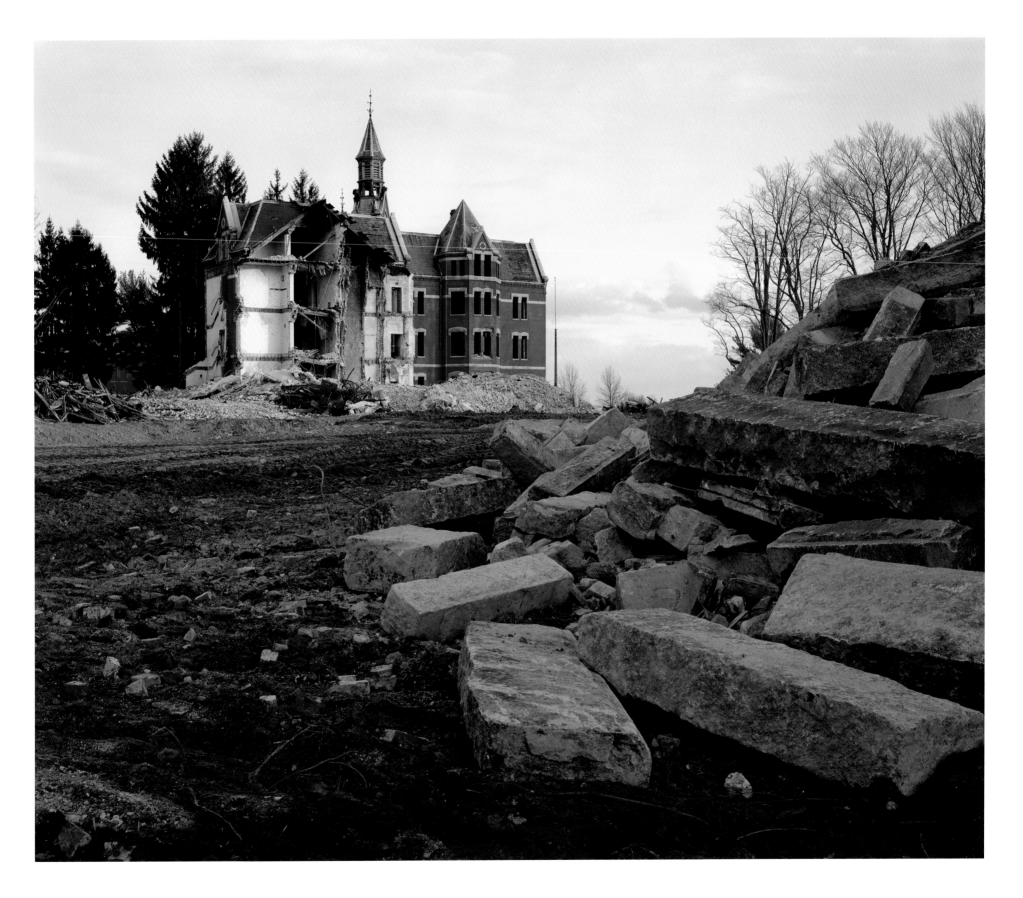

ACKNOWLEDGMENTS

THIS PROJECT would not have been possible without the generous cooperation and support of the state hospitals and departments of mental health, through which permissions were obtained to photograph the buildings. I would like to thank the following persons who were instrumental in providing information, facilitating access, and coordinating my visits: Bruce Aldrich, Mark Anders, Donna Ashbridge, Kim Ballard, Suzanne Barclay, TyLynne Bauer, Daniel Brennan, David Bennett, Jon Berry, Lester Blumberg, Janice Bowen, Jessica Bradley, Daniel Broumley, Richard Buotte, Joel Campbell, Anna Chinappi, Roger Christenfeld, Tom Cisek, Anthony Clarke, Steve Cobb, Marj Colburn, Ira Collins, Laura Collins, Barry Cote, Wayne Dailey, Tom Daniels, Bhasker Dave, Tom Deiker, Sally Delgado, Lashunda Dennis, Kathleen Desmarais, Bill Dorholt, John Doster, Rosalie Etherington, Marvin Fickle, Thomas Ford, Lynne Garner, William Gibson, Linda Grant, Shadi Haghani, Elaine Hill, John Hutto, George Jessen, Phyllis Jones, Phil Jorgensen, Sara Kalvin, Suryabala Kanhouwa, Roger Klingman, Aaron Levin, Michael Loftus, Mike Lucas, Kevin Lynch, Faye McArthur, Mary Louise McEwen, Michael McGill, Michael Mefford, Adrienne Meli, Byron "Bud" Merritt, Cleo Mollett, Tony Morris, Garrell Mullaney, Elizabeth Murphy, Terrill Myers, Karen Nicholson, George Niles, Ray Price, Dusty Rhodes, Anthony Riccitelli, Gregory Roberts, Dominic Romeo, Clifford Schwartz, Mark Simmons, Elizabeth Smith, Gregory Smith, Stuart Stainman, Joy Stalnaker, Irene Taylor, Virginia Terpening, Brian Thayer, Stacey Ward, Andy Williams, Melvin Williams, John Ziegler.

Many hospital employees escorted me through the hospitals, opened locked doors, carried equipment, and showed me things that I would have missed otherwise, often on their own time and on weekends. Their recollections breathed life into the old buildings, and our friendly conversations made me feel welcome when I was far from home. In particular, I wish to thank: Don Abel, Ruby Anthony, Judy Barbeau, Bryan Bretschneider, Steve Burke, Doug Burnham, Al Cibelli, William Deblouwe, Larry Dody, Don Edwards, Kris Flowers, Tom Greer, Catherine Hickey, Heidi Johnson, Jeffrey Johnson, Dave Kearney, Barbara Kelly, Diane Knaack, Aaron Lewis, Richard Maroney, Charlie McCardle, Carl McCormack, Cory and Kimberly Nelson, Brian Newell, Blaine Paulus, Louise Perugini, Richard Reneau, David Roane, Kathy Schibanoff, Shane Shoemaker, Charles Stackhouse, Michael Wagner, Carter Wormeley.

I am indebted to my friend Frank Keefe, for his assistance in helping me gain access to Danvers State Hospital. When I had all but given up hope, Frank achieved a miracle.

I am grateful to Karen Bourdelais for the use of her wonderful period postcards, which allow us to see the asylums as they were originally intended to be seen, and to Ethan McElroy, for putting me in touch with Karen. Kathy Evavold at the Otter Tail County Historical Society provided photographs of Fergus Falls that I had been in search of for years, and Samantha Brennan located important archival images at the American Psychiatric Association. I am also grateful to Gregory Smith, of Allentown State Hospital, who provided me with historic photographs and post-cards from his personal collection, as well as advice and support. Other historic images appear courtesy of Greystone Park, Pilgrim, and Hudson River Psychiatric Centers. The identity of the Cherry State Hospital patient, shown on the grave marker on page 196, has been altered to protect family privacy.

Thanks to my friends Kelly Grider and Ayumi Sakamoto for their excellent work processing film; to Eric Jeffreys, my skillful Photoshop guru; and to

John Bartelstone, Joseph Elliott, and Gerry Weinstein, for all things photographic, and Fletcher Manley and Steve Orf for their expert help in the more esoteric aspects of image reproduction. Amy Akulin, Kate Allen, Alexandra Castano, Cemre Durusoy, Ian Ference, Lorenzo Mattii, Sara Jane Sloves, Benjy Ward, and Corey Yurkovich assisted me on shoots. Their company made the long drives to the hospitals pass quickly and the hours spent in the abandoned buildings not so lonely. Our times together are now among my fondest memories. Other friends made invaluable contributions along the way, from reviewing photographs and layout to simply providing a boost of confidence when I needed it: Ann Batchelder and Bruce Sunstein, David and Patricia Burson, Sophie Deutsch, Mike and Sadie Dyer, Donna Edelbaum, Emily Gordon, Eileen Heaney and James Hullett, Narguess Noshirvani, Jennifer Radden, Nicolas Rojas, Beth Tondreau, Marianna Wilcox and Bertrand Bell, Mimi Zeiger, Claire Zimmerman, and especially, Gaby Moss, for lending a creative hand to shape the first text drafts, and Catherine Brophy, for contributing her sharp editorial skills. Lauren Crahan was with me from the beginning of the project to its completion, and has been a constant source of encouragement and critical insight. Special thanks to Justin Weiner, for being the most accommodating employer anyone could ask for. And my very deep thanks to Vella Chan, for being my best friend and helping me with every aspect of this project.

I am fortunate to have wonderful friends and relatives who provided a home away from home while I was on the road: Tatiana Escobar, Christine and David Fitzgerald, Harry and Margaret Jones, Lisa Pruett and Greg Lawler, Mary Morgan, Eric and Martha Payne, and especially Timothy McQuestion, who lent me his room and slept in the architecture studio for five nights while I photographed Buffalo State Hospital.

When I was growing up in Boston, I remember driving by Boston State Hospital with Dr. Kyle Pruett, who recalled his experience there as a psychiatry resident in the early 1970s. Kyle has been a lifelong friend, and has helped me immeasurably, but for this moment I must thank him especially because he planted the seed of interest that grew many years later into this project.

I will forever be indebted to Oliver Sacks for his interest, his kindness, and his superb essay. His medical perspective and personal recollections add clarity to my work and place my photographs in a more humane context. I am also beholden to Kate Edgar and Michael McPherson, without whom I never would have met Dr. Sacks. Prof. Carla Yanni, a leading scholar of the hospitals, was an essential help in reviewing the texts and providing advice.

The original funding for this project was provided by grants from the New York State Council on the Arts and the New York Foundation for the Arts. Generous support toward the production of the book came from the HPB Foundation through Lucinda Jewell, to whom I am extremely grateful.

Two people have been most responsible for turning this book into a reality: Roger Conover, executive editor at MIT Press, for believing passionately in this project at a time when others were skittish, and Scott-Martin Kosofsky, whose roles in this book were key and many: agent, packager, editor, designer, typographer, and producer. Scott is a longtime family friend, as is his wife, Betsy Sarles, who contributed her acute design sense whenever and wherever it was needed.

Finally, I must thank my parents, Joseph and Phoebe Payne, for their unconditional love and support. This book is dedicated to the memory of my father, Joseph Payne, a great musical artist and lover of photography.

CHRISTOPHER PAYNE, a photographer in New York City, specializes in the documentation of America's vanishing architecture and industrial landscape. His first book, *New York's Forgotten Substations: The Power Behind the Subway* (2002), offered dramatic, rare views of the behemoth machines that are hidden behind modest facades in New York City. Trained as an architect, Payne is a graduate of Columbia University and the University of Pennsylvania. His interest in historic buildings and industrial architecture began shortly after college, when he documented cast iron bridges, grain elevators, and power plants for the Historic American Engineering Record of the National Park Service, and, later, produced measured drawings for New York University's excavations at Aphrodisias, a Greco-Roman city in Turkey. He has been awarded grants by the Graham Foundation, the New York State Council on the Arts, and the New York Foundation for the Arts.

OLIVER SACKS, a neurologist, is best known for his collections of case histories from the far borderlands of neurological experience, *The Man Who Mistook His Wife for a Hat* and *Awakenings*, the book that inspired both a feature film with Robert De Niro and Robin Williams, and the play *A Kind of Alaska*, by Harold Pinter. His most recent book is *Musicophilia: Tales of Music and the Brain*. Described by the *New York Times* as "the poet laureate of medicine," Dr. Sacks's work appears regularly in the *New Yorker* and the *New York Review of Books*, as well as in medical journals. In 2007, he was appointed a Professor of Neurology and Psychiatry at Columbia University Medical Center, and he was designated the university's first Columbia Artist.